The Romantic Spirit

THE ROMANTIC SPIRIT

German Drawings, 1780–1850,

from the Nationalgalerie (Staatliche Museen, Berlin)

and the Kupferstich-Kabinett (Staatliche Kunstsammlungen, Dresden),

German Democratic Republic

By

Peter Betthausen, Claude Keisch, Matthias Kühn, Gertraute Lippold,

Gottfried Riemann, Maria Ursula Riemann-Reyher, and Werner Schmidt

Edited by Gottfried Riemann (Berlin) and William W. Robinson (New York),

with the assistance of Pamela T. Barr

The Pierpont Morgan Library · Oxford University Press · New York 1988

Exhibition Dates
The Pierpont Morgan Library
17 November 1988–29 January 1989

This exhibition has been made possible, in part, by a grant from the National Endowment for the Arts and an indemnity from the Federal Council on the Arts and the Humanities. Additional support has been provided by the New York State Council on the Arts.

Cover:
Karl Friedrich Schinkel
Mountain Range in Bohemia at Sunset (Cat. No. 36, detail)

Designed, printed, and bound by Meriden-Stinehour Press
Meriden, Connecticut, and Lunenburg, Vermont

Contents

NOTE ON THE AUTHORS

Prof. Dr. Peter Betthausen, Director, Nationalgalerie, Staatliche Museen, Berlin

Dr. Claude Keisch, Research Assistant, Nationalgalerie, Staatliche Museen, Berlin

Dr. Matthias Kühn, Assistant Curator, Kupferstich-Kabinett, Staatliche Kunstsammlungen, Dresden

Dr. Gottfried Riemann, Curator, Sammlung der Zeichnungen, Nationalgalerie, Staatliche Museen, Berlin

Dr. Werner Schmidt, Director, Kupferstich-Kabinett, Staatliche Kunstsammlungen, Dresden

AUTHORS OF CATALOGUE ENTRIES

C.K. Claude Keisch (Nationalgalerie, Staatliche Museen, Berlin)

G.L. Gertraute Lippold (Kupferstich-Kabinett, Staatliche Kunstsammlungen, Dresden)

M.U.R. Maria Ursula Riemann-Reyher (Nationalgalerie, Staatliche Museen, Berlin)

G.R. Gottfried Riemann (Nationalgalerie, Staatliche Museen, Berlin)

Preface

In today's troubled and antagonistic political climate, literally every gesture of good will, reason, and international understanding contributes to the promotion of peace on our planet. While this multifaceted process of cooperation takes place primarily in the political and economic spheres, the roles of art and culture are also significant.

Witness the recently intensified cultural relations between the United States and the German Democratic Republic. Guest performances by important ensembles, such as the Gewandhaus Orchestra of Leipzig, are already a tradition in the United States. Other notable contributions include appearances by renowned vocal and instrumental soloists and leading conductors, the reciprocal publication of new and classic works of literature, and the lively exchanges between museums of both countries.

Following the major exhibition *The Splendor of Dresden*, which traveled to Washington, New York, and San Francisco, in 1978 and 1979, the Leipzig collection of Bernini drawings was shown in 1981 in Princeton, Cleveland, Los Angeles, Fort Worth, Indianapolis, and Boston. The Dresden museums have lent precious works by Dosso and Battista Dossi, Crespi, Bruegel, Klimt, van Gogh, and others to exhibitions in the United States. The jointly organized retrospective devoted to El Lissitsky in Cambridge (Massachusetts), Hanover, and Halle will be followed by a show in Los Angeles, Texas, Düsseldorf, and Halle that will survey the second wave of German Expressionism. In addition, the exhibition in the United States of works by contemporary artists from our country—professors Willi Sitte and Wolfgang Mattheuer have already had U.S. shows—will surely continue to interest American art lovers.

The present exhibition, which comes from outstanding museums in the German Democratic Republic—the Staatliche Museen, Berlin, and the Staatliche Kunstsammlungen, Dresden—marks another step on the path toward cooperation between our nations. It was supported by the governments of both countries, and graciously and perceptively organized by the two museums in the German Democratic Republic and The Pierpont Morgan Library. We hope that it finds an interested and receptive public, and that it will lay a solid foundation for future projects of this kind.

Prof. Dr. sc. Günter Schade
GENERAL DIRECTOR
STAATLICHE MUSEEN, BERLIN

Introduction

We are especially delighted to comply with The Pierpont Morgan Library's request for an exhibition of German drawings from the period 1780 to 1850 because this project enables us to contribute substantially to the lively interchange that has developed between museums in the United States and those in the German Democratic Republic.

The international renown of German culture during these years stemmed largely from the achievements of writers and musicians. To be sure, Peter Cornelius and Friedrich Overbeck were highly regarded by their Italian, French, English, and Russian contemporaries, Caspar David Friedrich had earned the esteem of connoisseurs in Paris and St. Petersburg, and, as early as 1834, the popular English art critic, Mrs. Anna Jameson, had praised Friedrich's work and compared it to Turner's: "His genius revels in gloom as that of Turner revels in light" (*Visits and Sketches at Home and Abroad*, New York, 1834). However, after the middle of the century the universal triumphs of Realism and Impressionism had confined the legacy of German Romantic painting, with its classicizing formal language, to the local level.

During the first half of the twentieth century, German artists and art historians undertook a major reappraisal of the Romantic period. However, this process was so deeply imbued with the nationalistic bias of the times that it was not until 1974, when exhibitions were held in Dresden and Hamburg to commemorate the bicentennial of Friedrich's birth, that the international public began to acknowledge the stature of German Romantic art. The series of shows that have taken place in London (1972), Paris (1976), Tokyo and Kyoto (1978–79), Stockholm and Oslo (1980–81), and Bern (1985) indicates the extent and the tempo of the current reevaluation. The renewed interest in the Romantic period among scholars in the German Democratic Republic began in 1965, when the Nationalgalerie organized the exhibition *Deutsche Romantik: Gemälde, Zeichnungen*.

The period covered by the present exhibition is bounded by two revolutions that profoundly affected the history of Europe. While historians generally place the beginning of the new artistic movement at about 1770, the earliest works in this selection date from a decade later, when its stylistic tendencies had developed fully and displaced the legacy of the Rococo and of the early Neoclassicism cultivated by the courts. Drawings executed after 1850 are excluded from the selection, even though this results in an abbreviated survey of the draftsmanship of important figures like Ludwig Richter, Adolph Menzel, and Rudolf Alt. In addition to artists born in the various principalities and free cities of the German empire (later, the German Confederation), Anton Graff and Adrian Zingg—natives of Switzerland who worked primarily in Dresden—are included, as is the Norwegian Johann Christian Claussen Dahl, while the Swiss Henry Fuseli, who spent little time in Germany, has been omitted.

No concise title can convey the great variety of artistic styles practiced by German artists in the nineteenth century. This diversity is reflected in the exhibition by the nearly equal numbers of Neoclassical, Realist, and Romantic drawings. However, the title *The Romantic Spirit* is justified insofar as the Romantics—at least from our perspective—were responsible for the most significant achievements in the draftsmanship of the period.

Drawing permits the most immediate expression of an artist's thoughts and feelings. Like the poem, the piano solo, and the song, the drawing is a characteristic art form of the Romantic age. The Nationalgalerie, Staatliche Museen, Berlin, and the Kupferstich-Kabinett, Staatliche Kunstsammlungen, Dresden, house particularly strong collections of German nineteenth-century drawings. While the outstanding draftsmen of the period dominate the exhibition, the great variety of individual achievement is also represented, and cognoscenti will note that only a few important artists, such as Johann Georg Dillis and Ferdinand

Georg Waldmüller, are missing. The selection, which has been made jointly by colleagues in both museums, is of high artistic quality and rich in historical insights.

Our sincere thanks go to the director of The Pierpont Morgan Library, Charles E. Pierce, Jr., and to William W. Robinson for their unfailing cooperation and for the publication of this handsomely illustrated catalogue, and to Charles Ryskamp and R. Bruce Livie, who initiated this project. In addition, we would like to thank everyone in New York, Berlin, and Dresden who contributed to the success of the exhibition, and especially the authors and translators of the catalogue. We hope that the American public finds their encounter with the German draftsmen a pleasant and spiritually rewarding experience, and, with this wish, we send the masterpieces of our museums on their journey.

Prof. Dr. sc. Peter Betthausen
DIRECTOR
NATIONALGALERIE,
STAATLICHE MUSEEN,
BERLIN

Dr. h.c. Werner Schmidt
DIRECTOR
KUPFERSTICH-KABINETT,
STAATLICHE KUNSTSAMMLUNGEN,
DRESDEN

Acknowledgments

This volume is at once a symbol and a product of international cooperation. For the past four years, men and women in the United States and the German Democratic Republic have worked closely together to produce *The Romantic Spirit*, which is the first book in English devoted exclusively to German drawings from 1780 to 1850. It has been a privilege to witness the common pursuit of scholarship and the appreciation of fine art by people of different backgrounds and beliefs.

The Kupferstich-Kabinett, Staatliche Kunstsammlungen, Dresden, and the Nationalgalerie, Staatliche Museen, Berlin, hold two of the most important collections of nineteenth-century German drawings in the world. In 1984 The Pierpont Morgan Library invited the museums to show 125 of these works at the Library, and they kindly agreed. *The Romantic Spirit*, published to coincide with this unprecedented exhibition, includes a catalogue of the drawings—none of which has been seen before in this country— and essays on aspects of nineteenth-century German draftsmanship. As will be clear to the reader, it is through drawings like these that the spirit of Romantic art is most immediately conveyed.

We are grateful to Peter Betthausen, director of the Nationalgalerie, Berlin, and to Werner Schmidt, director of the Kupferstich-Kabinett, Dresden, for allowing us to borrow their magnificent drawings. We should particularly like to thank Günter Schade, general director of the Staatliche Museen, Berlin, and Gisela Holan, deputy general director, for their keen interest and gracious participation in all phases of this undertaking.

The exhibition was conceived by Charles Ryskamp, former director of the Morgan Library. R. Bruce Livie was a great help to him during the preliminary negotiations. We are indebted to both gentlemen for laying the solid foundation on which the rest of us have been able to build.

Primary responsibility for the organization of the exhibition here at the Library has rested with our curator of drawings and prints, William W. Robinson, whose diligence, kindness, and good humor have endeared him to all who have participated in this project. Mr. Robinson edited *The Romantic Spirit* in conjunction with Gottfried Riemann of the Nationalgalerie in Berlin. They were ably assisted by the sharp pencil and sharper eye of Pamela T. Barr. Many members of the Morgan Library's staff also contributed to the completion of the book; among those deserving special mention are Elizabeth Allen, Frederick C. Schroeder, Stephanie Wiles, and Fredric Woodbridge Wilson.

Several individuals and agencies of the American government have aided us in significant ways. Jaroslav J. Verner, press and cultural counselor at the American embassy in Berlin, was a vital communications link between New York and Berlin. Charles B. Skinner, G.D.R. desk officer at the U.S. State Department, provided invaluable advice. The exhibition has been made possible, in part, by a grant from the National Endowment for the Arts and an indemnity from the Federal Council on the Arts and the Humanities. Additional support has been provided by the New York State Council on the Arts.

The English translation was rendered primarily by Mr. Robinson. He was assisted by the following associates of the Center for Research in Translation, State University of New York at Binghamton: Dr. phil. William H. Snyder; Daniel J. Brooks; Jeanne Tracy Eichelberger; Cheryl Spiese McKee; Roger C. Norton; Myrna Ritterskamp (State University College, Oneonta, New York); James B. Stack; George D. McKee; and Alice Otis.

The publication of *The Romantic Spirit* represents yet another successful collaboration between the Morgan Library and Oxford University Press. Our thanks go to Joyce Berry at Oxford for her unflagging enthusiasm for a subject that is still relatively—if undeservedly—unknown in this country.

With this book we also continue our long-standing relationship with Meriden-Stinehour Press in the production of fine

books. We thank the staff of the Press for their hard work and patience. However, we reserve our deepest gratitude for the late Stephen Harvard, who, as vice-president at Meriden-Stinehour, designed many distinguished Morgan Library publications over the years. His recent death, during the last stages of this catalogue's production, is a loss to us all.

Charles E. Pierce, Jr.
DIRECTOR
THE PIERPONT MORGAN LIBRARY

Chronology

1789 Beginning of the French Revolution
Peasant uprisings in Baden and the Palatinate. Civil unrest in the Rhineland region
M. H. Klaproth discovers uranium
First steam pump put into operation in the Ruhr region
J. H. W. Tischbein becomes director of the Naples Academy
C. G. Langhans: Brandenburg Gate in Berlin (completed 1794)
H. F. Füger: *Death of Germanicus* (Vienna, Österreichische Galerie)

1790 Leopold II becomes German emperor
Peasant revolt in Saxony
First German industrial exhibition in Hamburg
I. Kant: *Kritik der Urteilskraft*
G. Schadow: *Tomb of Count von der Mark* (Berlin, Nationalgalerie)

1791 Spinning Jenny put into production in Berlin
W. A. Mozart: *The Magic Flute*
W. A. Mozart dies

1792 Franz II becomes German emperor
Nuremberg Kunstverein and Berlin Singakademie founded

1793 Second partition of Poland by Russia and Prussia
The Mainz Republic proclaimed
The first war of the European coalition against France under the leadership of England (until 1797)
J. G. Herder: *Briefe zur Beförderung der Humanität* (part 1; part 10 published in 1797)

1794 J. G. Fichte: *Grundlage der gesamten Wissenschaftslehre*

1795 Peace of Basel between France and Prussia
Third partition of Poland by Russia, Austria, and Prussia
H. F. Füger becomes director of the Vienna Academy
J. C. F. Schiller: *Über die ästhetische Erziehung des Menschen*
I. Kant: *Zum ewigen Frieden*
A. v. Zauner: *Joseph II* equestrian monument in Vienna (completed 1806)

J. A. Carstens: *Night with Her Children* (Weimar, Kunstsammlungen)

1796 Construction of the first coke blast furnace in Gleiwitz
Prague Academy founded

1797 Friedrich Wilhelm III becomes king of Prussia
Peace of Campo Formio between Austria and France
A. Senefelder invents lithography
D. Chodowiecki becomes director of the Berlin Academy
F. Hölderlin: *Hyperion* (part 2)
W. H. Wackenroder: *Herzensergiessungen eines kunstliebenden Klosterbrüders*
A. W. Schlegel: vol. 1 of the Shakespeare translations (vol. 10 published in 1810)
Birth of H. Heine and F. Schubert

1798 Peasants from the regions on the left bank of the Rhine are freed of all feudal burdens. The Rhine becomes the customs border between France and Germany
The literary journals *Das Athenäum* (edited by F. and A. W. Schlegel) and *Die Propyläen* (edited by Goethe) published (both until 1800)
J. C. F. Schiller completes his *Wallenstein* trilogy
L. Tieck: *Franz Sternbalds Wanderungen*
J. Haydn: *Creation*

1799 Beginning of the second coalition war (until 1801–2)
A. v. Humboldt sets out on an expedition to Venezuela, Ecuador, Peru, Mexico, and Cuba
The Weimar Kunstfreunde (among them Goethe) establish an annual competition and exhibition for the promotion of contemporary art (until 1805)
Novalis writes his fragment *Die Christenheit oder Europa*

1800 F. W. J. Schelling: *System des transzendentalen Idealismus*
Novalis: *Hymnen an die Nacht*
J. Paul: *Titan* (vol. 1; vol. 4 published in 1803)

1801 Peace of Lunéville between Austria and France
Annexation by France of the German regions on the left bank of the Rhine
C. F. Gauss establishes the modern theory of numbers
Novalis dies

1802 Treaty of Amiens between France and England

1803 Reichsdeputationshauptschluss (the "final recess" of the diet of the empire turns over the task of compensations for territorial losses west of the Rhine to a "deputation"; the fragmentation of the German empire into states diminishes)
F. Schlegel: *Gemäldebeschreibungen aus Paris und den Niederlanden*
J. H. Dannecker: *Ariadne on the Panther* (completed 1814; Frankfurt am Main, Liebighaus)
Ph. O. Runge: *The Times of Day* (Hamburg, Kunsthalle)
J. G. Herder dies

1804 Introduction of the Code Napoléon in France and in the German regions on the left bank of the Rhine
German Emperor Franz II assumes the title "Emperor of Austria"
Conditions of serfdom lifted in Schleswig-Holstein
Royal iron foundry in Berlin established
S. and M. Boisserée begin their collection of medieval art
I. Kant dies

1805 Beginning of the third coalition war. Battle at Austerlitz. Peace between France and Austria
Bavaria and Württemberg become kingdoms
J. C. F. Schiller dies

1806 Establishment of the Rhenish Confederation, a federation of German states under the protection of Napoleon
Franz II resigns the crown of the German empire
Fourth coalition war. Battles at Jena and Auerstedt
Trade embargo prohibiting trade with England for all states allied with France (until 1813)
Napoleon transports German art collections to Paris as war booty
J. W. v. Goethe: *Faust* (part 1; part 2 published in 1831)
A. v. Arnim and C. Brentano: *Des Knaben Wunderhorn* (vol. 1; vol. 2 published in 1808)

1807 Peace of Tilsit between France, Russia, and Prussia
Freiherr vom und zum Stein becomes prime minister of Prussia
Serfdom is lifted in Prussia (edict in October); beginning of agrarian reform
Napoleon imposes a constitution on the kingdom of Westphalia
J. G. Fichte gives public lectures in the winter of 1807–8 ("Reden an die deutsche Nation")
G. W. F. Hegel: *Phänomenologie des Geistes*
J. Görres: *Die deutschen Volksbücher*

1808 Military and government administration reform in Prussia
Introduction of universal conscription in Austria
Constitution decreed in the kingdom of Bavaria
Munich Academy founded
A. W. Schlegel holds lectures on drama and literature in Vienna
W. Kobell: *Siege of Kosel* (Munich, Neue Pinakothek)
C. D. Friedrich: *Cross in the Mountains* (Dresden, Kunstsammlungen)

1809 Tyrolean rebellion led by Andreas Hofer (executed in 1810 in Mantua)
Fifth coalition war. Battles at Aspern and Wagram. Peace of Vienna between Austria and France
F. Overbeck et al. form the Brotherhood of St. Luke in Vienna, a society of Romantic artists
A. Thaer: *Grundzüge der rationellen Landwirtschaft* (completed 1812)
J. Haydn dies

1810 Prince von Hardenberg becomes prime minister of Prussia
Promulgation of the finance edict and the regulation governing domestic servitude
University of Berlin founded
A. Müller: *Die Elemente der Staatskunst*
H. v. Kleist: *Prinz Friedrich von Homburg*
F. Weinbrenner: *Architektonisches Lehrbuch* (completed 1819)
Ph. O. Runge: *Die Farbenkugel*
Birth of R. Schumann

1811 Introduction of freedom in the choice of trade in Prussia
F. L. Jahn opens the first gymnasium in Berlin
B. G. Niebuhr: *Römische Geschichte* (completed 1812)

F. Pforr: *Sulamith and Maria* (Schweinfurt, Schäfer collection)
F. Overbeck: *Italia and Germania* (completed 1828; Munich, Neue Pinakothek)
J. A. Koch: *The Schmadribach Falls* (Leipzig, Museum der bildenden Künste)

1812 France completes military agreements with Prussia and Austria
Convention of Tauroggen between the Prussian general York von Wartenburg and the Russian general von Diebitsch
Emancipation of the Jews in Prussia
J. and W. Grimm: *Kinder- und Hausmärchen* (vol. 1; vol. 2 published in 1814; vol. 3, in 1822)
G. F. Kersting: *Woman Knitting* (Weimar, Kunstsammlungen)

1813 Uprisings against the French in the Rhineland states and in northern Germany
Battle of Leipzig. Napoleon suffers a decisive defeat
End of the Rheinbund (Rhenish confederation)
Birth of R. Wagner

1814 First Peace of Paris
Congress of Vienna (until 1815)
Promulgation of a constitution in Nassau
Berlin Künstlerverein founded
A. Chamisso: *Peter Schlemihl*
E. T. A. Hoffmann: *Der goldene Topf*

1815 Creation of the German Confederation, a federation of forty-one sovereign German states (until 1866), and the Holy Alliance by the monarchs of Russia, Austria, and Prussia
Return to Germany of the works of art taken by Napoleon
J. G. Schadow becomes director of the Berlin Academy
Birth of O. v. Bismarck

1816 Crop failures lead to hunger and starvation in Germany (until 1817)
Promulgation of a constitution in Saxony-Weimar
L. v. Haller: *Restauration der Staatswissenschaft* (vol. 1; vol. 6 published in 1834)
L. v. Klenze: Glyptothek in Munich (completed 1834)
K. F. Schinkel: Neue Wache in Berlin (completed 1818)
F. Overbeck, W. Schadow, Ph. Veit, P. Cornelius: frescos in the Palazzo Zuccari (Casa Bartholdy) in Rome (completed 1817; Berlin, Nationalgalerie)

1817 The Wartburg Festival, gathering of German students
Serfdom abolished in Württemberg
J. W. v. Goethe and H. Meyer: *Neudeutsche religiös-patriotische Kunst*
J. A. Koch et al.: frescos in the Casino Massimo in Rome (completed 1829)

1818 Abolition of internal customs in Prussia
Promulgation of constitutions in Bavaria and Baden
Formation of the Allgemeine Deutsche Burschenschaft (university fraternities)
Society for Art and Industry for the Grand Duchy of Baden founded in Karlsruhe
University of Bonn founded
K. F. Schinkel: Schauspielhaus in Berlin (completed 1821)
P. Cornelius: frescos in the Glyptothek in Munich (completed 1830)
Birth of K. Marx

1819 Karlsbad resolutions of ten German states suppressing civil opposition
Beginning of the crisis in German agriculture, which does not subside until the thirties
Promulgation of a constitution in Württemberg
Establishment of the German General Union of Trade and Commerce
Exhibition of German artists in Rome at the Palazzo Caffarelli
Reestablishment of the Düsseldorf Academy; P. Cornelius becomes its first director
A. Schopenhauer: *Die Welt als Wille und Vorstellung* (vol. 1; vol. 2 published in 1844)
J. S. v. Carolsfeld: *The Wedding at Cana* (Hamburg, Kunsthalle)
C. G. Carus: *Moonlit Night near Rügen* (Dresden, Kunstsammlungen)

1821 Formation of the Society for the Promotion of Productivity and of a technical trade school in Prussia
C. M. v. Weber: *Der Freischütz*
C. Rottmann: *The Hintersee* (Leipzig, Museum der bildenden Künste)

1822 Beginning of steamship traffic on the Rhine
First national professional conference of physicians and natural scientists in Leipzig
Hamburg Kunstverein founded

1824 First use of the English "puddling" method in a foundry in Neuwied
Berlin Architektenverein founded
P. Cornelius becomes the director of the Munich Academy
L. v. Beethoven: *Ninth Symphony*
F. Krüger: *Parade in the Opernplatz* (completed 1829; Berlin, Nationalgalerie)
Birth of A. Bruckner

1825 Ludwig I becomes king of Bavaria
Opening of the first German institute of technology in Karlsruhe

1826 G. S. Ohm discovers the law of electricity that bears his name
Beginning of the installation of gaslights in the streets of Berlin
Beginning of the restoration of the Cathedral of Cologne
W. Schadow becomes the director of the Düsseldorf Academy
First volume of the *Monumenta Germaniae Historica* published
J. v. Eichendorff: *Aus dem Leben eines Taugenichts*

1827 J. Ressel invents the screw propeller
N. Dreyse invents the firing-pin rifle, which is introduced in the Prussian army in 1841
Württemberg Kunstverein founded in Stuttgart
A. v. Humboldt presents his *Kosmos* lectures in Berlin
Ludwig of Bavaria acquires the art collection of the Boisserée brothers for Munich
H. Heine: *Buch der Lieder*
F. Schubert: *Die Winterreise*
L. v. Beethoven dies

1828 Bavaria and Württemberg form the southern German Customs Union
The Institute of Technology and the Saxon Kunstverein founded in Dresden
F. Wöhler succeeds in synthesizing urea
F. Schubert dies

1829 Kunstverein for the Rhineland and Westphalia founded in Düsseldorf
In Berlin, F. Mendelssohn conducts the first performance of the *St. Matthew Passion* since Bach's death
F. v. Gärtner: Ludwigskirche in Munich (completed 1840)
F. Schlegel dies

1830 There are 245 steam engines in operation in Prussia
Civil unrest in several German cities (Aachen, Brunswick, Leipzig, Cassel) set off by the July Revolution in France
Constitutions promulgated in Saxony, Hanover, Brunswick, Hesse, and Cassel
Cholera epidemic in Germany (until 1831)
Opening of the Altes Museum in Berlin and the Glyptothek in Munich
An average of 15,000 students attend German universities each year

1831 L. v. Klenze: *Walhalla* near Regensburg (completed 1842)
J. S. v. Carolsfeld: Nibelungen frescos in the Munich Residenz (completed 1867)
G. W. F. Hegel dies

1832 Hambach festival, first mass demonstration for national unity
C. v. Clausewitz: *Vom Kriege* (from his unpublished works)
L. Börne: *Briefe aus Paris* (completed 1834)
F. Mendelssohn: *The Hebrides Overture*
K. F. Schinkel: Bauakademie in Berlin (completed 1836; destroyed)
K. Blechen: *The Park of the Villa d'Este* (Berlin, Nationalgalerie)
J. W. v. Goethe dies

1833 Formation of the German Customs Union
C. F. Gauss and W. Weber construct an electromagnetic telegraph
Birth of J. Brahms

1834 In Prussia, F. v. Quast is installed as the first state curator of public monuments
K. v. Rotteck and K. Th. Welcker: *Staatslexikon* (vol. 1; vol. 15 published in 1843)
G. Büchner: *Der Hessische Landbote*

E. Gaertner: *Panorama of Berlin* (West Berlin, Staatliche Schlösser und Gärten)

1835 First German railway between Nuremberg and Fürth
D. F. Strauss: *Das Leben Jesu*
W. v. Humboldt: *Über die Verschiedenheit des menschlichen Sprachbaus und ihren Einfluss auf die geistige Entwicklung des Menschengeschlechts*

1836 The Alte Pinakothek opens in Munich
K. F. Lessing: *Hussite Sermon* (Düsseldorf, Kunstmuseum)

1837 Seven professors at the University of Göttingen (the "Göttingen Seven") protest against the revocation of the constitution in Hanover
Borsig Engineering Works founded in Berlin
Construction of the Leipzig-Dresden railway (completed 1839)
A. Lortzing: *Zar und Zimmermann*
G. Semper: Opernhaus in Dresden (completed 1841)
L. Schwanthaler: *Bavaria* on the Theresia Meadow in Munich (completed 1843)
A. L. Richter: *Crossing near the Schreckenstein* (Dresden, Kunstsammlungen)

1838 Construction of the first German locomotive in a shipyard near Dresden
R. Schumann: *Kreisleriana*
E. v. Bandel: *Hermann Monument* near Detmold (completed 1875)
F. G. Waldmüller: *View of Ischl* (West Berlin, Nationalgalerie)

1839 E. F. Zwirner: Church of Apollinaris in Remagen (completed 1843)
H. Hübsch: *Pump Room in Baden-Baden* (completed 1842)
Chr. D. Rauch: *Friedrich II* equestrian monument in Berlin (completed 1851)
C. Spitzweg: *The Poor Poet* (Munich, Neue Pinakothek)
A. Menzel: illustrations for F. Kugler's *Geschichte Friedrichs des Grossen* (completed 1842)

1840 Friedrich Wilhelm IV becomes king of Prussia
J. v. Liebig introduces the use of artificial fertilizer
A. Fröbel introduces the first kindergarten in Bad-Blankenburg
F. Hebbel: *Judith*
Birth of A. Bebel

1841 L. Feuerbach: *Das Wesen des Christentums*
R. Schumann: *First Symphony*
L. Persius: Church of Our Savior in Sacrow near Potsdam (completed 1844)
F. v. Rayski: *Chamberlain Count Zech-Burkersroda* (Dresden, Kunstsammlungen)
K. F. Schinkel dies

1842 First German General Industrial Exhibition in Mainz
J. R. v. Mayer discovers the law of the conservation of energy
German Architektenverein founded in Leipzig
Laying of the groundstone for the expansion of the Cathedral of Cologne
Rheinische Zeitung für Politik, Handel und Gewerbe published in Cologne (until 1843)
G. A. Demmler and F. A. Stüler: palace in Schwerin (completed in 1857)
W. Weitling: *Garantien der Harmonie und Freiheit*

1843 The first German illustrated newspaper published in Leipzig
F. G. Waldmüller: *Peasant Wedding in Lower Austria* (Vienna, Österreichische Galerie)
Birth of R. Koch
F. Hölderlin dies

1844 Weavers' rebellion in Silesia
German National Industrial Exhibition in Berlin
H. Heine: *Deutschland—ein Wintermärchen*
E. Deger, A. and K. Müller, and F. Ittenbach: frescos in the Church of Apollinaris in Remagen (completed in 1849)
K. W. Hübner: *The Silesian Weavers* (Düsseldorf, Kunstmuseum)

1845 F. Engels: *Die Lage der arbeitenden Klassen in England*
M. Stirner: *Der Einzige und sein Eigentum*
R. Wagner: *Tannhäuser*
A. Menzel: *Balcony Room* (West Berlin, Nationalgalerie)

1846 Starvation in Germany
C. Zeiss founds a workshop in Jena for the mechanical production of optical products
Population in the states of the German Federation is now 45 million

1847 Germany experiences its first cyclical economic crisis
Production of pig iron within the German Customs Union has doubled since 1834 and now exceeds 230,000 metric tons
Convention of the united provincial parliaments in Prussia called
A. Rethel: frescos in the Town Hall in Aachen (completed 1852)
M. v. Schwind: *The Rose* (Berlin, Nationalgalerie)

1848 Beginning of the revolutions of 1848. Uprisings in Vienna, Berlin, Munich, and Baden
The National Constitutional Convention opens in the Church of St. Paul in Frankfurt am Main
Abdication of Ludwig I of Bavaria
The *Kreuzzeitung* published
K. Marx and F. Engels: *Communist Manifesto*
F. Freiligrath: *Die Toten an die Lebenden*
A. Menzel: *The Honoring of the Insurgents Killed in March 1848* (Hamburg, Kunsthalle)
J. P. Hasenclever: *Workers before the Magistrate* (Düsseldorf, Kunstmuseum)

1849 There are 1,965 steam engines in operation in Prussia
The German National Assembly passes a national constitution and offers the crown to Friedrich Wilhelm IV, king of Prussia, who turns it down
Civil rebellion on the Rhine, in Berlin, Dresden, and Baden is put down
Mass emigration to the United States of America and to Switzerland
First attempts of the Prussian artillery to use cannon barrels of cast steel
A. Rethel: *Another Dance of Death* (woodcut cycle)

Art and Society in Germany from 1789 to 1848

PETER BETTHAUSEN

I. The 125 drawings in this exhibition all date from a period of approximately seventy years, from about 1780 to about 1850. During these seven decades, events occurred in Germany and in the rest of Europe that changed the world and that continue to influence the course of social development. A new age was ushered in, the age of capitalism and of middle-class society. Many persons born between 1750 and 1770 realized that they were witnesses to matters of great moment. Johann Wolfgang von Goethe, who took part in world affairs to a far greater extent than most individuals, considered himself lucky, and declared at the end of his life: "I have enjoyed the great advantage that I was born at a time when the most significant world events were the order of the day, and that has remained the case throughout my long life." The greatest of these events was undoubtedly the French Revolution, and Goethe clearly foresaw its historical ramifications. In 1792, as a member of the retinue of Duke Karl-August of Saxony-Weimar, he witnessed the battle of Valmy, and proclaimed to the officers of the coalition army that was defeated by the French: "A new epoch in the history of the world began here today." Goethe did not live to see the civil war in Germany, which took place sixteen years after his death. It was a feeble echo of the French Revolution, transacted without power or purpose, and ended in a fiasco.

However, between 1789 and 1848, even in a politically and economically backward Germany, the machine replaced manual labor, and the foundations were laid for the nation's subsequent rise to the status of a world power. This process occurred more slowly and more laboriously than in France, not to mention England, the cradle of the Industrial Revolution, where, around 1800, coal production was twenty times greater than in Germany, and the output of pig iron, four times greater. The principal cause of this discrepancy was the political fragmentation of Germany.

While the French and the English had long since established nation-states ruled by a centralized government, in 1789 the Holy Roman Empire of the German Nation consisted of nearly 1,800 sovereign territories. During the subsequent period, Napoleon's intervention in German affairs reduced the number of territories considerably, but enough of them remained to retard capitalist development and, consequently, to keep the middle class weak. Seen from another point of view, the persistence of feudal structures provided the basis for the continued prosperity of the nobility. Resolute and capable, the aristocracy managed to accommodate its own interests to economic changes, and, when development could not be avoided, the nobles kept it under control by permitting cautious reforms. This process resulted in the transformation of the old feudal order into a class of capitalist landowners, the Junkers, with whom the German bourgeoisie compromised after 1848.

In 1789, when the citizens of Paris stormed the Bastille, symbol of the absolutist regime, the living conditions of the great majority of Germans were no better than those of the French. However, one could scarcely speak of a revolutionary crisis situation east of the Rhine, particularly because the apparatus of feudal power there remained largely intact. Only the intellectuals— among them, Friedrich Gottlieb Klopstock, Friedrich Schiller, Friedrich Hölderlin, and Georg Wilhelm Friedrich Hegel—greeted the Revolution as the dawn of a new era, and endorsed its goals. Most, however, were disgusted by the atrocities of the Jacobins, and eventually reversed their views.

The military conflicts with France, which lasted from 1792 to 1815, proved that the feudal order in Germany, too, was decayed and obsolete. Under the powerful onslaught of the Napoleonic armies, the two major German powers, Prussia and Austria,

collapsed, and took the medieval German empire with them. Napoleon annexed large parts of the imperial domain, which he plundered unscrupulously. However, in many territories on the left bank of the Rhine, Napoleonic rule meant the end of feudalism and the encouragement of modernization in Germany, to which the Prussian reformers Karl, Freiherr vom und zum Stein, and Prince Karl August von Hardenberg contributed during this period.

The defeat of Napoleon brought the conservative forces back into play. Prussia and Austria joined with Russia in the Holy Alliance in an attempt to stabilize monarchical rule and to guarantee the observance of the resolutions of the Congress of Vienna. Nevertheless, prerevolutionary conditions could not be reinstated — the world of 1815 was not the world of 1789.

After the war, damage was repaired, general economic prosperity began, and a national market gradually developed. The establishment of the German Tariff Union in 1834 marked an important step in this direction. Industrial growth took place primarily in the Rhineland, Saxony, Silesia, and Berlin. However, craftsmen and manufacturers continued to make up the largest share of total production. In the countryside, the agrarian reforms of 1807–11 led to some progress toward the elimination of serfdom, but these reforms were not effectively implemented until after 1850 and not firmly in place until the 1860s.

General economic prosperity fostered the political emancipation of the middle class, which, led by the industrial entrepreneurs, challenged the domination of the nobility. The antifeudal movement came to a head in the years 1815–19, 1830–34, and 1840–48; the proletarian forces became involved in the thirties.

In the wake of the revolutionary uprising of early 1848, the liberal wing of the bourgeoisie gained representation in the governments of most German states. Whether out of fear of its own boldness or of radical democratic elements that would establish a "red" republic in Germany, or out of weakness, the bourgeoisie, having scarcely grasped the levers of power, sought a compromise with the old ruling class. The aristocracy had hardly given up, and could now get on with crushing the revolution, which was carried out with unrelenting harshness against the democratic left. Democracy and republicanism were stopped, and so, for the time being, was national unity. The nobility reconquered political power, while the bourgeoisie retained its hereditary field of activity, the economy.

II. These complex and, in many ways, interrelated political and economic events played an essential role in shaping German intellectual history from 1789 to 1848. These were the kinds of events that stimulated creative activity, so it is not difficult to comprehend why this period constitutes the most brilliant chapter in the history of German culture. One must also keep in mind that the intelligentsia, drawn primarily from the middle classes, could not participate in politics. Their impetuous energies, nourished by the awareness that they lived during a time of great change, turned to art, literature, and philosophy. The nobleman and the cleric gradually relinquished their dominant role in culture; by the end of the eighteenth century, a pronounced courtly and ecclesiastical cultural sphere no longer existed. During the following decades, art and literature—and the appreciation of art and literature—assumed a bourgeois character. The middle class defined the aesthetic criteria, even though the church and the nobility recovered some lost ground after 1820.

German cultural history between 1789 and 1848 is multifaceted, but three basic tendencies can be discerned. All three grew out of the Enlightenment and the Sturm und Drang movement; each influenced the other, and each had its consummate moments. The classical period of German philosophy, literature, and music was the expression of the abiding faith of the middle class in the ability of man to educate himself in the spirit of reason and humanity, in his ability to understand the world around him, and in his ability to progress toward a truly human social order. Among the leading exponents of these ideas were Johann Wolfgang von Goethe, Friedrich Schiller, Immanuel Kant, Georg Wilhelm Friedrich Hegel, Joseph Haydn, and Ludwig van Beethoven.

Later, Romanticism developed as a disillusioned reaction to

the bloody realities of the French Revolution and to the consolidation of a middle-class society in France, which was anything but humane. The alternative world invented by the Romantics lay in a distant paradise, attainable only in art or in dreams. In man they saw primarily an individual who contemplates and feels, more than he thinks and calculates. The most important representatives of Romanticism were Novalis, Friedrich Schlegel, Friedrich Wilhelm Schelling, Franz Schubert, and Carl Maria von Weber. Common to both intellectual trends was an epistemological and ethical idealism. Man's highest calling was to become an intellectual and spiritual being.

An interest in reality as such, unveiled and unadorned, first appeared at the end of the so-called Kunstperiode (art period), as Heinrich Heine aptly characterized the years before the death of Goethe. This development was undoubtedly related to the growth of industry, which hastened the decline of the speculative nature philosophy of the Romantics and encouraged the empirical natural sciences. From the 1830s on, literature and philosophy served the political struggle of the middle class, and subjected the Christian religion to particularly sharp criticism. The materialism of the philosophers corresponded to the writers' efforts to come to terms with contemporary life. The outstanding figures of this phase were Heinrich Heine, Karl Marx, and Anselm Feuerbach; the most important German composer was Robert Schumann. Shortly before 1848, a contemporary described the general situation: "Although you do not yet notice it in the capital, in the commercial and provincial cities the emerging generation, forgetting or opposing all idealistic aspirations, crudely and impudently takes bare reality by storm, and soon it will tolerate only what satisfies its superficial needs and pleasures."

III. German artists of this period are scarcely known outside their native land, and even less so in America than in Europe. To be sure, none of them ranks with Goethe, Beethoven, or Heine — names that epitomize German culture. Nor can their works sustain comparison with those of the great French painters or with Goya in Spain or Constable in England, as long as one accepts formal qualities and painterly values as the highest criteria. Nevertheless, German painters and sculptors deserve to be better known than they are, as this exhibition will confirm. Their number includes creative, independent personalities, whose works, seen in the context of historical conditions in Germany, should certainly attract broader interest.

Well into the eighteenth century, the great majority of German artists belonged to the class of skilled craftsmen, who were organized into guilds and commanded relatively little social prestige. All of this changed with the advent of the academies. From 1750 to 1790, more academies—twenty-one in all—were founded or reorganized in the German empire than anywhere else. Absolutist princes regarded them not only as educational institutions, but also as instruments for the control of art and culture. The academies provided architects and practitioners of all branches of the visual arts with a basic education that served to instill certain stylistic norms. In addition, the academies contributed to the improvement of the aesthetic quality of local manufactures, thus enhancing their competitiveness; this was the reasoning behind admitting artisans in many places.

The academies decisively raised the artists' educational level, introducing them to contemporary humanistic and scientific learning, which, in turn, contributed to the evolution of a new self-awareness on their part. This sparked their desire to rise above the artisan class and to strive for intellectual ennoblement, much as the writers and philosophers (who preceded the visual artists in the attainment of social emancipation) had done. The artist's social standing was a more or less significant factor in the development of several friendships between painters and authors during the years around 1800. The amicable relationships between Asmus Jakob Carstens and Karl Ludwig Fernow, Johann Heinrich Dannecker and Friedrich Schiller, Johann Heinrich Wilhelm Tischbein and Johann Wolfgang von Goethe, and Philipp Otto Runge and Ludwig Tieck are but a few examples.

While the academies established by absolutist rulers liberated the artists from the restrictions of the medieval craft guilds, their regimens and artistic doctrines constituted new instruments of

coercion, and as the eighteenth century came to a close, more and more artists began to resist them. Asmus Jakob Carstens exemplifies the rebellion against academic conventions. After studying at the academy in Copenhagen, Carstens was appointed professor in Berlin. He traveled to Rome in 1792 on a stipend from the Berlin Academy, and at the end of the prescribed period, he refused to return to Berlin. In his famous letter of 20 February 1796 to the Prussian minister Freiherr von Heinitz, Carstens wrote that he did not belong to the Berlin Academy, but "to humanity," and added that he valued his freedom more than material security.

Carstens's attitude was widespread at the time. Artists felt an obligation to only their own genius. They expected material support from society, to be given on their own terms (i.e., as independent creators of works of art). The author Karl Ludwig Fernow, a great champion of artists, condemned "the accepted procedure of prescribing subjects for an artist to depict. . . . This compels him to perform compulsory, manual labor, like that of an artisan. The artist should choose a subject that suits his talent, and should only represent a theme that truly moves and inspires him." Until the 1820s the preconditions for this type of artistic production did not exist. There was no art market to speak of, and the feudal German governments had no intention of providing material support for artists without receiving anything in return. Few were as consistent in their beliefs and actions as Carstens, who died prematurely and impoverished in Rome in 1798. The majority of artists earned a living where they could, working for princely courts, the state, and occasionally even the church, or teaching at an academy or art school.

Conditions improved perceptibly after the Napoleonic Wars. The increase in building activity in Munich, Berlin, Vienna, and the Rhineland benefited sculpture and mural painting. The art trade, though still limited primarily to prints, became livelier, and exhibitions took place more frequently. In 1836, when the total population of Berlin numbered about 300,000, the Academy exhibition attracted 111,954 visitors. The Kunstvereine (art unions) represented a new element in the cultural life of the large cities.

Through commissions and exhibitions, these middle-class organizations promoted art for private consumption.

Artists, too, formed associations. The beginnings of these organizations can be traced to the end of the eighteenth century, and especially to the artists' communities of the Romantic period. They were, in essence, professional societies for the free, independent artist—a type that became more clearly defined as the century progressed. By about 1850, artists had essentially established themselves as middle-class professionals. Their social standing had improved significantly and their parity with craftsmen was now a thing of the past. Artists such as Wilhelm Schadow, Peter Cornelius, and later Adolph Menzel were even elevated to the aristocracy.

IV. Like the political makeup of Germany, the art world in which these social events took place was extremely diverse. It had no dominant center comparable to Paris in France. While this fragmentation makes the art more interesting because of its variety, it also accounts for the provincialism of the German scene. At the end of the eighteenth century, the center of gravity of German art lay in the southern regions. Vienna played an important role, thanks to its well-managed and generously financed academy. Around the turn of the century, Dresden and Berlin experienced a renaissance. While the Romanticism of the Nazarenes had its roots in Vienna, the city of Early Romanticism was Dresden, where Caspar David Friedrich and Philipp Otto Runge worked alongside some of the outstanding literary figures of the movement, such as Ludwig Tieck and the Schlegel brothers. After 1815, Munich and Berlin evolved into the most important artistic centers in Germany, largely because of the patronage of the Bavarian and Prussian courts. Following the reorganization of its academy by Peter Cornelius and Wilhelm Schadow, Düsseldorf also gained recognition. Artistic instruction there was modernized by the introduction of the so-called master class, and Schadow had the foresight to cultivate good relations with the middle-class art world in the Rhineland.

Rome occupied a special place in German artistic life. After

the middle of the eighteenth century, multitudes of German artists, most of them supported by stipends from the academies, flocked to the Eternal City. More than five hundred made their way there between 1800 and 1830. They came primarily to study the exemplary works of antiquity and the Renaissance, but also in the hope of finding clients and patrons. Rome was also attractive because it offered freedom; it provided, in Fernow's words, "what outweighs everything else, the great good fortune of independence, which can be enjoyed without coercion or restriction only in the Roman artists' republic." As a consequence of this longing for Rome, a significant proportion of German art of this period was created outside of Germany. After 1800, the study trips of German architects, painters, and sculptors also brought them to Paris, where the works of art Napoleon had plundered throughout Europe formed a unique educational resource, and where Jacques-Louis David, one of the leading Neoclassical painters in Europe, operated a studio frequented by artists from all over the continent.

V. The three major currents that characterize the cultural history of the period embrace the visual arts as well. Neoclassicism was a European phenomenon. It took the art of antiquity and the Renaissance as its point of departure; man served as the measure of all things, and the large figural composition depicting a historical or mythological subject was considered the artist's most exalted task. Neoclassicism originated in Rome shortly after the middle of the eighteenth century, and Rome continued to nurture the movement until it died out around 1830. The earliest exponents, such as Anton Raphael Mengs, Angelika Kauffmann, Jakob Philipp Hackert, and Heinrich Füger were much indebted to Baroque and Rococo art, which explains their delicate, quivering forms and the lyrical tone of their works.

The mature Neoclassical style formulated in the 1790s exhibits more rigor and severity, characteristics that evolved from the analysis of antique sculpture. It was no coincidence that the first masterpieces of German Neoclassical sculpture were created shortly before 1800: Johann Gottfried Schadow's double portrait of the Prussian princesses Luise and Friederike (Berlin, Nationalgalerie); Franz Anton Zauner's equestrian portrait of Joseph II (Vienna); and Johann Heinrich Dannecker's bust of Schiller (Stuttgart, Staatsgalerie). Painting and printmaking were dominated by a linear style appropriate to the representation of powerful masculine figures. Asmus Jakob Carstens was the progenitor of heroic Neoclassicism, and he pursued his personal mission with an uncompromising determination that was well suited to this lofty artistic concept. His creative power expressed itself only in drawing. This exclusive reliance on line articulated Carstens's craving for precision and ideality.

The draftsmanship of most German artists of the first half of the nineteenth century falls within the tradition established by Carstens. This is especially true of Peter Cornelius, whose work incorporates both Neoclassicism and Romanticism. Even Cornelius's paintings display a linear character; his color, cool and devoid of sensuousness, is mere ornament. Some of the other exponents of mature Neoclassicism were Philipp Friedrich Hetsch, Eberhard Wächter, and Gottlieb Schick, all from Württemberg; Johann Heinrich Wilhelm Tischbein; Johann Christian Reinhart; and Joseph Anton Koch. Although these artists regarded the great historical themes as the artist's most elevated task, they were more successful in portraiture and in landscape, presumably because the cultural climate in Germany was not favorable to history painting. Reinhart and Koch were outstanding landscapists. In their works, nature, which seems eternal and immutable, serves as the setting for important historical scenes. Compared to the cosmic dimensions of the landscape, the human events appear small and insignificant.

After 1815 Neoclassicism entered a final phase, during which it lost its progressive character. Between 1820 and 1830 Peter Cornelius, at the head of a small army of pupils and assistants, executed the frescos in the Glyptothek in Munich, a monumental cycle devoted to the intellectual world of antiquity. The patron was Crown Prince Ludwig of Bavaria, an enthusiastic admirer of the antique, who became king of Bavaria in 1825. The evocation of

the authority of antiquity bestowed the appearance of timeless validity upon a superannuated regime.

Romanticism in German art consisted of several loosely connected tendencies, which are apparent primarily in painting, drawing, and printmaking; sculpture generally adhered to a Neoclassical style. In contrast to Neoclassicism, Romanticism had no specific aesthetic system, no set of artistic rules, so it lacked stylistic homogeneity. Essentially, the concept "Romanticism" denotes a view of the world, and as such it is more easily distinguished from Neoclassicism. In formal terms, the German Romantic painters were descendants of the Neoclassical academies. They remained indebted to this tradition, particularly as draftsmen with a preference for the clear outline.

Early Romantic painting, which emerged in Germany shortly after 1800, reached its high point in the field of landscape. The principal representatives of the movement were Caspar David Friedrich and Philipp Otto Runge, both North Germans, Protestants, and patriots. The landscape they chose to depict was their homeland. In their art, landscape serves as an emblem of a comprehensive, divine world order, of which man is a component. As an individual, he stands apart from nature, in which he immerses himself longingly, achieving a union in his imagination that is impossible in reality. This is especially true in the art of Friedrich. From 1812 on, his paintings alluded in various ways to social developments, to the Wars of Liberation and the Restoration, and to the betrayal of German unity by the German princes. The converse of Friedrich's symbolism was his interest in effects of light and color, which intensified over the course of time, making him one of the pioneers of German *plein-air* painting.

Runge gave visual form to his world view, which encompassed the cosmos as well as the human realm, in the series of engravings *The Times of Day* (Cat. Nos. 33–35). His was a vision of utopia, a dream of ideal social conditions, which he expressed in symbolic, allegorical imagery. The recurring leitmotif of the child symbolizes man, living uncorrupted in harmony with nature as he did before original sin, and now the object of Romantic longing. Like Friedrich, Runge had a thoroughly developed sense of

reality, which emerges in his numerous portraits. After 1804 he executed several large group portraits, including one of his parents, of 1806 (Cat. No. 32).

A second trend in German Romantic painting, Nazarene Romanticism, developed in the Catholic south, primarily in Vienna. It was principally a figural art, influenced by the Middle Ages in Germany and by the Italian Quattrocento. Among its leading exponents were the members of the Viennese, and later Roman, Brotherhood of St. Luke. They produced their most important work in the frescos of 1816–17, representing the story of Joseph, in the palazzo of the Prussian consul in Rome, the Casa Bartholdy. This project exemplified their belief in communal work modeled on the medieval workshops, and in mural painting as a new, popular art devoted to great historical subjects. It also embodied their hope of executing similar works in Germany, as their contribution to the reformation of society.

After returning to Germany, the Nazarenes (Wilhelm Schadow, Peter Cornelius, Julius Schnorr von Carolsfeld, and Philipp Veit) defected to the Restoration camp. As directors and professors at the academies that they had formerly despised, they entered the service of the feudal princes and became artistically reactionary, not in the creative manner of their early years, but in a dogmatic way. This applies particularly to the monumental mural projects that they or their pupils executed in Munich, Berlin, Frankfurt, and elsewhere. After 1830, Romantic painting, like Neoclassical painting, no longer contributed to the progress of art. The emerging industrial bourgeoisie no longer cared for high ideals and evocations of the past, but for reality and the present.

As early as the eighteenth century, a strong realistic current existed in the visual arts, which was based on stylistic elements of seventeenth-century Dutch painting. Even during the heyday of Neoclassicism and Romanticism, the tendency toward objective representation continued. During the entire period, a practical, middle-class sense of reality was expressed, and it left unmistakable traces even in the intellectual art of Neoclassicism and Romanticism. From 1820 on, as those movements went out of fashion, this sense of reality became increasingly important—

above all in the form of Biedermeier art—as a reaction against the political Restoration. After the hopes of the middle class of participating in the political reform of society were dashed, the Biedermeier retreated into the private sphere, into the cozy little world of the familiar and the local. Biedermeier painters depicted all of this objectively, without pathos, with an eye for detail, with cool colors, and with a strong appeal to the sense of form.

The increasing gravity of the social conflicts of the 1830s and 1840s put an end to the Biedermeier idyll. The new Realism, associated primarily with Adolph Menzel, is distinguished by looser composition, a pictorial space that is no longer constricting but opens up to the viewer, and a painterly description of form that renounces definite contours.

Munich, Vienna, Dresden, and Berlin were the principal centers of Realist art, but Hamburg, Karlsruhe, Frankfurt am Main, and Düsseldorf were also important. In Munich, where Romanticism had scarcely established a foothold, a diverse, realistic landscape art took root at the end of the eighteenth century. The protagonists of this style, which evolved into *plein-air* colorism, were the brothers Franz and Ferdinand Kobell, Johann Georg Dillis, Johann Adam Klein, Wilhelm Kobell, Friedrich Wasmann, and Carl Spitzweg.

Although Ferdinand Waldmüller attracted the most attention in Vienna, Friedrich von Amerling, and Jakob and Rudolf Alt were equally accomplished. All were brilliant colorists, and in their paintings—whether landscapes or portraits—a cool daylight clearly reveals the subject.

In Dresden, the home of Caspar David Friedrich, his pupils and friends, such as Johann Christian Claussen Dahl and Carl Gustav Carus, carried on and developed his artistic legacy. Their landscapes no longer embody the soulfulness and intellectual depth of Romanticism; rather, they are almost reports on the observation of nature. Georg Friedrich Kersting, whose tidy, but evocative, interiors show man absorbed in his daily activity, also belonged to Friedrich's circle. Ferdinand von Rayski, like Menzel, overcame the intellectually contrived character of the Romantic portrait. Rayski's depictions of Saxon noblemen, executed with painterly verve, are relaxed, self-conscious, and sophisticated.

A feeling for reality has distinguished the art of Berlin right up until the present. A realistic element informs even the art of Daniel Nikolaus Chodowiecki, a leading exponent of the Berlin Rococo. Later, realistic styles were cultivated by Johann Gottfried Schadow, a Neoclassical artist who had a pronounced sense for individual characterization; Franz Krüger, the portraitist of the Berlin Biedermeier; Eduard Gaertner, who executed precisely drawn, brightly illuminated architectural paintings; Karl Blechen, whose light-flooded Italian scenes and overcast German landscapes are distinguished by spatial unity and homogeneity; and Adolph Menzel, who, more than any other nineteenth-century German artist, based his work exclusively on reality, especially in his drawings. When Menzel drew—and he drew constantly—he pursued detail to the point of absurdity, and was always careful not to depict reality as it ought to be, but to show it as changeable and fluctuating.

Menzel represented the German revolution in a painting, *The Honoring of the Insurgents Killed in March 1848* (Hamburg, Kunsthalle), which, significantly, he left unfinished. Alfred Rethel created the other famous work that deals with the political events of 1848–49, the woodcut series *Auch ein Totentanz* (Cat. Nos. 104, 105). Rethel's woodcuts and Menzel's painting mark the end of the period covered by this exhibition. *Auch ein Totentanz* sums up the ambivalent attitude toward the revolution that was shared by most Germans at the time, which accounts for the extraordinary popularity of the woodcuts. In a letter of May 1849 to his mother, Rethel lamented the victory of the king and the military: "A grand and glorious testament to the honor of Germany has fallen under cold-blooded, calculating military force and the saber." On the other hand, Rethel also regarded the revolution as an inappropriate way of resolving social conflicts. He maintained that it always ran the risk of getting out of control, of becoming a true revolution "from below." As a member of the middle class, he must have shuddered at the thought.

Drawing in Germany around 1800

GOTTFRIED RIEMANN

As historians recognized long ago, around the turn of the nineteenth century a revolution in the arts followed in the wake of the social transformations that were taking place, albeit in varying degrees, in most European countries. Although in France revolutionary events were more vehement and the intellectual phenomena that accompanied them more distinct, the consequences of this social and spiritual upheaval were also apparent in artistic life in Germany. The outward forms of architecture, painting, sculpture, literature, music, design, and fashion were in a state of flux because the social preconditions for these arts had changed. New styles and subjects emerged, inspired by a Zeitgeist that expressed itself in a variety of events and processes.

The repercussions of these transformations were recorded—almost seismographically—in one of the most sensitive modes of artistic expression: drawing. The testimony presented in drawings from this transitional period assumes a greater significance than at other times. Indeed, in the years before and after 1800, drawing was the art form that perhaps expressed most immediately the trends and problems of the age. New ideas and objectives could be presented more easily in the quick and readily available technique of drawing than in other media. The draftsman, who worked only for himself and did not have to comply with the restrictions imposed by a patron, expended little time or money. To a far greater extent than in earlier periods, drawings were executed as autonomous works of art, and finished sepia drawings or watercolors might even function as substitutes for paintings. Many of the pictorial drawings by two of the most important artists of the period, Koch and Friedrich, were created, in a certain sense, in place of paintings. Having attained a new social status, artists used these works to present their recently acquired convictions, whether these consisted of ethical objectives—expressed through themes from Christian history or classical antiquity—or derived from an innovative, more penetrating perception of nature and of society. At the same time, artists continued to use drawings in their traditional roles as sketches made for practice or experiment, and as preparatory studies for other works.

While there were enormous differences among the assorted movements, generations, and personalities, there were three principal impulses that shaped German drawing in about 1800. These tendencies, though distinct, also had much in common. In the various centers of artistic activity—including Rome—these three trends were expressed in decidedly diverse forms.

I. The traditions of the eighteenth century survived in the declining, but still authoritative, Neoclassicism. The Neoclassical artist looked back to the multifaceted world of antiquity, and even composed his landscapes after Mediterranean models. In the exhibition, this movement is represented by Tischbein, Füger, Hackert, Carstens, Reinhart, and Koch. Their works demonstrate in various ways that Neoclassicism was a style based primarily on drawing. Black and red chalk, and pen and ink were the preferred media. Line and contour dominate: even when watercolor or gouache were used, the areas of color were carefully delineated and contrasted with one another. Typical of Neoclassical drawing is the frequent use of sepia, which was applied with both pen and brush to achieve an integrated effect.

II. Often associated with the Neoclassicists are several draftsmen who strove for a pronounced realism, combining commonplace subject matter with precise execution. In the exhibition, the princi-

pal exponents of this style are Chodowiecki, Schadow, and Wilhelm Kobell. While their favorite media were pen and ink, and chalk, and occasionally also the graphite pencil (which was invented in about 1790 and patented in 1795), they also used watercolor to describe and differentiate details, as seen in the work of Kobell. In a certain sense, the realists functioned as a bridge between the Neoclassicists, who were oriented toward the past, and the emerging Romantics.

III. The generation of the Romantic revolution gave the period after 1800 its distinctively novel character. The works of Runge and of Friedrich, the great protagonists of this revolution, demonstrate most clearly that landscape and portraiture were given totally new dimensions: landscapes were spiritualized and invested with religious sentiment; portrait drawings were endowed with a new psychological depth. Runge, with his emancipated powers of invention, combined plant forms and lighting effects to create an original nature symbolism. Once again, the preferred media were pen and ink, wash, and chalk. Beginning with his earliest works, Friedrich also made use of the newly available graphite pencil. Only a few years later, the Romantic style of drawing was further developed in the impressive works of Kersting, Cornelius, Schnorr, the Olivier brothers, and Fohr.

Dresden, traditionally important as the primary residence of the electors of Saxony, became the capital of German art during the eighteenth century, when it was known as the "Florence on the Elbe." Around 1800 the most potent artistic forces still converged in Dresden. On the foundations constructed by the older generation—particularly the Swiss immigrants Graff and Zingg, as well as Johann Christian Klengel (Fig. 1) and Ferdinand Hartmann (Fig. 2), who are not included in the exhibition—a new development was inaugurated with the arrival of the North Germans Friedrich and Runge. This transition, which occurred at the opening of the nineteenth century, was not an abrupt break, but part of a gradual and continuous evolution. Zingg's sepia landscapes continued to exert a profound influence upon the motifs,

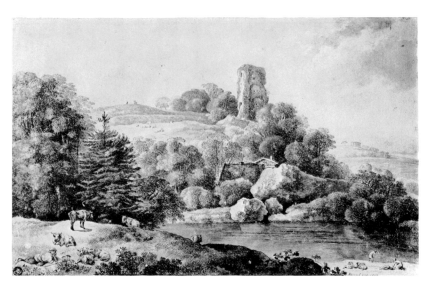

FIGURE 1 Johann Christian Klengel, *Landscape with a Ruin*, 1787. Sepia wash. Berlin, Nationalgalerie

formal conception, and technique of Friedrich's early drawings, until the younger artist developed an entirely novel vision of the landscape and its range of moods. Runge's early figure style was decisively molded by the classicizing art of Hartmann.

In addition to Friedrich and Runge, Dahl, Carus, and other notable artists lived in Dresden, which ranked among the principal centers of early Romanticism in Germany. While Friedrich's work progressed in this milieu, Runge soon departed for Hamburg, a city that had previously played a minor role in the visual arts. His preoccupation with a single theme in *The Times of Day*, and his portraits, which are the most penetrating human characterizations to come out of this period in German art, made Runge the embodiment of the Romantic artist.

Berlin, the capital of Prussia, reflected other aspects of the artistic spectrum around 1800. Austerity and objectivity had always distinguished the art of this city, and Chodowiecki's realistic

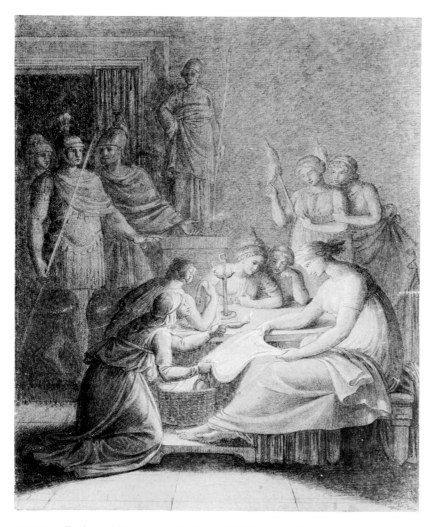

FIGURE 2 Ferdinand Hartmann, *The Wager of Collatinus and Sextus Tarquinius*. Charcoal, heightened with white. Berlin, Nationalgalerie

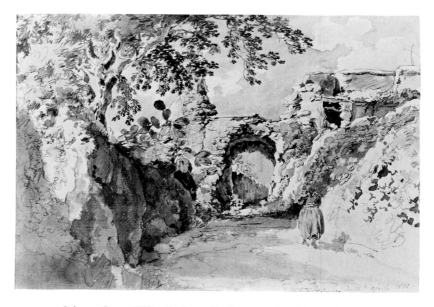

FIGURE 3 Johann Georg Dillis, *Road near San Lorenzo*, 1830. Watercolor, over graphite. Berlin, Nationalgalerie

approach, influenced by the Rococo as well as by the Enlightenment, was carried on and enhanced in the work of Schadow. At the turn of the century, Schadow, whose drawings combine objectivity and grace, was the outstanding draftsman in Germany. In contrast to Schadow's drawings, in his Berlin works, Carstens strove for an idealized Neoclassicism. Schinkel's early, emotionally charged landscapes and portraits are the only manifestation of a Romantic style comparable to that cultivated in Dresden.

In the Bavarian capital of Munich, as in Berlin, a realistic draftsmanship took root at an early date in the work of Wilhelm Kobell and in that of an artist not represented in the exhibition, Johann Georg Dillis (Fig. 3). Elsewhere, important draftsmen emerged, more or less sporadically and in the early stages of their development, in the years immediately after 1800; among them, Cornelius in Frankfurt and Fohr in Heidelberg.

The imperial city of Vienna was the gathering point for a group of young North German artists led by Pforr and Overbeck.

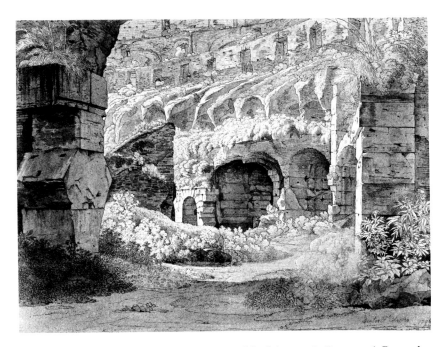

FIGURE 4 Johann Martin Rohden, *The Interior of the Colosseum in Rome*, 1796. Pen and brown ink, sepia wash, heightened with white. Berlin, Nationalgalerie

They began as students at the Academy, broke with the ossified traditions embodied most conspicuously by its director, Füger, and founded the Brotherhood of St. Luke in 1809. For several years after their departure for Rome, outstanding German draftsmen, such as the Olivier brothers, Schnorr, and Erhard, continued to reside in Vienna.

Finally, Rome was also among the cities that played a crucial role in the development of German art during this period. Long before the arrival of the Nazarenes, Tischbein and Hackert were active there, and Carstens joined them in 1792. Carstens's classicizing figure style, distinguished by its vitality, plasticity, and compositional effects, is unique among the approaches of the multitude of German artists active in Rome. These included Reinhart and Koch, exponents of the heroic landscape, as well as Johann Martin Rohden, who is not represented in this exhibition (Fig. 4).

The history of German draftsmanship around 1800 is so diverse and filled with gifted individuals that its radiance equals that of any of the fixed stars—Goya, David, Fuseli, and Blake—that shone across Europe during the period.

German Draftsmen in Rome, from 1790 to 1830

CLAUDE KEISCH

In 1823 Ferdinand Olivier published a suite of lithographs of land-scapes in and around Salzburg. The series opens with a family tree of German art (Fig. 5). On the branches of this oak, guarded by angels, hang plaques bearing the names of German artists, nearly all of whom worked in Rome: at the left, the generation of Carstens and the other Neoclassicists; at the right, the Brethren of St. Luke and their circle. Distant ancestors are indicated, but not the artists' immediate eighteenth-century forebears. Olivier, who belonged to the Brotherhood of St. Luke though he never traveled to Italy, evoked the complex relationships within the group of German artists who worked in the Eternal City, but saw them as isolated from the rest of the art world. He regarded them—as they regarded themselves—as the protagonists of a renaissance of their nation's art. Vigorous polemics—provoked by Carstens in the 1790s and later by what Goethe called the "new German religious-patriotic art" of the Nazarenes—only strengthened the missionary zeal of these artists and their literary allies.

German art in the early nineteenth century was in a unique and remarkable situation, because essential decisions affecting its evolution were made abroad, specifically in Rome. Art that was not produced in Rome, or not based on developments initiated there, remained isolated or misunderstood for many years. As late as 1876, in his *Geschichte des Wiederauflebens der deutschen Kunst zu Ende des 18. und Anfang des 19. Jahrhunderts*, Hermann Riegel devotes 2½ pages to Runge, 1½ to Caspar David Friedrich, and 20 to a respectful, but determined, polemic against Gottfried Schadow's Realism, while Schadow's work is only summarily described. In contrast, entire chapters of Riegel's book are given over to the German idealists in Rome. Granted, Riegel was fighting a rearguard action in favor of Neoclassicism, which, by that time, was not espoused by any living artist. Nonetheless, his position

underscores the lingering intellectual attitude that decisively favored the "elevated," idealized style and resolutely opposed any attempt to create a realistic art.

Sixteen years earlier Ernst Förster, a friend of Peter Cornelius and another advocate of the "intellectual wealth" of Nazarene art, published his *Geschichte der deutschen Kunst*. In part 4 of this work Förster traces the "reawakening" of German art in Rome directly to the Enlightenment and the ideals of liberty propagated by the French Revolution. This interpretation may not apply to all the branches of Olivier's family tree; however, if one considers the practical circumstances of the artists' lives, Rome certainly offered them freedom from the social constraints they would have faced at home, and this personal liberty served as a substitute for revolution.

This analysis is confirmed by the art scholar Karl Ludwig Fernow, one of the most influential minds in Rome around 1800, who praised "the great good fortune of independence, which can be enjoyed without coercion or restriction only in the Roman artists' republic." The political ring of the word "republic" is hardly fortuitous. Moreover, it recalls the notion of a "republic of letters," best known in Friedrich Gottlieb Klopstock's formulation (*Die deutsche Gelehrtenrepublik*, 1774). In another image drawn from the political sphere, Friedrich Schlegel called for "all artists to join as confederates in an eternal union," an idea that had long stood in the forefront of German thought. The intimate friendships among artists of the early nineteenth century and the foundation of the Brotherhood of St. Luke were limited attempts to establish such covenants.

Espousing the ideal of the artist's responsibility to the great ideas of his time, Fernow's friend Asmus Jakob Carstens accepted the creative freedom that Rome offered and unhesitatingly severed

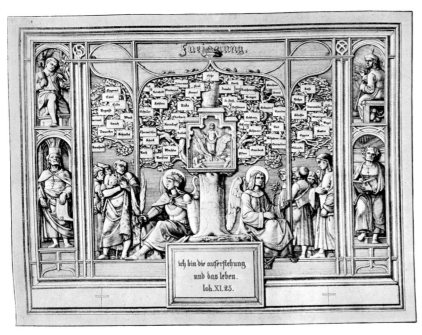

FIGURE 5 Ferdinand Olivier, Dedication Page to *The Seven Days of the Week*, 1823. Lithograph. Dresden, Kupferstich-Kabinett

his association with the Berlin Academy. Carstens's passionate letter includes his famous refusal "to spend my life as the serf of an academy."

The antiacademic protest was closely linked to middle-class ideals of freedom. Academies were condemned as the symbols and tools of the "tyranny" of absolutism. Joseph Anton Koch, like Carstens, counted among their enemies. Shortly after leaving the Karlsschule in Stuttgart, Koch scornfully cut off his pigtail and sent it to the school. Even in his old age, he could not heap enough criticism on the academic practice of dividing painting into different areas of specialization. While European academies awarded their best students with stipends for residence in Rome, pupils of the Vienna Academy, united by Pforr and Overbeck in

the Brotherhood of St. Luke, broke with the institution and settled in the Eternal City anyway, where they hoped to realize their ideal of a sincere, pious art that was devoid of virtuosity.

Yet, only a few years later, it was they who pondered most intensively how the state could promote the interests of artists. In August 1814, at a gathering that styled itself the General Convention of German Artists, Ernst Platner read a petition intended for the Austrian ambassador that demanded appropriate commissions from the state. A few months later, in his famous letter to the philosopher Joseph Görres, Cornelius asserted the necessity of reviving the art of fresco painting. Prussian diplomats in Rome wanted to accommodate his wish: Wilhelm von Humboldt and later Barthold Georg Niebuhr and Jakob Salomon Bartholdy supported a group of German artists who looked forward to the opportunity to undertake major mural projects in their native country. The efforts of King Ludwig I of Bavaria achieved the most spectacular results. While he was crown prince, Ludwig frequently traveled to Rome where he visited with the artists, and he maintained a permanent representative in Italy in the person of the sculptor Martin von Wagner (1777–1858). As soon as he ascended the throne, he summoned Cornelius, Schnorr, and others to Munich, and commissioned them to execute extensive fresco decorations.

These art policies were not restricted to natives of specific German states: Cornelius was Prussian and Schnorr, Saxon, and both went to work in Bavaria. On the other hand, the history of the Casa Bartholdy frescos (1816–17) demonstrates how difficult it was to overcome the habit of thinking in terms of territorial categories. Initially, only native Prussians were invited to participate in this project. It was only after several weeks that Overbeck, who hailed from Lübeck, was included.

Italy's capacity to attract and stimulate German artists cannot be attributed solely to its incomparable accumulation of earlier art, the character of its landscape, or the authority of Rome, albeit disputed, as the center of Christendom. For the Germans—who constituted what was probably the largest, and certainly the most enduring, contingent of the foreign colony concentrated in the

northern quarter of the city—there was another decisive factor. Since their homeland was divided and subdivided into countless independent states, it had no artistic capital where traditions could be established and standards set. If Rome had not provided them with a perennial forum for contacts with their German colleagues, the threat of isolation and provincialism might have become a reality. A few important figures, like Koch, Overbeck, and Reinhart, lived in Rome for decades and served as beacons to successive generations of artists. And, there were others who remained only a few years, but exercised an enduring influence, such as Carstens (Fig. 6), Schick, and Cornelius. In addition, the presence of colleagues from other countries stimulated the Germans to keep abreast of international artistic developments.

To be sure, life in Rome was very difficult. After the professors and court painters—from the generation of Mengs to that of Tischbein—had died out, the artists all lived without stable employment in an impoverished country. In Rome the Germans enjoyed their first taste of civil liberty and independence, which promised to satisfy their demands for complete self-realization and artistic truth, and, at the same time, jeopardized these demands, because their uncertain economic circumstances placed the artists at the mercy of the marketplace. This new situation had its external manifestations. The bohemian life, so typical of the nineteenth century, was cultivated by the Germans in Rome and spread from there to the mother country, where it affected even persons attached to the academies. The festivals held at the grottos of Cervaro in Rome became annual celebrations, marked by increasingly elaborate traditions that sustained the unconventionality of the—significantly designated—"artists' tribe" (*Künstlervolk*). Freedom from constraints could also become a moral principle. Overbeck, for instance, resolved to remain in Rome, despite all the temptations and the examples of other former Brethren of St. Luke, whose art permitted them to live like princes in Germany.

On the other hand, only in Rome was it possible for an artist, even without holding any kind of official post, to become a powerful and authoritative figure, as did Overbeck and, before him,

FIGURE 6 Asmus Jakob Carstens, *Philoctetes and Paris*, 1798. Watercolor. Berlin, Nationalgalerie

Carstens and Koch. Moreover, only there could artists form effective associations to advocate cultural policies. While the Brotherhood of St. Luke is the most conspicuous example, the same motivation lay behind the controversial writings of Joseph Anton Koch and of Johann Christian Reinhart, and behind the exhibitions that were meant to acquaint the public with new work. A logical progression led from the display of eleven compositions by Carstens in 1795 (and the ensuing polemics), to the shows organized by the German artists during princes' visits to Rome, to the inauguration in 1824 of regular annual exhibitions, to the foundation of the Künstlerverein in 1829.

All of this helps to account for the special role that drawing

played in the work of the German artists in Rome. The demand for originality and spontaneity, the contempt for the commerce in art and for the pursuit of art merely to earn a living, the rejection of rules, the stress on the godliness of art and its consequent responsibilities (the artist, said Friedrich Schlegel, is "the higher spiritual organ of humanity"), the elimination of bourgeois utility from the artistic sphere and the subjection of art to its own laws, the emphasis on the intellectual and the ethical, even at the expense of the technical and sensual—all these conditions furthered the importance of drawing. The new preference for this adaptable and personal medium was associated with revolt and rebirth, study and experiment, and the most rigorous idealism. The use of black and white also suited the ethos of Carstens's circle and the psychic asceticism of the Brethren of St. Luke. There were also practical considerations. As a result of the French occupation and the chaos in the States of the Church, Italian patrons were impoverished and the number of foreign tourists declined. Rome, lamented Joseph Anton Koch, was a "città dolente, where most artists chase after work like dogs hunting for bones." There was a market for landscapes, but, due to the lack of patrons for major commissions, artists did not carry history paintings beyond the design stage or they executed them without a specific site or client in mind.

As one would expect, drawing techniques and practices, as well as subject matter, varied considerably. Asmus Jakob Carstens, whose brief sojourn in Rome (1792–98) earned him a legendary reputation as the founder of a school, resorted to drawing because of the dearth of important commissions. Drawing also appears to have suited the conceptual, programmatic character of his work. Using black or red chalk on large sheets of paper, he created a purely figurative art of "noble simplicity," in the sense of Winckelmann's famous dictum. One might characterize his achievement as the most bourgeois manifestation of Neoclassicism. In contrast to the courtly-academic style, a liberal, democratic spirit animates Carstens's work. Within its circumscribed sphere of influence, his art was—albeit in a limited sense—as authoritative as French imperial painting. However, his work lacks the activist element of French painting, and, because Carstens eschewed decorative

FIGURE 7 Gottlieb Christian Schick, *Apollo among the Shepherds*. Pen and black ink, gray wash, heightened with white. Berlin, Nationalgalerie

values, it could not be adapted to any public function. His emphasis on the subjective indicates that the individual provided the source, the theme, and the purpose of his work, which, during this period, could perhaps have originated only in the unfettered atmosphere of the Roman artists' republic. Carstens's impressively serious variant of Neoclassicism, stamped with the ideas of the Sturm und Drang movement, made an autonomous contribution to European art and, through Wächter, Schick (Fig. 7), and Koch, profoundly influenced the Nazarenes.

Johann Christian Reinhart, who arrived in Rome at the age of twenty-eight and lived there for nearly sixty years, was the most persistent exponent of the classicizing landscape based on the example of Poussin. Reinhart's work consists largely of drawings and etchings, and his experience as a printmaker left its mark on his drawing style. In his studies, executed with disciplined chalk

33

hatchings on large sheets of paper, rocks, tree trunks, and foliage often loom oppressively in the foreground.

Joseph Anton Koch, one of the pillars of German art in Rome, specialized in landscape when he arrived in the city. However, he soon allied himself with Carstens and, under his influence, planned comprehensive series of illustrations of literary subjects. Koch later returned to landscape, achieving a synthesis of the Romantic style and the classical-heroic tradition that was possible only in Italy. E. T. A. Hoffmann's story *Die Jesuiterkirche in G.* (1817) describes the breakdown of an artist who cannot bridge the chasm between reality and the ideal. In Rome, where he works as a landscapist in the realistic style of Hackert, the young painter is pressed to forsake his specialty and embrace the more exalted task of history painting. A sinister stranger tries to lead him to the "sacred goal of all art," namely, the divination of the secret of nature. Finding himself at a similar crossroad, Koch created the "historical" landscape, in which nature serves as the setting for an important event. In his sublime or idyllic compositions, richly populated with figures, Koch strove for universality, in accordance with the idea that painting should comprehend all of God's creation. Gottlieb Schick, and Koch's pupils Fohr and Horny followed an analogous path. Koch's drawings vary greatly. In addition to numerous sheets of large format, meticulously executed with sepia or watercolor, he also executed drawings in graphite, and in pen and ink that are actually sketches, rather than studies. In these works, the clarity of large forms is not compromised by his rigorously disciplined stroke, which can be expressive and spontaneous in many of the pen drawings.

Koch lived in Rome for more than forty years. Thanks to his personal charisma, during his long career he was the mentor of many younger artists, some of whom, like the Brethren of St. Luke, espoused ideas completely different from his own. The Brotherhood's variant of Romanticism had germinated in Vienna in 1808–9 during weekly gatherings of the young Academy students, and its mature form was deeply influenced by their Roman sojourn. As early as 1804, Franz and Johannes Riepenhausen, who lived in Dresden, formulated the concept of a Catholic art

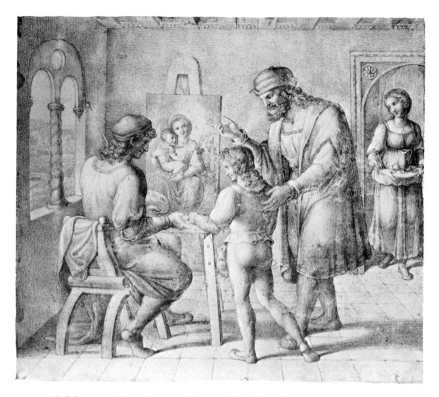

FIGURE 8 Johannes Riepenhausen, *Giovanni Santi Introduces Raphael to Perugino.* Black chalk, heightened with white. Berlin, Nationalgalerie

based on Italian painting of the period before Raphael (Fig. 8). Significantly, the Brethren of St. Luke, like the Riepenhausen brothers, felt drawn to Italy. All were inspired by the ideas expressed by Wilhelm Heinrich Wackenroder, a Berliner who died young, in his *Herzensergiessungen eines kunstliebenden Klosterbrüders* of 1797. In addition to a passionate prose poem, "Sehnsucht nach Italien," Wackenroder's book includes a meditation in which Dürer and Raphael come together as brothers.

In 1810 the Brethren of St. Luke arrived in Rome. As their community grew, their contacts increased. While the Brotherhood

could never have survived in the Austrian capital, in Rome it became the nucleus of an authoritative, prestigious movement, which, through the agency of Ferdinand and Friedrich Olivier and the young Schnorr, exerted an influence even in Vienna. Initially, their art was more broadly conceived and their world view more temporal and secular than one would assume from their programmatic writings and from the late paintings executed largely by their pupils. In the work of Cornelius, the young Overbeck, and Pforr, the desire to revive the art of painting through the infusion of a Christian and patriotic spirit is combined with a realistic feeling for life, with an earnestness and a sensitivity in the conception of the subject and in the execution.

While these artists cultivated an anachronistic style, their favorite drawing instrument was thoroughly modern. In 1795 the Frenchman Nicolas-Jacques Conté patented a process for compressing graphite to produce a wide range of textures, densities, and tonal values, and created the kind of graphite pencil still in use today. (In German, the graphite pencil is misleadingly called *Bleistift*, or lead point.) The visual effect of the graphite pencil remotely resembles that of German and Italian metalpoint drawings of the fifteenth and sixteenth centuries. "The graphite cannot be hard or sharp enough," wrote Ludwig Richter in the 1820s, "when drawing contours firmly and distinctly, down to the finest detail." The Brethren of St. Luke worked meticulously on white paper, emphasizing outline and utilizing rigorous parallel hatching and crosshatching, always conscious of the technique of German Renaissance engravings. They rejected academic formulas that prescribed the use of colored or prepared papers, black chalk with white heightening, and stumping. Meeting in a kind of private academy, they drew nude and drapery studies, while neglecting landscape and copying from antiquity. The Brethren held that their diligence had a moral, rather than a technical, value. It constituted evidence of their humility before God's creation—a humility that could not be tempted by virtuosity. Nature, according to Overbeck, is "the artist's only teacher." However, in art the sensual qualities of nature may easily become disembodied, as occurred in the works of Overbeck's younger followers. "Beauty!

It means freedom from accidental or unessential defects that cause trivial disruptions to the forms and disturb or weaken the overall impression," declared Overbeck in 1810.

The Brethren of St. Luke also executed carefully composed, highly finished drawings. The most important are those by a later initiate to the Brotherhood, Julius Schnorr von Carolsfeld, who preferred to work with the pen and often added wash to his compositions. In Schnorr's drawings the profuse penstrokes are improvisatory and free, and the linearity of the Nazarenes gives up its austere restraint and becomes weightless and melodious. Schnorr depicted various subjects, ranging from landscape to the human figure, from religious legend to contemporary idyll. The formal purity and delicate modeling of his drawings inevitably evoke comparison with Ingres. Later, when Schnorr became a successful mural painter, his penstroke assumed a dramatic, baroque character.

Drawings executed for reproduction in engraving, such as the *Bible in Pictures*—planned as a group project, but never realized as such—and the suites by Pforr and by Cornelius illustrating German medieval subjects, also played an important part in the artistic program of the Brotherhood of St. Luke. The serial and public character of these works offered a certain analogy to the idea of the public mural, which occupied these artists so intensively.

The portrait drawing was a genre in which the Nazarenes were particularly accomplished, and most of them contributed to its development (Fig. 9). Due to the scarcity of commissions, they resorted to depicting one another, and the systematic portrayal of the whole group of friends evolved into a ritual. The majority of these drawings were executed with the graphite pencil, and they served as studies, documents, mementos, and even cult images. They exude earnestness and profound respect for the sitter as a social equal. Winckelmann had related the concepts of freedom and friendship, and it is his ideas that gave rise to the Romantic cult of friendship and to Nazarene portrait drawing.

Scholars have rightly regarded the year 1819 as the end of a stage in the history of German art in Rome. In that year Peter Cor-

nelius and Wilhelm Schadow returned to their homeland and began to introduce Nazarene art and principles at German academies. Moreover, in 1819 the great mural projects got under way in Germany. These events form a historical paradox. In his famous letter of November 1814 concerning the revival of fresco painting, Cornelius, elated by the defeat of the French, clearly conveyed his desire that art should assume a new role in society. Art, he believed, would contribute to the rise of the fatherland, an idea supported by many Germans even as the Restoration began. Having barely tasted the freedom offered by emigration and residence in Rome, the artists longed for new social obligations. They wished to restore their patriarchal relationship to the feudal state, and expected to receive great commissions from German princes, which reveals the limits of their self-awareness. Neither the princes nor the church had the slightest intention of sponsoring works of art that promoted nationalist or democratic views. The frescos commissioned by private citizens, in the Casa Bartholdy and the Casino Massimo, in Rome, were to remain the most significant achievements in this field, which falls under the heading of nineteenth-century utopian ideas.

Of the Nazarenes who reached middle age, only Overbeck remained in Rome. The others returned to Germany to accept posts as teachers, court painters, and museum directors. Worldly success obliterated the memory of the Brotherhood's ambitious program, which had not only embraced issues of form and subject matter, but had affected the very basis of art as well (Fig. 10). While the strict Catholic branch of the Nazarenes began to wither as early as the 1820s, nearby there grew a younger and more productive shoot. Its first representatives arrived in Rome shortly before 1820. Dedicated primarily to landscape, they took Joseph Anton Koch as their model, and the younger artists, who specialized exclusively in landscape, also became disciples of Julius Schnorr von Carolsfeld. Karl Philipp Fohr was the most resolute imitator of Koch's multifaceted "historical landscape," but Fohr drowned in the Tiber at age twenty-three, only a year and a half after arriving in Rome. Heinrich Reinhold from Gera and Franz Horny from Weimar also died young. Horny's landscapes—often

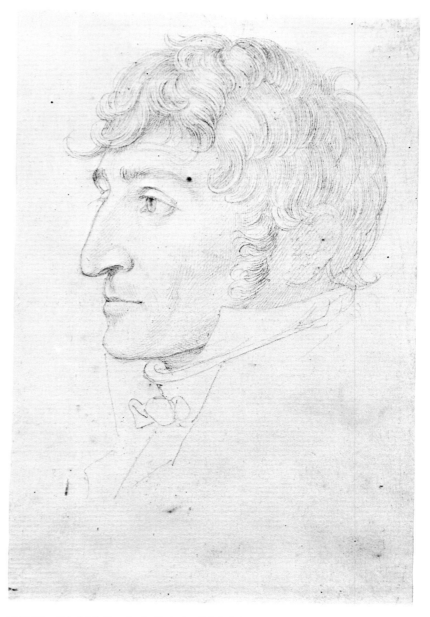

FIGURE 9 Friedrich Overbeck, *Portrait of Jakob Salomon Bartholdy.* Graphite. Berlin, Nationalgalerie

animated with pastoral staffage, and thus clearly finished compositions—were usually executed in pen and ink, with wash added to enhance the sense of space. Like Fohr, he strove to capture the powerful structural accents of grandiose mountains or groups of trees, the clear succession of planes in space, and the transparency of the atmosphere. In Horny's drawings, as in Fohr's, passages of wash or watercolor are contained within a profuse framework of lines. Slightly younger draftsmen, such as Ernst Fries, gradually dispensed with this linear skeleton as their interest in light increased and they focused on more intimate and specific landscape details. The heyday of the watercolor had arrived, and artists learned to manipulate monochrome washes to achieve effects similar to those of watercolor.

The free use of wash distinguishes the drawings of the brilliant Berlin artist Karl Blechen, whose Italian journey of 1828–29 inaugurated the era of German *plein-air* painting. Blechen, who had worked as a scene painter for a Berlin theater and was influenced by Caspar David Friedrich, discovered light effects in the campagna and in the area around Naples, and studied them in oil sketches, watercolors, and wash drawings. Without linear contours to divide them, one tone flows into another, while his indifference to modeling affirms Blechen's painterly approach to space and the spontaneity of his vision. He represented visual phenomena, rather than topographical facts. The totality of nature eludes representation in a single image, and Blechen's landscapes capture the random sights and the fluctuation of views both near and far that the eye normally sees. His work clearly has its roots in Romantic art: Blechen sought out what was moving, tense, even chaotic in nature—the momentary was his subject matter. However, a realistic component stands out in the drawings Blechen executed in Italy, especially in comparison to the works he did in Berlin both before and after this journey. The products of his Italian sojourn are all studies, though, and are not representative of his achievement as a whole.

German artists were prepared for this glorious debut of *plein-air* painting. Since the eighteenth century, they had admired and imitated the works of seventeenth-century Dutch landscapists,

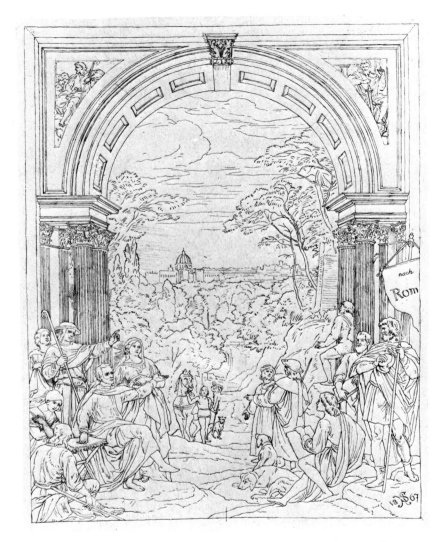

FIGURE 10 Julius Schnorr von Carolsfeld, *Artists and Pilgrims on the Way to Rome*, 1867. Pen and black ink, on tracing paper. Berlin, Nationalgalerie

who studied atmospheric impressions in unpretentiously composed, naturalistic views. However, the *plein-air* approach attained its fullest emotional and pictorial expression under the Italian sky, where the unified, serene tonal painting inspired by the Dutch school gave way to the depiction of light and color—at full strength—and of their characteristic values. But, the influence of the natural environment was only one factor that contributed to this development. *Plein-air* Realism, the most important artistic phenomenon of these decades, transcended national boundaries; French, English, German, Danish, and Eastern European artists followed its path. This influential communal achievement of about 1830 marked the end of the great period during which Rome had served as an international center for the exchange of artistic ideas. However, for German artists, Italy continued to be an indispensable refuge and training ground.

Nature and Reality

WERNER SCHMIDT

Art serves as a mediator between nature and man.
Caspar David Friedrich[1]

INSIDE AND OUTSIDE

In 1787 Johann Heinrich Wilhelm Tischbein made a drawing of his friend Goethe standing with his back toward the viewer, gazing out of a window of his apartment in Rome. This work proved to be the seed of a new pictorial device, the *Fensterbild*, which became one of the quintessential motifs of German painting of the first half of the nineteenth century.[2] In 1806 Caspar David Friedrich established the definitive form of this pictorial idea. He eliminated the figure and reduced the composition to its essential components. The window now frames only a narrow segment of the outside world. Like a picture within a picture, the exterior confronts the interior, and it is this relationship that Friedrich infuses with new meaning. The room becomes the sphere of the individual; the view through the window represents his environment. Through the *Fensterbild*, an artist could explore the relationship between inside and outside, knowledge and sensibility, subject and object, the individual and society. Artists who cultivated realistic styles were particularly fascinated by the philosophical and social ramifications of these issues, and during the following decades, they developed, altered, enhanced, and reinterpreted the *Fensterbild*.

Beginning in 1811, Friedrich's friend Georg Kersting took the lead. In a portrait drawing of about 1813–14 by Karl Philipp Fohr, both casements behind the young English sitter are open, permitting the branches of the lush bushes to push their way into the room. In a watercolor of 1818 (Cat. No. 27), Johann Adam Klein set the worktable of his friend Erhard close to an open window in a room flooded with light. The world outside predominates in works by Johann Christian Claussen Dahl (1823), Johann Gottfried

Schadow (1827; Cat. No. 21), Carl Gustav Carus (1829–30), Friedrich Wasmann (1833), and Jakob Alt (1836), and in the 1840s Adolph Menzel employed pictorial means to unite interior and exterior as one continuously illuminated space. Thus, the *Fensterbild*, which originated at the epicenter of Neoclassicism and assumed its distinctive form at the hands of the protagonists of the Romantic movement, found its fullest expression in German Realist painting of the second quarter of the century. The motif appears to have had a particular appeal for the Germans; in contemporary French painting, for example, it is used rarely, and then only as an incidental detail.

The artistic currents of the period between 1780 and 1850 may best be classified under the traditional rubrics of Neoclassicism, Romanticism, and Realism. However, these styles intersected, interpenetrated, overlapped, and enriched one another, even in the work of an individual artist. The combined action of these different forces is evident in the realist current that flowed through the entire period and influenced both the Neoclassical and the Romantic trends. From the 1770s on, the formal language of German art became increasingly veristic in an attempt to come to terms with reality, and Realism emerged as the dominant force in the second quarter of the century. However, the development of Realism sheds light on only one aspect of this period, the spirit of which was profoundly influenced by Neoclassical ideals and Romantic subjectivity.

REALITY AS A CRITERION

According to Paul Meyerheim,[3] Adolph Menzel promised a handsome reward to the nightwatchman of his Berlin precinct if he

would wake him when a fire broke out. Menzel wanted to experience a blaze firsthand in order to depict it convincingly in his painting *Battle of Hochkirch.* "Authenticity"—a word favored by Menzel—in the representation of visual phenomena was an essential artistic criterion for the Realists. As early as 1771, Jakob Philipp Hackert stressed the need for authenticity while executing six paintings of the naval battle of Tschesme for Czarina Catherine II. The painter convinced Count Orlov to burn a frigate of the Russian fleet anchored at Leghorn in order to give him a valid impression of a battle at sea. Goethe called this frigate "the most expensive and valuable model that ever served an artist."[4] In 1822 and 1824, when Friedrich depicted—with fascinating, persuasive power—jumbled masses of ice that had buried a ship, he was satisfied with making preparatory studies of the comparatively modest ice floes in the Elbe. Nonetheless, his goal, too, was the faithful reproduction of the appearance of reality. Friedrich qualified his statement (which is often quoted out of context), "the artist's feeling is his law," adding that: "The pure sensation can never be contrary to nature; it can only be in conformity with nature."[5] This remark confirms his belief in the harmony between the artist's feelings and objective reality. Friedrich perhaps regarded the degree of "conformity with nature" as a criterion for determining the purity of a sensation. Elsewhere in his writings, he pointedly placed "reality" in parentheses after "nature," emphasizing that he understood the concept of nature in the broadest sense.[6] Friedrich stressed the artist's personal responsibility to reality: "You must see with your own eyes, and you must faithfully reproduce objects the way they appear to you. . . ."[7] He adhered to this postulate with a rigor that was only strengthened by the religious premise of his art.

The younger generation, who rebelled in about 1830 against feudal repression, was passionately committed to the notion of the identity of nature, reality, and truth. The most outspoken of them was Georg Büchner, who wrote in 1835: "In everything, I demand life, the potential for existence. . . . My favorite poet or artist is the one who gives me nature at its most realistic."[8] With these words, spoken by the poet Jakob Lenz in Büchner's novella

Lenz, the writer deliberately and accurately ascribed the origins of the new awareness of reality to the Sturm und Drang movement of the late eighteenth century. By acknowledging his debt to Daniel Chodowiecki, Menzel located the beginnings of Realism in the period of the Enlightenment: "I am not the pupil of any living artist, but of Chodowiecki."

The concept of reality was influenced less by economic and political factors than by the ideal of *nature,* a word that recurs as a sign and a symbol in all of the writings of painters, authors, and musicians. Their conception of nature is reality outside the realm of man—nature, as opposed to culture.[9]

The subjectivity that is implicit in the perception of reality is inseparably bound to the concept of nature; hence, the fusion of Realism and Romanticism. Friedrich demanded: "Someone else's feelings must never be imposed on us as a law," thus elevating the objectivity of those sensations that are in "conformity with nature." The artist was, therefore, not contradicting himself when, on the one hand, he called nature "the best, never-erring leader," and, on the other, declared: "The only true source of art is our heart."[10] Between these two poles is suspended the art of the epoch known as the age of Romanticism. Even the relative objectivity of Menzel's work is nourished and animated by emotional subjectivity. This view of reality corresponds to the bourgeois character of the period as well as to contemporary events that were shaping the history of Germany. The liberated individual experienced and recognized the limits of his freedom. Like no other medium of the visual arts, drawing was capable of expressing the tension between submission to reality and immersion in feeling.

DRAWING FROM LIFE

Adolph Menzel's huge *oeuvre* of drawings—over 6,500 individual sheets and nearly as many studies in his seventy-seven sketchbooks—was executed for the most part in the presence of the object. The Romantics, as a rule, also drew from nature. As many hundreds of his drawings attest, Friedrich immersed himself de-

votedly in the study of reality, and most of the young Germans in Rome shared his commitment to working from nature. Painters and draftsmen regularly undertook summer walking tours, and an artist sketching in a landscape became a standard pictorial motif (Fig. 11). In 1795 the graphite pencil was patented and was immediately put into mass production, providing an ideal instrument for use on such journeys.

Drawing from life had been cultivated since the Renaissance, but, with the exception of the Dutch, artists neglected the practice during the Baroque period. Goethe noted the novelty of the work produced by Jakob Philipp Hackert and his brother in Italy around 1770: "Although it is important and absolutely necessary for the artist to study the subject of his work from nature itself, in Rome at that time, it was unusual to draw from nature . . .; least of all did one consider sketching and finishing a fairly large drawing from nature. The French *pensionnaires* were all amazed when they saw the two Hackerts roaming the countryside with large portfolios, executing finished outline drawings in pen and ink, or, indeed, highly finished watercolors and even paintings entirely from nature."[11]

During the same period, Adrian Zingg frequently left his home in Dresden to draw the Romantic valleys of the Erzgebirge, "Saxon Switzerland," and Bohemia, with their ancient castles, palaces, and mills (Cat. No. 14). To be sure, Zingg, like Hackert, did not regard most of these studies as finished works, but as a preliminary stage in the creation of finished landscape drawings with staffage, which he would execute with pen and wash in his studio. Julius Schnorr von Carolsfeld began his drawings outdoors, and elaborated and completed them in the studio. In some instances, Friedrich may have followed a similar procedure. However, he generally distinguished rigorously between nature studies, which he executed in a summary manner or left unfinished, and drawings composed in the studio, in which he incorporated individual motifs adapted from his nature studies. Menzel, too, used his nature studies as source material, which he would later rework in the studio.

The life study was cultivated by Realists, Romantics, and

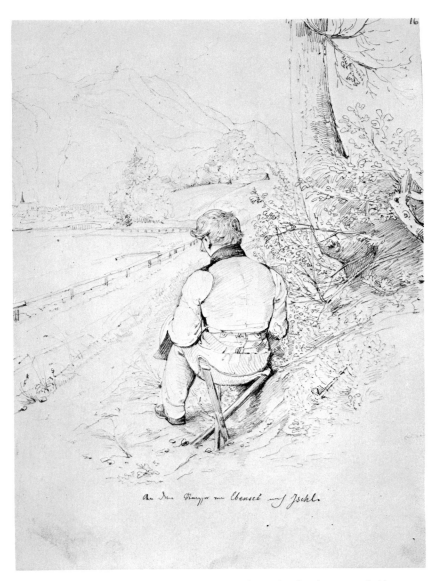

FIGURE 11 Ferdinand Georg Waldmüller, *A Draftsman in a Landscape near Ischl.* Graphite. Vienna, Graphische Sammlung Albertina

Neoclassicists alike. Following the example of the Renaissance masters, the Nazarenes devoted themselves to the meticulous description of drapery folds. Peter Cornelius based the poses of the figures in his murals upon studies he made after the nude model.

NATURALISTIC DETAIL

Naturalistic detail, which assumed its distinctive character in the 1770s, became a stylistic hallmark of German art between 1790 and 1850. It occurs both as a visual and as a literary component, and is in keeping with the tendency toward Realism.

Jakob Philipp Hackert devoted close attention to each block of masonry in the wall at Hohenheim (Cat. No. 3). Despite the uniform alignment of the neatly squared stones, he subtly differentiated between them, varying their size, profile, condition, lighting, or the presence of vegetation. In his drawing of the Kepp Mill (Cat. No. 15), Adrian Zingg incorporated various details within the lively flux of natural forms. These seemingly accidental, unique details—on the façade of the old mill, for example—are accentuated by this whimsical abundance. The difference between Chodowiecki's portrayal of a poetry reading in a summerhouse (Cat. No. 16) and an aristocratic salon of the Rococo could hardly be more pronounced. The stiff seating arrangement, the uncomfortable benches, the handwork of the ladies—all of these naturalistic details convey the moving earnestness of the scene.

The isolation of the incidental detail and its elevation to a pictorial motif is a product of the naturalistic outlook. Philipp Otto Runge, Franz Horny, Friedrich Olivier (Cat. No. 70), and Ludwig Richter paid homage to the rich tradition of flower and plant studies. As early as the 1770s, Goethe was drawing individual clouds and rocks. Friedrich loved to study isolated objects, such as cliffs, stone formations (Cat. No. 42), trees (Cat. No. 40), tree trunks, branches, and plants, as well as boats, masts, and tools. His remark, "Surely each phenomenon in nature, if understood correctly, judiciously, and with respect, can become a subject for art," pointed far into the future.[12]

The new sensitivity, which encouraged the investigation of reality down to its tiniest manifestation, culminated in Menzel's drawings. He conceived of a bookcase as a microcosm, in which each volume is granted a unique existence (Cat. No. 118). In *Unmade Bed* (Cat. No. 120), every fold of the rumpled bedclothes receives astonishingly close scrutiny, and the details acquire meaning through their unique form.

It is readily apparent that the Realists, from Johann Erdmann Hummel and Wilhelm Kobell to Adrian Ludwig Richter and Franz Krüger—who may all be considered Biedermeier artists—meticulously furnished their pictures with sharply observed details. However, seemingly incidental details also determined the formal language of the Viennese Romantics and the Nazarenes, and it was precisely this dedication to detail that lent their drawings an aura of devotion and consecration. In the work of the Nazarenes, the precision of materialistic observation blends in a strange way with their rapturous religiosity. Their painstaking conscientiousness with respect to things small was not limited to natural phenomena, which they perceived as creations of God, but was extended to more trivial man-made objects, such as crumbling plaster, rustic implements, or a piece of clothing. In Friedrich Olivier's drawing of a Christ-like pilgrim (Cat. No. 71), even the nails in the man's shoe are quite distinct. Using Franz Pforr's drawing of the young Maria as a guide (Cat. No. 52), a cabinetmaker could build the little folding table mounted on the wall. In his summary pen drawing of a visionary scene from Goethe's *Faust* (Cat. No. 57), Peter Cornelius took care to emphasize Faust's thickly creased topboots and the peacock feathers in his biretta. Karl Philipp Fohr calls attention to the bedsheets hanging in the sun on the balcony of the Tyrolean house nestled beneath the heroic alpine massif and the Hohenwerfen fortress (Cat. No. 77). In their severe portrait drawings, which strive to represent human ideals, Fohr, Theodor Rehbenitz, Julius Schnorr von Carolsfeld, and Friedrich Olivier depicted the hair styles of their models with penetrating exactitude (Cat. Nos. 61, 65, 72).

The desire to make objects almost tangible for the viewer permeates even idealistic allegories. Tischbein's *The Power of Man* (Cat.

No. 1) is an extreme case. The artist tried to extol the proficiency of the young hunter and his superiority over the spoils of the hunt by depicting the youth, the lion, and the eagle in the immediate foreground. However, they are so close to the viewer that they appear merely grotesque. In his *Times of Day*, Runge precisely characterized the poses of the heavenly children, right down to the tips of their toes. Kneeling on little cloud banks as if in a sandbox, they are distinguished as boys or girls by their genitals (Cat. No. 33). In his *Greek Princes in Achilles's Tent* (Cat. No. 6), Asmus Jakob Carstens did not shrink from depicting the trivial, and he shows how an ancient leather cushion was sewn together. Joseph Anton Koch has Amor act as a prompter in *Landscape with the Judgment of Paris* (Cat. No. 9). Richard Hamann emphatically singles out the hidden naturalism in German Neoclassicism.[13]

Through the painstaking manner of drawing, such details stand out and acquire meaning within a composition. Exacting detail may be regarded as a stylistic element, which informs both the naturalistic modeling and classicizing contours. The seemingly contradictory combination of lofty idealistic intentions and naturalistic interpretation constitutes what is innovative in this art. It is an index of the truthfulness and of the serious aspirations of these artists.

FIGURE 12 Christoph Nathe, *The Walls of Görlitz*. Watercolor. Dresden, Kupferstich-Kabinett

THE VIEW OF THE EVERYDAY

Christoph Nathe (1753–1806) led the Saxon veduta tradition beyond Bellotto and, in his drawings of Görlitz of around 1790, pointed the way to Menzel's cityscapes. Nathe's selection of an insignificant motif—secular buildings and the ramparts of a city, seen as if in passing—is in keeping with his factual, clear, and yet free execution (Fig. 12). In 1796 Johann Georg Dillis (1759–1841) depicted the demolition of the Roter Turm in Munich, which had been damaged the previous year during fighting between the Austrians and the French (Fig. 13). The Bavarian Realist treated that important event in the history of the city as merely a random incident, scarcely noticed by pedestrians, riders on horseback, and wagoners. Wilhelm Kobell brings out the everyday character of a

scene outside the city of Ingolstadt through the coincidental juxtaposition of figures and setting (Cat. No. 24). In a series of wash drawings of the banks of the Isar River, executed shortly after 1800, Franz Kobell took a remarkable step in the pictorial representation of anonymous, topographically insignificant motifs (Fig. 14). The close-up, frontal view, the painterly, free manner of drawing, and the investigation of light effects paved the way for Friedrich Wasmann, Johann Christian Claussen Dahl, Karl Blechen, and Adolph Menzel.

In Caspar David Friedrich's nature studies, clarity and simplicity predominate. The motifs are so simple that one could encounter most of them anywhere, and the mundane character of a

FIGURE 13 Johann Georg Dillis, *The Demolition of the Roter Turm in Munich*, 1796. Graphite and watercolor. Munich, Staatliche Graphische Sammlung

FIGURE 14 Franz Kobell, *The Bank of the Isar River*. Brown wash. Dresden, Kupferstich-Kabinett

site is further underscored by the straightforward representation. Johann August Heinrich's secular view of the Loschwitz cemetery, of 1822 (Cat. No. 96), anticipates similar drawings by Menzel, of twenty years later. In Eduard Gaertner's watercolor of 1826 (Cat. No. 115), the viewpoint is that of the workers, sailors, and officials on a quay by the Seine, below the Louvre, so that the towers of Notre-Dame remain hidden behind the apartment houses of the Ile de la Cité.

The vision of the everyday is raised to the level of an artistic principle in Adolph Menzel's Realism. He arrested and crystallized into a single moment the ceaseless ebb and flow of reality. A striking feature of Menzel's vision was his preference for the view from the rear, which allowed him to circumvent the more representative façade. The concern with the reverse side is a symptomatic

impulse of the Realist art of the nineteenth century. Figures seen from the back in Friedrich's work acquire additional meaning, as does Kersting's portrait of Friedrich, seen from behind (Cat. No. 48). Ferdinand Olivier's view of the back of the Starhemberg Palais, with utility buildings for livestock and a timber yard in the foreground (Cat. No. 73), predates by more than a decade Johann Erdmann Hummel's innovative painting of a similar motif, *View of the Schiffbauerdamm, Berlin* (destroyed; formerly Berlin, Märkisches Museum). In Alfred Rethel's representation of Charlemagne's entry into Pavia, we view the procession from halfway around to the rear (Cat. No. 103). The scene is filled with the dead and the wounded, destruction, and fire, revealing the other side of a military victory.

Cityscapes by the young Romantics in Vienna focus on the

modest suburbs of the imperial city, rather than on its famous sites. Ferdinand Olivier incorporated construction sites into his views of the area around Salzburg, and named the 1823 series of lithographs of these drawings after the days of the week. The German draftsmen in Italy liked to include indigenous shepherds and farmers in their landscapes, to add a human presence. They eschewed the standard views of Rome, preferring secluded spots in the mountains—the rural backside of Rome, so to speak. However, in spite of many naturalistic details, their landscapes do not impart a feeling of everyday reality because a sense of the idyllic predominates, a retreat from the oppressiveness of their homeland and the projection of their ideals of happiness onto a new and unfamiliar life.

The taste for unadorned reality informs some of the period's most striking portrait drawings. On 7 September 1800 Friedrich sketched himself grimacing in front of a mirror, and on 8 March 1802 he drew himself wearing an attribute of his profession, a "visor flap" covering one eye. In his *Self-Portrait* of 1838, Johann Gottfried Schadow added the marks of old age to his decidedly unprepossessing countenance (Cat. No. 22). Franz Krüger chose to depict himself during an illness (Cat. No. 112).

FIGURE 15 Joseph Anton Koch, *Peasants Listening to a Wanderer*, 1792–94 (?). Graphite, pen and ink. Dresden, Kupferstich-Kabinett

HUMANITY, PATRIOTISM, AND REVOLUTION

The artists' attitudes toward the political events of their time reveal another aspect of their relationship to reality. Prior to 1789, there were no pictures by German painters that criticized the despotism of the princes, although disaffection with aristocratic regimes had been expressed in plays such as Lessing's *Emilia Galotti* (1772), Goethe's *Götz von Berlichingen* (1773) and *Egmont* (1778), and Schiller's *Die Räuber* (1781) and *Kabale und Liebe* (1784). In a series of pointed caricatures of 1790, Joseph Anton Koch expressed his indignation over the conditions at the Württemberg court. The Jacobin convictions of his years in Switzerland (1792–94) emerge in a drawing of crude, emphatically plebian shepherds, who are listening attentively to an audacious-looking wanderer (Fig. 15). The cockade on his upturned hat brim probably identifies him as a partisan of the Revolution. Following his arrival in Rome in 1795, Koch embraced the Neoclassicism of Carstens, who may have been sympathetic to his republican ideas. The humanitarian ideals formulated by Goethe, Herder, and Schiller also inform the portraits of the period around 1800 by artists such as Anton Graff, Johann Gottfried Schadow, and Philipp Otto Runge (Cat. Nos. 12, 18, 31).

French repression during the Napoleonic era strengthened the German national consciousness. In 1809, motivated by a spirit of patriotism, Runge drew three allegories on the subjects of the downfall and the misery of the fatherland. Friedrich, who had

illustrated scenes from Schiller's *Die Räuber* in 1799, inscribed the words "for liberty and justice" on the sarcophagus of a freedom fighter in a painting of 1812 (Hamburg, Kunsthalle; Börsch-Supan/Jähnig, 1973, no. 205), thus associating his democratic stance with an affirmation of national liberation. He adhered to his convictions after 1819, when such views were persecuted as "demogogic intrigues."

Aroused by the "reborn spirit of the nation," in 1814 Peter Cornelius called for the revival of mural painting in the public buildings of German cities, so that art could serve all of the people instead of being "a whore for arrogant grandees."[14] The first works of this new German art form came into being under humble circumstances in the rented palazzo of Jakob Salomon Bartholdy in Rome (Cat. No. 58). In January 1818, while visiting the German artists in Rome, Crown Prince Ludwig of Bavaria endorsed the plans of the Brotherhood of St. Luke, and in 1819 he set in motion an ambitious program of monumental commissions that transformed Munich into an artistic capital during his reign. Drawings in our exhibition by Julius Schnorr von Carolsfeld and Carl Rottmann relate to two of Ludwig's most important projects (Cat. Nos. 69, 99). It is difficult to generalize about the various murals executed in numerous locations after 1820, but Rethel's Charlemagne frescos have the greatest artistic significance (Cat. Nos. 102, 103). Notably, the patron of this project was the Düsseldorf Kunstverein, which was supported by new industries in the Rhineland and Westphalia.

Among German painters active after 1830, there were no republican-minded figures of the stature of Heinrich Heine or Georg Büchner. However, all the centers of artistic activity witnessed the birth of a fresh, critical spirit, which especially animated draftsmen and printmakers, such as Adolf Schrödter in Düsseldorf, Theodor Hosemann and Adolph Menzel in Berlin, Adrian Ludwig Richter and Carl August Richter in Dresden, and Wilhelm Kaulbach in Munich. The painters Wilhelm Joseph Heine and Karl Wilhelm Hübner in Düsseldorf, and Ferdinand Georg Waldmüller and Josef Danhauser in Vienna, treated the theme of social misery, a reality that had only recently come to the public's

FIGURE 16 Carl Spitzweg, *Officer and Lady*. Graphite. Dresden, Kupferstich-Kabinett

attention. Carl Spitzweg invested Biedermeier social criticism, which threatened to become dissipated in flights of sentimentality or humor, with a unique note somewhere between amiable self-irony and penetrating characterization (Fig. 16).

The revolution of 1848–49 affected the most important artists. In Berlin, Theodor Hosemann honored the young barricade fighter Ernst Zinna in a lithograph. Menzel executed drawings depicting civil defense, public debates, and election assemblies, and worked on a history painting showing the public display of the caskets of the insurgents who died on the barricades. In Düsseldorf, Johann Peter Hasenclever portrayed a delegation of workers before the city magistracy—the first painting of a proletarian political action. In Dresden, where Richard Wagner and the architect Gottfried Semper took part in the uprising, Julius Scholtz forcefully depicted the fight at the barricades. By virtue of its bitter earnestness, Alfred Rethel's series of six large allegorical woodcuts (Cat. Nos. 104, 105) is also an accurate historical appraisal of the "truly unified and—in the most elevated sense—proud enthusiasm of the people," which brought about "the establishment of a great and noble Germany,"[15] as the artist wrote on the day the rebellion was suppressed. In the revolution that closed the period, the clash of Romantic spirit and real power proved once again to be a fundamental historical problem of the era.

NOTES

1 Caspar David Friedrich, *Bekenntnisse*, edited by Kurt Karl Eberlein (Leipzig: 1924), p. 118.

2 Schmoll, 1970.

3 P. Meyerheim, *Adolph von Menzel* (Berlin: 1906), p. 25.

4 Quoted in Johann Wolfgang von Goethe, *Ausgewählte Werke* (Stuttgart: 1867), vol. 26, p. 66 f.

5 Friedrich, *Bekenntnisse*, p. 110.

6 Ibid., p. 118.

7 Ibid., p. 103.

8 Georg Büchner, *Werke und Briefe* (Leipzig: 1835), p. 93.

9 Richard Hamann, *Die deutsche Malerei vom Rokoko bis zum Expressionismus* (Leipzig: 1925), p. 6 f.

10 Friedrich, *Bekenntnisse*, p. 121.

11 Goethe, *Ausgewählte Werke*, p. 56 f.

12 Friedrich, *Bekenntnisse*, p. 204.

13 Hamann, *Die deutsche Malerei*, p. 79 f.

14 Peter Cornelius in a letter to Joseph Görres, November 1814, quoted in A. Kuhn, *Peter Cornelius* (Berlin: 1921), p. 114.

15 See Cat. No. 105.

The Romantic Concept of a "Union of the Arts"

MATTHIAS KÜHN

With the aphorism "Hearing is seeing from within, the innermost consciousness," Johann Wilhelm Ritter establishes the physiological superiority of hearing over sight, in his *Fragmente aus dem Nachlasse eines jungen Physikers* of 1810. However, in the sentences that follow he soon relinquishes the scientific approach in favor of a philosophical and aesthetic one: "No view of the universe is totally and unconditionally valid, except the acoustic."[1] At a crucial point of *Kreisleriana* (1815), E. T. A. Hoffmann returns to the "remark of an ingenious physicist," and elaborates upon Ritter's idea: "Just as . . . hearing is seeing from within, for the musician, seeing becomes hearing from within—listening with the innermost consciousness to the music that, vibrating in unison with his spirit, emanates from everything his eye sees."[2] Hoffmann alludes not only to the synaesthetic relationship between hearing and seeing, but also to the connection between music and the visual arts. The Romantics were nearly unanimous in assigning to music the preeminent place in the hierarchy of the arts, ranking it above poetry and painting. Schelling, Tieck, Runge, Wackenroder, and Hoffmann all agreed on this point. They could even have reached a consensus on this issue with their opponents Goethe and Schiller.

In *Wilhelm Meisters Wanderjahre* (1829), Goethe affirms the special status of music, with its incorporeal character that excludes anything of an extramusical nature. "It is perhaps in music that the majesty of art appears most eminently, because music has no material component that must be taken into account. It is entirely form and content, and elevates and ennobles everything it expresses."[3] This idea approaches the Romantic concept of "absolute music." As early as 1793–94, in his *Briefe über die ästhetische Erziehung des Menschen*, Schiller defended the pre-Romantic concept of a convergence of the arts.

Music, at its most sublime, must become sheer form and affect us with the serene power of antiquity. The plastic arts, at their most perfect, must become music and move us by the immediacy of their sensuous presence. Poetry, when most fully developed, must grip us powerfully as music does, but at the same time, like the plastic arts, surround us with serene clarity. This, precisely, is the mark of perfect style in each and every art: that it is able to remove the specific limitations of the art in question without thereby destroying its specific qualities, and through a wise use of its individual peculiarities, is able to confer upon it a more general character.[4]

A few years later the protagonists of early Romanticism adopted similar views, but expressed them more decisively and emphatically. Goethe's reaction was brusque and authoritarian: "One of the principal symptoms of the decline of art is the intermixture of the different arts" (1798).[5] In his lectures on the philosophy of art, delivered at Jena in 1802–3, the young F. W. J. Schelling advocated "the most complete synthesis of all the arts." His goal was to reform the opera "in the most elevated and noble style" in order to revive the drama of classical antiquity.[6] In their journal *Athenäum* (1798–1800), the brothers August Wilhelm and Friedrich Schlegel also fostered a general awareness of the idea of a union of the arts, and of the "wonderful affinity of all the arts and sciences."[7] During this period the strict separation of art, philosophy, and the natural sciences became untenable.[8] The Romantics strove to break down the traditional barriers between the various arts—which had been reinforced by the aesthetic theories of Lessing and of Weimar Classicism—in favor of a synthesis of the arts, which they called for repeatedly.

The conviction that word, image, and sound are intimately

related is implicit in the works of early Romantic authors. In Ludwig Tieck's novel *Franz Sternbalds Wanderungen* (1798), one of the characters exclaims: "If only you could entice into your painting the miraculous music that the heavens have written today!"[9] In his *Herzensergiessungen eines kunstliebenden Klosterbrüders* (1797), Wilhelm Heinrich Wackenroder describes the visions the musician Joseph Berglinger has as he listens to music in church or in the concert hall. He transforms auditory sensations synaesthetically into images—the hallucinations that he experiences become reality. Furthermore, "many passages were so clear and vivid to him that the musical tones seemed to be words."[10] A letter written in 1802 by Philipp Otto Runge indicates that Wackenroder's contemporaries were rapidly adopting this synaesthetic mode of perception. Runge formulated his impression of Raphael's *Sistine Madonna* in words that suggest an intrinsic relationship between painting, music, and literature: "In front of this picture one comprehends that a painter is also a musician and an orator; one feels a higher devotion, as in church."[11]

The Romantics expected all of the arts to inspire a "higher devotion," regardless of whether a given work had a sacred function. Art was to convey a primarily mystical experience of the universe.[12] Music, above all the other arts, was considered capable of producing such an effect, "because music is certainly the ultimate mystery of faith; it is mysticism, religion completely revealed."[13] In a comparative analysis of the musical aesthetics of the early Romantics Wackenroder and Tieck, and the Protestant theology of Friedrich Schleiermacher, the music historian Carl Dahlhaus states: "That aesthetic contemplation could seem to be religious devotion was the converse of the phenomenon that religious devotion often reached the threshold of aesthetic contemplation."[14] This conclusion has extremely important ramifications that extend far beyond the realm of music; it illuminates an essential aspect of the visual arts around and after 1800, and can fundamentally enrich our understanding of the painting of Runge, Friedrich, and the Nazarenes. Moreover, it reveals an aspect of communality among the arts.

Also common to all the arts was the rediscovery of earlier traditions, which occurred simultaneously in literature, music, and painting. *The Nibelungenlied* and the lyrics of the Minnesingers, the music of Palestrina, Monteverdi, and Bach were rescued from obscurity. Giotto, Fra Angelico, Michelangelo, Leonardo, and Raphael became Romantic cult figures; for Wackenroder's "art-loving monk," Albrecht Dürer was the "venerable forefather" of contemporary artistic aspirations. This new, incisive historical consciousness, which often encompassed a period of several centuries, not only informed the literature on art, but affected artistic practice as well. In general, this historicism led to a transfiguration of the past. "One sought and found in history what modernity was incapable of providing. It was inevitable that their image of history assimilated their own dreams and hopes, and that the selection, interpretation, evaluation, and knowledge [of historical information] were determined by the ideas of an age that gravitated toward the past in order to replenish itself."[15] The idea of the "religion of art" was often associated with pride in the national past. In the preface to the anthology *Minnelieder aus dem schwäbischen Zeitalter* (1803), which he edited, Ludwig Tieck notes enthusiastically "that people not only take an interest in the monuments of a bygone age, but they also value them and . . . strive to divine, and ultimately to discover, a sacred, unknown land."[16] Johann Nikolaus Forkel, who rediscovered the music of Bach, similarly combined the religion of art with patriotism. Although Forkel did not belong to the Romantic movement, in his Bach monograph of 1802—"for patriotic admirers of genuine musical art"—he acknowledges that "anyone thoroughly familiar with Bach's works can speak of them only with rapture, and, for some, even with a kind of holy adoration."[17]

A new, almost sacred dignity was thus attached to art, which the Romantics redefined as a "premonition of the infinite" and a "revelation of the absolute." The devotional reverence for the arts soon inspired the cult of the artist. According to Dahlhaus: "In the religion of art, an artistic idea that tended toward religion met a religious idea that tended toward art, though there was no question of the one being mistakenly transferred to the other."[18]

The ideal of the "musically inspired union of the arts" derived

in a certain sense from the notion of the "religion of art." If, during the period after 1800, visual artists persistently strove to unite their works with music "in a synthesizing manner" (Schelling), their purpose was to appropriate the "holy" potential of music, which Schelling characterized as the "archetypal rhythm of nature and of the universe."[19] (In other respects, the ideas of "absolute music" and of a "synthesis of the arts" are mutually exclusive, though both *topoi* originated in the Romantic period; this was implied by Tieck[20] and explicitly stated by E. T. A. Hoffmann.)[21]

The younger generation paid scant attention to Goethe's verdict, which held that the "intermixture" of the arts was a sure sign of their decadence. It was one of the first times in history that painters, musicians, and writers had so deliberately and resolutely sought to bring the "sister arts" together, and exponents of the most varied art forms had rarely reacted so vividly to one another's work as in the decades around 1800.[22] In any event, during the Romantic period a "union of the arts" was not realized in a "collective work of art" (*Gesamtkunstwerk*, a term coined by Richard Wagner), in spite of many serious attempts. A convincing synthesis of *two* art forms occurred only in the blend of music and lyrics that so splendidly succeeded in the Romantic lieder of Schubert and of Schumann. One must abandon the realm of Romantic theory, and speak more modestly of "encounters" and "contiguities" among the arts, rather than of a "union." These contacts were fostered by the cultural milieu of this era, when educated persons shared an informed interest in various aspects of art, or dabbled in drawing, poetry, or musical composition.[23]

After moving to Dresden in 1801, the twenty-four-year-old Philipp Otto Runge did not choose a fellow painter as his closest friend, but the musician Ludwig Berger, his exact contemporary. The exhibition includes Runge's earnest, idealized portrait of Berger (Cat. No. 31), who later taught Felix Mendelssohn. The artist wrote of his friend: "We are completely of one mind. . . . He instructs me in music, and I teach him the visual arts. Everything is understood in theory only, but I know full well that it is a great advantage for an artist to be at home in the other arts, and how much clearer and purer our concepts of all human striving become

as a result, because the arts are the most faithful reflection of the age and of the beliefs of the human race."[24] Later, Runge and Berger made friends with an otherwise unknown, young architect named Schäfer, enabling them to carry on intensive, informed discussions about painting, architecture, and music. "We compare our three arts, and the combinations of our ideas give rise to new ones, which, in the end, amount to something; we try to discover amongst ourselves the prejudices in knowledge and in art that make others ridiculous, and thus guard against them."[25] In November 1801 Runge gained the confidence of Ludwig Tieck, the author of *Sternbald*, whom he greatly admired. Tieck provided Runge with encouragement and all manner of suggestions, introducing him to the writings of Jakob Böhme and probably to those of Novalis as well.[26]

In about 1802, Runge began to pursue his plan to "musicalize painting" (Lingner). This undertaking produced some results, but, admittedly, they were not always advantageous to his art. *The Nightingale's Lesson* (various versions, 1801–5), inspired by the verses of Klopstock, and his designs for "allegorical interior decorations" are not only products of his "synthesizing" efforts, but also represent stages in the consolidation, indeed the "hardening, of form."[27]

Runge executed the drawings for *The Times of Day* (Cat. Nos. 33–35) between Christmas 1802 and July 1803, when he was still in Dresden. Initially, they were meant as studies for murals in a music room, so Runge endeavored to infuse his allegories of morning (Fig. 17), evening (Fig. 18), day, and night with the spirit of music. The austere, geometric structure that underlies his designs derives from principles of both music and architecture, so it is likely that his debates with the musician Berger and the architect Schäfer did indeed "amount to something." The reference to the cosmic, which is implicit in the subject itself, suggests that Runge, as a visual artist, intended to compete with music's claim that it is the mirror of the universe. As Schelling put it: "The solar system expresses the entire system of music."[28] Runge never came close to realizing his plan to transform the drawings of *The Times of Day* into a mural decoration, or his dream of creating

FIGURE 17 Philipp Otto Runge, *Morning* from *The Times of Day*, 1805. Engraving and etching. Dresden, Kupferstich-Kabinett

FIGURE 18 Philipp Otto Runge, *Evening* from *The Times of Day*, 1805. Engraving and etching. Dresden, Kupferstich-Kabinett

a *Gesamtkunstwerk* based on the divine spirit. "When it is developed," he wrote, "it will be an abstract, painterly, fantastic-musical poem with choirs, a composition for all the arts collectively, for which architecture should raise a unique building."[29] Instead, the series appeared in the form of engravings; the first edition, in Dresden in 1805, the second, in Hamburg in 1807. Music plays a special role in Runge's complex, highly subjective allegory; it is embodied by the music-making genii, whose instruments produce a timbre that is appropriate for morning, day, evening, and night.[30] From his Hamburg period until his death, in December 1810, the vision of *The Times of Day* never lost its hold on the artist.

Musical symbolism of a singular, very different kind pervades the *oeuvre* of the music-lover Carl Gustav Carus.[31] Although the Romantic concerns of his friend Friedrich become superficial in Carus's work, his pictures are characteristic of the period style, which can be studied more readily in the achievements of mediocre talents than in those of the solitary geniuses. In 1823 Carus painted *Fantasy on Music*,[32] a picture intended to be an allegory, which Carus describes in his *Lebenserinnerungen und Denkwürdigkeiten*: night is falling, a vine-covered, empty Gothic hall looks out over the steeples of the cathedral to the sea.[33] In the hall, dominating the scene, stands "a solitary harp, its strings kissed by the beams of the full moon in the nocturnal stillness"—this, in any case, is how a rapturous reviewer described it, when the picture was exhibited in Dresden in 1824. "Here, painting becomes music, it speaks movingly and fervently to the heart, as words only rarely can."[34] To be sure, this assemblage of striking, meaning-laden visual symbols verges on the trivial; however, as the critic's reaction attests, Carus's work struck a public nerve.

The influential connoisseur and patron Johann Gottlob Quandt strenuously objected to the delicate sentimentalism of the critics: "This allegorizing in pictures has prevailed because of the lack of representational ability, and one cannot warn against it enough, since people are always too willing to take refuge in expedients. . . . Music must be heard, and an image, seen, and one should not allow a painting to make music or a sound to be painted."[35]

A finished drawing by Carus (Fig. 19), which depicts a solitary harp on a balcony before an antique or classicizing temple, certainly postdates his painting of 1823.[36] The drawing merely paraphrases the idea of a "divine music," and its composition is suitably solemn. In the small painting *Music* of 1826,[37] an angel touches the strings of a harp that is enveloped by moonlight. The iconographically capricious *Allegory on Goethe's Death* of 1832,[38] which one is tempted to interpret as the swan song to the German Orpheus, also belongs to this thematic group, as does Carus's highly ambitious attempt to honor the late Goethe in a painting, the visionary *Goethe Monument* of 1832 (Fig. 20).[39] In a bizarre, precipitous valley, surrounded by fog and illuminated by the moon, stands the author's enormous sarcophagus, upon which two praying angels kneel on either side of a tall metal harp.[40] The gigantic harp, incidentally, is an Ossianic allusion.[41]

Caspar David Friedrich, too, occasionally sought to combine his painting with the elevating and transfiguring effect of music, even though in his "Äusserungen bei Betrachtung einer Sammlung von Gemälden . . ." of about 1830,[42] he attacks the common Romantic notion of a union of the painter and musician in a single person. "Two halves make a whole, but whoever is half musician and half painter is still only a complete half. There may also be complete quarters, and, what is more, our schools seem intent on producing them."[43] Friedrich's aphorism reads like a reprise of Quandt's 1824 critique of Carus,[44] though the latter did endorse this position in a commemorative publication on Friedrich of 1841.

From 1826 to 1830 Friedrich worked on an unusual project, from which only two drawings survive: *The Harp Player* (Karl-Marx-Stadt, Städtische Kunstsammlung); and *The Musician's Dream*, of about 1826–27 (Fig. 21).[45] Years later, he sent to his friend and patron Vasily Zhukovsky—who had a copy made of Carus's *Fantasy on Music*—two chests containing a total of ten commissioned works, including "the four transparent pictures, drawn on paper and stretched on frames, protected by oilcloth and by

FIGURE 20 Carl Gustav Carus, *The Goethe Monument*, 1832. Oil on canvas. Hamburg, Kunsthalle

FIGURE 19 Carl Gustav Carus, *Allegory of Music*. Charcoal, heightened with white, on gray-green paper. Dresden, Kupferstich-Kabinett

53

FIGURE 21 Caspar David Friedrich, *The Musician's Dream*. Black chalk. Hamburg, Kunsthalle

boards on both sides."[46] In the letter of 12 December 1835 that accompanied the shipment, the painter describes in detail what provisions should be made for viewing the pictures: "In order to enhance the effect, so that these pictures . . . may give you hours of delight, I wish that they be seen only with a musical accompaniment." He then describes the character of the music he desired—"mournful," "secular," "spiritual," and "heavenly" pieces should follow one another—and even offers the patron "an authority on music, to whom I communicated my views, [who] immediately volunteered to write these pieces down for musicians in musical language."[47] In a letter of 9 February 1830, the artist had fully explained the iconographic program of the pictures and the instrumentation for the musical accompaniment.[48] Friedrich's lost cycle, probably executed at Zhukovsky's suggestion, may have been quite similar to Carus's musical allegories.

Neither the prognoses of the Early Romantic writers, nor Runge's concepts exerted a significant influence on the development of the arts in the nineteenth century. When a convergence of the arts did take place, it usually depended on a common literary subject. The literalization of music is evident in the Romantic song, in instrumental "program" music, in the lyrical piano solo, and in the symphonic poem. Literalization—not musicalization—also occurred in the visual arts.

A deeper, more penetrating analysis of such meetings among the arts should be conducted on various levels: first, with regard to motifs, iconography, and subject; second, with regard to form and structure, the relationships between the "languages" of the arts[49] (perhaps the most general characteristics of form—say, on the level of Wölfflin's concepts—could be meaningfully compared); and third, with regard to psychic and "human motives," in the sense of Rudolf Zeitler's observations on the goal of art-historical interpretation. "Confronted with all those methods of interpreting a work of art, which are *not* ultimately concerned with analyzing the human motives evident in the work, one must ask: how can one credibly explain that men create and accept works of art, if these works have no direct and normal human interest? May we presume the existence of a formal impulse that

is directed at nothing but itself? This assumption is unlikely. . . .
In art, too, it is a matter of human motives, life motives. And the
goal of interpretation is to understand these motives in the par-
ticular form they take in a given work of art."[50] If related or identi-
cal "life motives" could be identified in given works of literature,
the visual arts, and music, this would be a valuable contribution
to the study of encounters among the arts.[51]

NOTES

1 Johann Wilhelm Ritter, *Fragmente aus dem Nachlasse eines jungen Physikers* (Leipzig and Weimar:
 1984), no. 35, p. 166.

2 E. T. A. Hoffmann, *Fantasiestücke in Callots Manier* (Berlin and Weimar: 1982), p. 401.

3 Johann Wolfgang von Goethe, *Maximen und Reflexionen* (Leipzig: 1976), no. 486.

4 Friedrich Schiller, *Sämtliche Werke: Säkularausgabe* (Stuttgart and Berlin: n.d.), vol. 12, p. 84 f.,
 twenty-second letter. Translation from Friedrich Schiller, *On the Aesthetic Education of Man*,
 edited and translated by Elizabeth M. Wilkinson and L. A. Willoughby (New York: 1967).

5 Johann Wolfgang von Goethe, "Einleitung in die Propyläen" (1798), in *Sämtliche Werke in
 vierzig Bänden* (Stuttgart and Tübingen: 1857), vol. 30, p. 294.

6 *Der Hang zum Gesamtkunstwerk: Europäische Utopien seit 1800.* Exh. cat. (Zurich, Düsseldorf,
 and Vienna: 1983), p. 52 f.

7 Gerda Heinrich, ed., *Athenäum: eine Zeitschrift von August Wilhelm Schlegel und Friedrich Schlegel*
 (Leipzig: 1984), no. 444.

8 One need only recall Johann Wilhelm Ritter (who, in his *Fragmente*, blended physical knowl-
 edge with philosophical and theological speculation), Novalis, and Runge's *Farbenlehre*.

9 Michael Lingner, "Die Musikalisierung der Malerei bei Ph. O. Runge. Zur Vorgeschichte der
 Vergeistigung von Kunst," *Zeitschrift für Ästhetik und allgemeine Kunstwissenschaft* 24 (1979),
 no. 1, pp. 75–94, figs. pp. 75, 113–19.

10 Wilhelm Heinrich Wackenroder, *Dichtung, Schriften, Briefe*, edited by Gerda Heinrich (Berlin:
 1984), p. 233.

11 To his father, 10 May 1802. Philipp Otto Runge, *Hinterlassene Schriften*, edited by Daniel
 Runge (facsimile ed., Göttingen: 1965), vol. 2, p. 128.

12 "Does not the work of art emerge only in the moment when I undertake to clarify a relation-
 ship with the universe?" Philipp Otto Runge to his eldest brother Daniel, February 1802.
 Ibid., vol. 1, p. 6.

13 Ludwig Tieck, "Symphonien," in *Phantasien über die Kunst* (1799). Quoted in Wackenroder,
 Dichtung, p. 351.

14 Carl Dahlhaus, *Die Idee der absoluten Musik* (Leipzig: 1979), p. 87.

15 Heinrich Besseler, "Alte Musik und Gegenwart," in *Aufsätze zur Musikästhetik und Musik-
 geschichte* (Leipzig: 1978), p. 175.

16 Ludwig Tieck, *Werke in zwei Bänden* (Berlin and Weimar: 1985), vol. 2, p. 407.

17 Johann Nikolaus Forkel, *Über Johann Sebastian Bachs Leben, Kunst und Kunstwerke* (Berlin:
 1970), p. 12.

18 Dahlhaus, *Die Idee*, p. 91.

19 Lingner, "Die Musikalisierung," p. 75.

20 Ludwig Tieck, in Wackenroder, *Dichtung*, p. 353.

21 "If we speak of music as an independent art, we should always mean only instrumental
 music, which rejects any help, any mixing with another art, and is the only pure expression
 of the characteristic essence of the art form. It is the most Romantic of all arts—one might
 almost say, the only pure Romantic art." Review of Beethoven's *Fifth Symphony*, 1810.
 E. T. A. Hoffmann, "Die Schriften über Musik," in *Dichtungen und Schriften* (Weimar: 1924),
 vol. 12, p. 128.

22 This calls to mind the Dresden circle around Ludwig Tieck (with Carl Maria von Weber, Carl
 Gustav Carus, and Johann of Saxony, who, as a translator of Dante, called himself
 Philatathes), Franz Schubert's group of friends in Vienna (including the writer Eduard von
 Bauernfeld, Johann Mayrhofer, and the young painter Moritz von Schwind), the Berlin salon
 of Rahel Varnhagen, and, finally, those frequent guests in Carus's house in Dresden (above
 all, the musicians Felix Mendelssohn, Clara Wieck-Schumann, and Wilhelmine Schröder-
 Devrient). This list shows the development from the sworn friendship pacts of early Romanti-
 cism to the bourgeois social life of the salon.

23 Of the numerous multitalented figures in the age of Romanticism, it will suffice here to
 name only the lawyer, writer, draftsman, composer, and conductor E. T. A. Hoffmann, and
 the poetically as well as musically talented doctor, naturalist, and painter Carl Gustav Carus.

24 To his father, 26 March 1802. Runge, *Hinterlassene Schriften*, vol. 2, p. 122.

25 To Böhndel, September 1801. Ibid., p. 81.

26 See Traeger, 1975, p. 19.

27 Rudolf Zeitler, "Zu Philipp Otto Runges Werdegang," in *Runge—Fragen und Antworten.
 Symposion der Hamburger Kunsthalle* (Munich: 1979), pp. 11–19.

28 Quoted in Lingner, "Die Musikalisierung," p. 76.

29 To Daniel Runge, 22 February 1803. Runge, *Hinterlassene Schriften*, vol. 2, p. 202. Translation
 from Hugh Honour, *Romanticism* (New York: 1979), p. 122. Quoted by permission of Harper
 & Row, Publishers, Inc., New York.

30 Detailed attempts at interpretation by Traeger, 1975, nos. 265–83, pp. 46–52, 130–32. See
 also Hanna Hohl in Hamburg, 1977–78, pp. 188–92.

31 See "Miszellen zur Musik," in Carl Gustav Carus, *Mnemosyne. Blätter aus Gedenk- und
 Tagebüchern* (Pforzheim: 1848).

32 Prause, 1968, no. 1, illus.

33 Carl Gustav Carus, *Lebenserinnerungen und Denkwürdigkeiten*, edited by Elmar Jansen
 (Weimar: 1966), vol. 1, p. 428.

34 Quoted in Prause, 1968, p. 86.

35 Ibid. In some passages of the *Lebenserinnerungen* (vol. 1, p. 427 f.), Carus appears to go along
 with Quandt's remonstrations without mentioning the critic's name.

36 *Allegorie der Musik.* Inv. C 1937–514. See Bern, 1985, no. 33, fig. 193.

37 Prause, 1968, no. 6, fig. p. 86.

38 Ibid., no. 7, fig. p. 87.

39 Ibid., no. 98, fig. p. 112.

40 Franz von Schlechta treated a strikingly similar subject in the two last stanzas of his poem "Des Sängers Habe," which Franz Schubert set to music in February 1825 (D 832). The anonymous singer wishes for such a burial: "In den Grund des Tannenhaines / senkt mich leise dann hinab; / und statt eines Leichensteines / stellt die Zither auf mein Grab, / dass ich, wenn zum stillen Reigen / aus des Todes dunklem Bann / mitternachts die Geister steigen, / ihre Saiten rühren kann." Quoted in Dietrich Fischer-Dieskau, *Auf den Spuren der Schubert-Lieder* (Cassel and Munich: 1977), p. 253.

41 Compare the contemporary description, quoted in Prause, 1968, p. 112, as well as Carus, *Hünengrab nach Ossian* (1836–37), quoted in Prause, 1968, no. 326.

42 Autograph ms., Kupferstich-Kabinett, Dresden, Inv. CA 49 u.

43 Ibid., p. 9. See also Caspar David Friedrich, *Bekenntnisse,* edited by Kurt Karl Eberlin (Leipzig: 1924), p. 115; Sigrid Hinz, ed., *Caspar David Friedrich in Briefen und Bekenntnissen* (Berlin: 1974), p. 89.

44 Hoch dates Friedrich's "Äusserungen" to about 1830, and assumes that they were written down at Quandt's urging. See Karl-Ludwig Hoch, "Zu Caspar David Friedrichs bedeutendstem Manuskript," *Pantheon* 39 (1981), no. 3, p. 229 f.

45 Börsch-Supan/Jähnig, 1973, nos. 345–46, illus.; Hamburg, 1974, no. 193. See also the musical-iconographic study by Günter Bandmann, *Melancholie und Musik: ikonographische Studien* (Cologne and Opladen: 1960), pp. 132–36. The interesting parallel, from a cultural-historical perspective, between Franz Schubert's homage "An die Musik," which was composed in 1817 after a text by his friend Franz von Schober and was much sung in his time, and that of Arietta Hasse in E. T. A. Hoffmann's musical comedy fragment *Faustina* (see Hoffmann, *Dichtungen und Schriften,* vol. 12, p. 510), can only be suggested here.

46 Friedrich, *Briefe und Bekenntnisse,* p. 68.

47 Ibid., p. 70.

48 Ibid., p. 58.

49 Runge had already produced a highly speculative contribution on this subject, "Gespräche über Analogie der Farben und Töne." See Runge, *Hinterlassene Schriften,* vol. 1, pp. 168–70.

50 Rudolf Zeitler, "Worauf zielen die Interpretationen der Kunstwissenschaft ab?" *Zeitschrift für Ästhetik und allgemeine Kunstwissenschaft* 19 (1974), p. 22 f.

51 In an unpublished lecture manuscript from 1985, I attempted to compile observations on the affinity between the paintings of Caspar David Friedrich and the music of Franz Schubert.

The Collections of Neoclassical, Romantic, and Biedermeier Drawings in Dresden and Berlin

DRESDEN

The Kupferstich-Kabinett in Dresden, founded in 1720 as one of the first institutions dedicated to collecting prints and drawings, experienced its heyday during the period before the outbreak of the Seven Years War, in 1756. In the century that followed, collecting continued steadily, though more modestly, and the emphasis was on prints, at the expense of expanding the collection of drawings. The rich holdings, from which our exhibition has been selected, were acquired essentially after 1896.

Nevertheless, the acquisition of contemporary drawings during the first half of the nineteenth century was noteworthy, and sheds light on the maintenance of the feudal system during that period. While the elector-kings of Saxony, Augustus the Strong (r. 1694–1733), and his son Augustus III (r. 1733–63), purchased contemporary art with the same enthusiasm that they devoted to the acquisition of old masters, during the Neoclassical and Romantic periods the royal Saxon museums focused on the past and rarely accepted works by living artists. In keeping with this retrospective policy, which was characteristic of most European museums at that time, the Kupferstich-Kabinett often acquired groups of drawings after an artist's death: 9 sheets by Johann Christian Klengel were acquired in 1825; 3 by Anton Graff, in 1828; 18 by Simon Wagner, in 1829; 133 by Gustav Heinrich Naecke, in 1835; 4 by Caspar David Friedrich, in 1840; 660 by Carl Gustav Carus, in 1876; and 70 by Adrian Ludwig Richter, in 1886.

Many works were purchased because of their subject matter, such as Johann Christian Reinhart's representation of the Colosseum in Rome, acquired in 1828; Heinrich Bleuler's drawing of the Rhine Falls at Schaffhausen, bought in 1837; and Georg Emanuel Opiz's erotic scenes, which entered the collection in 1838. The Kupferstich-Kabinett assigned great significance to portrait drawings. The most expensive purchase made by the institution between 1760 and 1860 was the portrait collection of Carl Vogel von Vogelstein: the king ordered the expenditure of 1,980 taler, disbursed in installments in 1831, 1839, 1842, and 1846. As late as 1865, the 741 sheets from this collection still constituted three-quarters of the holdings of contemporary drawings.

Although many artists whom we admire were neglected, the Kupferstich-Kabinett made a notable effort to create a collection of contemporary drawings, and, by 1865, it consisted of 1,200 sheets by sixty-five artists, eleven of whom are represented in our exhibition: Chodowiecki, Erhard, Friedrich, Graff, Wilhelm Kobell, Ferdinand Olivier, Overbeck, Reinhart, Richter, Schnorr, and Zingg. High prices were paid for a few outstanding drawings: fifty taler in 1836 for a watercolor by Wilhelm Kobell; fifty taler in 1840 for four drawings by Friedrich; thirty louis d'or in 1853 for Overbeck's *Bearing of the Cross* (Cat. No. 55); forty louis d'or in 1854 for Schorr's *Conclusion of the Nibelungen*; and twenty-one taler in 1860 for a *Salzburg Landscape* by Ferdinand Olivier.

From 1815 to 1854 King Friedrich August II, who ascended the throne in 1830, assembled a large, independent private collection, which included important works by Caspar David Friedrich. Unfortunately, almost all of this collection and the relevant documentation disappeared after 1945, so we know little about the acquisition of contemporary works before 1854. A similar fate was met by the Dante collection of King Johann, who, from the 1830s on, assembled illustrations of *The Divine Comedy*.

Neoclassicism and Romanticism had run their course by the second half of the nineteenth century, but the works retained their cultural and educational value; this was reflected in the acquisitions. The existing holdings were filled out and amplified, with an emphasis on the German artists who worked in Rome. The

acquisition, in 1872, of 178 drawings by "modern artists" exemplifies the effort to overcome the local character of the collection, and to come to terms with the new national consciousness. This group included works by Franz Krüger, Karl Graeb, and Philipp Veit, of Berlin; Alfred Rethel, Eduard Bendemann, Johann Peter Hasenclever, and Adolf Schrödter, of Düsseldorf; Carl Friedrich Lessing, of Karlsruhe; Peter Hess and Carl Rottmann, of Munich; Bonaventura Genelli and Friedrich Preller, of Weimar; Eduard von Steinle, of Frankfurt; and Rudolf Alt and Moritz von Schwind, of Vienna. The acquisition of 317 study sheets by Julius Schnorr in 1887, the purchase of 24 drawings by Overbeck in 1888, and the transfer of 190 drawings by Moritz Retzsch in 1892 is evidence of the high regard for Neoclassical and Romantic art. On the other hand, the Realist tendencies that determined the course of German art after 1850 were only tentatively acknowledged by the acquisition of a few individual sheets. In 1875, for example, the Kupferstich-Kabinett bought one gouache by Adolph Menzel.

A scholarly reappraisal of Romanticism gradually altered the focus of the acquisitions of the Kupferstich-Kabinett. In 1882 the name Karl Philipp Fohr appeared in the inventory for the first time. In 1889, 3 drawings by Caspar David Friedrich entered the collection. The purchase of 111 drawings by Alfred Rethel for the large sum of 80,000 marks testifies to the profound admiration for German art of the first half of the century. Max Lehrs, who became the director of the Kupferstich-Kabinett in 1895, and Woldemar von Seidlitz, the general director of the Dresden art collections, made fundamental contributions to the new appreciation for Romantic art. Von Seidlitz's gifts, in 1899 and 1900, of drawings by Fohr, Horny, Koch, Ferdinand Olivier, Adrian Ludwig Richter, and Schwind, strikingly anticipated the 1908 purchase of the collection of Eduard Cichorius. The acquisition of this collection, which was as refined as it was comprehensive, immediately made the Kupferstich-Kabinett one of the preeminent centers for the study of German Romanticism. Among the 1,200 Cichorius drawings were 356 by Adrian Ludwig Richter, 210 by Julius Schnorr, 46 by Bonaventura Genelli, 36 by Joseph Anton Koch, 29 by Karl Philipp Fohr, 25 by Franz Horny, 24 by Moritz von Schwind, 16 by

Johann Christoph Erhard, 9 by Friedrich Overbeck, 7 by Ferdinand Olivier, and 5 by Johann August Heinrich.

Of the purchases that were made during the following years, among the most significant were those that augmented the collection of drawings by Caspar David Friedrich. The artist's economical drawing style was undervalued for a long time, and even Cichorius classified two of Friedrich's works as anonymous. In 1889 Max Lehrs paid 24 marks for three sheets, and in 1913, only 10 marks for two drawings and a watercolor. In 1919, six graphite drawings were purchased for 135 marks, and a watercolor, for 275 marks, and, that same year, Woldemar von Seidlitz donated seven sheets. From 1920 on, others were added almost annually, while twelve drawings were acquired in 1927, and in 1937 Friedrich Lahmann bequeathed twenty. Ferdinand von Rayski's importance was also acknowledged belatedly; only in 1908 did the Kupferstich-Kabinett acquire his work (forty-two drawings). The purchase in 1928 of eleven sheets by Karl Blechen filled a major gap in the collection. The holdings of sketchbooks were also enriched: one by Rayski was acquired in 1920; one by Friedrich, in 1933; and seventy-eight by Ludwig Richter, in 1941.

Since 1945, 4,816 drawings have been missing from the Kupferstich-Kabinett, including many works of the Neoclassical and Romantic periods: 5 by Peter Cornelius; 23 by Johann Christoph Erhard; 3 by Caspar David Friedrich; 19 by Paul Mohn; 13 by Ernst Ferdinand Oehme; 28 by Adrian Ludwig Richter; and 101 by Carl Vogel von Vogelstein. During the years since the end of World War II, it has been possible to acquire single sheets and groups of drawings by several artists: 72 drawings by Ferdinand von Rayski have been acquired since 1949; 14 by Johann Erdmann Hummel were acquired in 1960; and 247 by Eduard Bendemann entered the collections in 1981. In 1946 the Kupferstich-Kabinett acquired the very significant collection of Prince Johann Georg of Saxony (1869–1938), which comprised about 1,200 nineteenth-century German drawings.

The local character of the holdings, sustained through 150 years of acquisitions, is typical of earlier European collections, and it is especially true of collections of nineteenth-century Ger-

man art, as the print rooms of Berlin, Bremen, Frankfurt am Main, Hamburg, Leipzig, Munich, Stuttgart, Weimar, and Vienna all attest. In Dresden the rich groups of drawings by Saxon artists and by artists associated with that city—from Graff and Zingg to Rayski and Rethel—are outstanding. Next to these holdings in importance are those of drawings by German artists who worked in Rome, such as Joseph Anton Koch, Karl Philipp Fohr, Franz Horny, and Bonaventura Genelli. Only Runge's productive Dresden period is not significantly represented at the Kupferstich-Kabinett. However, artists active in other German cities are so strongly and diversely represented that the Dresden collection offers a solid survey of German draftsmanship during the period from 1770 to 1850.

<div align="right">Werner Schmidt</div>

BERLIN

In contrast to the history of the venerable Kupferstich-Kabinett in Dresden, the development of the Sammlung der Zeichnungen in the Nationalgalerie began long after the period covered by our exhibition. The Nationalgalerie was founded in 1861, and, initially, acquired only paintings and sculpture produced after 1780. Twenty-five years elapsed before the first director, Max Jordan, started to build a collection of German drawings and watercolors. With the addition of these drawings, which were selected to parallel the existing holdings and which are themselves best studied in conjunction with paintings, the representation of German art became much more complete.

Berlin museums began to acquire modern drawings with the establishment of the Kupferstichkabinett of the Königliche Museen in 1831. More than 5,000, mostly German, nineteenth-century drawings were transferred from the Kupferstichkabinett to the Nationalgalerie in 1877–78. Works by several major artists featured in the present exhibition were part of this group, including 450 sheets acquired from the estate of Karl Blechen, 35 by Johann Adam Klein, 25 by Johann Christoph Erhard, 12 by Joseph Anton Koch, 13 by Peter Cornelius, 33 by Johann Gottfried Schadow, 16 by Karl Friedrich Schinkel, and more than 300 by Adolph Menzel. In general, this nucleus was comprised of only a few drawings by each artist, with the accent on those who worked in Berlin and Prussia. (From its foundation until 1945 the Nationalgalerie was an institution of the state of Prussia.) Outstanding among these were Friedrich's *Self-Portrait* (Cat. No. 43) and Runge's *Morning* (Cat. No. 33).

After the inauguration of the collection in 1877–78, a deliberate acquisition policy was implemented. The earliest purchases came from groups of drawings that had been under consideration for several years. Exhibitions organized by the museum, and estates and private collections offered further opportunities for enriching the collection. The first substantial groups of works by individual artists were assembled: 61 drawings by Julius Schnorr von Carolsfeld were acquired in 1878; 75 by Alfred Rethel, in 1877; 21 by Asmus Jakob Carstens, in 1878; 220 by Jakob Philipp Hackert, in 1878; 460 by Heinrich Dreber, in 1879; 100 by Ernst Fries, in 1880; 48 by Carl Friedrich Lessing, in 1880; 170 by Adolph Menzel, in 1880, and the Puhlmann collection of 115 Menzel drawings, in 1882; 41 by Julius Schnorr, in 1883; 24 by Erhard, in 1884; and 84 by Philipp Veit, in 1884.

All too often only single sheets were acquired, so that the Sammlung der Zeichnungen did not at first constitute a comprehensive survey of Neoclassical or Romantic draftsmanship. An exception was a group of 85 large cartoons, by Cornelius, Schnorr, Veit, Eduard Steinle, Rethel, and Wilhelm Kaulbach, that were transferred in 1877 from the painting department of the Nationalgalerie. The museum's holdings of drawings by the "contemporary" artist Adolph Menzel immediately became the most important in terms of sheer numbers with the acquisition in 1889 of the extensive collection of Menzel's dealer Paechter. Menzel's estate, which included over 4,000 drawings, was acquired in 1906. In 1891 the remaining, larger portion of Blechen's estate (849 drawings) joined those already in the collection. That year, the museum also received 1,200 early nineteenth-century watercolors as the bequest of the chemist Dr. Theodor Wagener, whose father,

the banker and consul J. H. W. Wagener, had founded the Nationalgalerie in 1861 by presenting his painting collection to the king of Prussia. We can cite only a few examples of the many acquisitions made just after the turn of the century: 13 drawings by Moritz von Schwind were acquired in 1900; 1 drawing each by Caspar David Friedrich, Ferdinand Olivier, Franz Fohr, and Franz Horny, in 1901; drawings by Koch and Johann Christian Reinhart, in 1903; and 3 drawings by Wilhelm Kobell, in 1905. The 1902 catalogue *Handzeichnungen, Aquarelle und Ölstudien in der Königlichen Nationalgalerie*, compiled by Lionel von Donop, gives a good idea of the growth of the collection up until that year.

The renowned "Deutsche Jahrhundert-Ausstellung," organized by the Nationalgalerie in 1906, sparked a revival of interest in Romanticism and other artistic tendencies of the period around 1800, and purchases of drawings reflected this new enthusiasm: twelve sheets by Friedrich; two drawings by Georg Friedrich Kersting (the only works by this artist in the collection); twelve portraits by Wilhelm Kobell; five landscapes by Johann Martin Rohden; nine drawings by Ferdinand von Rayski; and twenty-two drawings and watercolors by Henry Fuseli. In 1907 additional Romantic drawings and watercolors—by Fohr, Horny, Schnorr, and others—and single sheets by draftsmen from Carstens to Gaertner entered the collection with the estate of Max Jordan.

After 1910 there was a steady increase in the number of acquisitions of drawings dating from the first half of the nineteenth century by artists such as Friedrich, Kobell, Koch, Schadow, Joseph von Führich, and Schwind. The institution adopted a more resolute policy aimed at forming a collection that would reflect the personalities, moods, strengths, and continuity of German draftsmanship from the late eighteenth and early nineteenth centuries until the present. The installation, in 1920, of a "viewing collection" (*Schausammlung*), which consisted of more than three thousand sheets dating from 1780 to 1920, presented a didactic

survey of the various styles, subjects, and artistic centers that both supplemented and enhanced the collection of paintings. These selected examples enabled the regular visitor to comprehend artistic developments by scanning the portfolios. Steadily—but often, of course, fortuitously—the holdings continued to grow, particularly in the field of German Romantic drawings. In 1923 more than twenty drawings by Friedrich and more than fifty by Rohden were acquired by exchange. Thanks to gifts from artists' descendants and to timely purchases, between 1932 and 1938 the Nationalgalerie assembled a group of drawings by Runge that is second in size only to that of the Hamburg Kunsthalle.

Unfortunately, nationalistic acquisition policies resulted in the complete neglect of works by foreign artists. Because the authorities prohibited the purchase of modern works, after 1933 there was a stronger emphasis on Neoclassical, Romantic, and Biedermeier drawings. This policy led to the 1938 purchase of Johann Gottfried Schadow's "Family Album," containing thirty portrait drawings by Schadow and nineteen sheets by other artists—an acquisition that was comparable in importance to the 1917 purchase of Friedrich's two "Berlin" sketchbooks.

Under the altered conditions that have prevailed since 1945, there have been many important purchases and transfers of works by artists such as Friedrich, Johann Georg Dillis, Karl Wilhelm Wach, Johann Erdmann Hummel, Blechen, Friedrich Gilly, Schnorr (55 drawings), Adrian Ludwig Richter (140 drawings), Carl Morgenstern, and Schwind.

During the course of more than 100 years, a specialized collection devoted to German draftsmanship has been developed in the Nationalgalerie. For the period covered by our exhibition, and, indeed, for the entire nineteenth century, this collection, despite some limitations, remains one of the richest.

Gottfried Riemann

Catalogue of the Exhibition

Catalogue

EDITORS' NOTE: All the drawings in the exhibition are from the Sammlung der Zeichnungen, Nationalgalerie, Staatliche Museen, Berlin, and the Kupferstich-Kabinett, Staatliche Kunstsammlungen, Dresden, German Democratic Republic. In the catalogue entries these collections are indicated by the name of the city (Berlin or Dresden) before the accession number. A biography of each artist precedes the catalogue entries on that artist's drawings. At the end of the biography, the number of drawings in the Berlin and Dresden collections is listed, the collection holding more drawings appearing first.

"Nationalgalerie" and "Berlin, Nationalgalerie" refer to East Berlin, while the institution of the same name in West Berlin is designated "West Berlin, Nationalgalerie."

I. NEOCLASSICISM

JOHANN HEINRICH WILHELM TISCHBEIN
Haina (Hesse) 15 February 1751 – 26 June 1829 Eutin (Holstein)

Probably the most famous member of the extensive Hessian family of artists, Johann Heinrich Wilhelm is occasionally known as "Goethe Tischbein" because of his friendship with the author. He studied first in Cassel with his uncle Johann Heinrich Tischbein the Elder, then in Hamburg with another uncle, Jacob Tischbein, and with his cousin Johann Dietrich Lilly. He visited Holland and Bremen in 1771–72, and, after a stay in Cassel, spent the years 1777–79 in Berlin. In 1779, with the support of a stipend from the Cassel Academy, Tischbein traveled to Rome. He visited Zurich and returned to Cassel in 1781. In 1783 he departed for Rome, where he remained for many years. He met Goethe there in 1786, and, a year later, portrayed him in the painting *Goethe in the Cam*

pagna. In 1787 Tischbein became director of the Academy in Naples. After visiting Cassel and Göttingen in 1799, he stayed in Hamburg from 1801 to 1808, before settling permanently in Eutin. In 1810 he began writing his memoirs, *Aus meinem Leben*, which remained unfinished at his death.

Nationalgalerie, Berlin: 17 drawings
Kupferstich-Kabinett, Dresden: 4 drawings

1
The Power of Man, 1786
Pen and brown ink, brown and gray wash, watercolor
483 x 646 mm.
Signed and dated, lower left, *W. Tischbein Rom 1786*
Provenance: acquired in 1935 at the sale of Herold's art and auction house, Berlin
Berlin, Tischbein, no. 4

During the first days of his stay in Rome, Tischbein became acquainted with Goethe, whose name would later be closely associated with his because of the well-known painting *Goethe in the Campagna* (Frankfurt am Main, Städelsches Kunstinstitut). In *Die italienische Reise* (1816), Goethe recalls the events of 7 November 1786: "He has made one very curious drawing showing man as the tamer of horses, superior not in strength but in cunning to all the beasts of the field, the air and the waters. This composition is of extraordinary beauty and should look most effective when done in oils. We must certainly acquire a drawing of it for Weimar" (translated by W. H. Auden and Elizabeth Mayer, 1962. Reprinted courtesy of Pantheon Books, a division of Random House, Inc., New York). This is the earliest indication of the artist's complex and continuing preoccupation with a composition that he ultimately classified as a "reason image" (*Vernunft-Bild*), the concept being that by virtue of his reason, man was ruler over nature, here represented by the animal kingdom.

Although the Berlin sheet is dated 1786, and we have no reason to doubt Goethe's notes, Tischbein's own recollection places the initial impulse for this theme in the year 1787. In his memoirs, *Aus meinem Leben*, which he began at an advanced age, he reminisces:

In Naples, after I had taken leave of Goethe who was traveling with Kniep to Sicily, I returned with Prince Christian von Waldeck to Rome in May of the same year. . . .The day had scarcely dawned when I went outside. There I saw a man riding toward me who, in the blue morning fog, seemed much larger than he actually was. This dark apparition on a horse aroused my fantasy. I thought generally about man and how he rules exalted over all creatures. He subjugates them, uses them for his purposes, brings them from the forest, and from the heights, captures them on the open plains. None can escape him; he lays claim to one, slaughters it, removes its skin and clothes himself; he prepares small delicacies from its flesh, loads them on another animal, seats himself on it, and lets himself be carried wherever it pleases him to eat. . . .While on my way back from the spot where I had encountered the man on his horse, it occurred to me that this was a subject for painting, but that I would have to ennoble it, since sheep hanging on a horse are a pitiful sight. As I climbed the stairs in my house, at each step I thought of more beautiful creatures to include: man, horse, dog, lion, and, as I reached the top step, the eagle. I immediately set to work and did a small picture of the scene. It was thus that the idea originated forty years ago, although I did not put it into a full-scale painting until much later. Since connoisseurs praised the composition and amateurs made frequent requests, however, it appeared many times in small format before the full-scale production. I called it *The Power of Man* (Tischbein, *Aus meinem Leben*, edited by L. Brieger, Berlin, 1922, pp. 239–40).

By 1790 Tischbein had executed several similar versions in watercolor and also a small oil painting. In his unpublished novel, *Die Eselsgeschichte; oder, Der Schwachmatikus und seine vier Brüder, der Sanguinikus, Cholerikus, Melancholikus und Phlegmatikus*, completed in 1812, this theme is given an evocatively embroidered setting:

I was about to ask the lad to whom these possessions might belong, when two hunters with a great entourage emerged from the forest. They approached slowly and majestically and, watching these heroic figures, I lost sight of their retinue; one was in the full bloom of youth, the other in his vigorous maturity. Both bore the imprint of nobility on their brows, and desperate fear had never paled their countenances. Their shoulders and arms were bare, their bodies covered with light garments; they sat on splendid horses and engaged in earnest conversation. The man seemed to be instructing the boy. Their quivers rattled on their shoulders; one hand grasped the powerful bow, the other held the reins lightly. A mighty lion that the strong man had felled was tied to his horse and he dragged it along behind him; even in death it seemed menacing to me. The boy bore a great eagle behind him, the tips of its wings touching the earth. A large hunting dog followed the lion. They rode past us and approached the beautiful knoll. "Who are these mighty heroes?" I asked the lad. "It is Nimrod, the divine hunter," he answered, "the embodiment of heroic strength." "How wonderful to be here, where the deeds of antiquity pass before me in living form and illuminate my obscure thoughts with clarity," I cried out (Mildenberger, 1987).

In 1821 Tischbein completed an oil painting of the subject commissioned by the duke of Oldenburg for his castle as part of a comprehensive, Late Neoclassical didactic program (306 x 427 cm., in the Weisser Saal).

<div align="right">G. R.</div>

Bibliography: Keiser, 1973, p. 36, fig. 7; Mildenberger, 1987, no. 65 (version of 1790 from Naples)

FRIEDRICH HEINRICH FÜGER
Heilbronn 8 December 1751 – 5 November 1818 Vienna

After early artistic experiments (miniatures, copies of engravings of battle scenes) in Heilbronn and Ludwigsburg, Füger spent an interlude studying law in Halle in 1768. He was a pupil of Adam Friedrich Oeser in Leipzig and attended the Academy in Dresden, where his miniatures and drawings were enthusiastically received

in the exhibition of 1772. Following a stay in Heilbronn, he went to Vienna in 1774 and secured his first commissions from the imperial family. From 1776 to 1783 Füger lived in Rome. Appointed vice-director of the Vienna Academy in 1783 and director in 1795, he led this institution skillfully but was unsympathetic to the new ideas of the young Romantics. In 1806 he became director of the imperial picture gallery.

Kupferstich-Kabinett, Dresden: 12 drawings
Nationalgalerie, Berlin: 8 drawings

2

Self-Portrait with His Wife and Son, ca. 1795

Black chalk, on blue prepared paper
465 x 345 mm.
Signed and inscribed, lower right, *H. Fuger Nihil*; at top, *aut Caesar, aut nihil*
Provenance: acquired in 1910 at a sale of the collection of Adalbert, Freiherr von Lanna, Vienna
Berlin, Füger, no. 6

Heinrich Füger, a highly regarded painter in Vienna who executed portraits for the imperial court and the highest nobility, married the actress Josepha Müller in 1791. Judging from the age of his son, the drawing can be dated about 1795, the year Füger became director of the Vienna Academy. In the drawing, he shows himself at the zenith of his personal happiness and professional standing, with a self-consciousness that finds verbal expression in the proud motto "Aut Caesar, aut nihil" (Either Caesar, or nothing; once the motto of Cesare Borgia). The sitters assume pleasant poses, the artist pointing with one hand to the bust of Raphael and with the other to a picture sketched in the background. His wife turns toward him in an elegant attitude, at the same time reaching over to hold her son who is posed on a pedestal and, imitating his father, points to the bust. The portfolio and rolled sheet of paper in front of the pedestal allude to the activities of the artist.

Füger was exceptionally well educated in literature and history, and his works were generally characterized by a theatricality and, along with all of the studied casualness, a stiffness, a striving for enhancement through idealization. With the bust of Raphael he refers to one of the greatest models of this transitional period. During his stay of several years in Rome, Füger developed a particular admiration for the work of Raphael as well as for the works of classical antiquity and of the Baroque painters Annibale and Lodovico Carracci and Domenichino. Both artistic currents, the waning Neoclassicism embodied by Füger and the Romanticism of the new generation of artists such as Overbeck and Pforr, emulated his idol, Raphael. However, the new generation would later turn away in disappointment from the Vienna Academy under Füger's direction.

G. R.

JAKOB PHILIPP HACKERT
Prenzlau 15 September 1737 – 28 April 1807 San Piero di Careggio (near Florence)

Jakob Philipp was the son of the portrait painter Philipp Hackert. He studied with Blaise Nicolas Le Sueur at the Berlin Academy, initially making copies after Claude Lorrain and Dutch landscape painters. In 1762–63 he received commissions for landscapes and portraits in Stralsund and in Rügen. Hackert visited Stockholm in 1764, Paris in 1765, and Normandy in 1766. In 1768 he traveled to Rome with his brother Johann Gottlieb, with whom he collaborated, and settled in Naples in 1770. Hackert received commissions for landscapes and *vedute*, which established his reputation, but typed him at the same time. His principal patrons were Catherine II and Paul I of Russia, and Pope Pius VI. Hackert's youngest brother, Georg, became his assistant and engraver. After working for King Ferdinand IV of Naples from 1782 onward, he was appointed his court painter in 1786. In 1787 he met Goethe, who was traveling in Italy and who, according to the artist's papers, edited his biography in 1811. From 1799 until his death Hackert resided in Leghorn and near Florence.

Nationalgalerie, Berlin: 40 drawings
Kupferstich-Kabinett, Dresden: 20 drawings

3

Entrance to the Catacombs in the Park at Hohenheim, probably 1778

Pen and black ink, watercolor, heightened with white
708 x 540 mm. (sheet); 858 x 610 mm. (mount)
Inscribed, on the mount, *Ansicht / DES EINGANGS IN DIE KATAKOMBEN. / eine Garten-Parthie in Hohenheim*
Provenance: acquired in 1911 at a sale of the collection of Adalbert, Freiherr von Lanna, Berlin
Berlin, Hackert, no. 227

Between 1776 and 1783 Duke Karl Eugen of Württemberg, one of the most despotic of the absolutist princes in Germany, had a park laid out at Hohenheim, near Stuttgart, in the new style of the English landscape garden. It included artificial re-creations of fragments of ancient Roman buildings, as they had appeared — following the model of Hadrian's Villa near Tivoli — in reduced dimensions in the vicinity of feudal estates. These sentimental allusions to antiquity were meant to evoke the idyllic life and thus legitimize the diversion of the idle class. The "catacombs" represented by Hackert were a part of this program, as were the Temple of Vesta, the cottage of an "English village," and other structures, and the ambling pair of elegant strollers here also fit into the conception. While Schiller, writing in 1795, took a positive view of the program of the park at Hohenheim ("It is nature inspired with intelligence and exalted by art, which satisfies not only the man of simple tastes, but even the man jaded by culture"), Goethe, in 1797, penned a severely critical assessment of the scattered imitation ruins (". . . the park overgrown with the monstrous creations of a restless and petty fantasy").

From 1768 on, Hackert lived continuously in Rome and Naples, returning only once, in 1778, to spend some time north of the Alps. Whether he visited Württemberg and the park at Hohenheim as well as Switzerland on this journey, or whether this scene of overgrown ruins animated by spectators is a product of his fantasy, must remain an open question.

G. R.

4

Ideal Landscape with Ruins, Cliffs, and Waterfall, ca. 1790

Pen and gray and brown ink, gray and brown wash
330 x 472 mm.
Provenance: acquired in 1911 at a sale of the collection of Adalbert, Freiherr von Lanna, Berlin
Berlin, Hackert, no. 228

The pictorial form of the ideal, classical landscape established by Claude Lorrain had become a firm tradition in European painting. Varied time and again, especially in the age of Neoclassicism, it became the measure of art in painting and drawing. The typical elements of its themes and compositions are evident in Hackert's drawing. In the center the view opens out onto an ideally composed landscape, sweeping from architectural ruins over hills to distant mountains. Dominating the foreground and crucial to the entire design is the face of a towering mountain formation, the bizarre form of which is enriched by a waterfall, a cave, and clusters of trees. Groups of figures act as ornamental, animating accessories in these compositions. Hackert's numerous landscapes include actual views, especially of the Italian countryside, as well as idealized scenes.

G. R.

FRANZ INNOCENZ JOSEF KOBELL
Mannheim 23 November 1749 – 14 January 1822 Munich

Franz was the younger brother of the painter Ferdinand Kobell, who was also his artistic mentor. The two brothers traveled in Italy from 1779 to 1784. Franz worked for Elector Karl Theodor von der Pfalz, and followed him to Munich in 1784. In addition to his training in the Dutch tradition, Kobell studied the works of Claude Lorrain and Salvator Rosa. Apart from a few oil paintings, he produced etchings and countless drawings of idealized, idyllic, or wild landscapes, which were highly esteemed by Goethe.

Kupferstich-Kabinett, Dresden: 67 drawings
Nationalgalerie, Berlin: 16 drawings

5

Imaginary Mountain Range on the Coast

Brush and sepia wash, over graphite and pen and gray ink
257 x 409 mm.
Provenance: transferred in 1877–78 from the Kupferstichkabinett, Königliche Museen (with eleven other large sheets and two albums containing pen drawings by Franz Kobell)
Berlin, F. Kobell, no. 16

The obituary of Franz Kobell published in 1822 in *Das Kunstblatt* states that his drawings numbered more than ten thousand. A limited array of set pieces recur repeatedly but in inexhaustibly varied arrangements. In our sheet, which is recognizably idealized and composite, the elements of this vocabulary include the rock formations, the natural bridge, and the waterfall. It would exude an almost Ossianic mood were it not for the staffage of contemporary figures. Particularly striking in this gloomy drawing, marked by the spirit of Sturm und Drang, is the harshness and weight of the cliffs, buffeted by foaming surf, which tower above the scene, and the persistent repetition of the same forms in the structure of the rock, in the layered clouds, in the evenly spaced waves of the middleground, and in the contrast between the waterfall and the churning sea. No one element in this drawing dominates; each appears a frozen and self-contained plastic form.

<div align="right">C. K.</div>

ASMUS JAKOB CARSTENS

St. Jürgen (Schleswig) 10 May 1754 – 25 May 1798 Rome

Carstens worked for a wine merchant in Eckernförde from 1771 to 1776. He studied under Nikolai Abraham Abildgaard in Copenhagen from 1776 to 1781, but was opposed to the pedagogical routine and remained only loosely associated with the academy there. With his brother Frederik he made his first trip to Italy in 1783, traveling as far as Mantua. From 1783 to 1787 he worked as a portrait painter in Lübeck, but also concentrated on themes of his own device. It was at this time that he struck up a friendship with the author Karl Ludwig Fernow. After moving to Berlin in 1787, Carstens executed book illustrations, and, after his large drawing *The Fall of the Rebel Angels* was enthusiastically received at the Academy exhibition of 1789, he became a professor there in 1790. Disgusted by the obligations of teaching, he left Berlin in 1792 and went to Rome. There, the art of antiquity, of Raphael, and of Michelangelo were the models that helped him attain full artistic maturity. He became the principal exponent of an intellectually oriented Neoclassicism, which was characterized primarily by an emphasis on linearity. The success of an exhibition behind him, and with the words "I belong to humanity, not to the Berlin Academy," Carstens withdrew his name from its roster and remained in Rome. His late works focus on themes from Homer, Dante, Ossian, and Goethe, as well as on the myths of Jason and the Argonauts, and of the Golden Age. In spite of his short career, artists such as Bertel Thorvaldsen, Joseph Anton Koch, Gottlieb Christian Schick, Peter Cornelius, Friedrich Overbeck, and others were inspired by Carstens's *oeuvre*.

Nationalgalerie, Berlin: 59 drawings
Kupferstich-Kabinett, Dresden: 5 drawings

6

The Greek Princes in Achilles's Tent, 1794

Watercolor, over graphite
450 x 660 mm.
Signed and dated, *Asmus Jacobus Carstens. / ex Chers: Cimbr: faciebat Romae. 1794.*
Provenance: transferred about 1885 from the Akademie der Künste, Berlin
Berlin, Carstens, no. 27

Following his arrival in Rome in 1792, Carstens was increasingly attracted to the inspiring themes of Greek mythology. He attained his artistic maturity in 1794 with two scenes from Homer's *Iliad*: *Priam Asks Achilles for the Body of His Son* and the present sheet, which depicts the main theme from the ninth book of the work. Odysseus, Ajax, and the aged Phoenix, the ambassadors of Agamemnon, try in vain to persuade Achilles, who has withdrawn embittered from the conflict, to take up the battle against the Trojans once more. In the effective composition, for which there is an unfinished preparatory drawing in chalk (Weimar, Kunstsammlungen), Achilles is strongly illuminated while the

main emphasis is placed on Patroclus, who is behind him at the right. Each of the five main figures is accented through the use of colors that are confidently chosen and harmonized. The abbreviated inscription *ex Chers. Cimbr.* indicates Carstens's birthplace: *Chersonesus Cimbrica* is the Latin name for Jutland, the peninsula that forms mainland Denmark, once the homeland of the Cimbri. Carstens was born there in the village of St. Jürgen near Schleswig.

G. R.

Bibliography: Kamphausen, 1941, p. 169 f., pl. 18

JOSEPH ANTON KOCH
Obergibeln (Tyrol) 27 July 1768 – 12 January 1839 Rome

Koch studied drawing in Dillingen, Witislingen, and Augsburg in 1782–83 before attending the Karlsschule in Stuttgart from 1785 to 1791, where he executed caricatures and studies after nature. He went to Strasbourg, where he was active in Jacobin circles, and in 1792 he moved to Basel. He remained in Switzerland until 1794. Supported by a stipend from the Englishman Sir George Nott, Koch settled in Rome in 1795 after traveling over the Alps on foot. In Rome, he associated with Asmus Jakob Carstens, Johann Christian Reinhart, and Bertel Thorvaldsen. During his early years in Italy, Koch executed landscape drawings and watercolors, illustrations for Dante's *Divine Comedy,* and mythological and biblical subjects. His discovery of the artistic beauty of the picturesque town of Olevano and of the Sabine Hills stimulated his development as a landscapist. In 1803–4 Koch executed his first oil paintings. After a sojourn in Vienna from 1812 to 1815, he returned to Rome, where he was regarded as the leader of the German artists' colony and became a role model for its younger members. From 1825 to 1829 Koch completed the frescos begun by Philipp Veit in the Dante room of the Casino Massimo. However, Koch's importance lies primarily in his contribution to the field of landscape painting.

Kupferstich-Kabinett, Dresden: 51 drawings
Nationalgalerie, Berlin: 47 drawings

7
Via Mala, ca. 1795
Pen and gray ink, gray wash, graphite, heightened with white, squared in graphite, on light brown paper
860 x 587 mm.
Provenance: "gift of an anonymous friend of the arts," 1939
Berlin, Koch, no. 41

Before settling in Rome, Koch stayed for an extended period (1792–94) in Switzerland, where he succumbed to the spell of the high mountains, at that time still a neglected subject. During the disruptions following the French Revolution, the mountain homeland of the free Swiss citizens had become for him and many of his contemporaries a symbol of liberty with which they could identify. The present sheet was probably executed during this period and is based on a preliminary sketch from nature (*Via Mala, Ravine with Bridge*; Lutterotti, 1940/1985, no. z112). The menacing and jagged wildness of the famous ravine in Graubünden is represented in a magnificent mixture of monumentality and penetrating detail. With its animated composition and vigorous execution, the style of the drawing is unusual for Neoclassicism. The quality of the line, especially in the branches and roots of the trees, and also in the bizarre rock formations and the distant mountain ranges, invites comparison with the graphic works of artists of the Danube school, such as Albrecht Altdorfer and Wolf Huber (see Lutterotti, 1940/1985). Koch's lifelong preoccupation with variations on the theme of the "heroic landscape" began with this drawing and with others from this period, especially those depicting the Bernese Oberland. During his many years in Rome, Koch created his paintings of alpine landscapes from this inventory of studies. In Rome in 1804, the painter and writer Karl, Freiherr von Uexküll, commissioned a painting from Koch (Karlsruhe, Kunsthalle) that corresponds almost exactly to our drawing.

G. R.

Bibliography: Lutterotti, 1940/1985, no. z68

8

Amanda Gives Birth to Hüonnet in Titania's Grotto, 1800

Sepia wash, heightened with white
528 x 744 mm.
Inscribed and dated, *fait p. Coch a Rom / 1800*
Provenance: acquired in 1908 from the collection of Eduard Cichorius
Dresden, c 1908–276

During the political upheaval at the end of the eighteenth century (Napoleon seized Rome in 1798 and had the pope taken prisoner), artistic life in Rome had come to a standstill, and Koch, like many other artists who had not left the city, found himself in financial need. To help out, the Nuremberg art dealer Johann Friedrich Frauenholz commissioned Koch to illustrate Christoph Martin Wieland's poem *Oberon*, written in 1780 in Weimar. We know of eight drawings, dating from 1798 to 1800, which are today in Dresden (Lutterotti, 1940/1985, nos. z161–166), Munich (Lutterotti, 1940/1985, no. z545), and Vienna (Lutterotti, 1940/1985, no. z943). The scene represented in the drawing exhibited here takes place in Book 8, verses 73 to 75:

> In sweet confusion now before her soul
> Fair glimmering forms arise and pass away,
> Or wondrously within each other roll.
> She thinks three kneeling angels to survey
> With secret mysteries to aid her wants.
> A woman, whom light's rosy tint infolds,
> Beside her stands, and when for breath she pants
> Close to her lips a bunch of roses holds.
>
> A last short, keen, though partly softened pain
> Now seemed her high-distended heart to break:
> The forms are fled, her sense is lost again,
> But tuneful echoes cause her soon to wake,
> Wafting away and dying on her ears:
> She looks: no more the sylphids charm her sight:
> Alone, the queen of fairies now appears
> And smiles before her eyes in rosy splendor bright.
>
> And in her arms a new born infant lay . . .
> (Translated by John Quincy Adams, 1799–1801. Reprinted courtesy of Hyperion Press, Inc., Westport, Conn.)

Emulating his great model Carstens, Koch had mastered the representation of the human figure, which he combines here with a natural landscape. He depicts a romantically beautiful grotto with a waterfall and a pleasant lawn, carefully studying the structure of the rock in the grotto walls and achieving immediacy and freshness in the details of the landscape.

G.L.

Bibliography: Berlin, 1939, no. 160; Lutterotti, 1940/1985, no. z165

9

Landscape with the Judgment of Paris, ca. 1796

Pen and gray and brown ink, brown, gray, and blue wash, graphite, heightened with white
530 x 752 mm.
Inscribed, lower center, *comp. par / Coch*
Provenance: acquired in 1910 from C. G. Boerner, Leipzig
Berlin, Koch, no. 26

In 1795, at the invitation of his English patron Sir George Nott, Koch took up residence in Rome. There, during the next few years, before he began to occupy himself with oil painting in about 1803, he created a number of sepia drawings in large format that for Koch and his public assumed the importance of paintings. His concept of landscape is clearly expressed in these works and acquires the character of a model that he would later vary or, at times, repeat as an inflexible convention. In sheets like this one he employed the elements of the idealized landscape, very much in the tradition of his great model Claude Lorrain: a broad, open view across the shore and the sea to the distant horizon, clusters of trees and rock formations, and groups of figures taken from ancient mythology or the Bible in the foreground. Paris and the Three Graces in the present example are replaced in other works by Apollo and the Shepherds, Orpheus and Death, Hercules at the Crossroads, or Noah's Sacrifice.

G.R.

Bibliography: Lutterotti, 1940/1985, no. z71

10

Malatesta Surprises Francesca and Paolo, ca. 1804–5

Pen and brown ink, over graphite
370 x 497 mm.
Provenance: acquired in 1908 from the collection of Eduard Cichorius
Dresden, c 1908–289

This drawing illustrates a scene from Dante's *Divine Comedy* (*Inferno*, Book v, verses 121–31). Around 1800 Koch developed an enthusiasm for Dante's poetry, which he continued to cultivate for the rest of his life. He was the most prolific illustrator of Dante since the Renaissance, having executed some 210 drawings and five etchings during his career. His efforts in this regard culminated in the frescos in the Casino Massimo in Rome (1824–28). The powerful strokes of the present work have little in common with the simple outlines that were typical of Neoclassicism. This sheet is a first sketch for a finished drawing, now in Vienna (Lutterotti, 1940/1985, no. z710) that, in turn, is closely related to a watercolor in Copenhagen (Lutterotti, 1940/1985, no. z501), a drawing in Weimar (Lutterotti, 1940/1985, no. z644), and a lost painting of 1807 (Lutterotti, 1940/1985, no. G103).

G.L.

Bibliography: Lutterotti, 1940/1985, no. z168, fig. 148; Andrews, 1964, pl. 47b; Winter, 1965, p. 165; Hartmann, 1968; Lippold, 1968, title page; Paris, 1976–77, no. 125

JOHANN CHRISTIAN REINHART
Hof (Bavaria) 24 January 1761 – 9 June 1847 Rome

After studying theology, Reinhart received his earliest instruction in art from Adam Friedrich Oeser in Leipzig. He moved to Dresden in 1783 and continued his artistic training under Johann Christian Klengel. Reinhart met Schiller in 1785, and worked in Meiningen (Thuringia) from 1786 to 1789. In 1789 he settled permanently in Rome, where he, Asmus Jakob Carstens, and Joseph Anton Koch made up the nucleus of the German artists' colony. Reinhart's early, innovative, realistic vision gave way in Rome to an adaptation of the composed, "heroic" landscape, enriched with biblical or mythological staffage. In addition to his paintings and drawings, Reinhart also executed a series of etchings.

Nationalgalerie, Berlin: 36 drawings
Kupferstich-Kabinett, Dresden: 29 drawings

11

Classical Landscape with Monument to Leonidas, ca. 1832

Pen and brown ink, brown wash
298 x 431 mm.
Provenance: acquired in 1910 at a sale of the collection of Adalbert, Freiherr von Lanna, Vienna
Berlin, Reinhart, no. 19

After 1789, when the young Reinhart settled permanently in Rome, his paintings and drawings belong to the continuation and renewal of the idealized landscape tradition, which was so brilliantly introduced in Rome in the seventeenth century by Claude Lorrain and Nicolas Poussin. Once he had established his canon of the "heroic" landscape, Reinhart varied it decade after decade, always utilizing similar basic forms and derivations of them. In front of these stagelike backgrounds, the figural and architectural staffage, borrowed mostly from classical antiquity, is the only element he altered from one commission to the next. The artist showed little development, and classicist tendencies of the late eighteenth century survived anachronistically in his work well into a period when Romanticism and Realism had long since determined the character of landscape painting. This observation is confirmed in the late landscape by Reinhart shown here, of which an almost identical version exists, dated 1832 (Leipzig, Museum der bildenden Künste). The monument in the foreground alludes to the Battle of Thermopylae, the narrow pass in Greece that was gloriously defended in 480 B.C. by Leonidas with his Spartans and a small Greek force against an overwhelming number of Persian invaders.

G.R.

Bibliography: Feuchtmayr, 1975, no. z20, fig. 325

II. EARLY REALISM

ANTON GRAFF
Winterthur (Switzerland) 18 November 1736 – 22 June 1813 Dresden

From 1753 to 1756 Graff studied painting and drawing with Johann Ulrich Schellenberg in Winterthur. He continued his training with the engraver Johann Jakob Haid in Augsburg in 1756–57, and was a pupil of the portraitist and court painter Ludwig Schneider in Ansbach from 1757 to 1759. After working as a portrait painter in Augsburg, Regensburg, and Zurich, in 1765 he returned to Winterthur, where he became friends with the painter/engraver/poet Salomon Gessner. In 1766 Graff and his countryman Adrian Zingg were summoned to the Dresden Academy, which had been reorganized in 1764. Graff was named professor there in 1788. He made numerous trips from Dresden, visiting Leipzig, Berlin, Karlsbad, Teplitz, and Switzerland. Graff ranks among the most important and prolific portraitists of his time. His realistic representation of the sitter and the penetrating liveliness of his characterizations particularly influenced Philipp Otto Runge, who visited Graff in Dresden in 1801, and Ferdinand von Rayski. Graff's portraits provide a chronicle of the German intelligentsia during the age of Enlightenment.

Kupferstich-Kabinett, Dresden: 40 drawings
Nationalgalerie, Berlin: 3 drawings

12
Portrait of Duchess Louise Auguste von Sonderburg–Augustenburg, 1791
Black chalk, charcoal
462 x 298 mm.
Provenance: A. O. Meyer, Hamburg; acquired in 1914 from C. G. Boerner, Leipzig
Dresden, C 1914–59

The sitter is the duchess of Schleswig-Holstein-Sonderburg-Augustenburg, born princess of Denmark, the daughter of King Christian VII. On the return trip from Karlsbad in 1791 she stopped in Dresden and was painted by Graff. This work is a study for the full-length painting in Copenhagen. Without accessories and focused wholly on the duchess's features, particularly her clear and sensitive eyes, the drawing is an especially charming example of Graff's ability to capture the spiritual expression of his sitter.

G.L.

Bibliography: Dresden, 1913, no. 126; Berlin, 1963, no. 112, fig. p. 31 (1810–12); Dresden, 1964, no. 102 (ca. 1810); Berckenhagen, 1967, no. 913

13
Portrait of the Artist's Son, Carl Anton Graff, 1808–9
Black and white chalk, on blue paper
378 x 281 mm.
Inscribed, on the verso, by another hand, *Carl Graff Landschaftsmaller Anto Graff's Sohn*
Provenance: acquired after 1835 from the estate of Carl Anton Graff
Dresden, C 2469

As pointed out by Glaubrecht Friedrich, the sitter is the son of Anton Graff, Carl Anton, and not Ludwig Kaaz, as assumed by Hans Geller and Ekhart Berckenhagen (Tokyo, 1986, no. 27). Carl Anton Graff, born in 1774 in Dresden, was a pupil of Adrian Zingg and spent the years 1801 to 1807 studying in Italy. Upon his return, his father painted a portrait of him dated 1809, which is now in the Nasjonalgalleriet, Oslo (inv. no. 177; Berckenhagen, 1967, no. 594). In addition to the present sheet, there is one other known study for the painting (Basel, Kupferstichkabinett, inv. no. 1927.198; Berckenhagen, 1967, no. 593). Graff concentrated entirely on the sitter's expression, depicting a serious, reflective, perhaps somewhat melancholy young man. Carl Anton Graff died in 1832 in Dresden.

G.L.

Bibliography: Leipzig, 1912, no. 345; Dresden, 1928, no. 65; Geller, 1961, fig. 82; Heidelberg, 1964, no. 136; Berckenhagen, 1967, no. 777, illus.; Tokyo, 1986, no. 27, illus.

ADRIAN ZINGG
St. Gall (Switzerland) 16 April 1734 – 26 May 1816 Leipzig

Zingg was a pupil of Johann Rudolf Holzhalb in Zurich from 1753 to 1757, and later studied with Johann Ludwig Aberli in Bern. From 1759 to 1766 Zingg lived with Aberli in Paris, where he worked with Johann Georg Wille and met the landscapist Jakob Philipp Hackert. His prints after Dutch and French masters established Zingg's reputation in Saxony, and in 1766 he was called to Dresden to teach engraving at the Academy, which had been reorganized in 1764. He was named professor there in 1803. Zingg maintained a workshop in Dresden, where he employed, among other engravers, his former pupil Carl August Richter, the father of the landscapist and illustrator Adrian Ludwig Richter. Zingg and Anton Graff made frequent walking tours through the Elbsandsteingebirge which, in addition to Thuringian and other Saxon scenery, furnished the subject matter for his drawings and etchings. His large *oeuvre*, which has not yet received the attention it deserves, was of great importance for the development of Romantic and Realist landscape painting.

Kupferstich-Kabinett, Dresden: 75 drawings
Nationalgalerie, Berlin: 10 drawings

14
The Prebischkegel in Saxon Switzerland, ca. 1780
Sepia wash
514 x 684 mm.
Provenance: gift of the artist, 1815
Dresden, C 1976–228

The Prebischkegel is located in the Elbsandsteingebirge. In the background on the left rises the Rosenberg, situated in the Bohemian Mittelgebirge. The two Swiss artists Adrian Zingg and Anton Graff, who adopted Saxony as their home, apparently contributed to the spread of the name "sächsische Schweiz" (Saxon Switzerland) for this area in the Elbsandsteingebirge, which was still untraversed at that time. This name appeared in 1790 in Elisa von der Recke's diary and, in his *Mahlerische Wanderungen durch die sächsische Schweiz* of 1794, Engelhardt refers to it as "one of the

most frightening but also one of the most romantic areas of Saxony."

In contrast to the ideal—or fantasy—landscape, Zingg's sepia drawings correspond more closely to reality, and were in essence topographically accurate. To be sure, Zingg's handling of the foreground in particular reflects his artistic aims as much as it does the topography. It has not been established whether a cross actually stood at this spot. As Werner Schmidt points out, the sheet recalls Caspar David Friedrich's *Cross in the Mountains* in the central arrangement of the cross, the limitation of the field of vision by a mountain range, the linear rays of light, and the solemn tone. While a direct influence cannot be determined, the relationship between the two works may be seen as the result of the overall effect Zingg's large sepia drawings had on the early works of Friedrich.

G.L.

Bibliography: Wiedemann, 1944, p. 32, no. 766; Paris, 1976–77, no. 255; Dresden, 1984, no. 21; Bern, 1985, no. 283, illus.

15
The Kepp Mill near Pillnitz, ca. 1780
Pen and sepia ink, sepia wash
647 x 485 mm.
Provenance: gift of the artist, 1815
Dresden, C 1977–155

This sheet belongs to a group that Zingg "presented as a memento to the Königliche Kupferstich Cabinet free of charge" in August 1815. It consisted of six large-format drawings and fifty-seven "sheets of varying format painted in sepia over etched lines." Daniel Chodowiecki recorded the working method of his friend Adrian. Zingg would make on-site outline sketches of his subject in pencil in an album. He would then work these up at home with pen and wash or watercolor into finished studies after nature. His landscapes are for the most part topographically correct. Since Zingg hardly varied his drawing style or technique, his works can be dated only in rare cases.

The Kepp Mill on the Keppgrund near Pillnitz, which is in the vicinity of Dresden, still stands today, although it is much al-

tered in appearance. Beginning in the late eighteenth century, the Kepp Mill was a favorite excursion spot, especially for artists such as Ludwig Richter. As in all of Zingg's drawings, the landscape is clearly divided into foreground, middleground, and background. The figures animate the wildly romantic spot, and the effect is intensified even further by the use of light.

<div style="text-align: right">G. L.</div>

Bibliography: Wiedemann, 1944; Dresden, 1978, no. 152; Dresden, 1984, no. 22

DANIEL NIKOLAUS CHODOWIECKI
Danzig 16 October 1726–7 February 1801 Berlin

Although he began as a merchant's apprentice in Danzig in 1740, Chodowiecki was working as a miniaturist and an enamel painter in Berlin by 1743 and became an independent master in 1754. He took up etching in 1758, initially turning out series of illustrations, primarily for the numerous literary pocket calendars that were quite popular at the time. Increasingly, professional engravers executed Chodowiecki's many commissions, following his preparatory drawings. A trip to Danzig to visit his mother in 1773 inspired him to produce a series of drawings that has become of great interest to cultural historians. Chodowiecki is known for his numerous lively observations of the daily life of the bourgeoisie of Berlin, rather than for historical or allegorical subjects. He became a member of the Berlin Academy in 1764, its vice-director in 1790, and its director in 1797.

Kupferstich-Kabinett, Dresden: 95 drawings
Nationalgalerie, Berlin: 40 drawings; 105 drawings on long-term loan from the Akademie der Künste of the German Democratic Republic

16
A Reading in a Summerhouse, ca. 1780
Pen and gray-black and brown ink, brush and gray wash, some red wash, over graphite
196 x 240 mm.
Provenance: given in 1865 to the Akademie der Künste, Berlin, by the artist's daughter-in-law (with a collection of works by Chodowiecki)
Berlin, Chodowiecki, no. Akad 101 (long-term loan to the Nationalgalerie from the Akademie der Künste of the German Democratic Republic)

This sheet, which cannot be dated more precisely than to about 1780, illustrates most strikingly the way of life of the aspiring middle class in Berlin during the years right before and after the death of Frederick the Great. The mixed party of men and women of petit-bourgeois or, perhaps, middle-class origin are sitting in rows in an open, roughly constructed wooden summerhouse listening to a man who is sitting in their midst and reading aloud. The women are also occupied with their needlework. The demeanor of the figures expresses a sobriety and a pronounced sense of reality that were to become more and more characteristic of both art and life in Berlin. A feeling of respectability and modesty informs the scene, but it is combined with the rising intellectual and literary interest that visibly animates the listeners. Precise objectivity characterizes the style of Chodowiecki, who produced an enormous number of prints.

<div style="text-align: right">G. R.</div>

JOHANN GOTTFRIED SCHADOW
Berlin 20 May 1764–27 January 1850 Berlin

The son of a master tailor from a village south of Berlin, Schadow took his first drawing lessons from Giovanni Battista Selvino, and continued his training with the court sculptor Jean-Pierre Antoine Tassaert (1727–1788) and at the Berlin Academy, where Daniel Nikolaus Chodowiecki was one of his teachers. In 1783 Schadow became Tassaert's assistant. He traveled to Rome in 1785, stopping in Dresden, where he visited Anton Graff, and in Vienna, where he met Heinrich Füger. In Rome he befriended Antonio Canova, and executed his first important sculptures, including projects for a monument to Frederick the Great. Schadow returned to Berlin in 1787, and in 1788 he became a member of the Academy and head of the court sculpture workshop, executing commissions for tombs and monuments and for the decoration of palaces in Berlin and in Potsdam. In 1790 he joined the Freemasons' lodge Royal York de l'Amitié, and the following year he traveled to Copenhagen, Stockholm, and St. Petersburg. His sculptural decoration, including the quadriga, for the Brandenburg Gate dates from

1792–93, and his double portrait of the Prussian princesses Luise and Friederike, from 1795. In 1802 he visited Goethe in Weimar, stopping at several cities in central Germany. The most important portrait busts, portrait drawings, and architectural sculptures by this prolific artist date from about 1800. Schadow was the outstanding sculptor of the Neoclassical period in Germany as well as one of its finest draftsmen. Appointed vice-director of the Berlin Academy in 1805, he succeeded to the directorship in 1815. As his artistic powers gradually waned, he turned to writing: *Polyklet; oder, Von den Massen des Menschen* (1831–32); *National-Physiognomien* (1835); *Kunstwerke und Kunstansichten* (1849).

Nationalgalerie, Berlin: 214 drawings; 1,102 drawings on long-term loan from the Akademie der Künste of the German Democratic Republic
Kupferstich-Kabinett, Dresden: 19 drawings

17
The Muse Terpsichore, ca. 1801

Black and red chalk, heightened with white, on gray-green paper
607 x 444 mm.
Provenance: acquired by the Akademie der Künste, Berlin, from the artist's widow with the estate of Johann Gottfried Schadow
Berlin, Schadow, no. Akad. 800 (long-term loan to the Nationalgalerie from the Akademie der Künste of the German Democratic Republic)

Schadow produced a design of hovering muses for the stage curtain of the National Theater, a major work of early Berlin Neoclassicism built by Carl Gotthard Langhans in 1800–1801 on the Gendarmenmarkt. In addition to Terpsichore, the study for Thalia has also been preserved. Johann Gottfried Niedlich (1766–1837), a professor at the Berlin Academy who had worked since 1801 as a history painter and ornament designer, was responsible for the actual execution of the painting. Schadow also contributed to the sculptural decoration of the building, chiefly with stucco reliefs of figures of the muses. Karl Friedrich Schinkel's Schauspielhaus (1818–21) was built on the foundation of the National Theater, which burned down in 1817.

G.R.

Bibliography: Berlin, 1964–65, no. 119

18
Portrait of Friederike Unger, ca. 1802

Black and red chalk
380 x 273 mm.
Inscribed, lower center, *la Unger*
Provenance: acquired in 1938 with Schadow's family album
Berlin, Schadow, no. 79

Friederike Unger was the daughter of the sculptor Christian Unger (1746–1827), an assistant of Jean-Pierre Antoine Tassaert, who preceded Schadow as Prussian court sculptor. Later she became the wife of the Berlin actor Karl Stawinsky. Being closely associated with Schadow, she was portrayed by him several times. This drawing, which is contemporary with his life-size plaster statue *Hope* (1802), for which Friederike Unger also served as the model, is one of the most beautiful of Schadow's female portraits.

G.R.

Bibliography: Berlin, 1964–65, no. 127

19
Marianne Schlegel as Mignon, 1802

Black and red chalk
488 x 366 mm.
Signed, dated, and inscribed, lower right, *G. Schadow / 1802 / nach Marianne / Schlegel / als Mignon*
Provenance: bequest of Johanna Elise Wolff, 1892
Berlin, Schadow, no. 19

Marianne Schlegel (1791–1869), the daughter of Schadow's friend Johann Andreas Schlegel, director of the Berlin mint, was the godchild of Schadow, who portrayed her at various stages of her life. Here, he depicted the eleven-year-old girl with wings and a guitar, posing as Mignon, a character from Goethe's novel *Wilhelm Meisters Lehrjahre*, which appeared in 1795. The book quickly became well known in Germany's cultured circles. Schadow's drawing impressively attests that the novel was not only read, but also that people wanted to see its characters represented visually.

G.R.

Bibliography: Mackowsky, 1927, p. 161; Berlin, 1964–65, no. 123; Bern, 1985, no. 224, fig. p. 89

20

The Senior Government Auditor Rudolf Schadow, 1824

Black chalk and graphite
306 x 200 mm.
Inscribed, lower center, *Rechnungsrath Schadow*
Provenance: acquired in 1938 with Schadow's family album
Berlin, Schadow, no. 89

This drawing can be dated on the basis of an entry in Schadow's diary of 1824 (preserved, unpublished, in the archives of the Nationalgalerie with the rest of Schadow's surviving diaries). In the entry for 2 September he notes, "drew mon frère in full length." The drawing served as the model for a lithograph of 1824 (Mackowsky, *Schadows Graphik*, Berlin, 1936, no. 100). Rudolf Schadow (1766–1838), two years younger than his brother, was an accountant in the Prussian Ministry of the Interior.

G.R.

Bibliography: Berlin, 1964–65, no. 173, fig. p. 142

21

The Window in Nenndorf, 1827

Graphite and black chalk
204 x 282 mm.
Inscribed, lower center, *G. Schadow da mit Frau, geb. Rosenstiel Felix u. Lida*; dated, lower right, *la fenetre a Nenndorf. Juillet 1827*
Provenance: acquired by the Akademie der Künste, Berlin, from the artist's widow with the estate of Johann Gottfried Schadow
Berlin, Schadow, no. Akad. 233 (long-term loan to the Nationalgalerie from the Akademie der Künste of the German Democratic Republic)

In July and August 1827 the aging Schadow stayed with his wife and his children Felix and Lida at Nenndorf, a small spa near Hanover in Lower Saxony, where he had gone to take a cure. This drawing, showing the trees and pavilions of the spa grounds through a half-opened window, is an example of the Romantic device called the *Fensterbild* (view through a window). Unlike Friedrich, for example, Schadow's sober, objective sense of reality avoids any symbolism. The window frame is very nearly the frame of the composition, which is enhanced by the mullions that divide

the scene and by the items arranged on the sill—the glasses and inkwell—that refer to the artist himself.

G.R.

Bibliography: Berlin, 1964–65, no. 179, fig. p. 48; Schmoll, 1970, p. 119, fig. 177; Bern, 1985, no. 225, fig. p. 90

22

Self-Portrait, 1838

Brush and black ink
203 x 170 mm.
Signed, dated, and inscribed, lower center, *1838. G. Schadow. 75 Jahr.*
Provenance: acquired in 1938 with Schadow's family album
Berlin, Schadow, no. 91

Marked by age and suffering, the artist depicts himself here in one of the most merciless self-portraits of the time. Sustained by early successes and revered as court sculptor, after the Napoleonic Wars, Schadow was displaced more and more in competition for official commissions by Berlin sculptors of the next generation (Christian Daniel Rauch and Christian Friedrich Tieck). In addition to his bitterness at this turn of events, he suffered a serious, life-threatening illness in 1819. A progressively worsening eye ailment, which explains the eye shade he is wearing on his head, added to his misery.

G.R.

Bibliography: Berlin, 1964–65, no. 192, fig. p. 144

WILHELM ALEXANDER WOLFGANG VON KOBELL
Mannheim 6 June 1766–15 July 1853 Munich

Wilhelm was the son of the Mannheim landscape painter Ferdinand Kobell and a nephew of Franz Kobell. After studying at the Mannheim drawing academy and in his father's studio, he assisted in the execution of Ferdinand's commissions. In 1793 Kobell was summoned to Munich as court painter. Apart from landscapes, genre paintings, and prints, he made numerous studies of family members over the course of several years. After 1800 the initially predominant influence of seventeenth-century Dutch painting gave way to an increasing emphasis on clarity of composition and

of color. Equestrian motifs and, during the Napoleonic period, military themes were important subjects. Kobell executed suites of battle pictures for Louis Alexandre Berthier, marshal of France, and for Crown Prince Ludwig of Bavaria. In 1809–10 Kobell visited Paris. He became professor of landscape painting at the Munich Academy in 1813, and was knighted in 1817. After 1817 he concentrated on cattle pieces and on infinitely varied arrangements of horsemen and standing figures set in broad, sunny landscapes. He executed studies for these scenes during extensive walking tours. The professorship of landscape painting was abolished in 1826, and although Kobell lost his appointment, his paintings and watercolors—among the outstanding achievements of the German Biedermeier—remained very popular with aristocratic and with middle-class collectors.

Nationalgalerie, Berlin: 22 drawings
Kupferstich-Kabinett, Dresden: 16 drawings

23

Portrait of Aunt Pfetten, ca. 1791–94
Colored chalk
238 x 164 mm.
Inscribed, lower left, *Tant Pfetten*; and below, by another hand, *Nr. 113*
Provenance: acquired in 1906 from Major General von Kobell, Munich (with eleven other drawings)
Berlin, W. Kobell, no. 14

In his early period, especially between 1789 and 1795—from the end of his activity in Mannheim to his first years in Munich— Kobell sketched many of the members of his family and their friends. The inspiration for these works, the evenings spent among the artist's middle-class domestic circle; the conspicuous curiosity of the draftsman, who is not interested in the potential use of the motifs in larger compositions; the recurrence of figures who are turned away, reading, or sleeping; the emphasis upon the momentary—all of this has parallels in Daniel Chodowiecki and, later, in Adolph Menzel. The young "Tante Pfetten," the artist's sister-in-law, also appears in a chalk drawing dated 1791 (Wichmann, 1970, no. 140) that has the same dimensions as this

sheet and as many other works from the same year. This is one reason, perhaps, for dating the drawing exhibited here and one other study of Tante Pfetten (Wichmann, 1970, no. 289) around 1791. The Berlin portrait also belongs to the "family cycle," as Siegfried Wichmann labels this group of works, in which the artist creates a sense of spontaneity through the placement of the model and through the execution. The fine color hatching models the face in the most delicate gradations, evokes pictorially the tactile characteristics of the sitter's hair and the velvet ribbon, and reveals through powerful shading the space behind the figure. In the treatment of the shoulder and upper torso, the meticulous application of chalk, which recalls a crayon-manner print, gives way to a sketchy suggestion of the form. The inspiration behind this work, particularly its technical aspect, is the tradition of French eighteenth-century drawing, which Kobell studied either directly or, more likely, through the works of other German artists (Daniel Chodowiecki and Johann Heinrich Wilhelm Tischbein; see Wichmann, 1970). The portrait's unpretentious, contemplative dignity, its concentration and straightforward objectivity, and its petit-bourgeois, "pig-tailed" aloofness capture the German character of the end of the eighteenth century.

C.K.

Bibliography: Justi, 1919, fig. 6; Berlin, 1954, no. 76; Munich, 1966, no. 27; Wichmann, 1970, pp. 51, 213, no. 261, fig. p. 212

24

Resting Wagoners across the Danube from Ingolstadt, 1803
Watercolor, over pen and black ink
238 x 422 mm.
Signed and dated, lower right, *Wilhelm Kobell 1803*
Provenance: acquired in 1905 at Amsler & Ruthardt, Berlin (with two other drawings by Kobell)
Berlin, W. Kobell, no. 7

In addition to his carefully prepared depictions of battles and other military themes, rustic genre scenes constituted Kobell's primary subject matter in the years around 1800. He especially liked to paint crowded cattle markets in which he gave just as

much attention to the expertly represented horses and cows as to the frequently numerous human figures. Often the silhouette of a city forms the background of these compositions. His objective interest in details of the daily life of the people, and in costumes and tools was as penetrating as his interest in uniforms and topography. The agitation of the early scenes decreased with time.

In this watercolor there are fewer figures than there usually are in Kobell's genre scenes, and their isolation in space emphasizes the somewhat stiff tranquility of their existence and the still-life character of the representation. The woman sitting at the left with the baskets seems frozen, even absent. This composition anticipates the *Begegnungsbild* (encounter scene), a work containing a few figures in a broad landscape. Kobell produced the earliest consummate example of this type of composition, which characterizes his later work, in the same year, 1803. On the whole, however, the present watercolor, with its manifold narrative elements, and additive, obsessively detailed execution, still shows signs of Kobell's early style, though the initially decisive influence of seventeenth-century Dutch painters (such as Both and Wouwerman) can no longer be specifically identified. A study for the peasant youth reclining in the left foreground is in a private collection (Wichmann, 1970, no. 794). The Upper Bavarian city of Ingolstadt, depicted in the background, lies on the Danube, halfway between Munich and Nuremberg. In the foreground is the right bank of the river.

C.K.

Bibliography: Berlin, 1936, no. 162; Berlin, 1949, p. 43; Berlin, 1955a, no. 104; Wichmann, 1970, p. 320, no. 795

25

A Gentleman on Horseback and Peasant Girls on the Bank of the Isar, with Munich in the Background, 1831

Watercolor
237 x 306 mm.
Signed and dated, lower right: *Wilhelm v Kobell 1831*
Provenance: acquired in 1905 at Amsler & Ruthardt, Berlin (with two other drawings by Kobell)
Berlin, W. Kobell, no. 8

This watercolor is a late work of Kobell, whose productivity diminished after his sixty-fifth year. It is one of the last variations of the encounter motif, which he refined in watercolors and small oil paintings over a period of thirty years—particularly intensively in the 1820s—into a progressively purer, almost abstract form. The view from the southwest of the Isar River and of Munich—left of the gentleman one can clearly distinguish the Frauenkirche—often recurs in Kobell's paintings. The upright figures, whose positions are clearly denoted by the long, distinct shadows, stand out against the low horizon that enhances the recession of space into the distance. As is so frequent in the work of Kobell, these travelers who pause on their journey are frozen in solemn stillness and isolation. Despite the genre subject, the faithful reproduction of the Tegernsee peasant dress, and the miniaturistic observation of detail, the narrative element remains subordinate. The emphasis is upon the arrangement of objects in the open space, which is filled with the clear light of a cool afternoon. The horizontal lines of the river, riverbank, and silhouette of the city—punctuated by the relieflike layering of the planes of the figures—are harshly interrupted by the lateral boundaries of the picture. This absence of framing devices recalls Caspar David Friedrich's approach to composition. Siegfried Wichmann emphasizes the relationship of this representation of space to panorama painting and also demonstrates the significant influence of English sporting prints—those of George Stubbs, for example—not only with regard to the equestrian motif, which was so important for Kobell, but to the design in general. A comparable composition (in reverse) is in the Staatliche Kunsthalle, Karlsruhe (Wichmann, 1970, no. 1462). A sketch of the two female figures (graphite tracing) is in a private collection (Wichmann, 1970, no. 1501).

C.K.

Bibliography: Berlin, 1954, p. 11, no. 80; Weimar, 1958–59, no. 164; Berlin, 1965, no. 3, fig. p. 206; Berlin, 1966–67, p. 256 (unnumbered); Wichmann, 1970, no. 1502, fig. p. 481

JOHANN ADAM KLEIN
Nuremberg 24 November 1792–21 May 1875 Munich

Klein took his first drawing lessons at the age of eight, and in 1805 he became the pupil of the engraver Ambrosius Gabler in Nuremberg. Klein was trained in the late eighteenth-century genre and landscape tradition, which was based on Dutch painting of the seventeenth century, and he admired the work of Wilhelm Kobell. After studying at the Vienna Academy from 1811 to 1815, he lived intermittently in Nuremberg. During his many trips through Bavaria, Austria, and Hungary, he executed drawings and watercolors that later served as studies for his realistic military subjects, populous rustic genre scenes, and animal pieces. From 1819 to 1821 Klein sojourned in Italy, and in 1837 he settled in Munich. He enjoyed a long and stimulating friendship with Johann Christoph Erhard. In terms of both quality and quantity, Klein's etchings are considered more important than his paintings.

Nationalgalerie, Berlin: 56 drawings
Kupferstich-Kabinett, Dresden: 54 drawings

26
Hungarian Wagoners Resting, ca. 1811–18
Charcoal and watercolor
312 x 415 mm.
Provenance: acquired in 1908 from the collection of Eduard Cichorius
Dresden, C 1908–623

This work certainly predates Klein's journey to Italy in 1819 and apparently belongs to the period he spent in Vienna, where he eagerly studied wagoners and their companions, dress, customs, and horses. In his autobiography, Klein wrote: "I became very interested in the lively traffic in the main streets and marketplaces of Vienna, and in the various picturesque national costumes of the Hungarians, Poles, Wallachs, and Austrians as well as their vehicles." Klein drew people and animals, mostly at rest; animated scenes, like the man driving out an unwelcome stallion in the background, are unusual.

G.L.

27
The Painter Johann Christoph Erhard in His Vienna Studio, 1818
Watercolor, over graphite
Verso: *The Hohensalzburg Fortress*, graphite
256 x 324 mm.
Inscribed, lower center, *J. C. Erhard* [illegible] *Wien 1818*; signed and dated, upper left, *A Klein: del 1818*
Provenance: acquired in 1908 from the collection of Eduard Cichorius
Dresden, C 1908–269

The interior scene is an exception in Klein's work. It is related to the *Fensterbild* (view through a window), which enjoyed great popularity in the first half of the nineteenth century. The Dresden Kupferstich-Kabinett and the Berlin Nationalgalerie each own a pendant to this sheet; both are executed by Johann Christoph Erhard and show Klein at the easel in his Vienna studio (Dresden, C 1908–268; Berlin, Erhard, no. 7). In 1816 Klein and Erhard, who were friends, had gone to Vienna together from Nuremberg (Klein's second visit), and both rented ateliers in the Chotek Palace in the Josefstadt. In 1817 Klein also drew the view from his atelier into the garden and out over the houses and churches of Vienna (Vienna, Historisches Museum, no. 95656). In comparison to the emphatic austerity of Caspar David Friedrich's atelier, as we know it from Georg Friedrich Kersting's painting (West Berlin, Nationalgalerie), Erhard's seems almost cozy. A comfortable chair, a mirror, and a picture give a certain hominess to the room. The well-stocked portfolio against the wall is supported by a saber, a symbol of the victory achieved in the national struggle against Napoleon, which indicates the convictions of the young painter.

G.L.

Bibliography: Bernhard, 1973, p. 708; Freitag-Stadler, 1975, p. 24, fig. 11; Koschatzky, 1982, fig. 107

28
Battle Scene (Waterloo?)
Pen and gray ink, gray wash, watercolor
399 x 547 mm.
Provenance: bequest of Dr. Theodor Wagener, 1891 (with 1,290 other sheets)
Berlin, Klein, no. 23

In his autobiography Klein relates that in the war years of 1813 and 1814 he sought out the landscapes traversed by soldiers around Vienna—where he lived from 1811 until 1815—and, in 1815, around Pommersfelden. Because of this, as he tells us, "when I was doing nature studies I was often taken for a spy" and got into trouble. "During this time [1813–14] I executed many watercolors, among them some war scenes, etc., for Artaria and Comp." The Viennese art dealer Artaria was then one of his patrons, as were Frauenholz in Nuremberg and Count Franz Erwein von Schönborn-Wiesentheid. This drawing, which might be from this period, was painstakingly sketched out, but remains unfinished. In the right half of the picture one can see the light, though precise and detailed, pen lines of the sketch, which in the next stage are further defined through modeling with gray wash; this is the state in which most of the sheet was left. Only the central figure is elaborated, in watercolor over the wash, indicating that the artist intended to finish the work in this manner.

Klein's drawn and etched military subjects are usually conceived as genre scenes, showing the routine of daily life during a war. Only seldom does he depict battles, as in this drawing, which can be identified with at least some certainty. According to the military historian Heinz Helmert of Leipzig (correspondence with the author), the battle depicted here must have taken place between 1813 and 1815, since the shako (the cylindrical hat with a visor) was adopted by European armies for the first time around 1809, and Prussian troops—visible in the right middleground—did not confront the French in the field before 1813. One can see the latter gathered around the flag with the Napoleonic eagle in the foreground. The bearskin caps of the infantry and their 1772 model flintlocks with brass fittings indicate that these are soldiers of the Imperial ("Old") Guard. The man in the foreground who is supporting a fallen comrade certainly belongs to this unit. The rider to his left could be a division general, and behind him is a colonel of the hussars. The Prussian infantrymen, recognizable by their shakos, are fighting at the lower right. In the background, French dragoons and cuirassiers—with drawn broadswords and with carbines, respectively—are attacking a Prussian artillery battery defended by infantrymen. The amount of powder smoke, which has darkened the air, indicates that the battle has been in progress for several hours, and the sun has already reached its zenith.

Helmert believes that this might well be the point in the battle of Waterloo (18 June 1815) when the Prussian troops attacked, unsettling the French command. The neat uniforms of the French troops make it unlikely that this is an event of 1813–14: by that time it would not yet have been possible, after the severe losses of materiel during the Russian campaign, for them to have returned to the conditions of strength of the summer of 1812. On the other hand, the artist, who made use of documentation obtained from second-hand sources as well as from his own observations, may have neglected this temporary deviation from the actual situation.

C. K.

JOHANN CHRISTOPH ERHARD
Nuremberg 21 February 1795–20 January 1822 Rome

Erhard studied at the municipal drawing school in Nuremberg, where he was encouraged by Johann Adam Klein. In 1816 the two traveled together to Vienna, where Erhard drew landscapes and plant studies, and in 1818 they visited Salzburg and the Salzkammergut with a few of their artist friends. Erhard concentrated increasingly on etching, executing the series *Views of the Surroundings of the Schneeberg* in 1818, and, a year later, *Studies of the Salzburg Region*. In 1819 he traveled with Heinrich Reinhold to Rome, where Erhard committed suicide in 1822.

Kupferstich-Kabinett, Dresden: 80 drawings
Nationalgalerie, Berlin: 72 drawings

29
The Untersberg near Salzburg, 1818
Watercolor, pen and gray-black ink, graphite
277 x 388 mm.
Inscribed, lower left, *Der Untersberg bei Salzburg gez. v. J. C. Erhardt*
Provenance: transferred in 1877–78 from the Kupferstichkabinett, Königliche Museen Berlin, Erhard, no. 36

In the summer of 1818 Erhard made an excursion with his friends Johann Adam Klein, Ernst Welker, and the brothers Heinrich and

Friedrich Philipp Reinhold from Vienna—where he had been living since 1816—to Salzburg. Artists had begun to discover the pictorial possibilities of the city and of the Salzkammergut in 1815 and in the years immediately following, when Ferdinand Olivier and a few draftsmen from his Viennese circle—particularly his brother Friedrich, Julius Schnorr von Carolsfeld, Johann Christoph Rist, and Karl Philipp Fohr, who had just returned from Italy—produced works of great originality.

Topographically accurate views of the city by other artists, such as the series of sixty aquatints by Friedrich Schlotterbeck of 1803, had paved the way, and in 1811 Karl Friedrich Schinkel had created large-format pen drawings (of the Traunsee, the Königssee, and of the Lueg Pass), based on impressions from his travels. It was the artists of the Vienna Romantic circle, however, who first saw the beauty of the mountains and of other natural forms with a new intensity. In the facility of its lines and passages of delicately applied watercolor, Erhard's drawing of the Untersberg seen from the Mönchsberg belongs among the most magnificent products of this discovery. It is, as Ernst Buschbeck observes (Salzburg, 1959), "of the greatest appeal in its unfinished condition, with the wistful blue distance; such a vivid depiction of the boughs attests to a most powerful, almost Japanese, sense of nature."

<div align="right">G.R.</div>

Bibliography: Schwarz, 1958, fig. p. 74; Salzburg, 1959, no. 13

30

Portal in the Ruprechtsbau of Heidelberg Castle, 1818

Pen and black ink, gray wash, watercolor
255 x 188 mm.
Signed and dated, lower left, *J. C. Erhardt. fec. 1818*
Provenance: transferred in 1877–78 from the Kupferstichkabinett, Königliche Museen
Berlin, Erhard, no. 34

Erhard, like his friend Johann Adam Klein, came from Nuremberg, and was thoroughly familiar, from his youth on, with German art of the fifteenth and sixteenth centuries, which gradually became the object of deep historical and artistic interest to him. His stay in Vienna from 1816 to 1818 in the circle of the Romantic artists further strengthened his curiosity. This sheet is dated 1818, the year Erhard visited the Salzkammergut with Klein, Welker, and the Reinhold brothers, but, as far as we know, was not in Heidelberg, which indicates that he used a sketch he had made previously or a model by another artist. The picturesque character of the ruins of Heidelberg Castle, which was destroyed in 1693, was discovered at the beginning of the nineteenth century, and the Krautturm, or Gesprengte Turm, in particular, the oldest section besides the Ruprechtsbau, was represented by nearly every Romantic artist. The Late Gothic Ruprechtsbau (named after Ruprecht III, elector palatine and German king, r. 1400–1410) is distinguished by this portal with its famous and sculpturally rich keystone; it is understandable that the motif of two hovering angels holding a garland of roses attracted the deeply emotional Romantic artist. However, Erhard put greater emphasis upon the figure group placed next to the left wall of the portal: a mother and three children composed just as in a Gothic sculpture. Like Klein, Erhard is known for his numerous, painstakingly executed etchings. The same care is evident in the decidedly graphic ductus of the lines in this richly worked drawing.

<div align="right">G.R.</div>

III. EARLY ROMANTICISM

PHILIPP OTTO RUNGE
Wolgast (Pomerania) 23 July 1777–2 December 1810 Hamburg

Runge, the son of a prosperous shipper and grain trader, grew up in the Baltic port city of Wolgast, where the poet Ludwig Gotthard Kosegarten was one of his teachers at the municipal school. In 1795 he moved to Hamburg and worked for the transport company operated by his older brother Daniel, who introduced him to his intellectually stimulating circle of friends which included

Matthias Claudius. After receiving his earliest instruction in drawing and painting from Hamburg artists, in June 1798 he decided to dedicate himself exclusively to his development as an artist. He studied with Nikolai Abraham Abildgaard and others at the Copenhagen Academy from October 1799 to March 1801, when he produced his first important works. In Dresden from June 1801 to November 1803, Runge made friends with the painter Christian Ferdinand Hartmann and the author Ludwig Tieck, and in 1801 he participated in the "Preisaufgaben für bildende Künstler" sponsored by Goethe. He began to correspond with Goethe and studied the pantheistic philosophy of the mystic Jakob Böhme. Runge developed a program for a Romantic, cosmic-symbolic landscape art. At the end of 1802 he began work on his four *Times of Day*, which appeared as drawings six months later and as engravings in April 1805. Runge settled in Hamburg at the end of 1803, married in 1804, and painted his first group portrait, *We Three*, in 1805. After a visit to his parents in Wolgast in 1806–7, he returned to Hamburg and started work on his color theory, which appeared in 1810. In 1808 he began to make studies for the paintings of *The Times of Day*, of which only two versions of *Morning* were executed. During this time he carried on a correspondence with the poet Clemens Brentano. Already gravely ill by March 1810, he died of consumption in December of that year. Runge was personally acquainted with many of the leading figures of German Romantic literature and philosophy, and his unique, multilayered artistic concept, to which he gave form within a period of only ten years, was linked in various ways with their ideas. Runge's brother Daniel published the artist's letters and writings in 1840.

Nationalgalerie, Berlin: 35 drawings
Kupferstich-Kabinett, Dresden: 2 drawings

31
Portrait of Ludwig Berger, 1801–2

Black chalk, stumping, heightened with white, on brown prepared paper
471 x 378 mm.
Inscribed, on the verso, by Daniel Runge, *Berger / Original von Philipp Otto Runge 1801/2*
Provenance: the artist's heirs; acquired in 1938 from C. G. Boerner, Leipzig
Berlin, Runge, no. 30

The relationship with his contemporary Ludwig Berger (1777–1839), a composer and pianist from Berlin, was one of the important friendships that the young Runge formed in the Romantic circles of Dresden. Berger had gone to Dresden in September 1801 to study under Johann Gottlieb Naumann, at whose death shortly thereafter he composed a memorial cantata. He returned to Berlin in February 1803. Berger was later associated with Muzio Clementi for several years. From 1814 on, he lived in Berlin, where, in addition to concert appearances, he became an important piano teacher. Felix Mendelssohn was one of his pupils. "I have not yet found anyone among the young people here who has the desire to travel the same path as I, except for my friend, the musician Berger," wrote Runge to his father (26 March 1802), and he reported how they instructed each other in their respective arts. Berger took his friend to a Catholic service and set to music a Low German poem of Runge's. Following his conception of the unity of the arts, Runge intended to provide a "poetic commentary" for his engravings *The Times of Day*, which Berger was to have put to music.

Before painting his first portrait (*Self-Portrait*, 1802, Hamburg, Kunsthalle), Runge executed a series of painstakingly composed bust-lengths in chalk. From early on Runge avoided the academic method of drawing from "ideal" plaster busts: "How afraid I was of losing feeling, that I might one day draw a face without expression, without something else being there besides eyes, mouth, and nose: and how afraid of this I am still!" (26 November 1799). He was strongly aware of what was unique to the portrait artist: "It is as if you had the person in front of you and felt around his face with the chalk; where there are concavities, you stroke the paper more often . . . in the end, you get to know the faces of people very well . . ." (14 August 1792).

The composition and technique of this drawing are what one would expect of a thoroughly well-prepared and finished painted portrait. The choice of tinted paper, the measured hatching in black chalk, and the use of white chalk for light accents conform to standard practices. The artist allowed himself greater freedom of handling in the hair; over matte traces of lightly stumped chalk, he worked with a broader, firmly applied stroke, creating dark, more spontaneous flowing lines, dashed off here and there in a zigzag pattern. Like other portrait drawings by Runge, the sheet is highly finished. (The neck and shoulder area remain unelaborated, which may indicate that the artist did not intend to give the drawing away.) The importance of the portrait lies in the decisive, powerful objectivity of the interpretation: in the monumentality of the large head, raised and thrust forward, with its attentive expression focusing on a point above the level of the eyes; in the unifying modeling, which concentrates on essentials, striving attentively to subordinate the details of the face to the overall form of the head, as in a classical sculpture; in the depiction of a type who is at once ideal and stamped by a contemporary ethos, whose prevalent characteristics are modesty, stability, and self-determination.

C. K.

Bibliography: C. G. Boerner, *Deutsche Handzeichnungen der Romantikerzeit*, Leipzig, 25 May 1938, p. 10, no. 85, pl. VI; Leonhardi, 1938, p. 87; Isermeyer, 1940, p. 126, fig. 11; Hinz, 1973, p. 16; Traeger, 1975, pp. 88, 309 f., cat. no. 193, fig. p. 309; Hamburg, 1977–78, no. 212, illus.; Betthausen, 1980, fig. 95

32

The Artist's Parents, 1806

Pen and gray ink, gray wash, over black chalk and graphite
539 x 363 mm.
Inscribed, on the verso, by Daniel Runge, *Original von Philipp Otto Runge 1806/07*
Provenance: the artist's posthumously born son, Philipp Otto Runge, about 1890; acquired in 1935 from Paul Cassirer, Berlin (with eight other drawings by Runge)
Berlin, Runge, no. 20

The artist's parents lived in the Pomeranian port city of Wolgast, which at that time belonged to Sweden. Daniel Niklaus Runge (1737–1825) was a grain dealer and shipowner. The couple had eleven children. Runge's older brother Daniel, who edited and provided commentary for the painter's letters and writings, inherited his parents' piety, which in the case of the mother, Magdalena Dorothea Runge (1737–1818), was governed by an emotional "and even poetic sense" and in the father, by an alert intelligence. His mother became seriously ill during the execution of the painting.

Runge had planned to paint his parents' portrait since January 1805. He stayed in Wolgast with his wife and child from the end of April 1806 until the end of April 1807. The sketch exhibited here, which served as the model for an oil study painted in May (private collection), dates from shortly after their arrival, and is later than, or contemporary with, two individual portrait studies in oil. The large painting with life-size figures acquired in 1904 by the Hamburg Kunsthalle (after the Nationalgalerie had also tried to procure it) was already finished in September 1806. It differs from the study primarily in the addition of two grandchildren in front of the fence and of a river scene in the background, and in details such as the rose that the old woman holds in her hand. The figures are also larger and closer to the foreground. The tempo of their stride is slower, their heads are turned more emphatically toward the viewer, and the overall effect is more solemn and monumental. The physiognomies, treated in the drawing in a casual, everyday manner, are endowed in the picture with fixed, almost forbidding expressions.

Like the portrait of the Hülsenbeck children, done a few months before, the painting of the artist's parents is a "staged" composition; the figures are depicted while out for a stroll, passing before the viewer, which is emphasized by the father's gesture of greeting. This everyday activity also constitutes the basis of the work's allegorical program; the symbolism of the journey (of life), which underlies the drawing, is enhanced in the later development of the composition through the addition of children, plants, and color. The large scale of the sheet indicates that it is a working drawing. Linear values and surface relationships are explored, while problems of form and space are neglected (as seen in the transposition of the walking stick and the hat). Pentimenti can be

seen in the figure of the father; there are traces of erased graphite lines that do not correspond with the application of the chalk, indicating that the leg was originally positioned farther back and the stick held more upright. The Nationalgalerie also owns a view in wash of the Peene River, which is a preparatory study for the background of the painted portrait (Berlin, Runge, no. 24).

<div align="right">C. K.</div>

Bibliography: Runge, 1840, vol. 1, p. 366; Heydt, 1938, fig. 59; Isermeyer, 1940, p. 129 f., fig. 44; Einem, 1948, p. 9, fig. 4; Dörries, 1950, fig. p. 79; Weimar, 1958–59, p. 64, no. 247; Berlin, 1962, p. 42 (unnumbered); Geismeier, 1964, pp. 10, 24, no. 6, fig. 6; Berlin, 1965, no. 217, fig. p. 134; Bernhard, 1973, p. 1567; Traeger, 1975, pp. 86, 502, no. 350

33

Morning, 1808

Pen and gray and black ink, gray and black wash, over traces of graphite
422 x 334 mm.
Inscribed, on the verso, by another hand, *Otto Philipp Runge*
Provenance: acquired by the Kupferstichkabinett, Königliche Museen, apparently from the estate of the artist's friend Henrik Steffens (d. 1845); transferred in 1877–78 to the Nationalgalerie
Berlin, Runge, no. 1

By 1802–3 Runge had already drawn four compositions of *The Times of Day*, which were published in 1805 as engravings (a second edition appeared in 1807). The symmetrical, arabesquelike designs, symbolic down to the smallest detail, in which flowers, children, and rays of light all play an important role, reflect the philosophically based program that Runge conceived for a new, universal landscape art. Runge abandoned his original intention of executing them as a room decoration. However, some years later—the outline engravings had in the meantime caused a great sensation—Runge went back to the compositions and designed, following an earlier plan, four monumental paintings, but his premature death prevented him from realizing this project. Runge had intended to exhibit these pictures in their own neo-Gothic shrine. Only two intermediate versions of *Morning* were executed, the *Small Morning* and the so-called *Large Morning* (which was

later cut up; the fragments were reassembled in 1927), both in the Hamburg Kunsthalle.

While the axial composition of the engraving is determined by the form of an ornamental, symmetrically unfolding lily over a cloud-veiled terrestrial globe, for the painting, Runge designed instead a real landscape space—the first version of the picture shows a flat meadow with the sea in the background—in which symbolic figures enact a cosmic event: the birth of day, of light, of man, and, in the broadest sense, the way to the redemption of the soul. The central figure is surrounded by subsidiary figures arranged in a circle. Above the horizon hovers Aurora (who is also Venus and the Virgin Mary), bathed in golden radiance, and out of her flaming hair, which she grasps like a torch, grow the lilies of light, inhabited by children. Rays of light diffuse through winged music-making genii. Below, children kneeling on clouds strew roses around the newborn, who "sees the light of day," but who is himself, in the Christian interpretation of the multilevel symbolism, the Light of the World, the Redeemer. Far above, the morning star is fading. The framing composition extends the symbolic program even further. At the bottom, the light of the sun is veiled by the earth, and children and flowers lead the ascent from the dark soil, in which amaryllis bulbs are planted, to divine light, adored by two lily-angels.

The materialization and changing conditions of light are the themes of the picture, which can only be suggested in the black-and-white sketch. The latter is the result of many variations of the pictorial idea, the studies for which are preserved in the Hamburg Kunsthalle (including an earlier version of the entire design showing the framing composition; see Traeger, 1975, no. 384). The execution of the *Small Morning* differs only in insignificant details from the Berlin drawing. In 1825 Otto Speckter reproduced the design in a lithograph of the same size. The title with which the drawing entered the Berlin Kupferstichkabinett is significant: "Allegorical Representation of Schelling's Philosophy. A Fairy Play." This title appears to refer to conversations the art historian Carl Friedrich von Rumohr had with the philosopher Friedrich Wilhelm Joseph von Schelling when Rumohr showed him the drawing in

Munich early in 1808. Previously, Runge had shown it to Goethe. Soon, it came into the possession of Runge's friend, the philosopher Henrik Steffens, who showed it to Jakob Grimm, among others. Apparently, the drawing served, even more than as a practical working design for his painting, as advance publicity for it and for the exchange of ideas with those of a like mind.

C. K.

Bibliography: Runge, 1840, vol. 1, pp. 173, 232; vol. 2, pp. 346 (?), 359, 360; Steffens, 1908, p. 256 f.; Justi, 1919, p. 54, fig. 30; Böttcher, 1937, pp. 86, 122, 178 f., 289, 300, pl. 31; Berlin, 1949, p. 50; Weimar, 1958–59, no. 249; Berefelt, 1961, pp. 30, 35, 156, 166, 176 f., 205, 224, fig. 109; Berlin, 1964, pp. 9 f., 23 f., no. 4; Berlin, 1965, no. 220, fig. p. 131; Dresden, 1970, no. 144, fig. p. 105; Traeger, 1975, pp. 22, 159 f., 168, 180, 424 f., no. 395 (with annotated bibliography); Hamburg, 1977–78, no. 185, illus.; Bern, 1985, no. 214, fig. p. 143

34
Aurora, 1809

Red and black chalk, heightened with white, on brownish card
563 x 395 mm.
Inscribed, on the verso, by Daniel Runge, *Original von Philipp Otto Runge 1809*
Provenance: bequeathed by Runge's son Otto Sigismund to the Künstlerverein, Hamburg; acquired in 1937 from C. G. Boerner, Leipzig
Berlin, Runge, no. 28

This chalk drawing is one of five lighting studies for the *Large Morning*. In this version, Aurora—who, in the iconographic context of the picture signifies both Venus and the Virgin Mary—has been fundamentally altered in comparison to earlier designs. The figure is, on the whole, heavier and more static, and is no longer inscribed in a narrow oval that is pointed at the top and the bottom; the legs now are separated and the right hand, which grasps a lock of flaming hair, is raised to the side instead of over the head. The hair runs like flames along the arm and the upper torso, and its double nature is clearly stressed. Compare also the sketch of the same motif in the Hamburg Kunsthalle (Traeger, 1975, no. 484).

C. K.

Bibliography: Runge, 1840, vol. 1, pp. 172, 236; Hamburg, 1935a, no. 107; Hamburg, 1935b, no. 21; C. G. Boerner, Cat. 195, Leipzig, 1937, no. 179, pl. II; Berlin, 1938, no. 62; Berefelt, 1961, pp. 157, 209, fig. 100; Traeger, 1975, pp. 88, 460, no. 485 (with annotated bibliography); Bern, 1985, no. 216, fig. p. 145

35
Two Music-making Genii, Floating in the Air, 1809

Red and black chalk, heightened with white, on brownish card
349 x 532 mm.
Inscribed, on the verso, by Daniel Runge, *Original von Philipp Otto Runge 1809*
Provenance: bequeathed by Runge's son Otto Sigismund to the Künstlerverein, Hamburg; acquired in 1937 from C. G. Boerner, Leipzig
Berlin, Runge, no. 29

One of five lighting studies for the *Large Morning*, the second painted version of *Morning*. *Die Musika*, as Runge called the angels arranged in a semicircle around the lily, differs from the *Small Morning* (cf. Cat. No. 33) only in details, but enough to allow us to relate this drawing to the later painted version. See also the outline drawings of the same motif in the Hamburg Kunsthalle (Traeger, 1975, no. 487).

C. K.

Bibliography: Runge, 1840, vol. 1, pp. 172, 236; Hamburg, 1935a, no. 110; C. G. Boerner, Cat. 195, Leipzig, 1937, no. 181, pl. III; Berlin, 1949, p. 50; Weimar, 1958–59, no. 250; Traeger, 1975, p. 461, no. 488 (with bibliography); Bern, 1985, no. 215, fig. p. 144

KARL FRIEDRICH SCHINKEL
Neuruppin (Mark Brandenburg) 13 March 1781 – 9 October 1841 Berlin

Schinkel, the son of a clergyman, moved to Berlin in 1794. After beginning his architectural training in 1798–99 as the private pupil of David and Friedrich Gilly, he continued his studies at Berlin's academy of architecture from 1799 to 1800. His earliest designs—for villas, palace buildings, a museum, furniture, porcelain—date from 1800 to 1803. He traveled in Italy from 1803 to 1805, returning by way of Paris. During this journey, he executed a great many landscape drawings. From 1806 to 1813 he worked primarily on dioramas and panoramas. Schinkel was appointed assessor of works for court and "luxury" buildings in 1810, and became a member of the Berlin Academy in 1811. From 1813 to 1815 he executed Romantic paintings—primarily "architectural landscapes"—and drawings. Following his promotion to the board of works in 1815, he began to carry out major commissions for state buildings

in Berlin, including the Schauspielhaus (1818–21) and the museum (1822–30). Schinkel traveled in the Rhineland in 1816, made his second journey to Italy in 1824, and visited Paris and Great Britain in 1826. With his appointment as director of works in 1830, Schinkel took charge of all building activity in Prussia and executed numerous commissions for buildings outside of the kingdom. From 1831 on, his professional responsibilities necessitated frequent trips through the provinces of Prussia, and he recuperated by taking cures at Bohemian and alpine spas. His designs for ideal building projects—an acropolis, the villa Orianda, the residence of a ruler—date from 1834 to 1838. Signs of paralysis appeared in 1839, and in 1840 he suffered a stroke. Schinkel was the most important Neoclassical architect in Germany, and his work has remained influential to this day.

Nationalgalerie, Berlin: 4,470 drawings
Kupferstich-Kabinett, Dresden: 1 drawing

36
Mountain Range in Bohemia at Sunset, ca. 1805
Gouache
215 x 353 mm.
Provenance: acquired in 1844 from the estate of Karl Friedrich Schinkel
Berlin, Schinkel, no. 2.2

At the beginning of an extended study trip, the destination of which was Italy, the twenty-two-year-old Schinkel passed through Bohemia in 1803. In addition to recording landscapes and buildings in hundreds of sketches during his two-year tour, he executed drawings from nature of the Bohemian mountains. This finished work in gouache was produced after his return, using one of the sketches; the study itself has not survived. It shows the two main peaks of the Bohemian Mittelgebirge, the Milleschauer and the Kletschen. Schinkel describes the view in a letter (22 June 1803; K. F. Schinkel, op. cit.): "A steep drop behind this place lets you enjoy the view of a rich valley that rises up again on the other side and grows into the distant mountains, where a series of innumerable cone-shaped peaks form a vast panorama."

While Schinkel usually executed drawings in pen and ink,

this landscape made such a profound impression upon him—it was his first visit to the mountains—that he chose to give form to it in color. At this time, he had still not decided whether he would concentrate on painting or architecture—he produced most of his landscape paintings before 1815—and his artistic talents and Romantic disposition were becoming quite pronounced. The monumentality of the mountains, the silhouette of the evergreen forest before them, and the colorful glow of the evening light are already characteristic Romantic features that, in many ways, anticipate elements of the landscape art of Caspar David Friedrich. The latter discovered the Bohemian Mittelgebirge as a subject several years later. Friedrich's *Bohemian Landscape with the Milleschauer,* 1807–8 (Dresden, Gemäldegalerie Neue Meister), depicts the landscape from nearly the same viewpoint.

G. R.

Bibliography: E. Riehn, "K. F. Schinkel als Landschaftsmaler," Phil. diss., Göttingen, 1940, pp. 68–70; K. F. Schinkel, *Reisen nach Italien,* Berlin, 1979, pp. 19–20, color pl.; Berlin, 1980–81, no. 84, color pl. p. 45; K. L. Hoch, "K. F. Schinkel und das böhmische Mittelgebirge," *Sächsische Heimatblätter* 27 (1981): 157–59

37
Castle on a River, ca. 1816
Pen and brush and black ink, gray and light blue wash, heightened with white
526 x 644 mm.
Provenance: acquired in 1844 from the estate of Karl Friedrich Schinkel
Berlin, Schinkel, no. 1a. 13

The manifold relationships between the artistic and literary aspects of Romanticism in Germany are demonstrated in the theme of this elaborate composition and in the occasion of its inspiration. Schinkel's Romantic character revealed itself most clearly in the years before 1815 (after which he began to practice architecture). During this early period, the versatile artist was predominantly occupied with fantastic architectural designs, mostly in a Gothicizing style. He also produced the majority of his approximately forty paintings of "architectural landscapes," with which the present work may be associated.

Schinkel was close to the Romantic circle formed in Berlin around the writers Achim von Arnim and Clemens Brentano, and

he and Brentano became close personal friends in 1811. In 1816, probably the year this drawing was executed, Brentano asked Schinkel to illustrate an edition of his fairy tales, a project that never materialized. The inspiration for our drawing came to Schinkel during an evening party in his house. Brentano recited a fairy tale—the text has not survived—in order to raise anew the old artistic debate as to whether a narrative can be represented pictorially. A contemporary account by the scene-painter Karl Gropius provides a vivid description of the event as well as of the subject of our drawing:

> Schinkel sat, nearly oblivious of all that was going on around him, and drew. At one point the conversation turned to the difficulty of expressing in a drawing what could be so easily achieved in poetic representation. Schinkel opposed this view, and Brentano wanted to prove that he could, on the spur of the moment, invent a narrative that Schinkel could not possibly retell and express intelligibly through drawing. After much discussion and after settling on the extent of such a narrative, everyone happily agreed to the experiment. Brentano narrated and Schinkel composed. It was a very clever and complicated story of an old hunting lodge that had been abandoned after the death of the prince, but had later been turned over to the head gamekeeper's family to be kept up and used as a residence. The tale for the first evening came to a close, and, in approximately the same length of time, Schinkel had produced on paper a sketch of the castle with every conceivable detail contained in the story, mastering in every way the layout and terrain, which the narrator had intentionally described in the most complicated manner. By the end of the week the story was finished, but so was the drawing. The head gamekeeper of the story died, but the terrain that was described was of solid rock, so there was not the smallest place where the dead man could be buried; the coffin, therefore, had to be brought down the cliff and then across the river in a gondola, to be laid to rest opposite the castle. A stag, which had nothing more to fear from the dead gamekeeper, entered the abandoned place, and a small child blew dandelion puffs into the air as a sign of life's transitoriness. All of this is represented in the picture. It is a pity that stenography had not been invented at the time; it could have

preserved Brentano's story for us as faithfully in words as Schinkel has done in a picture (von Wolzogen, op. cit.).

The deliberate way in which the castle enthroned upon the rock is placed above the clearly ordered landscape conforms perfectly to Schinkel's fundamental idea of making architecture an active part of its environment. The Christian motifs of church, cemetery, and grapevine are juxtaposed with the other components of the landscape. The artist's predilection for the Romantic world view is manifest in the combination of evidence of an art-filled human past, a fervent veneration of nature, and the appearance of religious motifs. The castle jutting out over the river calls to mind Heidelberg Castle, in ruins since 1693, which, like the city itself and the surrounding landscape, had become a kind of symbol of Romanticism. Schinkel had seen it during his journey along the Rhine in 1816. In 1820 Schinkel used this drawing to create a larger painting (West Berlin, Nationalgalerie), commissioned by the collector and founder of the Nationalgalerie, Consul Wagener. A second version of the drawing also exists (Berlin, no. SM 15 a. 7).

G. R.

Bibliography: A. von Wolzogen, *Aus Schinkels Nachlass*, vol. 2, 1862, pp. 340–41; Berlin, 1980–81, pp. 46–47

38

Portrait of the Artist's Daughter Marie, 1816

Black chalk, on reddish prepared paper
532 x 422 mm.
Signed and dated, lower right, *Schinkel 1816*
Provenance: acquired in 1936 from a private collection, Berlin
Berlin, Schinkel, no. 54.2

In 1816, when Schinkel traveled to Heidelberg, the Rhineland, and the Netherlands, his wife Susanne and his daughter Marie (1810–1857), the eldest of his four children, accompanied him. On 14 November 1816 he wrote to Christian Daniel Rauch: "Can you imagine Marie in the Amsterdam theater? Where Mine Heeren presented a tragedy? And on the shores of the North Sea near Scheveningen, where she played in the sand with fisher-

men's boys whom she only half understood, and looked for shells?" (K. F. Schinkel, op. cit.).

Schinkel's drawings of his daughter, which date from the last years of his Romantic phase (1813–16), are portraits of the highest quality. The similarity to portraits by Philipp Otto Runge, particularly that of the little Luise Perthes of 1805 (Weimar, Staatliche Kunstsammlungen), is unmistakable. The influence that Runge's work, particularly his *Times of Day*, exercised on Schinkel has been noted frequently (for example, see Schinkel's tondo *Morning* of 1811; Berlin, 1980–81, fig. p. 49). In 1817, at Achim von Arnim's request, Schinkel adapted with only minor changes Runge's 1810 cover for the periodical *Vaterländisches Museum* for his own design for the title page of Arnim's novel *Die Kronenwächter*.

G. R.

Bibliography: K. F. Schinkel, *Briefe, Tagebücher, Gedanken*, edited by Hans Mackowsky, Berlin, 1922, p. 95; Berlin, 1980–81, no. 110

CASPAR DAVID FRIEDRICH
Greifswald 5 September 1774–7 May 1840 Dresden

After studying drawing with Johann Gottfried Quistorp, the drawing master at the university of Greifswald, in 1794 Friedrich enrolled at the Copenhagen Academy, where he remained for four years. In 1798 he settled in Dresden, where his work was initially influenced by that of Johann Christian Klengel, Adrian Zingg, and Philipp Veith. He made his first trip to the island of Rügen in the summer of 1801, and met Philipp Otto Runge in Greifswald. In 1802, 1806, 1809, 1815, and 1818 he visited Rügen, Greifswald, and Neubrandenburg. He traveled in northern Bohemia in 1807 and 1808, and in July 1810 he and Georg Friedrich Kersting made a tour of the Riesengebirge. Goethe and Johanna Schopenhauer visited Friedrich in Dresden in 1810, the year that also saw the publication of Heinrich von Kleist's article on *Monk by the Sea* in the *Berliner Abendblatt* and the artist's acceptance into the Berlin Academy. Friedrich visited Goethe in Weimar in 1811, and traveled in the Harz Mountains. In 1816 he became a member of the Dresden Academy, and was appointed *ausserordentlicher Professor* in 1824. His friendships with Carl Gustav Carus and Johann Christian Claussen Dahl began in 1818, and in 1820 Peter Cornelius visited him. Friedrich went to Rügen for the last time in 1826. He took cures in Teplitz in 1828 and in 1835. The sculptor David d'Angers visited him in 1834, and in 1836 Wilhelm von Kügelgen paid a call on the artist, who was already seriously ill.

Nationalgalerie, Berlin: 111 drawings
Kupferstich-Kabinett, Dresden: 92 drawings, 1 sketchbook with 19 pages, and 1 manuscript

39

Landscape on the Island of Rügen, with a View from Stresow toward Reddewitz and Zicker, 1801

Pen and brown ink
220 x 350 mm.
Dated, lower center, *den 17 t Juni 1801*
Provenance: acquired in 1926 from Kunstausstellung Kühl, Dresden
Dresden, C 1926–42

The allure of the island of Rügen for Friedrich was due in no small part to the enthusiastic writings of his countryman Ludwig Gotthard Kosegarten. Friedrich first explored Rügen in 1801, and it was then that he produced this drawing. The sky, running parallel to the picture plane, takes up more than three-quarters of the composition, creating the illusion—typical of Friedrich—of a limitless expanse of landscape. Referring to the painting *Monk by the Sea*, completed in 1810, Siegmar Holsten traces Friedrich's radical break with the tradition of the coastal landscape to the use of this compositional device (see Hamburg, 1974, p. 31). Although our drawing is topographically accurate, the horizontally receding division and articulation of the picture surface seem to anticipate this important departure from tradition.

G. L.

Bibliography: Eberlein, 1940, fig. 26; Hinz, 1966, p. 36, no. 271; Vienna, 1974, no. 156; Dresden, 1978, no. 155, illus.

40

A Bare Oak, 1806

Graphite
281 x 191 mm.
Dated, lower center, *den 26t May 1806*
Provenance: acquired in 1927 from Kunstausstellung Kühl, Dresden
Dresden, C 1927–73

This study of an oak was executed in the vicinity of Neubranden-
burg during Friedrich's trip to Rügen in 1806. He used it for the
central oak in the finished sepia drawing of 1807, *Dolmen by the
Sea* (Weimar, Staatliche Kunstsammlungen, inv. no. 516; Börsch-
Supan/Jähnig, 1973, no. 147), as well as in the painting *Winter*,
also known as *Monk in the Snow,* for the oak at the center left in
the middleground (destroyed in a fire in Munich in 1931; Börsch-
Supan/Jähnig, 1973, no. 165).

G. L.

Bibliography: Dresden, 1940, no. 52; Hinz, 1966, pp. 44, 46; Sumowski, 1970,
p. 145, fig. 188; Börsch-Supan/Jähnig, 1973, nos. 147, 165, p. 501; Dresden, 1974,
no. 157; Hamburg, 1974, no. 69

41

Coastal Landscape with Cross and Statue, ca. 1807

Brown wash and graphite
401 x 580 mm.
Provenance: possibly from the collection of J. G. von Quandt, auctioned in Dresden
in 1860; acquired in 1980 from a private collection, Leipzig
Berlin, Friedrich, no. 111

This sheet, so characteristic of Friedrich's conception of a "sym-
bolic landscape," dates from about 1807. Werner Sumowski points
to stylistic similarities with sepia drawings in Weimar (*Pilgrimage
at Sunrise*, 1805; *Dolmen by the Sea*, 1807). The Berlin work, which
became known through Reitharovà and Sumowski's publication
of 1977, was previously thought to have been lost. Sumowski was
able to identify it with two contemporary literary descriptions,
one in the *Journal des Luxus und der Moden* of 1807 (in connection
with an exhibition at the Dresden Academy that opened on 5
March 1807) and the other in the *Jenaische Allgemeine Literatur-*

Zeitung, Neujahrsprogramm 1809 (in connection with an exhibition
in Weimar in November 1808). Both references describe a substan-
tially larger work that included a herd of sheep with their
shepherd at the left and a mountain at the right. Sumowski
suggests that the sheet has been cut on both sides. Problems with
the condition of the drawing could have led to its truncation,
which reduced the composition to its essential components. Fur-
thermore, Friedrich's fastidiously finished sepia landscapes, to
which this work unquestionably belongs, were invariably exe-
cuted on sheets of a larger format.

Sumowski proves that two nature studies dated 1806 were
used for the composition: the middle group of trees was taken
from a drawing of 24 May 1806 and the landscape in the right
background, from one of 2 July 1806 (both are in Oslo, Nasjonal-
galleriet). The review of 1808 already interpreted the statue on its
pedestal as a symbol of faith or hope. Börsch-Supan also sees in it
a symbol of "holy art," referring to Zacharias Werner's tragedy
The Cross on the Baltic Sea (1806), which might have been Fried-
rich's inspiration. The cross could substantiate this interpretation:
its location "apparently signifies that religion stands above art"
(Börsch-Supan/Jähnig, 1973, p. 293).

G. R.

Bibliography: Sumowski, 1970, nos. 74, 85; Börsch-Supan/Jähnig, 1973, no. 151;
Reitharovà/Sumowski, 1977, pp. 41–42, fig. 5

42

Path in the Forest, with Rocks, 1810

Watercolor and graphite
180 x 260 mm.
Inscribed by the artist, lower left, *Schatten / der Weg ist weiß / die Fichte 3 ist nur halb /
zu sehen*
Provenance: bequest of Dr. Friedrich Lahmann, Dresden, 1937
Dresden, C 1937–416

During his trip in the Riesengebirge (see also Cat. No. 48), Frie-
drich executed a series of drawings in graphite and watercolor as
studies of nature and of color. The present sheet belongs to this

group. The inscriptions, the numbers on the trees, and the color notes served as *aides-mémoires* for the artist. G. L.

Bibliography: Dresden, 1940, no. 79; Hinz, 1966, no. 534; Sumowski, 1970, p. 159, fig. 348

43

Self-Portrait, ca. 1810
Black chalk
228 x 182 mm.
Provenance: donated by Johann Jakob Otto August Rühle von Lilienstern, one of Friedrich's Dresden friends, to the Kupferstichkabinett, Königliche Museen; transferred in 1877–78 to the Nationalgalerie
Berlin, Friedrich, no. 1

This is the most famous of the eight surviving self-portraits drawn by Friedrich. The date of about 1810 has been convincingly established — after some hesitation — on the basis of comparison with other depictions of the artist (such as those by Caroline Bardua, Georg Friedrich Kersting, and Franz Gerhard von Kügelgen). Werner Sumowski was the first to establish that in its outward form, this work recalls a portrait bust. The garment draped around the upper torso recalls Roman dress and also recalls Neoclassical busts; it is deliberately in contrast to contemporary fashion. Börsch-Supan suggests that Friedrich could also have perceived himself as a monk.

 With an intensively penetrating and self-conscious gaze that is at the same time directed inward and at the observer, the artist depicted himself at the height of his success. With the *Tetschen Altar* (also known as *The Cross in the Mountains*) of 1808, and the pendants *Monk by the Sea* and *Abbey in the Oak Forest* of 1809, begun after a journey to his North German homeland, he had created his most significant works to date and had won universal esteem. The two companion pieces were displayed at the Berlin Academy exhibition of 1810 and purchased by the Prussian king, Friedrich Wilhelm III, at the suggestion of the young crown prince. Friedrich became a member of the Berlin Academy that year.

 G. R.

Bibliography: Hinz, 1966, no. 709; Sumowski, 1970, p. 92 f.; Börsch-Supan/Jähnig, 1973, no. 170

44

Two Men on the Mönchgut Peninsula, Island of Rügen, ca. 1826
Pen and black ink
171 x 186 mm.
Provenance: gift of Woldemar von Seidlitz, 1919
Dresden, C 1919–20

The dating of this work is disputed. Because of the similarities in stroke, technique, and format with *Ships on the Sea* (Börsch-Supan/ Jähnig, 1973, no. 347), Börsch-Supan's dating of about 1826 seems justified. As he demonstrates, for the landscape, Friedrich used a sketch of the Gross-Zicker headland, dated 17 August 1801, which is now in Hamburg (Kunsthalle, inv. no. 41094). The landscape and the two men are very similar to those in an undated drawing in Frankfurt am Main (Städelsches Kunstinstitut, inv. no. 13946; Sumowski, 1970, fig. 343).

 According to Börsch-Supan, the man who is looking out at the sea through the telescope supported upon his friend's shoulder embodies yearning or longing, a motif that in turn relates to a lost sepia drawing, probably of 1806, *The Chalk Cliffs on the Island of Möen* (Börsch-Supan/Jähnig, 1973, no. 134). He interprets the ship as a symbol of transcendence. Mönchgut, an irregular peninsula with two promontories on its eastern coast, is part of the Baltic island of Rügen.

 G. L.

Bibliography: Dresden, 1940, no. 44; Wilhelm-Kästner, 1940, pl. 35; Hinz, 1966, no. 670; Sumowski, 1970, p. 157; London, 1972, no. 88; Börsch-Supan/Jähnig, 1973, no. 348, illus.; Bernhard, 1974, p. 637; Dresden, 1974, no. 209; Hamburg, 1974, no. 174; Bern, 1985, no. 66, illus.

45

Sailing Ships on the Sea, ca. 1826
Pen and black ink
168 x 185 mm.
Provenance: acquired in 1920 from a private collection, Leipzig
Dresden C 1920–183

This finished work belongs to a group of pen drawings that were probably produced in the studio from earlier sketches. Sigrid Hinz

points out that the ship at the right appears in reverse in the painting *Coastal City in Moonlight* of 1811 in Winterthur. Because of similarities in composition and execution, a drawing in the collection of Dr. Hirschland in New York (Börsch-Supan/Jähnig, 1973, no. 347), which bears the date 1826 written in an unknown hand, should be regarded as a companion piece to the Dresden sheet.

G. L.

Bibliography: Dresden, 1940, no. 45; Hinz, 1966, no. 736; Sumowski, 1970, pp. 157–58, fig. 342; London, 1972, no. 87; Bernhard, 1974, p. 743; Dresden, 1974, no. 208, illus.; Bern, 1985, no. 67, illus.

46
The Schlossberg near Teplitz, ca. 1835

Graphite, pen and brown ink, sepia wash
243 x 359 mm.
Provenance: acquired in 1923 from Caspari, Munich (with thirteen additional works by Friedrich)
Berlin, Friedrich, no. 25

Teplitz is the oldest and, apart from Karlsbad, the most important Bohemian health spa, mainly because of its beautiful location between the Erzgebirge and the Bohemian Mittelgebirge, and it greatly appealed to many important persons at the turn of the nineteenth century. Like other artists, Friedrich stayed there frequently. His extended sojourn in Teplitz in 1835 for treatment following a stroke was particularly fruitful for his art, even more so than his visit in 1828 had been. Hinz and Sumowski point to thirteen surviving drawings of the surroundings of Teplitz executed in 1835.

This panoramic view shows the ridge of the Erzgebirge and the Schlossberg. Friedrich also depicted the ruins of the castle in two watercolors (Börsch-Supan/Jähnig, 1973, nos. 377–78). Teplitz itself remains hidden behind the mountain in the middleground. Without giving any significant reasons, Börsch-Supan doubts that this sheet is by Friedrich. However, in addition to his generalized "symbolic landscapes" with allegorical meanings, Friedrich's *oeuvre* abounds with topographically accurate views of places that were of particular interest to him.

G. R.

Bibliography: Hinz, 1966, no. 769; Sumowski, 1970, no. 378/13, fig. 209; Börsch-Supan/Jähnig, 1973, p. 484, no. IV; Hoch, 1987, p. 150, fig. 75

47
Rocky Shore with Anchor, 1835–37

Brown wash, over graphite
247 x 357 mm.
Provenance: bequest of Dr. Friedrich Lahmann, Dresden, 1937
Dresden, C 1937–418

Fritz Nemitz relates this sheet to the painting *Evening on the Baltic Sea* (Börsch-Supan/Jähnig, 1973, no. 350) and dates it about 1805. Börsch-Supan notes a connection with a study of a beach from the Oslo sketchbook that bears the date 9 August 1818, but places this sheet among Friedrich's late works, of about 1835–37. He interprets the anchor as a symbol of hope for resurrection and the rocks as a sign of faith, with which he equates the crescent of the waxing moon, a symbol of Christ. Sumowski draws attention to a stylistic correlation with two sepia drawings in Leningrad, *Two Men with the Rising Moon by the Sea* and *Boat on the Shore by Moonlight*.

G. L.

Bibliography: Dresden, 1928, no. 118; Dresden, 1933, no. 314; Dresden, 1940, no. 56; Eberlein, 1940, fig. p. 28; Nemitz, 1941–42, p. 269; Börsch-Supan, 1960, p. 53 n. 1; Hinz, 1966, no. 694; Sumowski, 1970, p. 154; Börsch-Supan/Jähnig, 1973, p. 55, no. 482; Bernhard, 1974, p. 691; Dresden, 1978, no. 156, illus.; Bern, 1985, no. 79, illus.

GEORG FRIEDRICH KERSTING
Güstrow (Mecklenburg) 31 October 1785 – 1 July 1847 Meissen

The young Kersting learned the elements of painting from his father, a glazier and glass painter, before studying at the Copenhagen Academy from 1805 to 1808. His move to Dresden brought him into contact with Franz Gerhard von Kügelgen, Caspar David Friedrich, and Louise Seidler. He lived temporarily in Güstrow (where he joined a Freemasons' lodge in 1809) and in Rostock. In 1810 Kersting accompanied Friedrich on a walking tour in the Riesengebirge. The following year Kersting's work was enthusiastically received by Goethe, among others, at exhibitions in Dresden

and Weimar. During this period he produced his finest "Zimmerporträts," which show the sitters in their domestic settings. Gripped by the general patriotic mood of the time, from 1813 to 1815 Kersting took part in the Wars of Liberation against the Napoleonic armies. In 1816 he worked briefly as a drawing teacher in Warsaw. Two years later Kersting was appointed chief painter at the porcelain factory in Meissen, where, apart from short trips to Berlin, Weimar, and Nuremberg, he remained for the rest of his life.

Kupferstich-Kabinett, Dresden: 8 drawings
Nationalgalerie, Berlin: 2 drawings

48
Caspar David Friedrich on an Excursion in the Riesengebirge, 1810

Watercolor and graphite, on light gray paper
310 x 240 mm.
Inscribed, lower right, *Prof. Caspar David Friedrich / gezeichnet von / G. Kersting 1810 / Malrath in Meißen / auf der Fußreise ins Riesengebirge*; signed and dated, upper right, *d. 18ten July 1810. — / George Kersting*
Provenance: acquired in 1906 from Prof. H. Friedrich, Hanover (with one other drawing by Kersting and twelve by Friedrich)
Berlin, Kersting, no. 1

Kersting, who lived in Dresden from 1808 on, was eleven years younger than Friedrich, whom he accompanied on his trip of 1810 to the Riesengebirge, visited by many Romantic artists because of its scenic beauty and imposing mountain formations. Although Friedrich was there only this one time, the Riesengebirge had an enduring influence on his work, and he used the impressions recorded in studies again and again in his paintings. According to Herbert Pée (Munich, 1972–73), Friedrich apparently depicted Kersting in a watercolor, *Boulders at Kochelfall*, dated 17 July 1810, the day before Kersting drew him (Dresden, C 2606). Kersting, whose work was profoundly influenced by that of Friedrich, portrayed him a few times—at work in his Dresden studio, for example (1811, Hamburg, Kunsthalle; 1812, West Berlin, Nationalgalerie).

G. R.

Bibliography: Berlin, 1985, no. 122, frontispiece

49
Biedermeier Interior

Graphite and watercolor
261 x 191 mm.
Provenance: acquired in 1946 from the collection of Prince Johann Georg of Saxony
Dresden, C 1963–954

This view of a room without people exudes the atmosphere of an inhabited space. The high narrow window throws an even light on the modest Biedermeier furniture. The sewing table at the left stands ready for the housewife, the easel at the window for the husband; the piano and stool attest to the cultivation of *Hausmusik*, and the sitting area evokes hospitality. The viewer gets the impression of tranquil domesticity without pomp, but with a sense of beauty and a little luxury, indicated by the high mirror at the left, the hanging glass vitrine at the right, and the pictures on the walls. The prototypes for the depiction of middle-class interiors are to be found in Dutch painting of the seventeenth century—in the work of Pieter de Hooch, for example. The sharp graphite pencil of the Romantics is enhanced in this work with light-blue and red watercolor, giving the room a restrained atmosphere.

G. L.

Bibliography: C. G. Boerner, catalogue of the sale of the collection of Prince Johann Georg, Leipzig, 1940, no. 347; Güstrow, 1985, p. 78, illus.

CARL GUSTAV CARUS
Leipzig 3 January 1789 – 28 July 1869 Dresden

A physician, scientist, painter, and art theorist, Carus attended drawing classes at the Leipzig Academy while pursuing his studies in the natural sciences, particularly medicine. In 1814 he was appointed professor of obstetrics and head of the maternity clinic in Dresden, and in 1827 he became court and personal physician of the king of Saxony. In 1816 Carus showed paintings at the Academy exhibition in Dresden for the first time. His friendship with Caspar David Friedrich, whose conception of landscape cor-

responded to Carus's early ideas, began in 1818. Carus traveled to Rügen, and through the Riesengebirge, Switzerland, France, Italy, England, and Scotland. In 1831 he published his *Neun Briefe über Landschaftsmalerei*, which, after Runge's writings, is among the most important theoretical treatises by a Romantic painter. Carus also wrote *Caspar David Friedrich, der Landschaftsmaler: zu seinem Gedächtnis, nebst Fragmenten aus seinen nachgelassenen Papieren*, a memorial publication that appeared in 1841, and his memoirs, *Lebenserinnerungen und Denkwürdigkeiten*, 1865–66. Carus's development as a landscapist reflects the stylistic transition from the Romanticism of Caspar David Friedrich to the early Realism of Johann Christian Claussen Dahl.

Kupferstich-Kabinett, Dresden: 707 drawings
Nationalgalerie, Berlin: 3 drawings

50
On the Ridge of the Riesengebirge, 1820

Watercolor, over graphite
145 x 235 mm.
Provenance: bequest of Dr. Friedrich Lahmann, Dresden, 1937
Dresden, C 1937–1444

As Marianne Prause points out, on his hiking trip in the Riesengebirge, from 12 to 18 August 1820, Carus chose the same route his friend Caspar David Friedrich had followed ten years earlier. In his memoirs Carus wrote of this walk along the mountain ridge:

> This four-day tour over the ridge of the Riesengebirge, with all of its highlights . . . left a deep and unforgettable impression on me. If I got to know the great waves of the sea for the first time at Rügen, so these mountains were to me like a great, silent wave on the land mass of the planet. . . . All of this was new to me and gave me much to observe. And beyond that, the pure alpine air of the high altitudes that I had never breathed before . . .

In this sheet Carus captures not only the visual impression, mood, and character of the landscape, but also shows the structure and color of the stone, which was in keeping with his schol-arly interests. This objective research into the physical essence of nature clearly shows the gradual development of Carus's conception of landscape away from that of Friedrich and toward a pictorial, scientifically oriented realism.

G. L.

Bibliography: Prause, 1968; Dresden, 1969, no. 45, fig. 25

IV. NAZARENES

FRANZ PFORR
Frankfurt am Main 5 April 1788 – 16 June 1812 Albano

Pforr received his earliest instruction in art from his father, a painter who specialized in landscapes and horses, before studying in Cassel with his uncle Johann Heinrich Tischbein. From 1805 to 1810 he attended the Vienna Academy, where he met Friedrich Overbeck. In July 1809 Pforr, Overbeck, and four other students from the Academy, who were dissatisfied with the moribund Neoclassical pedagogical routines, founded the Brotherhood of St. Luke, dedicating themselves to the renewal of German art within a framework of religious and patriotic values. Inspired by early German painting, Pforr executed such works as the *Entry of Rudolf of Swabia into Basel*. The Brotherhood of St. Luke settled in Rome in May 1810, living communally for a time in the secularized monastery of S. Isidoro. In 1809, when he was still in Vienna, Pforr had suffered from profound depression for several months, and in Rome he contracted consumption. A rest trip to Naples in the fall of 1811 did not improve his health, and he passed his last months in Albano, near Rome. Pforr's premature death deprived the Brotherhood of St. Luke of its proponent of an austere, "early German" style. Religion does not play an autonomous role in Pforr's work; it constitutes only one aspect of his fairy-tale, unpretentious scenes.

Nationalgalerie, Berlin: 24 drawings
Kupferstich-Kabinett, Dresden: 16 drawings

51

Adelheid and Weislingen, 1809–10

Graphite
204 x 139 mm.
Provenance: acquired in 1885 from the estate of Friedrich Overbeck (with twenty other drawings by Pforr, and eighty-five sheets and three sketchbooks, later dismembered, by Overbeck)
Berlin, Pforr, no. 6

After the Riepenhausen brothers' illustrations of the life of St. Genevieve (1806), Pforr's drawings for Goethe's dramatic work *Götz von Berlichingen* (1773) are among the earliest graphic series depicting literary themes, which were so significant for the beginning of the Romantic period.

Pforr became acquainted with the subject matter in 1805, when he copied a drawing by his uncle and teacher Johann Heinrich Tischbein. In the following years, he took up themes from Schiller's *Wallenstein* and *Wilhelm Tell*, and from Shakespeare's *Macbeth*. The *Götz* drawings were the last works undertaken by Pforr (then twenty-one years old) in Vienna, before he and the other members of the Brotherhood of St. Luke emigrated to Rome, while he was still recovering from a severe psychological crisis suffered in the summer of 1809. At the end of March 1810 he showed ten sketches to his confreres, and from these he made outline drawings that were sent to Goethe. The latter's cool reaction did not keep the artist from producing drawings with careful attention to internal modeling, which he intended to have published as engravings. Even as his final illness began in the summer of 1811, he was still working on them and designing the opening and closing pages (the design for the title page is in the Nationalgalerie, Pforr, no. 3). Four drawings—although not the Weislingen scene—were engraved posthumously; the original of one of them is lost. They appear in *Compositionen und Handzeichnungen aus dem Nachlass von Franz Pforr*, 2 vols., 1832–34.

The sheet exhibited depicts Act II, scene 6 ("Adelheid's Room"). Weislingen, Götz's childhood friend, now serves the royal party, against whom the knights are rebelling. Vacillating between two political camps and between two women, he is the opposite of the stubbornly intransigent hero of the title. Adelheid von Walldorf, who fascinates Weislingen and who will later poison him, uses the tactic of rejecting him in order to keep him at the court:

> Adelheid: Have you anything further to say to me?
> Weislingen:——I must be going.
> Adelheid: Then go!
> Weislingen: My Lady!...I cannot.
> Adelheid: You must.
> Weislingen: Is this to be the last sight of you?
> Adelheid: Go. I am ill, most inopportunely.
> Weislingen: Don't look at me like that.
> Adelheid: You decide to be our enemy and we are supposed to smile? Go!
> (From *Götz von Berlichingen* by Johann Wolfgang von Goethe, translated by Charles E. Passage. Copyright © 1965 by the Frederick Ungar Publishing Company. Reprinted by permission of the publisher.)

The action takes place at the bishop's palace in Bamberg. On the wall in the background hang portraits of the emperors Friedrich III and Maximilian.

Apart from the present drawing (which belongs to the series of four original sketches, all at the Nationalgalerie), the following variations of this composition are known: two outline drawings (one made for Goethe, from a suite of ten sheets, all in the Goethe-Nationalmuseum, Weimar; a later tracing of this drawing, from a series of eight sheets, is in the Kupferstich-Kabinett, Dresden); a larger version (300 x 206 mm., also in the Nationalgalerie); as well as the finished drawing with shading (on loan from the Frankfurter Künstlergesellschaft to the Städelsches Kunstinstitut, Frankfurt am Main). While the outline drawings and the enlarged version deviate substantially from our sketch (in the relative proportions of the figures and surface area, in the background, in Weislingen's dress, and in Adelheid's pose), for the final drawing Pforr returned to his original idea, enriching the detail and defining the flow of the forms more precisely. He even seems to have traced it, as the meticulous incised lines attest. Thus, he reintroduced the sense of space that is so effective in the preliminary

sketch in spite of its linearity: the receding diagonal of the fireplace makes the movement into depth of Adelheid's arm and Weislingen's backward step understandable; it emphasizes the mass and simple characterization of the figures in opposition—one hesitating, the other acting. Pforr created an image of the German past using creative means derived from Asmus Jakob Carstens by way of Eberhard Wächter (1762–1852). The need for pure, clearly defined forms strikes a balance with the tendency toward realistic depiction. There are pentimenti visible in this sketch, especially in the position of Weislingen's legs.

C.K.

Bibliography: Lehr, 1924, p. 344, no. B68; Benz, 1941, p. 22, pl. III; Frankfurt am Main, 1977, no. E81

52

Sulamith and Maria, 1811

Graphite
340 x 317 mm.
Provenance: acquired in 1885 from the estate of Friedrich Overbeck (with twenty other drawings by Pforr and numerous sheets by Overbeck)
Berlin, Pforr, no. 6

Nowhere is the autobiographical impulse, which is an essential part of Pforr's work, so clearly displayed as in the allegorical, fairytale compositions of Sulamith and Maria (1810–11). This drawing served, without changes, as the model for the small painting executed in the fall of 1811 and now in the Schäfer collection, Schweinfurt. During his last months of good health, Pforr executed the painting for Friedrich Overbeck as a testament to their friendship. It was Overbeck's idea that each should paint a picture for the other "in which the essential beauty and the character of the artistic expression unique to each of them would be expressed; these, he thought, could be very well portrayed in representations of two female figures, which would show the 'painter's art' that each of them had chosen" (Howitt, 1886).

Pforr composed a story, the first version of which was complete in 1810, that served as a text for both artists. Written in the style of Luther's Bible, with a number of themes and names taken from the Old and New Testaments, it tells of the twin sisters Sulamith and Maria, both endowed with many virtues and with good breeding. Two wandering painters, Johannes (Overbeck) and Albrecht (Pforr), choose them to be their brides. After the wedding the painters receive a commission from the king to decorate the cathedral. The tale bespeaks youthful wish fulfillment, as does Pforr's panel.

While Overbeck began work on a picture that was only completed much later and entitled *Italia and Germania* (Munich, Neue Pinakothek), Pforr designed a diptych that resembles a Late Gothic private altarpiece. In a letter to Overbeck that accompanied the drawing, Pforr describes his project precisely and asks his friend for objections and corrections. John the Evangelist, the patron saint of the recipient of the picture, is in the spandrel at the top center. The left field belongs to Sulamith, the wife of Johannes, who is entering through the garden gate in the background. She resembles an Italian Renaissance madonna as well as the Italia of Overbeck's painting. "I would like to paint everything in this picture as if it were covered with a golden haze," Pforr wrote. The city in the background "should have in its character something similar to glorious Rome." On the other hand, Pforr's Maria, seated in the small Düreresque chamber with its bull's-eye glass windows, is reminiscent of the simple, pious maiden of the early German tradition. Plants, animals, and inanimate objects are, as the letter indicates, significant down to the smallest detail.

There are several other preparatory studies for Pforr's diptych in the Städelsches Kunstinstitut, Frankfurt am Main, and in the Akademie der bildenden Künste, Vienna. There are two detail studies in the Nationalgalerie, along with the composition drawing *The Wedding Morning of Sulamith and Maria*, dated 1810.

C.K.

Bibliography: Howitt, 1886, vol. 1, pp. 195–205; Lehr, 1924, pp. 86–92, 187–98, 350, no. B136, fig. 57; Pforr, 1927, p. 51; Berlin, 1965, no. 172, fig. 149

JOHANN FRIEDRICH OVERBECK
Lübeck 3 July 1789 – 12 November 1869 Rome

Overbeck, who came from a Lübeck patrician family, began to study painting in 1805. Romantic art and prints after Italian paintings were early influences on his work. In 1806 he enrolled at the Vienna Academy, where he met Franz Pforr. Overbeck, Pforr, and other students opposed to academic instruction founded the Brotherhood of St. Luke, dedicating themselves to a reformation of art based on the model of the early German school. The Brotherhood settled in Rome in May 1810, initially working together in the secularized monastery of S. Isidoro. Overbeck remained in Rome for the rest of his life. In 1813 he converted to Catholicism, which increasingly determined the course and content of his work. After Franz Pforr's death in 1812, and following Peter Cornelius's departure from Rome in 1819, Overbeck remained the Brotherhood's principal exponent of Nazarene art. In 1816–17 he participated in the fresco decoration of the Casa Bartholdy, and from 1817 to 1827, worked on the murals in the Casino Massimo. Only once, in 1831, did he return briefly to Germany. Overbeck's late paintings are somewhat dogmatic and stiff.

Nationalgalerie, Berlin: 235 drawings
Kupferstich-Kabinett, Dresden: 88 drawings

53

Male Figure in a Cloak, 1813

Graphite, on gray paper
271 x 135 mm.
Dated, lower center, *Dec. 1813*
Provenance: acquired in 1885 from the estate of Friedrich Overbeck (with eighty-four other sheets and three sketchbooks, later dismembered, by Overbeck, and twenty-one drawings by Pforr)
Berlin, Overbeck, no. 128

On 11 December 1811 Overbeck entered the following admonition in his diary: "My drawings from models . . . have earned me excessive words of praise—be careful Fritz! Don't let yourself be blind to your faults; draw from nature at all times with the utmost care and effort, as she will instruct you in everything. Seek the character of each thing, and then reproduce it faithfully and lovingly." These remarks reflect the ethos that characterized the drawing sessions at the refectory of S. Isidoro. During the time that they lived in the monastery—from September 1810 to September 1812—the Brethren of St. Luke spent their evenings drawing from the model, after the fashion of the private academies that had been established earlier in Rome. They took turns posing, for nude or for drapery studies, or they had Roman boys pose. The use of nude female models was avoided, at least initially. After the young artists moved from the uncomfortable convent cells into Johannes Veit's home in the Via di Porta Pinciana, their "academy" appears to have declined to the same degree as the coherence of the Brotherhood of St. Luke (as Overbeck admitted "with shame and remorse" in a letter to Joseph Sutter dated 21 May 1813).

Still, Overbeck pursued the path once chosen, as is apparent in this study, in which the subject and expression are dominated by severity and purity. The model must have been one of the artist's friends, since professional models—corrupted by academic conventions—were spurned. Glancing downward and stepping forward simply, with one arm raised, he serves only as an armature for the drapery—though, perhaps, the staff may evoke the image of a pilgrim. The elaboration of the piece of drapery descending from the forearm into a grand independent cadence of folds is a recurring motif of robed Gothic figures. However, Dürer's prints, such as the St. Bartholomew engraving of 1523, appear to be the more likely model; at a later date, Overbeck himself did a series of engravings depicting the apostles. In his memoirs, *Der moderne Vasari* (1854), Wilhelm Schadow (1786/88–1862), one of the former Brethren of St. Luke, praises the "earnestness and purity" of Overbeck's studies from models, but acknowledges at the same time that they were created without any connection to his paintings. Overbeck's respect for nature and fear of sensual "naturalism" are intimately related.

C.K.

Bibliography: Heise, 1928, no. 20, pl. 20; Geismeier, 1964, p. 13, fig. 11; Berlin, 1965, no. 163, fig. p. 171; Frankfurt am Main, 1977, no. E9, fig. p. 217

54

The Raising of the Daughter of Jairus, 1815

Watercolor, pen and black ink
307 x 373 mm.
Signed and dated, lower left, *FO 1815*
Provenance: presumably identical to the composition done for Christian Schlosser, Frankfurt am Main, which was in the possession of a Herr von Bernus, Stift Neuburg, in 1886; acquired in 1911 at Gilhofen und Rauschberg, Vienna, at a sale of the collection of Adalbert, Freiherr von Lanna
Berlin, Overbeck, no. 237

Overbeck produced several compositions for Dr. Christian Schlosser, Frankfurt am Main, a young relative of Goethe who had lived for several years in Rome and was a close friend of the Brotherhood of St. Luke. Schlosser showed the compositions to Goethe: the merely temporary endorsement that was coaxed from the writer reflected his ambivalent attitude toward Romanticism in general, and in particular toward the "new German religious-patriotic art." *The Raising of the Daughter of Jairus* appears to have been among the drawings that prompted him to remark in September 1815 that "something is lacking in all of them." Schlosser had intended to give the drawing to a young female friend who, according to Margaret Howitt, was his future wife Helene Gontard.

The Book of Matthew (9:18–26), the Book of Mark (5:22–43), and the Book of Luke (8:41–56) describe among the miracles of Jesus the resurrection of the twelve-year-old daughter of the school (synagogue) president Jairus, even as her death was being mourned. The key idea of the episode is the invitation to have faith: "Be not afraid, only believe!" Overbeck's depiction of the event follows the evangelists' accounts closely: all bystanders, except for the child's parents and the disciples Peter, James, and John, are sent from the house. Jesus takes the child's hand, while the parents are "astonished with a great astonishment" (Mark 5:42–43). The lofty, refined stylization of the figure types, expression, and contour also characterizes the clear, restrained modeling and the pale coloring of the neatly delineated forms. The cool disposition of the Nazarenes is already fully apparent here in the form that will persist well into the middle of the century. The sophisticated depiction of the pale, dreamy dead child—which

approaches occultism—finds an echo in the works of the Pre-Raphaelites. A second version is in the Kunstmuseum, Düsseldorf (graphite).

C.K.

Bibliography: Howitt, 1886, vol. 1, p. 365; vol. 2, p. 403; Heise, 1928, p. 33, no. 23; Berlin, 1964, p. 13, no. 12; Frankfurt am Main, 1977, no. E49, fig. p. 236

55

The Bearing of the Cross, 1815

Graphite
354 x 436 mm.
Signed and dated, lower right, *FO 1815*
Provenance: acquired in 1853 from Wilhelm Schadow, Düsseldorf
Dresden, C 2511

Wilhelm Heinrich Wackenroder's *Herzensergiessungen eines kunstliebenden Klosterbrüders* (1797) and Ludwig Tieck's *Franz Sternbalds Wanderungen* (1798) stimulated an enthusiastic interest in early German art, and particularly in the prints of Dürer and his contemporaries, which inspired the Nazarenes. Overbeck's knowledge of early German graphic art, which he had acquired from Fohr, and his admiration for Italian art of the fifteenth and early sixteenth centuries find equal expression in this sheet. The drawing technique and the multifigure composition are reminiscent of the work of Martin Schongauer, whose famous engraving *Road to Calvary* (Lehrs, 1908, no. 9), executed before 1485, was undoubtedly known to Overbeck. The fallen Christ is the focal point of both depictions. In comparison to the Schongauer engraving, Overbeck increased the size of the figures at the expense of their number, and he added two of Christ's disciples, one of whom has the facial features of St. Peter in Dürer's engraving *St. Peter and St. John at the Gate of the Temple*, to the group of executioners around the cross. The way the drawing is monogrammed and the treatment of the vegetation in the foreground also attest to Dürer's influence. The forms, the group of women in front of the gate, the view of the city, and the landscape are rem-

iniscent of Italian art of the early Renaissance. The drawing was engraved in Düsseldorf in 1840 by F. A. Pflugfelder.

<div align="right">G. L.</div>

Bibliography: Howitt, 1886, vol. 1, p. 338; Dresden, 1970, no. 154, illus.; Stendal-Weimar, 1975–76, p. 69, fig. p. 71; Bern, 1985, no. 167

56

Young Couple under the Trees, 1818

Graphite
169 x 236 mm.
Inscribed, lower left, *81*
Provenance: acquired in 1885 from the estate of Friedrich Overbeck
Berlin, Overbeck, no. 84

Among the items from Overbeck's Roman estate that are preserved in the Nationalgalerie are several portrait drawings of Nina Overbeck, née Schiffenhuber, foster daughter of the Vienna theater director Hartl and a friend of Dorothea, Friedrich, and August Wilhelm Schlegel. The artist met her in April 1818, and they were married on the Feast of St. Luke in October of the same year. She served as the model for the heroine in the drawing *Ruth and Boaz* (Lübeck, Museen für Kunst und Kulturgeschichte).

J. C. Jensen believes that *Young Couple under the Trees* is an idealized double portrait of the betrothed couple, even though the young man in the "German jacket" and beret (Overbeck's attire on his wedding day) and the bride in the drawing bear little resemblance to the artist and his fiancée. A festooned boat, filled with girls and young men in Renaissance dress playing music, approaches on the river. Their worldly and festive mood contrasts with the contemplative, introspective silence of the young couple. St. Stephen's Cathedral in Vienna is recognizable among the church steeples in the background, an allusion to the bride's origin. The sheet is unfinished: while the two main figures are thoroughly elaborated with fine hatching in the manner of early German engravings, the background is less clear, and in the right third of the composition, sketchy, pale strokes merely hint at the two large shapes that were to occupy this area.

Overbeck's most impressive monument to his marriage is the small self-portrait with his wife and child painted for his parents between 1820 and 1830 (also in Lübeck).

<div align="right">C. K.</div>

Bibliography: Berlin, 1906, no. 2846; Leipzig, 1926, no. 317; Schilling, 1935, p. XI, pl. 12; Jensen, 1962, pp. 364, 366, 373 n. 19, fig. 4; Berlin, 1965, no. 166

PETER VON CORNELIUS

Düsseldorf 23 September 1783 – 6 March 1867 Berlin

Cornelius was the son of the supervisor of the Düsseldorf Gallery. Following his early training in drawing, he studied at the Düsseldorf Academy from 1798 until 1805, participating from 1803 to 1805 in Goethe's "Preisaufgaben für bildende Künstler." From 1809 to 1811 he lived in Frankfurt am Main, where he began his first important graphic work, the illustrations to Goethe's *Faust*, completed about 1815. Cornelius arrived in Rome late in 1811, and joined the Brotherhood of St. Luke the following year. Eventually, he and Friedrich Overbeck became the leaders of the group. In Rome, where he remained until 1819, Cornelius illustrated the *Nibelungenlied* and participated in the fresco decoration of the Casa Bartholdy. His 1814 challenge to the German princes to support the art revival by commissioning fresco cycles was accepted by Crown Prince Ludwig of Bavaria: from 1820 to 1830 Cornelius decorated the Glyptothek in Munich with frescos that he had begun preparing in Rome in 1818. Cornelius served as director of the Düsseldorf Academy from 1819 to 1824, and as director of the Academy in Munich from 1825 to 1840. In 1825 he was granted a Bavarian patent of nobility. The artist spent 1830 to 1840 executing frescos in the Ludwigskirche in Munich. In 1841 King Friedrich Wilhelm IV summoned him to Berlin, where he worked from 1843 to 1867 on cartoons for frescos for a Hohenzollern family Campo Santo at the Berlin Cathedral, which was never built. His work in both Berlin and Munich was interrupted by lengthy sojourns in Rome; the longest, from 1853 to 1861. Cornelius's creative activity

was devoted largely to designing the compositions and preparing the cartoons for frescos. Following an "early German" phase, he soon turned to the Italian Renaissance for inspiration, devising a highly ambitious monumental style, at once Romantic and idealized, that stood in splendid isolation against the Realistic mainstream of contemporary German painting.

Nationalgalerie, Berlin: 130 drawings and cartoons
Kupferstich-Kabinett, Dresden: 24 drawings

57

Faust and Mephistopheles on the Rabenstein, 1811

Pen and sepia ink, over traces of graphite
348 x 519 mm.
Signed and dated, lower right, *P. Cornelius invt. 1811*
Provenance: acquired in 1903 at Gutekunst, Stuttgart
Berlin, Cornelius, no. 98

This drawing is a preliminary study for plate 11 of Cornelius's illustrations to Goethe's *Faust*. It shows an episode from the next to last scene (a brief section consisting of only six verses) of part I of the tragedy, which was published in its definitive form in 1808. The scene is entitled "Night" (excerpts taken from Goethe, *Faust*, translated by Louis MacNeice, 1951. Reprinted by permission of Oxford University Press, New York). On their way to Gretchen's prison, Faust and Mephistopheles, flying "past on black horses," ride by the place of execution, which is encircled by ravens. A "witch corporation" around the executioner's block seems to be preparing for a black mass. A young woman who murdered her infant is led to the block, a crucifix in her hand. "Floating up, floating down, bending, descending." Mephistopheles urges on the horrified Faust: "Come on, come on!" In Cornelius's drawing, the abrupt backward turn of the riders and Faust's extended arm are in opposition to the thunderous motion of the horses, which run parallel to each other. The power of the artist's dramatic device lies in this opposition within the foreground group, balanced by the scene of the witches in the background. The artistic language is consciously "Düreresque": with the *Faust* cycle it was Cornelius's intention "to appear all at once as a German, and, in my

opinion, not merely superficially." He subscribed to the Romantic and patriotic striving for the renewal of a national art based on the model of the Gothic and on the art of the age of Dürer. His efforts were aided by the Boisserée brothers of Heidelberg, who assembled an important collection of early German paintings (acquired in 1827 by the Alte Pinakothek, Munich).

From the very beginning, the *Faust* cycle was intended for publication as engravings. Probably inspired by Franz Pforr's *Götz* drawings (see Cat. No. 51), Cornelius produced seven of the twelve compositions in Frankfurt am Main between late 1810 and the summer of 1811. The rest were done in Rome between 1814 and 1816 after a hiatus of a few years, during which Cornelius executed a *Nibelungen* cycle, among other works. Engraved by Ferdinand Ruscheweyh, the *Faust* illustrations were published, with one exception, by Wenner in Frankfurt am Main in 1816. *Faust and Mephistopheles on the Rabenstein* is considered to be the latest of the sheets from 1811, though it was among the group of compositions shown to Goethe in May of that year. The scene was one of the four selected by Osiander to illustrate the first edition of *Faust* (1808).

Two quick preliminary sketches in graphite are in the Städelsches Kunstinstitut, Frankfurt am Main. The design established in the later of these is elaborated in outline in the sheet exhibited here. The final drawing (also in Frankfurt am Main) is executed in graphite in a larger format, with rich gray tones and austere, strongly contrasted modeling. The Nationalgalerie owns two other composition drawings for *Faust*. In 1828 Goethe said of the engravings, "I have to admit that I had not envisioned it as perfectly myself."

C.K.

Bibliography: Raczynski, 1841, vol. 2, p. 166, illus.; Riegel, 1866, p. 28 f.; Koch, 1905, p. 43; Johann Peter Eckermann, *Gespräche mit Goethe in dem letzten Jahren seines Lebens*, Leipzig, 1923, entry for 29 November 1828; Salomon, 1930, p. 27 f.; Simon, 1930, pp. 12–14, fig. p. 4; Weimar, 1958–59, no. 38, fig. p. 55; Berlin, 1965, no. 34, fig. p. 157; Büttner, 1980, pp. 26–28, 32, fig. 31

58
Joseph Interpreting Pharaoh's Dream, 1816

Gouache, over graphite, on brownish card
388 x 353 mm.
Signed and dated, lower left, *P. Cornelius Roma 1816*
Provenance: Carl Christian Vogel von Vogelstein; C. G. Boerner, Leipzig, 1866;
acquired in 1880 from Eduard Cichorius, Dresden
Berlin, Cornelius, no. 20

In the spring of 1816 Jakob Salomon Bartholdy, the Prussian coun-
sel general in Rome, commissioned four Prussian artists—Peter
Cornelius, Wilhelm Schadow, Philipp Veit, and Hans Catel—to
decorate a room in his residence in the Palazzo Zuccari. Catel's
participation dwindled, and Overbeck was soon drawn into the
project. The commission was the first attempt to demonstrate the
possibilities of fresco painting within the limited confines of a
private dwelling. The Brotherhood of St. Luke—Cornelius most
emphatically—called for the revival of the technique in order to
provide socially significant tasks for art. The political stability fol-
lowing the victory of the allies over Napoleon lent new topicality
to this idea. The Old Testament legend of Joseph was selected as
the theme for the fresco cycle because of the Jewish heritage of
the patron. The frescos were executed between July 1816 and the
summer of 1817. The eight main scenes were later detached from
the wall and in 1886–87, were moved to the Nationalgalerie.

The Book of Genesis, chapter 41, tells how Joseph, who has
been brought from his prison cell, interprets Pharaoh's dream
about seven fat and seven lean cows and is thereupon "set over
all the land of Egypt." There are several strikingly different
preparatory sketches for Cornelius's second fresco in the Casa
Bartholdy, *Joseph Makes Himself Known to His Brothers*, but this one
colored sheet is the only surviving preliminary study for *Joseph
Interpreting Pharaoh's Dream*. It shows the final form of the essential
features of the monumental composition, which is based on the
works of Raphael and of Michelangelo. To be sure, during the
execution of the fresco, the nearly square format was changed to a
horizontal one, and the form of the throne, the background, the
arrangement of the group of Magi at the left, and the coloring
were also modified. In addition, in the fresco, the accompanying

scenes are not the same: neither the *sopraporte* with Joseph riding
in Pharaoh's triumphal chariot, nor the lunette composition on
the theme of the seven years of plenty, were executed in this form.
The latter subject is represented in the fresco by an illusionistic
landscape behind a double arch and a female figure, in which the
influences of Michelangelo and Philipp Otto Runge are evident.
(Frank Büttner points to Runge's Mother Earth in the engraving
Day, 1803–5.) Two graphite sketches, also in the Nationalgalerie,
show how Cornelius intended to transform the composition; ulti-
mately, Philipp Veit decorated this part of the wall. Several detail
studies and the cartoon for *Joseph Interpreting Pharaoh's Dream* also
survive (Hanover, Niedersächsisches Landesmuseum).

C. K.

Bibliography: Riegel, 1866, p. 388; Boetticher, 1891, no. I-51.1; Berlin, 1965, no. 33,
fig. p. 151; Geismeier, 1967, p. 48, pl. 131; Büttner, 1980, pp. 80–86, fig. 66;
McVaugh, 1981, no. A3, fig. 18

JOHANN ANTON ALBAN RAMBOUX
Trier 5 October 1790 – 2 October 1866 Cologne

Ramboux studied in the art workshop of the Florenville monastery
in Luxembourg from 1803 to 1807, and became a pupil of Jacques-
Louis David in Paris in 1808. He remained with David until 1812,
when he began to work as a portrait painter in Trier. In 1815 he
left Trier, resided briefly in Munich, and in 1816 traveled through
Switzerland to Italy. After visiting Florence and central and south-
ern Italy, he settled in Rome, where he became associated with
the Brotherhood of St. Luke and with the circle around Julius
Schnorr von Carolsfeld. In 1822 Ramboux returned to Trier,
where, in 1826, he executed designs for murals and for portraits.
Following his second Italian sojourn, which lasted from 1832 until
1842, he became curator of the Wallraf collection in Cologne, a
post he occupied for the rest of his life. In 1849 he traveled to Hol-
land, Belgium, and northern France, and in 1854 made a pil-
grimage to Jerusalem. Ramboux's importance lies primarily in his

copying and collecting activities, and in his pioneering research in Italian art of the Trecento and the Quattrocento.

Nationalgalerie, Berlin: 8 drawings
Kupferstich-Kabinett, Dresden: 2 drawings

drawing exhibited here differs in composition only slightly from one in the Kupferstichkabinett, Düsseldorf (inv. no. FP 5838).

G. L.

Bibliography: C. G. Boerner, catalogue of the sale of the collection of Prince Johann Georg, Leipzig, 1940, no. 594; Verbeek, 1965, pp. 293–98; Cologne, 1966–67, no. 28; Dresden, 1970, no. 159; Stendal-Weimar, 1975–76, p. 73, fig. p. 71

59

Noli Me Tangere, ca. 1818

Graphite, pen and gray ink, gray wash, heightened with white and gold
310 x 266 mm.
Provenance: acquired in 1946 from the collection of Prince Johann Georg of Saxony
Dresden, C 1963–1146

Ramboux has depicted the moment when Mary Magdalene recognizes Jesus in the guise of a gardener, and, uttering the word "Rabbuni" (Hebrew for My Master), falls down in adoration before him (John 20:16–17). But, Jesus warns her, "Touch me no more, for I have not yet ascended to my Father."

The Dresden sheet is the third of Ramboux's five drawings of this theme. The first two differ from the rest in the Gothic character of the figures, and show Ramboux's study of Dürer. Under the influence of fifteenth-century Italian art, Ramboux subsequently revised his figures in a Renaissance style, as Cornelius had done in his *Faust* drawings. He eschewed the Gothic S-curve and showed Christ not with a naked upper body and loincloth, but standing upright and fully clothed. The landscape recalls the style of the early Renaissance, as one finds in the work of Pintoricchio, for example. The drawing technique resembles that of Ramboux's early sketchbook (Darmstadt, Hessisches Landesmuseum). Cornelius treated this theme at the same time, as Ramboux was aware. Both followed the compositional type established in Duccio's fresco in Siena. Mary Magdalene kneels at the left, while Christ stands to the right holding the banner of the cross, as in Schongauer's engraving. Here, Ramboux emphasized the lyrical aspect of the scene, while in the design for his murals of 1828 in the Cathedral of Trier, he represented the same subject with lively movement and a fluttering cloak and drapery. The unfinished

60

Dante and Virgil before the Three Wild Animals at the Entrance to Hell, ca. 1828

Watercolor, heightened with gold
266 x 186 mm.
Provenance: the estate of Christian Schuchardt, cataloguer of Goethe's art collection; acquired in 1924 from Amsler & Ruthardt, Berlin
Berlin, Ramboux, no. 5

Ramboux got to know the works of classical Italian literature during the first of his extended stays in Italy (1816–22). From 1817 to 1827 the German Nazarenes in Rome—Cornelius, Overbeck, Koch, Veit, and Schnorr von Carolsfeld—worked on fresco cycles in the Casino Massimo, illustrating Dante's *Divine Comedy*, Torquato Tasso's *Gerusalemme Liberata*, and Ariosto's *Orlando Furioso*. After he was summoned to Munich in 1818, Cornelius proposed that Ramboux continue his part of the project, composing the murals for the *Divine Comedy* in the Dante room. Although these decorations were ultimately completed by Philipp Veit, Ramboux must have received from the project the initial impulse for the work on the same powerful subject matter that he took up in Trier in 1826. There, along with some cartoons and additional studies, Ramboux produced this watercolor (a companion piece, representing Dante and Virgil before the passage through hell, is in the Städelsches Kunstinstitut, Frankfurt am Main), which illustrates an episode from the first canto of the *Inferno*. As he prepares to climb the mountain, the symbol of the virtuous life, Dante has to turn back when confronted by three menacing animals: the panther, symbol of lust; the lion, symbol of arrogance; and the she-wolf, symbol of greed. In this difficult situation, Virgil—

Dante's artistic and philosophical model—appears and offers himself as a guide through hell.

German Romantic artists and writers recognized early on the importance of Dante. Tieck, the Schlegel brothers, and Schelling, in particular, attempted to interpret the enormous artistic and philosophical riches of his work. Following an inadequate translation that appeared in the eighteenth century, in 1828 the future king, Johann of Saxony, working under the pseudonym Philatathes, produced the first part of a respectable translation that was to enhance Dante's influence in Germany.

The naïveté and the freshness of color, the gestures of the figures, and the simplified elements of landscape and nature, which appear to be based on Italian Trecento and Quattrocento models, are combined here in a depiction of fairy-tale charm. The work does not, however, achieve the ingenious inventiveness of the Dante illustrations of Joseph Anton Koch (see Cat. No. 10).

<div align="right">G.R.</div>

THEODOR MARKUS REHBENITZ
Borstel (Holstein) 2 September 1791 – 19 February 1861 Kiel

After studying law in Heidelberg, Rehbenitz attended the Vienna Academy from 1813 to 1816. In Vienna he was closely associated with Joseph Sutter, Julius Schnorr von Carolsfeld, and the Olivier brothers. From 1813 to 1823 Rehbenitz lived in Rome, where, with Friedrich Olivier and Schnorr, he belonged to the "Capitolines," a group of artists who were Protestant, unlike the Catholic Nazarenes. In 1818 Rehbenitz carried out commissions for Carl Friedrich von Rumohr in Florence. In 1824 he was hired by King Ludwig I of Bavaria to teach German to the Marchesa Florenzi in Perugia. Rehbenitz visited Capri in 1827, and then returned to Rome. He returned to Germany in 1832, and lived in Munich for ten years before settling in Kiel, where he taught drawing at the university.

Kupferstich-Kabinett, Dresden: 14 drawings
Nationalgalerie, Berlin: 1 drawing

61
Self-Portrait, 1817
Graphite
195 x 159 mm.
Signed and dated, *18 TR 17*
Provenance: in the portrait collection of Carl Christian Vogel von Vogelstein, 1831
Dresden, C 3327

This portrait, drawn with remarkable precision using a sharp graphite pencil, attests to the admiration, shared by all of the Nazarenes, for early German art and particularly for Dürer. Friedrich Overbeck, the spiritual leader of the Brotherhood of St. Luke, owned a Dürer drawing of the head of a pope (Winkler, 1936, no. 380), which was, of course, familiar to Rehbenitz and may well have inspired this self-portrait. The hardness and fineness of the graphite gives the sheet an effect reminiscent of drawings in silverpoint. Rehbenitz wore long hair parted in the middle, a fashion encouraged by Overbeck because it fostered the resemblance to Christ that was a goal of the Brotherhood and that led to the designation "Nazarene."

<div align="right">G.L.</div>

Bibliography: Singer, 1911b, no. 703; Heise, 1928, pl. 82; Martius, 1934, no. 14, fig. 3; Winkler, 1936, vol. 2, pp. 90–91; Grote, 1938, fig. 93; Geller, 1952, no. 1055; Martius, 1956, p. 123, fig. 62; Berlin, 1965, no. 182, fig. p. 176; Bernhard, 1973, p. 1252; Stendal-Weimar, 1975–76, p. 75, fig. 43; Paris, 1976–77, no. 179; Jensen, 1978, p. 178; Bärwald, 1984, illus.; Bern, 1985, no. 179, illus.

JULIUS VEIT HANS SCHNORR VON CAROLSFELD
Leipzig 26 March 1794 – 24 May 1872 Dresden

Schnorr studied with his father, Johann Veit Friedrich Schnorr von Carolsfeld, a painter and the director of the Leipzig Academy, before he enrolled at the Vienna Academy in 1811. In Vienna he became friends with Ferdinand Olivier, and frequented the circle around Friedrich Schlegel. In 1818 he arrived in Rome, where he joined the Brotherhood of St. Luke and was closely associated with Friedrich Overbeck, Peter Cornelius, Theodor Rehbenitz, and Friedrich Olivier. From 1818 to 1826 Schnorr worked intermit-

tently on the murals in the Casino Massimo. In 1825 he was summoned by King Ludwig I of Bavaria to Munich, where he settled in 1827 after a study trip to southern Italy. His first commission in Munich was the design of the *Nibelungenlied* frescos in the Residenz. In 1835 he executed murals of scenes from German history in the Residenz and the Hofgarten. He was summoned to Dresden in 1846 to serve as professor at the Academy and as director of the painting gallery.

Kupferstich-Kabinett, Dresden: 365 drawings
Nationalgalerie, Berlin: 203 drawings

62

Wezlas Castle, with a River and a Family on the Bank, 1815

Pen and black ink
249 x 382 mm.
Signed, dated, and inscribed, lower left, *18 JS 15 / Wezlas*
Provenance: acquired in 1879 from the artist's widow
Berlin, Schnorr, no. 2

In 1815 Schnorr departed from Vienna, where he had lived since 1811 among the Romantic circle around Friedrich Schlegel, for a walking trip through the Kamp Valley in Lower Austria. The view of Wezlas Castle near Allensteig, which dates from this journey, is a major document of his artistic precocity and of his early development as a draftsman. In the conception and technique of such landscape drawings, Schnorr was influenced by Ferdinand Olivier and by their common model Joseph Anton Koch. The landscape scenery is transformed into pictorial resolution, man and nature united in Romantic harmony. The hard and brittle style is characteristic of Schnorr, even more than of the other draftsmen of the Nazarene circle. Here, the programmatic dependence on German and Netherlandish prints of the time of Albrecht Dürer is obvious. The engravinglike hardness of the line produces a clear, precise effect that combines with the skillful arrangement of the compositional elements. At this same time, Schnorr created his first important portraits and biblical scenes.

<div align="right">G. R.</div>

Bibliography: Berlin, 1965, no. 236; Berlin, 1974, no. 1

63

The Visit of the Parents of John the Baptist to the Parents of Jesus, 1816

Pen and brown ink, brown wash, and graphite, heightened with white and gold
368 x 315 mm.
Signed and dated, lower left, *18 JS 16*
Provenance: acquired in 1892 from a private collection
Berlin, Schnorr, no. 3

During his years in Vienna (1811–17), Schnorr, following the ideas emanating from the Romantic circle around Friedrich Schlegel, became interested in biblical and historical subjects. As in his landscapes of this period, works of early German art, particularly the engravings of Dürer and of Schongauer, served as his models. In this drawing, for example, Schnorr freely adapted the theme of the Virgin of the Rose Arbor from early German prints. There is another drawing of this subject (Dresden, Kupferstich-Kabinett), also from 1816, which Schnorr used the following year as the design for a painting (Dresden, Gemäldegalerie Neue Meister).

<div align="right">G. R.</div>

Bibliography: Grote, 1938, p. 146, fig. 88; Dresden, 1970, no. 161; Berlin, 1974, no. 18

64

Seated Female Nude, 1820

Pen and brown ink, brown wash, over graphite
289 x 223 mm.
Dated, *d. 26 ten Febr. / 1820*
Provenance: acquired in 1908 from the collection of Eduard Cichorius
Dresden, C 1908–758

In his memoirs, Ludwig Richter describes the difference between drawing from nude models in Germany and in Rome: "In the evening hours we . . . attended the so-called Accademia, where one draws from the nude. . . . It was a pleasure to be able to sketch from these various and always beautiful figures, and that same difference in the natural forms of the landscape, which so delighted me upon arriving in Italy, I now saw also in the human form: a beauty in the proportion and in the finest development of the individual parts such as I rarely found at home. But there is

just as great a difference in the way in which the models are treated here. Back home the figure would always be posed according to a certain mannered standard; there is a lack of respect for nature and its consequent forms; they assumed a general, I would almost say an abstract human shape, that people didn't necessarily believe really existed. It was just some person who modeled for them, and not Hans or Ambrosio, Peter or Cecco. Here, people draw with the greatest care, with endless effort and discipline, in order to capture individuality" (Richter, 1922, p. 143).

The models were usually young people whose advantage lay in their freshness and in the naturalness of their posture and expression. Unlike the Catholic Nazarenes, the "Capitolines" (Protestant artists, including Schnorr, who resided on the Capitoline Hill) worked from nude female, as well as male, models. Their drawings were not preparatory studies for specific paintings, but were made purely for practice. In our drawing, the support, which makes the position of the girl's head understandable, is only suggested, and the seat is omitted entirely. The charm of these drawings lies more in the beauty of the line than in the sculptural modeling of the form. In spite of the wash, the figure remains bound to the picture plane, without being realized in the round.

<div align="right">G. L.</div>

Bibliography: Singer, 1911a, p. 46, fig. 17; Bernhard, 1973, p. 1712; Berlin, 1974, no. 51, illus.; Bern, 1985, no. 240; Trenkmann, 1985, no. 97

65
Portrait of a Girl with Pinned-up Hair, 1820

Pen and brown ink, brown wash, over graphite
263 x 257 mm.
Dated, lower left, *d. 27 ten Octobr. / 1820*
Provenance: acquired in 1908 from the collection of Eduard Cichorius
Dresden, C 1908–678

"There is one thing they cannot demand of me: that I recognize a superficial uniformity, a mask of beauty, as true beauty. I see beauty as an imprint of the spirit and do not accept those well-proportioned forms in its place. And if someone wants to paint pictures of people for me, then I don't want him to paint those evenly proportioned dolls, but bodies and faces that reflect the inner spirit." By 1820 Schnorr was already practicing what he advocated in this letter of 30 January 1823 to his friend Johann Gottlob Quandt. In its simplicity and naturalness, this portrait of a girl reveals a beauty that is not the result of uniformity but, rather, of the intimate expression of the forms, in which the beauty and purity of the line are equated with the beauty and purity of the sitter.

<div align="right">G. L.</div>

66
The Church of Santi Giovanni e Paolo in Rome, 1821

Pen and brown ink, brown wash, over graphite
292 x 225 mm.
Inscribed and dated, *St. Giovanni e Paolo d. 17 Mai 1821*
Provenance: acquired in 1908 from the collection of Eduard Cichorius
Dresden, C 1908–849

This sheet and Cat. No. 68 belonged to an album of 116 drawings, the so-called "Italian Landscape Book," assembled by Schnorr according to topographical criteria. Schnorr later wrote twelve letters to his friend Eduard Cichorius about this album. Both the drawings and the letters are now in the Dresden Kupferstich-Kabinett. Petra Trenkmann has undertaken a reconstruction of parts of the album. In his sixth letter, Schnorr wrote: "The twelve drawings from pages 10 to 27 contain things taken for the most part from the city of Rome or the immediate vicinity. Several sheets are filled exclusively with picturesque buildings. In others, architecture is combined with landscape. These objects appealed greatly to me and were quite useful in designs for historical subjects." In his *Lebenserinnerungen eines deutschen Malers* (1922, p. 197), Schnorr's friend Ludwig Richter describes the impact of this "Italian Landscape Book": "Far more effective and successful than our debates about art were the impressions that Schnorr's works imparted. One evening, for example, he brought along his landscape drawings in two albums that were examined with much

interest, indeed admiration. . . . These drawings were mounted at that time in two folio volumes, as he observed the utmost order and tidiness in all of his things. . . . As Schnorr did not want them broken up, these drawings later found their way into the collection of my friend Eduard Cichorius. . . . Devoid of all conventional form and of all artificial pathos, they breathe unadulterated magic, a sweet innocence of nature, as mirrored in a spirit cultivated by art."

The arched border at the top and the masonry at the bottom create the effect of a landscape viewed through a window. Schnorr makes frequent use of this compositional device in his Italian drawings, focusing attention on the center of the sheet. The origins of the venerable basilica, a martyrs' church, date to the sixth century. By the middle of the twelfth century, under Hadrian IV, it appeared just as it does in the drawing. As in Salzburg, it is not the Baroque city that interests the artist, but its early Christian foundations.

G.L.

Bibliography: Schnorr von Carolsfeld, *Zwölf Briefe zum Landschaftsbuch*, 1867, vol. 6, pp. 12–13; Leipzig, 1926, no. 440: Trenkmann, 1985, no. 127

67
Study of a Nude Youth, 1821

Pen and brown ink, over graphite
430 x 285 mm.
Dated, lower right, *d. 4 n Dec. 21*
Provenance: acquired in 1908 from the collection of Eduard Cichorius
Dresden, C 1908–755

The model is rendered in the natural posture of a rider who is turning around while seated on a horse. There is no indication of his seat or of a background. The hatching is densely applied here and is used to model the body.

G.L.

Bibliography: Singer, 1911a, p. 48, illus.; Leipzig, 1926, no. 439, illus.; Dresden, 1928, no. 415; Andrews, 1964, pp. 114–15; Bernhard, 1973, p. 1726; Berlin, 1974, no. 53, illus.; Trenkmann, 1985, no. 123

68
The Garden in the Vineyard of the Archpriest, with a View of Olevano, 1821

Pen and brown ink, brown wash, over graphite
228 x 305 mm.
Inscribed and dated, lower right, *OLEVANO. 1821. / gez. in der Vigna des Arciprete zu Olevano*
Provenance: acquired in 1908 from the collection of Eduard Cichorius
Dresden, C 1908–808

This drawing, like Cat. No. 66, belonged to the "Italian Landscape Book." Because of its picturesque location in the Sabine Hills, Olevano was a favorite resort of the German artists working in Rome. The *vigna* belonged to the archpriest of Olevano. Like his artist friends, Schnorr often spent time in the vineyard, and he made four drawings of it. In this sheet he includes the hill town, making effective use of its stepped structure.

G.L.

Bibliography: Bernhard, 1973, p. 1718; Trenkmann, 1985, no. 130

69
Siegfried's Return from the Saxon War, ca. 1829

Pen and brown ink, brown wash, watercolor, over graphite
369 x 436 mm.
Provenance: acquired in 1908 from the collection of Eduard Cichorius
Dresden, C 1908–506

King Ludwig I of Bavaria commissioned Schnorr von Carolsfeld to paint frescos of scenes from the *Nibelungenlied* in five rooms on the ground floor of the new Königsbau that Leo von Klenze had added to the Munich Residenz. Schnorr presented the king with a plan that included fifty-six scenes of varying dimensions. This drawing is the design for the entrance wall of the second chamber, the Saal der Hochzeit. The *Nibelungenlied* is a Middle High German chivalric epic that originated about 1220 in the region of Bavaria and Austria and is the most important heroic poem of medieval German literature. It was rediscovered by Jakob Bodmer in 1757 and, with the Romantics' predilection for the Middle Ages, it attained the status of a national epic at the beginning of the

nineteenth century. This scene shows the victorious Siegfried, who joined King Gunther of Burgundy in his war against the Saxons, returning to Worms; the two captured Saxon kings follow in his retinue. During the execution of the mural the composition was altered slightly, and the decorative elements and the lunettes were somewhat modified.

<div align="right">G.L.</div>

Bibliography: Singer, 1911a, fig. 53; Berlin, 1974, no. 80; Nowald, 1978, no. 42, fig. p. 33; Bern, 1985, no. 266, fig. 220

FRIEDRICH WOLDEMAR VON OLIVIER
Dresden 23 April 1791 – 5 September 1859 Dresden

Friedrich Olivier was trained by his brother Ferdinand, with whom he traveled in the Harz Mountains in 1810. In 1811 he moved to Vienna, where he befriended Friedrich Schlegel and his circle, Philipp Veit, and Joseph Anton Koch. Olivier fought in the Wars of Liberation in 1813–14. He accompanied his brother Ferdinand and Julius Schnorr von Carolsfeld on a trip to Salzburg in 1817, and the three of them traveled to Rome together the following year. In Rome Olivier was associated with the Nazarenes. He returned to Vienna in 1823, and in 1829 he settled in Munich, where he collaborated with Schnorr on the *Nibelungenlied* frescos in the Residenz. He returned to Dresden in 1850.

Kupferstich-Kabinett, Dresden: 50 drawings
Nationalgalerie, Berlin: 15 drawings

70
Wilted Maple Leaves, 1817
Pen and brown ink, graphite, gray wash, heightened with white
153 x 249 mm.
Dated, lower left, *1817. / den 10ten Januar*
Provenance: Schmedl collection, Vienna; acquired in 1941 from C. G. Boerner, Leipzig
Berlin, Fr. Olivier, no. 12

In January and February 1817 Friedrich Olivier and Julius Schnorr von Carolsfeld—the closest friend of the Olivier brothers in Vienna—were occupied with drawing wilted leaves. Four such

studies by Olivier are known. They clearly refer to the style of German prints of about 1500, which is typical of the work of the Nazarene group in Vienna. Ludwig Grote observes: "Of course, they were inspired in this by Schongauer's engravings and Dürer's drawings. However, their lines do not have the steely strength of the Gothic, but are drawn softly, the rhythm of the contour undulates and complements the interior modeling. . . . Both [Schnorr and Friedrich Olivier] loved these small gems and Schnorr had them forwarded to them in Rome."

<div align="right">G.R.</div>

Bibliography: Grote, 1938, p. 147

71
The Pilgrim, 1817
Pen and brown ink, heightened with white; trial strokes in the margin
174 x 175 mm.
Signed, lower left, *Fr. v. Olivier*; inscribed and dated, lower right, *Wien den 9 ten Aprill*
Provenance: acquired in 1908 from the collection of Eduard Cichorius
Dresden, C 1908–361

Our sheet is the earlier of two versions of this theme. The second, a pen drawing with watercolor (Düsseldorf, Kunstmuseum), is inscribed *Montag den 10.ten. November 1817* and is dedicated to a friend, possibly Julius Schnorr von Carolsfeld.

The character of the representation suggests a profound religiosity. The burden that strains this large, powerful man seems to have been borne by the artist as well. The massive figure is hemmed in by the confines of the picture surface, adding to the sense of oppression. This earthly pilgrim, with his bundle, the crown of thorns, and Christ's cross, certainly symbolizes the Christian path through life, but without considering the joyous message of the Gospel of Matthew 11:28–30: "Come to me, all ye that labor and are weary; for I will give you relief. . . . For my yoke is easy and my burden is light."

<div align="right">G.L.</div>

Bibliography: Grote, 1938, p. 144; Geismeier, 1984, fig. 69

72

Portrait of Friedrich Overbeck, ca. 1820

Graphite
242 x 213 mm.
Provenance: acquired in 1908 from the collection of Eduard Cichorius
Dresden, c 1908–369

Friedrich Olivier had already tried his hand at drawing portraits during the Wars of Liberation. In Rome his talent was encouraged by Julius Schnorr von Carolsfeld, who expanded his own collection with likenesses of his friends and patrons. Olivier and Friedrich Overbeck were close companions. Despite the objective, even cool, effect of this portrait, it reflects in its very restraint the special human bond between two men absorbed in an earnest relationship. The hair style, like that worn by Theodor Rehbenitz (see Cat. No. 61) and others, is in accord with their Nazarene convictions. The costume is summarily indicated so that all of the emphasis is upon the head, which is built up with extremely fine lines drawn with a sharp, hard, graphite pencil, describing with the most delicate hatching an expression of vitality and immediacy.

G. L.

Bibliography: Grote, 1938, p. 252, fig. 146; Grimschitz, 1941, fig. 31; Geller, 1952, no. 940

FERDINAND JOHANN HEINRICH VON OLIVIER
Dessau 1 April 1785 – 11 February 1841 Munich

Ferdinand Olivier took drawing lessons in Dessau from Carl Wilhelm Kolbe and from Christian Haldenwang. From 1804 to 1806 he and his brother Heinrich studied under Jakob Wilhelm Mechau and under Carl Ludwig Kaaz, in Dresden, where he met Caspar David Friedrich and Philipp Otto Runge. Olivier spent 1807 to 1810 in Paris with a diplomatic mission. With his brother Friedrich he made a trip to the Harz Mountains in 1810, and a year later they settled in Vienna, where they became friends with Philipp Veit, Joseph Anton Koch, and Friedrich Schlegel. In 1814 and 1817 Ferdinand visited Salzburg. He joined the Brotherhood of St. Luke in 1816. He used his Salzburg landscape drawings for

a series of lithographs, *The Days of the Week*, published in 1823. In 1830 he joined his brother Friedrich and Julius Schnorr von Carolsfeld in Munich, where he became professor of art history at the Academy in 1833.

Kupferstich-Kabinett, Dresden: 26 drawings
Nationalgalerie, Berlin: 16 drawings

73

Farmstead in Wieden beside the Starhemberg-Schönburg Palais, 1814–15

Pen and black and gray ink
177 x 256 mm.
Provenance: acquired in 1939 from C. G. Boerner, Leipzig
Berlin, Ferd. Olivier, no. 16

Ferdinand Olivier, who had lived in Vienna since 1811, belonged to a circle of Romantic artists and literati that included his brothers Friedrich and Heinrich, and the painters Julius Schnorr von Carolsfeld and Theodor Rehbenitz. The focal point of their activities was a house they occupied from 1814 on, which was located in the Carolysche Garten in the suburb of Wieden outside the gates of Vienna. The setting was the inspiration for a number of drawings—chiefly by Ferdinand Olivier—that depict, with hard and sharp lines, novel and unusual views of suburban landscapes and farms that until then had hardly seemed worthy of representation. Fenced-in paddocks with sheds and severely geometric stalls make up the fore- and middleground. Only the attic story of Lukas von Hildebrandt's Starhemberg Palais (1705–6), seen from the side, is visible. In the background at the right, the Minoritenkirche (1685–1727) is discernible, and in the distance are the Kahlenberg and the Leopoldberg. The two youthful figures at the left evoke literary allusions to German Romanticism: one might readily think of Franz Sternbald and his friend Sebastian, the itinerant artists in Ludwig Tieck's novel *Franz Sternbalds Wanderungen* (1798), or of one of the heroes in a novella by Joseph Eichendorff.

G. R.

Bibliography: Grote, 1938, p. 138, fig. 77; C. G. Boerner, Cat. 201, Leipzig, 1939, no. 3, pl. 1; Andrews, 1964, p. 109 f., pl. 37; Novotny, 1971, no. 1, pl. 1

74

View from the Mönchsberg toward the Untersberg, near Salzburg, probably 1817

Graphite
310 x 460 mm.
Provenance: acquired in 1908 from the collection of Eduard Cichorius
Dresden, C 1908–511

On 17 July 1817 Olivier journeyed to Salzburg with his brother Friedrich, and the artists Karl Frommel and Johann Christoph Rist. Julius Schnorr von Carolsfeld was visiting his parents and siblings in Leipzig at the time and was much missed by his friends. In a letter to Schnorr, Ferdinand Olivier describes their experiences: "First, we went to the churchyard of St. Peter's and then on up the Mönchsberg. It was a revelation to us all. Friedrich reeled at the sight of these endless vistas, just as he had when we first arrived. I, too, discovered wholly new and wonderful places. Frommel, who was quite convinced that there could never be a similarity with Italy, now conceded that he, too, had never seen anything more beautiful. At every step you were in our thoughts." On 1 August Schnorr arrived in his "much longed for" Salzburg, on his way to Italy.

This sheet attests to the artist's profound immersion in the landscape and to his diligent craftsmanship, reminiscent of that of the old masters, which bespeaks a striving for absolute fidelity to nature, born of his awe for God's creation. In 1824 Olivier used the drawing as the basis for a painting that is now in the Gemäldegalerie Neue Meister, Dresden.

G.L.

Bibliography: Grote, 1938, p. 206, fig. 123; Frankfurt am Main, 1977, no. B19; Bern, 1985, no. 159, fig. p. 162

75

St. Peter's Cemetery in Salzburg, 1818

Graphite, heightened with white
510 x 420 mm.
Signed and dated, lower right, *FO / 1818*
Provenance: acquired in 1908 from the collection of Eduard Cichorius
Dresden, C 1908–508

Following his sojourn in Dresden from 1804 to 1806, Olivier espoused the call of Ludwig Tieck and Philipp Otto Runge for a new religiosity in landscape painting. The Romantics, including Olivier, were especially fascinated by the graveyard of St. Peter's in Salzburg. Fohr, Erhard, Ernst Fries, and others sketched there. In this view, the west wall of the medieval St. Margaret's Chapel (1485–91) dominates the scene, but we can still see the Hohensalzburg fortress in the background, rising above the arcades of 1626. Unlike Fohr, Olivier did not include the rock wall with catacombs that is to the right of the churchyard, even though it constitutes the earliest evidence of Christianity in Germany and would have reinforced the religious aspect of the drawing. The style of the work, in which every minute detail is carefully elaborated, emphasizes its medieval flavor. This sheet, which is dated 1818, belongs to the group that Olivier sketched at the scene in 1817, but completed and signed in Vienna during the winter of 1818.

G.L.

Bibliography: Grote, 1938, p. 202, fig. 118; Schwarz, 1958; Salzburg, 1959, no. 115; Berlin, 1965, no. 154; Straub-Fischer, 1966; Dresden, 1970, no. 155, illus.; Bernhard, 1973, p. 1002; Paris, 1976–77, no. 156; Dresden, 1978, no. 159; Bern, 1985, no. 151, fig. p. 166

76

Street in Mödling, 1823

Pen and black ink, heightened with white
306 x 240 mm.
Signed and dated, lower left, *FO / 1823*
Provenance: acquired in 1908 from the collection of Eduard Cichorius
Dresden, C 1908–694

Because of its iron and sulfur springs, which were discovered in 1815, Mödling became a popular spa on the eastern slope of the Wienerwald (Vienna Woods) and a favorite destination of outings for the Viennese. Beethoven composed his *Missa Solemnis* there in 1819. Olivier spent the summer of 1823 with his family in Mödling, and executed four pen drawings of their house, yard, garden, and street (three of these are in the Kupferstich-Kabinett, Dresden; the fourth, in the Staatliche Graphische Sammlung, Munich). This work shows a village street with an arched buttress,

which one still finds occasionally today. The artist's precise observation of reality and detailed technique are evident in this sheet: note the blossoming elderberry bushes that are growing in profusion from the window on the left; the weeds on the buttress, roof, and sides of the street; the carnations in the window; the precise construction of the roof; and the crumbling stucco on the wall.

<div align="right">G. L.</div>

V. ROMANTICIZING LANDSCAPISTS

KARL PHILIPP FOHR
Heidelberg 26 November 1795 – 29 June 1818 Rome

After taking drawing lessons in Heidelberg, Fohr lived from 1811 to 1813 in Darmstadt, where he continued his artistic training, largely on his own. From 1813 until the end of his life, the artist was sustained by commissions, and later by an annuity, from Crown Princess Wilhelmine of Hesse. After a stay in Heidelberg, where he produced numerous landscape drawings as well as figural compositions in a style based on early German art, in 1815 Fohr moved to Munich, where he befriended Ludwig Ruhland, and executed his first oil paintings. Returning to Heidelberg in 1816, Fohr drew magnificent portraits of students at the university. In the fall of that year, he arrived in Rome, where he shared a studio with Joseph Anton Koch. Fohr executed landscape drawings and watercolors, and portrait drawings that were intended to serve as preparatory studies for an etching—never executed—of the German artists residing in the city. In 1818, barely twenty-three years old, he drowned in the Tiber. Fohr's work is characterized by a productive tension between his Romantic, chivalric view and his fresh, immediate observations of nature, which he effortlessly transformed into sublime compositions.

Kupferstich-Kabinett, Dresden: 52 drawings
Nationalgalerie, Berlin: 20 drawings

77
The Village of Werfen on the Lueg Pass, 1815
Pen and brown ink, gray wash
345 x 434 mm.
Inscribed, lower right, *Werfen. am Paß Lueg / Fohr. Originalz.*
Provenance: acquired in 1886 at the sale of the collection of Ludwig Richter
Dresden, C 1886–17

The Lueg Pass near Werfen, in the vicinity of Salzburg, is a magnificent gorge (about 5½ miles long, with an average width of only forty-nine feet) through which the Salzach River flows. Lying between the Tennengebirge on the east and the Hagengebirge on the west, it serves as a gateway from the foothills to the high mountains and, as such, played a significant role in the Tyrolean rebellion of 1809 against Napoleon. A drawing of 1818 by Johann Adam Klein captures the narrow and perilous character of the pass.

During the summer of 1815, Fohr went on a six-week trip to Venice. As he informed his patron Philipp Dieffenbach in Darmstadt, he made seventy drawings during this journey. This sheet, executed in Werfen on his return trip, shows a view from the village of a typical Tyrolean farmhouse, on the left, and of the Hohenwerfen castle, a fortress constructed in 1076 and rebuilt in the sixteenth century. It is possible that Ludwig Richter acquired this drawing in 1865 at the auction of the Ferdinand Meyer and Adolf Senff collections in Leipzig. Even though he knew of Fohr only through the recollections of his friends in Rome, Richter thought very highly of the artist's work.

<div align="right">G. L.</div>

Bibliography: Schmidt, 1922, p. 65, fig. 88; Dörries, 1950, fig. p. 111; Salzburg, 1959, no. 30, fig. 2; Frankfurt am Main, 1968, no. 49; Bern, 1985, no. 45, fig. p. 224

78
View of the Roman Forum and the Colosseum from the Farnese Gardens, 1818
Watercolor, over pen and gray ink
238 x 351 mm.
Inscribed, lower right, *gez. v. Carl Fohr 1818*
Provenance: acquired in 1907 from Frau Agnes Jordan, Berlin-Steglitz (with thirty sheets by thirteen artists, including four other drawings by Fohr)
Berlin, Fohr, no. 6

This watercolor is one of the last works by Fohr, who drowned in June 1818. It dates from approximately the same time as his numerous studies for a group portrait, never executed, that was to depict German artists in the Café Greco. In contrast to the composition of the mountain landscape with shepherds, also of 1818 (private collection), here, horizontal planes recede gradually into space and, complemented by the color scheme, clearly distinguish foreground from background. A view from a rise looking down on ancient Rome is a motif that recurs frequently in the works of Fohr's contemporaries.

During his first months in Rome, the young artist had already sketched "the splendid villas, the enchanting gardens with the most wonderful fountains, the great urns with the loveliest flowers," as he wrote in a letter of 17 February 1817 to Crown Princess Wilhelmine of Hesse. Fohr may be referring to the Farnese Gardens, laid out by Giacomo da Vignola in 1555 on the summit of the Palatine Hill, legendary site of the founding of Rome. The observation terrace of the Farnese Gardens, constructed on the ruins of the ancient palace of Tiberius, forms the foreground of our drawing. The view is to the northeast, toward the eastern part of the Roman Forum. On the left are the great apses of the Basilica of Constantine (see also Cat. No. 111); to the right is the Colosseum; and in between is the tower of the church of Sta. Francesca Romana (Sta. Maria Nova). Two watercolor studies from a sketchbook (Frankfurt am Main, Städelsches Kunstinstitut), each depicting half of the background, were drawn from the same vantage point, but differ from the finished composition in the disposition of light.

Some elements of this watercolor are reminiscent of the art of Joseph Anton Koch, with whom Fohr was closely associated. The foreground of the work, which is part landscape and part pastoral fairy tale, is characterized by rapt attention to small forms and everyday activities; the preciousness of every plant is emphasized, and, in the crystal light of morning, suggested by the pure colors, gardeners and maids move about like figures in an early German picture of the Garden of Paradise.

The sheet was included in an exhibition of works by German artists at the Palazzo Caffarelli on the Capitoline Hill in April 1819. In 1821 Franz Horny painted a large watercolor of the same view (Heidelberg, Kurpfälzisches Museum), but showing the foreground as it appeared in the sixteenth century.

<div align="right">C. K.</div>

Bibliography: Passavant, 1820, p. 207; Grossberger, 1924, no. 518; Hardenberg/Schilling, 1925, p. 46, pl. 34; Heidelberg, 1925, no. 88; Leipzig, 1926, no. 87; Geismeier, 1964, p. 15 f., 26, fig. 17; Berlin, 1965, no. 58; Berlin, 1966–67, p. 231 (unnumbered); Frankfurt am Main, 1968, no. 217 (cf. also no. 182 f.); Munich, 1972–73, no. 169, color pl. p. 152

FRANZ THEOBALD HORNY
Weimar 23 November 1798 – 23 June 1824 Olevano

From 1806 to 1816 Horny studied under Johann Heinrich Meyer at the public drawing school in Weimar. In 1816 he traveled with his patron, Carl Friedrich von Rumohr, to Rome, where he was a pupil of Joseph Anton Koch. In Rome Horny's friends included Julius Schnorr von Carolsfeld, Theodor Rehbenitz, and Friedrich Olivier; and Peter Cornelius invited him to participate in the fresco decorations at the Casino Massimo. During the summer of 1817 he made his first excursion to Olevano in the Sabine Hills, and eventually settled there permanently. In 1818 he developed a pulmonary condition that drained him of his creativity and limited his activity mainly to drawing.

Kupferstich-Kabinett, Dresden: 39 drawings
Nationalgalerie, Berlin: 24 drawings

79
Italian Landscape with Three Women and a Shepherd,
ca. 1819–24
Watercolor, over graphite
423 x 590 mm.
Provenance: gift of Woldemar von Seidlitz, 1899
Dresden, C 1899-8

This sheet belongs to a group of drawings, dated by Walter Scheidig between 1819 and 1824, for which there is no established chronological sequence. The four known studies for this water-

color—a large landscape (Berlin, Nationalgalerie), an elaborate composition design (Dresden, Kupferstich-Kabinett), and two studies for the figural groups (Weimar, Staatliche Kunstsammlungen)—suggest that Horny may have planned to execute a painting. The meticulous pen drawing in Berlin differs from this sheet in its placement of the trio of peasant women, who fill the place occupied by the shepherd here. While the composition of the Berlin landscape tends to emphasize the individual elements, this work exhibits a well-balanced harmony. Here, pictorial form is no longer determined by line, but by the structural role of color—a principle that deviates from, and goes beyond, the views held by the Nazarenes. The freshness and vitality of this watercolor are enhanced by the arbitrary lighting that, as in nature, could only be accounted for by the broken clouds.

G. L.

Bibliography: Schmidt, 1922, fig. 91, p. 68; Manteuffel, 1924, p. 277, no. 29; Schilling, 1935, pl. 27; Dörries, 1950, fig. 153; Scheidig, 1954, no. 319; Bern, 1985, no. 110, fig. 253

80

Landscape near Olevano, ca. 1822

Graphite, pen and brown ink
447 x 616 mm.
Provenance: acquired in 1908 from the collection of Eduard Cichorius
Dresden, C 1908–233

As with most of his drawings, Horny began this landscape in graphite and worked it up with pen, though he often finished a sheet with both pen and brush. Horny felt a special fondness for Olevano and, attracted by its beautiful and interesting structure, depicted it many times. The Kupferstich-Kabinett in Dresden alone has six of his drawings of the hill town.

The representation of pure landscape was Horny's forte. For him, man was an organic part of nature, not the vehicle for a particular meaning. Consequently, he took Fohr as his model and rejected Koch's view that a landscape had, above all, to be inhabited by figures that embody a poetic mood or subject. Horny be-

longs with Camille Corot and Karl Blechen at the beginning of the increasingly vigorous development of Realism in landscape art.

G. L.

Bibliography: Scheidig, 1954, no. 273; Bern, 1985, no. 117, illus.

81

View of Olevano, ca. 1822

Pen and black and gray ink, graphite, watercolor
531 x 431 mm.
Inscribed, on the verso, *Andenken aus dem Nachlaß des verstorbenen Franz Horny. Herrn Oberbeck verehrt von seiner Mutter*
Provenance: Friedrich Overbeck (see inscription); acquired in 1883 from Carl Hoffmann, Berlin
Berlin, Horny, no. 2

In 1803 Joseph Anton Koch discovered the artistic possibilities of the striking and unusual mountain scenery of the Sabine Hills and the town of Olevano, with its clusters of houses ascending a hillside crowned by the ruins of a fortress. In the following years, the town and its surroundings were the subject of drawings and watercolors by Koch and other German artists who flocked to Rome. Horny, who arrived in Rome in 1817 and visited Olevano the same year, lived primarily in the hill town from 1818 until his death. In a letter to his mother dated 31 July 1817, he wrote, "Olevano de Borghese is the name of the place where I spent three unforgettable weeks in the company of Herr von Rumohr, Count Seinsheim, and the painter Cornelius. It is a truly magical place, certainly one of the loveliest and most significant spots in Italy, and yet practically none of the innumerable tourists who travel through Italy visit there, since it does not even have an inn. Consequently, we stayed in the Borghese casino, where no one has been in perhaps the last fifty years. König made an excellent cook, and we lived there like princes in an enchanted castle, which our casino did indeed resemble, with its old furniture and paintings. Really, the entire region is so fantastic that nobody in Germany would believe it if they saw drawings of it. We were surrounded by the Sabine Hills. All the sites, with old castles and fortresses, lie up on top of the cliffs, like swallows' nests. To reach

them you must often go for hours up bare precipices on narrow footpaths where only a mule can be used; and the color—you cannot imagine" (Bernhard, 1973, vol. 1, p. 585).

This is perhaps the best known of the numerous studies Horny made of Olevano and its environs during the years before his premature death in 1824. Horny demonstrates an early, significant artistic advance in the way he uses line and color to suggest form. The sharp ridges of the linear network, together with the delicate and transparent watercolor, produce a heightened sense of space that few other artists of the period could create. Horny describes atmospheric lighting effects, and must also have been fascinated by the cubic forms of the ascending houses. In contrast to Koch, who still favored the *veduta*-like overview, Horny elevated the perception of nature to encompass its three-dimensionality.

In the following decades and into our century, the unique atmosphere of Olevano and its hills has inspired an increasing number of German artists. Among those in our selection, in addition to Horny and Koch, they include: Reinhart; Schnorr von Carolsfeld (see Cat. No. 68); Erhard; Richter; Rottmann; Klein; and Blechen.

<div align="right">G. R.</div>

Bibliography: Scheidig, 1954, no. 286; Belloni, 1970, pp. 64–66; Berlin, 1985, pp. 5–6

KARL BLECHEN
Cottbus 29 July 1798–23 July 1840 Berlin

The son of a tax official, Blechen was trained in the banking profession in Berlin from 1814 to 1822. He was already twenty-four years old when he began to study at the Academy, where he remained from 1822 to 1824. During this period, he was a pupil of Heinrich Anton Dähling and Peter Ludwig Lütke. In 1823 Blechen visited Dresden and "Saxon Switzerland," produced his first important works, and met J. C. Dahl. He first exhibited at the Berlin Academy in 1824. From 1824 to 1827 he worked as a scenery painter in the Königstädtisches Theater in Berlin. Blechen visited the island of Rügen in the Baltic in 1828, and from September 1828 to October 1829 he journeyed through Italy. During his stay in Rome, and in the vicinity of Naples, and on his excursions into the Roman Campagna, he produced an abundance of drawings and oil sketches, achieving a breakthrough to Romantic *plein-air* painting. Upon returning to Berlin, he used this material for larger pictures, but also studied the countryside of the Mark Brandenburg. Blechen was appointed professor of landscape painting at the Berlin Academy in 1831, and became a member in 1835. During the latter year, he took a four-week trip to Paris. After 1836 Blechen suffered a mental and physical breakdown. Bettina von Arnim intervened on his behalf. Part of his estate came into the possession of the Academy.

Nationalgalerie, Berlin: 1,299 drawings and oil studies; 150 drawings and oil studies on long-term loan from the Akademie der Künste of the German Democratic Republic
Kupferstich-Kabinett, Dresden: 17 drawings

82
The House of the Poet in Pompeii, 1829
Watercolor, heightened with white, over graphite
237 x 335 mm.
Inscribed, upper right, *Casa del / Poeta*
Provenance: given in 1840 to the Akademie der Künste by the artist's widow Henriette with the estate of Karl Blechen in exchange for an annuity; this collection was divided in 1841 between the Akademie der Künste and the Kupferstichkabinett, Königliche Museen; transferred in 1877–78 to the Nationalgalerie
Berlin, Blechen, no. 162

Early in May 1829, after a six-month stay in Rome, Blechen went to Naples with the artist Leopold Schlösser, his companion for the entire Italian journey. They remained there until the middle of July. Among the first of many excursions from Naples that Blechen undertook was a visit to the ruins of Pompeii, where he made two graphite sketches and four watercolors (Rave, 1940, nos. 1223–28) that belonged to the so-called "Neapolitan Sketchbook" (Rave, 1940, nos. 1210–39).

Located on the Strada delle Terme, north of the Forum Civile, the Casa del Poeta Tragico, or House of the Tragic Poet, owes its name to an erroneous interpretation of one of the windows. The

house dates from the period between the earthquake of A.D. 63, and the disastrous eruption of Mt. Vesuvius in A.D. 79. It was excavated from 1824 to 1825, and provided the model for Edward Bulwer-Lytton's description of the house of Glaucus the Greek in his novel of 1834, *The Last Days of Pompeii*. Blechen's drawing shows the house from the entrance, looking into the atrium. In the immediate foreground is the impluvium, a basin for catching rainwater, and at the right we see the opening of the cistern connected to it. Our view is directed over and beyond the atrium through the tablinum, the reception hall, to the pillars of the peristyle, the garden court. In front of the rear wall of the court is the lararium, the shrine of the household gods. The living quarters were to the right and to the left.

<div style="text-align: right">C. K.</div>

Bibliography: Berlin, 1881–82, no. 330; Donop, 1908a, p. 51; Kern, 1911, pp. 57, 187; Rave, 1940, no. 1228, fig. p. 331; Cottbus, 1963, no. 146; Heider, 1970, fig. 119; Berlin, 1973, no. 133; Bern, 1985, no. 13, fig. p. 245

83

Trees and Houses in Amalfi, 1829

Sepia wash, over graphite
205 x 295 mm.
Inscribed, lower left, *Amalfi*
Provenance: given in 1840 to the Akademie der Künste by the artist's widow Henriette in exchange for an annuity
Berlin, Blechen, no. Akad. 48 (long-term loan to the Nationalgalerie from the Akademie der Künste of the German Democratic Republic)

In an account of his Italian sojourn that he compiled—doubtless from calendar notes—long after his return, Blechen wrote: "Then we traveled [departing from Naples] to Portici, Torre Annunziata, Castellamare; from there we took a boat to Sorrento, where we arrived toward evening, stopped at an inn, cleaned up, ate supper, took a look at the streets in the dark, and then went to bed. The next morning we explored the surroundings and did some sketching. After lunch, we went out for a bit and traveled by donkey to Amalfi, where we arrived at about nine o'clock in the evening. We stayed there for eight days, did some drawing in the valley, and hiked up the mountains to Ravello, where we also

made sketches, then we returned to Amalfi." This trip also included a stay in Salerno, which served, among other things, as the point of departure for an excursion to Paestum before Blechen and Leopold Schlösser returned to their lodgings in Naples.

Heinrich Brauer and Paul Ortwin Rave have assembled sixty-six drawings of identical format to reconstruct the so-called "Amalfi Sketchbook," which Blechen used frequently on these trips (Rave, 1940, nos. 1142–1206). The extensive use of wash is characteristic of all the sheets from this book. The light, economical outlines, drawn in graphite and occasionally in pen, served to guide the execution rather than to define form, which is the function of the white areas left in reserve during the application of the sepia wash. Only a few gray tones—three on our sheet—which were fluidly applied like watercolor, and contrast with the blank white areas, suggest atmosphere and bright, harsh light. In the work exhibited here, the tendency toward abstraction that is inherent in this technique is quite pronounced, even in comparison to a sheet with a very similar subject (Berlin, Blechen, no. Akad. 59; Rave, 1940, no. 1142). That Blechen was conscious of "style exercises" while drawing is confirmed by the contrast between the works of the "Amalfi Sketchbook" and the fourteen pen-and-wash drawings executed at Monte Mario at the beginning of his stay in Rome, in December 1828 (Rave, 1940, nos. 712–25), in which pen-and brushwork play equal roles in what is still an objective description of reality.

<div style="text-align: right">C. K.</div>

Bibliography: Kern, 1911, p. 177 f., fig. p. 88; Rave, 1940, no. 1145, fig. p. 321; Cottbus, 1963, no. 130; Berlin, 1966–67, p. 214 (unnumbered); Heider, 1970, fig. 174; Berlin, 1973, no. 135

84

Plateau near Marino, 1829

Pen and sepia ink, sepia wash, over traces of graphite
220 x 337 mm.
Inscribed, upper right, *Marino*
Provenance: see Cat. No. 83
Berlin, Blechen, no. Akad. 80 (long-term loan to the Nationalgalerie from the Akademie der Künste of the German Democratic Republic)

Forty-one related sheets, some owned by the Nationalgalerie, the rest by the Akademie der Künste (Rave, 1940, nos. 1409–49), belonged to a sketchbook that Blechen used on his return trip—"between Rome and Assisi, in Switzerland and in Heidelberg" (Rave, 1940, p. 363)—from September to October 1829. Marino, a small town north of Lake Albano (not to be confused with San Marino in central Italy), must have been one of the first stops on the journey home. Like a number of Blechen's Italian drawings, this sheet depicts an inconspicuous, almost arbitrarily selected motif. The subject here, as in some of his oil sketches (Rave, 1940, nos. 834–41), is the empty, barely structured expanse of space, its atmospheric character suggested by the varying tonal gradations of the wash. Contours play a totally subordinate role, and appear only in loose, broken strokes. This approach, however, is fundamentally different from the more powerfully structured, tectonic style of the best sheets from the "Amalfi Sketchbook."

In his appraisal of the Blechen estate (1840), the painter Karl Begas emphasizes that Blechen's unique gift lay in his ability to express "shifts in terrain, with such a sense of perspective and with such limited means" (Rave, 1940, p. 64).

C.K.

Bibliography: Kern, 1911, p. 178; Rave, 1940, no. 1409, fig. p. 366

85
Ruins of a Gothic Church, ca. 1834
Watercolor, over graphite
372 x 258 mm.
Provenance: see Cat. No. 82
Berlin, Blechen, no. 562

This unfinished watercolor served as a preparatory study for a painting commissioned by the Königlicher Kunstverein and exhibited in Berlin in 1834 (Rave, 1940, no. 1881). The painting, in the Städtische Kunstsammlungen, Königsberg, until 1945, is now lost. There are other directly related preparatory studies (Rave, 1940, nos. 1882–83; Berlin, Blechen, no. Akad. 229; Berlin, Blechen, no. 564).

Blechen produced a number of variations on the motif of a dilapidated monastery church surrounded by a forest and eroded by water; the first is a large painting, executed as early as 1826 (Rave, 1940, no. 172; Dresden, Gemäldegalerie Neue Meister). These compositions unite Blechen's knowledge of the elements of set design with his impressions of Caspar David Friedrich's work, which he saw in Dresden in 1823. The monastery ruins might be viewed as Blechen's response to the preservation efforts led by Karl Friedrich Schinkel in Prussia and as his rejection of Schinkel's vision of Gothic architecture in an undamaged, ideal state. Blechen emphasizes the inexorable decay and decomposition of human creation amidst the exuberant, bright, and colorful world of nature. The figure at the left, with hat and staff, is meant to be a pilgrim, as is clearly indicated in the finished painting.

C.K.

Bibliography: Berlin, 1881–82, no. 375 (?); Donop, 1902, no. 181; Kern, 1911, p. 188; Justi, 1919, p. 63; Rave, 1940, no. 1884; Berlin, 1954, no. 88, p. 46 f.; Hofmann, 1960, fig. 30; Berlin, 1965, no. 17; Heider, 1970, color pl. 62; Berlin, 1973, no. 214, color pl. IV; Geismeier, 1984, fig. p. 316

86
Forest Landscape with a Waterfall and Two Hunters, ca. 1830–35
Pen and brush and black ink, sepia wash, over faint traces of graphite
Verso: sketches
292 x 344 mm.
Provenance: Dr. Rolf Grosse, Berlin; acquired in 1967
Berlin, Blechen, no. 1317

This large sheet belongs to a group assembled by Rave (1940, nos. 1901–34) under the rubric "German Forest." Most of these compositions were apparently executed in the vicinity of Spandau, near Berlin, and all reveal the artist's interest in the forest interior and in the play of light among the tangled branches. The opaque blacks of individual background elements are variously broken up by the painterly delicacy of the wash, creating a unique silhouette effect. In other places, the artist uses hatching, which occasionally creates an effect reminiscent of a photographic nega-

tive, as in the figures of the hunters who are hidden as if in a picture puzzle. Evidently, this work was also a technical experiment—perhaps an attempt to imitate the look of chiaroscuro woodcuts of the sixteenth and seventeenth centuries.

<div style="text-align: right">C. K.</div>

Bibliography: Rave, 1940, no. 1923, p. 484; Bern, 1985, no. 9, fig. p. 239

87

Trees beside a Pond, ca. 1830–36

Brush and gray ink
183 x 274 mm. (lower right corner cut off)
Provenance: acquired in 1891 from the extensive Blechen collection of the banker Carl Brose
Berlin, Blechen, no. 910

The Nationalgalerie owns four sheets from a group of six that are very similar in technique and conception (Rave, 1940, nos. 1993–98). The outlines of the compositions were not sketched in beforehand, and the impulsively dashed off brushstrokes flow into one another in such a way that the integrity of the individual elements, distances, and surface textures is only vaguely discernible. The works convey a general emotional sensation of space, atmosphere, and rapidly changing light, "the, so to speak, categorical structures of each experience of nature" (Simson, 1975). That these sheets have been dated late in Blechen's career, "about 1835," perhaps reflects a reluctance to attribute their "informal" freedom to anything but the imminent mental illness that plagued the artist after 1836–37. We do not know what degree of representational clarity Blechen might have achieved had he worked further on these drawings. The two tree trunks traced with the point of the brush, the twigs, and the grasses are executed in a manner unparalleled in the three other Berlin compositions, and indicate that the rest of the work remains unfinished.

To elaborate upon more or less arbitrary blots was a widely disseminated creative method in the nineteenth century. Adolph Menzel frequently worked in this manner; his watercolors originated in brush smears; his pencil drawings, in faint gray traces of stumping. In 1857 the poet Justinus Kerner published lithographs

of *Klecksographien*—spots of ink economically extended to form figures. Following an idea of Leonardo da Vinci, in 1759 the English painter Alexander Cozens described a process designed "to facilitate the invention of landscapes" by reinterpreting random shapes as landscape compositions. However, Blechen's interest in indistinctly represented forms may go even deeper, as he left behind at least six sheets in this state of "prefiguration" (Gantner). He seems to have discovered, in a suggestive vagueness, a value similar to that described by Rudolf, in Ludwig Tieck's novel *Franz Sternbalds Wanderungen* (1798), who was content with "the bright colors with no inherent meaning" of a painted sunset: "I would gladly do without action, passion, composition—everything." The Romantic propensity for visual phenomena disengaged from their material context is found frequently, as in paintings by J. M. W. Turner and in the numerous cloud studies of the period.

<div style="text-align: right">C. K.</div>

Bibliography: Rave, 1940, no. 1995; Cottbus, 1963, no. 254; Berlin, 1973, no. 224; Simson, 1975, p. 251, fig. p. 249

88

Landscape in the Mark Brandenburg, with Pines and Figures Shoveling Sand, ca. 1830–36

Watercolor, over graphite
173 x 207 mm.
Provenance: bequest of Dr. Theodor Wagener, 1891
Berlin, Blechen, no. 700

Only twenty years after Blechen's death, the poet Theodor Fontane proclaimed him "the father of landscape painting in our Mark Brandenburg." Shortly before his trip to Italy, Blechen completed the large painting *Camp of the Semnones* (1828; formerly in the Nationalgalerie, destroyed during the war; studies preserved in the Nationalgalerie). The artist depicted a group of Germanic warriors set in a realistic landscape taken from the area around Berlin. The look of the painting, too, was determined by hills, pines, and sand—motifs that do not, in either content or composition, conform to the usual demands of heroic or idyllic landscape. Our watercolor is even more economically composed and conveys an

even more mundane effect. Undefined waves of sand, broken only by sparse clumps of grass, and the edge of the forest on the horizon extend parallel to the picture plane and are defined, almost arbitrarily, by its borders. A light-colored signpost in front of the woods indicates a nearby community. Without the commanding group of slender trees in the middle, the composition would resemble that of Caspar David Friedrich's *Monk by the Sea* (1809–10), the three figures in the foreground here having the same function as the figure of the monk. The essential features of the landscape are realized by thin strokes of watercolor that faintly tint large areas of the paper. The broad expanse is filled with diffuse light. The discovery of the beauty of the uneventful and commonplace, soon to be developed further by Adolph Menzel and later elevated to a program by the Naturalists, has already begun.

<div align="right">C. K.</div>

Bibliography: Donop, 1902, no. 202; Kern, 1911, p. 185; Rave, 1940, no. 2003, fig. p. 503; Berlin, 1954, p. 45; Cottbus, 1960, no. 115; Cottbus, 1963, no. 257; Heider, 1970, fig. 276; Berlin, 1973, no. 198, fig. 42; Berlin, 1987, no. F 31

ADRIAN LUDWIG RICHTER
Dresden 28 September 1803 – 19 June 1884 Dresden

Richter studied drawing and etching with his father, the printmaker Carl August Richter, and at the Dresden Academy with Adrian Zingg. In 1820–21 he was employed as a draftsman by Prince Narischkin, whom he accompanied on a trip to southern France and Paris. From 1823 to 1826 Richter was in Rome, where he joined the Nazarene circle and imitated the work of Joseph Anton Koch. He served as a drawing instructor at the Meissen porcelain factory from 1828 to 1836, and as professor of landscape and animal painting at the Dresden Academy from 1836 to 1876. His association with the Leipzig publisher Georg Wigand began in 1836. Richter ultimately executed some 3,500 illustrations for 150 books published by Wigand's firm (the Dresden Kupferstich-Kabinett owns most of the proof sheets). Richter, one of the most prolific illustrators of the nineteenth century, also issued numerous series of prints from his own press. His *oeuvre* includes about 120 paintings. Richter traveled through the Harz Mountains, the Alps, and northern Italy, along the Rhine, and to Belgium and Switzerland. His painting *Bridal Procession in the Springtime* won a gold medal at the Exposition Universelle in Paris in 1855. Richter began to write his memoirs, *Lebenserinnerungen eines deutschen Malers*, in 1869, and in 1876 he resigned his post at the Dresden Academy.

Kupferstich-Kabinett, Dresden: 630 drawings
Nationalgalerie, Berlin: 336 drawings

89
Group of Trees on a Slope, probably 1824
Pen and gray ink, gray wash
286 x 384 mm.
Provenance: acquired in 1908 from the collection of Eduard Cichorius
Dresden, C 1908–938

The ancient clusters of trees in the park of the Palazzo Chigi fascinated Richter and his friends. In his memoirs he wrote: "In order to be closer to the park, we moved to Ariccia, where we stayed for several weeks. According to legend, the park is said to be a remnant of the grove of Diana, and the owners allow this magnificent bit of nature to remain completely untouched by civilization. The mighty stands of oaks and the lichens crowned the steep hills and provided wonderful studies for the artist." From a comparison with two inscribed drawings of this park (Dresden, Kupferstich-Kabinett), it seems likely that our sheet was done there as well.

<div align="right">G. L.</div>

Bibliography: Dresden, 1984, no. 131, fig. 102; Bern, 1985, no. 191, fig. p. 266

90
The Elbe Valley near Aussig, with the Ruins of the Schreckenstein Fortress, 1834 or 1837
Watercolor, over graphite
208 x 335 mm.
Provenance: acquired in 1908 from the collection of Eduard Cichorius
Dresden, C 1908–1235

In September 1834, on a walking trip through the Elbsandstein-gebirge in Saxony and Bohemia, Richter rediscovered the appeal of this region, known since the end of the eighteenth century as "Saxon Switzerland." He had traveled in the area with his father in 1820, and had sketched a similar view of the Schreckenstein for the print series *Siebzig mahlerische An- und Aussichten der Umgegend von Dresden* (Hoff/Budde, 1922, no. 134), though the related etching was ultimately not published in this collection. The ruins of the Schreckenstein, a medieval fortress above the Elbe near Aussig, were also the subject of two paintings by Richter: *Storm at the Schreckenstein*, 1835, and the famous *Crossing near the Schreckenstein*, 1837. While both paintings portray the ruins from the foot of the mountain, the view in this drawing, from a greater distance and slightly above the left bank of the Elbe, dramatizes the commanding position that the ancient fortress has over the valley. Richter drew the same subject in one of his sketchbooks (no. 12, fol. 10; Dresden, Kupferstich-Kabinett). This watercolor was done either in connection with the painting of 1837, or on his trip in 1834. New for Richter is the free application of the watercolor to create a marvelous lighting effect in the low-lying fog, on the surface of the water, and on the mountainside.

G. L.

Bibliography: Franke, 1916, fig. p. 68; Singer, 1926, pl. 12; Friedrich, 1937, p. 55, fig. 79; Salzburg, 1959, no. 179; Neidhardt, 1969, p. 64, fig. 83; Richter, 1982, fig. p. 48; Werner, 1982, no. 144, fig. 59; Dresden, 1984, no. 291; Bern, 1985, no. 201

91
Two Beech Trunks, 1846
Pen and gray ink, watercolor
221 x 141 mm.
Dated, lower left, *d 8ten Jul. 1846*
Provenance: acquired in 1908 from the collection of Eduard Cichorius
Dresden, c 1908–1012

As a result of their interest in Dürer and in early German art, the Romantics developed a new attitude toward the representation of nature. Richter, who was imbued with a Christian reverence for creation, held this outlook well into his later years; it was the

source of the diligence with which he studied and carefully reproduced every detail.

G. L.

Bibliography: Richter, 1976, fig. 17; Dresden, 1984, no. 440

92
Rübezahl Frightens a Mother and Her Children, not after 1848
Graphite
444 x 285 mm.
Provenance: acquired in 1908 from the collection of Eduard Cichorius
Dresden, c 1908–926

After forming an association with the Leipzig publisher Georg Wigand in 1836, Richter began to produce an extensive body of designs for wood-engraved book illustrations, and painting gradually assumed a secondary role in his work. After his first project, drawing landscapes for the publication *Das mahlerische und romantische Deutschland*, he went on to illustrate chapbooks; the fairy tales of Musäus, Bechstein, and Grimm; folk and student song books; and editions of Goethe's and Schiller's poetry. Richter also created his own suites on the domestic life of the lower middle class and the peasantry, which are full of unusual details and constitute a rich source of information for folklorists. Richter's work appealed to a wide public because of the profound veracity that informs every sheet, the clear and unpretentious style, his insight into the experiences and concerns of the common man, and the marvelous blend of reality and fantasy that is found in genuine fairy tales.

According to a Silesian legend, Rübezahl, a mountain spirit from the Riesengebirge, was in the habit of teasing people either by helping or by punishing them. Musäus's *Volksmärchen* of 1842 included forty-two illustrations of this tale. Richter chose one scene from the legend for an etching that he himself executed and gave to the Sächsischer Kunstverein as payment for yearly dues in 1848; our drawing is the preparatory sketch (Hoff/Budde, 1922, no. 265). Upon the sudden appearance of Rübezahl, a mother moves to protect her children, even though she had just threatened the disobedient youngsters with precisely this occur-

rence. The figures at the bottom of the sheet—a couple, two girls, and a family of fauns—do not belong to the Rübezahl story. The studies of a head and of braids of hair, at the right, attest to Richter's interest in uniting aspects of earthiness and benevolence in the figure. There is another study for the figure of Rübezahl in one of the artist's sketchbooks (no. 26, fol. 24; Dresden, Kupferstich-Kabinett).

<div style="text-align: right">G. L.</div>

Bibliography: Franke, 1916, fig. p. 80; Grundmann, 1931; Dresden, 1984, no. 461, fig. p. 170; Bern, 1985, no. 203, fig. p. 276

ERNST FERDINAND OEHME
Dresden 23 April 1797 – 10 September 1855 Dresden

Oehme studied at the Dresden Academy and with Caspar David Friedrich, whose influence upon him was decisive. In 1819 he traveled in Switzerland and to Berlin. In 1822 Oehme went to Rome, where he stayed for three years. In 1825 he was appointed court painter in Dresden. Oehme was a close friend of Ludwig Richter.

Kupferstich-Kabinett, Dresden: 38 drawings
Nationalgalerie, Berlin: 8 drawings

93
The Wetterhorn, with the Glacier of Rosenlaui, 1825
Pen and gray-black ink, watercolor, heightened with white
236 x 332 mm.
Provenance: acquired in 1937 from a private collection, Breslau
Berlin, Oehme, no. 1

In September 1825 Oehme lingered in Switzerland on his return trip from Rome, where he had lived for three years among his fellow German artists. His numerous drawings of the Swiss landscape include studies of the imposing Wetterhorn massif in the Bernese Oberland. Probably inspired by Joseph Anton Koch, Oehme was fascinated by the world of the high mountains, as were many contemporary artists. Alpine scenes, especially views of Switzerland, increasingly appealed to a public who had either

visited there or longed to make the journey. One of the finest drawings to result from the Romantic artists' fondness for Switzerland, this sheet combines clear, dynamically accentuated lines and transparent, broadly applied washes of watercolor. In a large oil executed four years later, Oehme depicted the same motif from a more distant and effective point of view, and enriched the foreground with animals, mountain folk, and shepherds' huts (West Berlin, Nationalgalerie).

<div style="text-align: right">G. R.</div>

Bibliography: Neidhardt, 1981, p. 13, fig. 2

JOHANN CHRISTIAN CLAUSSEN DAHL
Bergen (Norway) 24 February 1788 – 14 October 1857 Dresden

After studying at the Copenhagen Academy from 1811 to 1818, Dahl traveled to Germany and settled in Dresden, where, for nearly twenty years, he shared a house—and similar artistic ideals—with Caspar David Friedrich. In 1820 Dahl became a member of the Dresden Academy, and in 1821 he stayed in Naples with the Danish crown prince Christian Frederick. Dahl was appointed *ausserordentlicher Professor* of landscape painting at the Dresden Academy in 1824. He traveled frequently to Copenhagen and Norway, and visited Paris in 1847.

Kupferstich-Kabinett, Dresden: 26 drawings
Nationalgalerie, Berlin: 7 drawings

94
The Towers of Dresden
Black chalk, on blue-gray paper
287 x 418 mm.
Provenance: acquired in 1946 from the collection of Prince Johann Georg of Saxony
Dresden, C 1960–131

Dahl ranks among the most important landscapists of the transitional phase between Romanticism and Realism. His realistic approach to landscape was also advocated in Dresden by Carl Gustav Carus and by Ludwig Tieck; Carus referred to Dahl as

"Promethean-sober." Dahl was interested in the phenomena of nature, not in their meaning. However, in his choice of motifs, he adhered to the view of nature held by the Romantics, whose moonlit landscape subjects he frequently adopted in his work. Dahl often added dramatic clouds that lend special interest to the lighting of his scenes.

<div align="right">G. L.</div>

Bibliography: C. G. Boerner, catalogue of the sale of the collection of Prince Johann Georg, Leipzig, 1940, no. 149

JOHANN AUGUST HEINRICH
Dresden 20 August 1794 – 27 September 1822 Innsbruck

From 1810 to 1812 Heinrich was a pupil at the Dresden and the Vienna academies. In Vienna he made friends with Julius Schnorr von Carolsfeld and the Olivier brothers. He returned to Dresden in ill health in 1818, and visited Johann Christian Claussen Dahl and Caspar David Friedrich the following year. Heinrich was listed as a pupil of Friedrich in the catalogue of the Dresden Academy exhibition of 1820, the year he traveled to Salzburg with Ferdinand Oehme. Heinrich returned to Dresden in late 1821, and on his way to Italy a year later, he succumbed to pulmonary disease in Innsbruck.

Kupferstich-Kabinett, Dresden: 20 drawings
Nationalgalerie, Berlin: 1 drawing

95
In the Rabenauer Grund, 1820
Graphite, black wash, heightened with white, on blue paper
276 x 426 mm.
Inscribed, lower left, *G II, 7. / Aus dem Rabenauer Grund*
Provenance: acquired in 1911 from the collection of W. Gasch
Dresden, C 1911–47

On stylistic grounds, Gode Krämer dates this work to 1820. The entire sheet is covered with tiny numbers and letters, presumably color notes, which indicate that the drawing was done in preparation for a painting. Similar numbers and letters that appear on drawings from 1822 are deciphered in Heinrich's diary. The

Rabenauer Grund, which borders the valley of the Rote Weisseritz River, south of Dresden, was a popular site for excursions and was especially favored by artists because of its Romantic motifs.

<div align="right">G. L.</div>

Bibliography: Berlin, 1965, no. 84; Krämer, 1979, no. 14, fig. 24

96
Churchyard in Loschwitz, 1822
Graphite, black and gray wash
249 x 320 mm.
Signed, lower right, *Heinrich*
Provenance: acquired in 1910 from Prof. A. Reinhardt
Dresden, C 1910–97

The Kupferstich-Kabinett in Dresden houses ten of the most important drawings from Heinrich's relatively small body of work. This is one of four surviving sheets that depict the Loschwitz cemetery, and it is dated by Gode Krämer on stylistic grounds to the first half of 1822. Today, Loschwitz is a part of Dresden. The cemetery is no longer used, and most of the gravestones have disappeared. The influence of the work of Heinrich's friends in Vienna, Friedrich Olivier and Julius Schnorr von Carolsfeld, is obvious. All three shared a positive, reverential world view. The Christian overtones are suppressed in Heinrich's work, and it lacks Caspar David Friedrich's profound lucidity. In his faithful reproduction of the actual site, Heinrich approached the Realism of Karl Blechen and Adolph Menzel.

<div align="right">G. L.</div>

Bibliography: Dresden, 1928, no. 177; Schwarz, 1960, no. 6; Berlin, 1965, no. 85; Neidhardt, 1976, p. 155; Krämer, 1979, no. 18

97
Wooded Hillside, 1820
Graphite, gray and black wash
399 x 187 mm.
Provenance: acquired in 1911 from the collection of W. Gasch
Dresden, C 1911–48

Gode Krämer dates this sheet to 1820. The site is probably in the area around the Rabenauer Grund, and this may be a detail study

for Cat. No. 95, which, in turn, was done in preparation for a painting.

<div align="right">G. L.</div>

Bibliography: Schmidt, 1922, fig. 89; Dresden, 1928, no. 177; Krämer, 1979, no. 13

CARL ROTTMANN
Handschuhsheim (near Heidelberg) 11 January 1797 – 7 July 1850 Munich

Carl Rottmann, Karl Philipp Fohr, and Ernst Fries studied together under Rottmann's father, Friedrich, the drawing master at the University of Heidelberg. Rottmann was later taught by Johann Christian Xeller, who introduced him to the collection of medieval art formed by the Boisserée brothers. He worked in Munich in 1821, journeyed to Salzburg a year later, and traveled through the Inn River valley in 1823. Rottmann met and became friends with the architect Leo von Klenze. In 1826 Rottmann traveled to Italy, and thanks to a commission for a cycle of frescos depicting Italian subjects, awarded in 1827 by King Ludwig I of Bavaria, he was able to extend his journey as far as Sicily. The king financed Rottmann's second trip to Italy in 1829. The artist worked on frescos of Italian scenes in the western wing of the Munich Hofgarten arcades from 1830 to 1834. He undertook a journey to Greece to prepare a proposed suite of Greek subjects that was to connect with the Italian cycle; he finished these frescos in 1850, but, contrary to the original plan, they were installed in the Rottmannsaal of the Neue Pinakothek in Munich, which was completed in 1854.

Nationalgalerie, Berlin: 15 drawings
Kupferstich-Kabinett, Dresden: 10 drawings

98
The Obersee, with the Watzmann, 1825
Watercolor, over graphite
305 x 445 mm.
Inscribed, lower left, *Am 14. Aug. 25*
Provenance: acquired in 1908 from the collection of Eduard Cichorius
Dresden, C 1908–434

Erika Bierhaus-Rödiger notes two peculiarities of this watercolor: the inscription recording the specific day it was executed; and the nearly total absence of a preliminary sketch. "It was rare for Rottmann to dispense with preliminary drawing to such an extent and to render form and surface structure with the brush alone. This slice of nature was selected so as to provide a pictorially complete composition. The cliff faces on either side simultaneously establish a sense of distance from the Watzmann massif and frame the view of it; the natural transition from shadow to light testifies to the immediacy of the impression, which is not felt in his depiction of the Staufen near Reichenhall, another work from this period. In the same year, Rottmann executed an oil painting based on this watercolor (Munich, private collection)" (Bierhaus-Rödiger, 1978).

The Watzmann massif, 8,900 feet high, is located near Berchtesgaden, in the Bavarian Alps, west of the Königsee and not far from the border of the province of Salzburg. Ludwig Richter painted the massif in 1824.

<div align="right">G. L.</div>

Bibliography: Krauss, 1930, p. 96; Decker, 1957, no. 38, p. 57, fig. 33; Bierhaus-Rödiger, 1978, no. 44, illus.

99
The Island of Delos, ca. 1840
Watercolor, over graphite
243 x 344 mm.
Provenance: acquired in 1908 from the collection of Eduard Cichorius
Dresden, C 1908–435

This sheet is a study for a mural cycle depicting Greek landscapes that was to connect with a suite of Italian scenes in the Hofgarten arcades in Munich. Ludwig I of Bavaria commissioned the cycle of thirty-eight paintings in association with the coronation of his son Otto I, who was proclaimed king of Greece by the Greek National Assembly in 1832. This study is the basis for the finished watercolor in the Graphische Sammlung, Munich, and is also related to a sheet in the Kurpfälzisches Museum, Heidelberg (Bierhaus-Rödiger, 1978, no. 569). It differs in a few details from the oil paint-

ing of 1836, now in Karlsruhe (Bierhaus-Rödiger, 1978, no. 519). In the distance rises Mount Kythnos, bathed in the light of the rising sun, while at center right, a standing figure awakens a sleeping man. Delos is said to be the birthplace of the sun god Apollo.

G. L.

Bibliography: Decker, 1957, no. 523, p. 84, fig. 248; Bierhaus-Rödiger, 1978, no. 570

VI. LATE ROMANTICS

KARL FRIEDRICH LESSING

Breslau 15 February 1808 – 5 June 1880 Karlsruhe

Lessing was the son of a jurist, and a great-nephew of the author Gotthold Ephraim Lessing. The artist took his first drawing lessons in his native Breslau. He studied architecture in 1822, and then enrolled at the Berlin Academy, where he studied under Johann Friedrich Collmann, Heinrich Anton Dähling, and Johann Gottlob Rösel. Lessing decided to become a landscape painter, and, following his first success in an exhibition in 1826, he entered the studio of Wilhelm Schadow. Later that year, when Schadow became director of the Academy in Düsseldorf, Lessing followed him there. Lessing founded a "Landschaftlicher Komponierverein" (landscape club) in 1827, and, at the same time, worked on frescos of historical subjects at Schloss Heltorf. His large work *The Hussite Sermon*, completed in 1836, was followed by other history paintings based on the lives of spiritual leaders like Jan Hus and Martin Luther, which caused a sensation because they depicted social protest in the guise of religious history. Lessing also continued to paint lofty, solemn landscapes based on observations made during his frequent travels. The first of his numerous pictures of the Eifelgebirge dates from 1832. Lessing was summoned to Karlsruhe in 1858 to head the grand-ducal painting gallery, and from 1863 to 1866 he was the artistic director of the city art school. Until the last years of his life, Lessing continued to take study trips and to play an active role in artistic politics. He suffered his first stroke in 1878. A large part of his estate (thirteen paintings, six cartoons, and 915 drawings) was acquired by Joseph Longworth of Cincinnati in 1880, and presented to the recently established Cincinnati Art Museum in 1882.

Nationalgalerie, Berlin: 53 drawings
Kupferstich-Kabinett, Dresden: 8 drawings

100
The Battle of Iconium, 1827
Watercolor and gouache, over graphite and pen and black ink
186 x 236 mm.
Signed and dated, lower right, C.F.L. 1827
Provenance: F. Fallou, Berlin, 1856; Carl Robert Lessing, Berlin, 1880; Anna Lessing, Berlin, 1925; Prof. Paul Arndt, Munich (?); acquired in 1934 from C. G. Boerner, Leipzig
Berlin, Lessing, no. 50

This sheet is a preparatory study for a fresco in a room overlooking the garden at Schloss Heltorf, near Düsseldorf. Peter Cornelius, director of the Düsseldorf Academy, had urged the princes and nobility to support the revitalization of fresco painting, and this prompted Count Franz von Spee to commission a cycle of six (seven, after a change of plans) murals on the life of Emperor Frederick Barbarossa, which were to be executed by Cornelius's students. When Wilhelm Schadow took over the directorship in 1826, the work was passed on to his students, Heinrich Mücke and Karl Friedrich Lessing, who had come with him from Berlin. Lessing completed only one painting, *The Battle of Iconium*, designed a second, and turned over the other works to his colleague Hermann Plüddemann. The Heltorf frescos are the first programmatic venture of the Düsseldorf school in the field of monumental history painting with strong overtones of Romantic nationalism. When he took over his part of the project, Lessing was just nineteen years old and had already successfully exhibited a Romantic *Landscape Composition with Cemetery*, in 1826.

The battle of Iconium, the capital of a Seljuk kingdom, took place on 18 May 1190 during the Third Crusade, only three weeks

before the death of Emperor Frederick Barbarossa, who fought in it. In his six-volume *Geschichte der Hohenstaufen* (1823–25), which may have inspired Count von Spee to select this subject, Friedrich von Raumer describes how the emperor incited his retreating knights with the cry "Christ is victorious! Christ rules!" while his son Frederick of Swabia stormed the fortress. Lessing's composition, which is limited to a few large, furiously battling figures, clearly shows the influence of Raphael's *Expulsion of Heliodorus*. Julius Schnorr von Carolsfeld's *Battle on the Island of Lipadusa*, a reproduction of which circulated in *Das Kunstblatt* in 1825, may also have influenced the grouping.

Friedrich von Uechtritz, one of the chroniclers of the Düsseldorf school and a friend of Lessing, wrote of the artist's working method: "Like Minerva from the head of Jupiter, the artistic ideas spring from Lessing's mind instantaneously, in a definite form, and, as it were, in full armor. He never makes use of a model. The most difficult, complex positions, the most daring movements stand before his inner eye with wonderful clarity, and he puts them down on paper with playful ease." This is certainly true of *The Battle of Iconium*. Apart from minor differences in detail, the two composition studies that survive correspond closely to each other. The study in the Cincinnati Art Museum (Karlsruhe, 1980, no. 4) is larger than our watercolor and almost square—only slightly vertical in format—while the horizontal form of our composition allows for the addition of several elements at the right. This strip on the right is omitted from the finished fresco, and though the horizontal format is retained, the action is concentrated in the upper register. Comparison of several details that appear in our drawing and in the fresco, but not in the Cincinnati work (the position of the head of the rider at the far left, the posture of the Turk falling in the background to the right, the right arm of the archer in the right foreground), shows, as Vera Leuschner points out, that the Berlin study is a second version. Twenty detail studies (Cincinnati, Art Museum) were used in the preparation of the cartoon, now lost, that was exhibited in 1828 and caused a sensation. The fresco (250 x 340 cm.) was executed in the summer of 1830. In the following years, Lessing became interested

in the theme of the Hussite Wars, the subject with which his reputation remains linked.

<div align="right">C. K.</div>

Bibliography: C. G. Boerner, Leipzig, 16 May 1834, no. 198; Schasler, 1856, vol. 2, p. 357; *Zeitschrift für bildende Kunst* 3, 1868, supp., p. 734; Berlin, 1880, no. 205; Boetticher, 1891, 1/2, no. II/39; Düsseldorf, 1925, no. 482; Berlin, 1965, no. 129, pl. VII; Jenderko-Sichelschmidt, 1973, pp. 13, 226 n. 38; Karlsruhe, 1980, no. 4; Leuschner, 1982, p. 658 f., no. 189; Geismeier, 1984, p. 356, fig. p. 354

101

Landscape with a Wanderer, 1834

Pen and sepia and black ink, brown wash, over graphite
225 x 461 mm.
Signed and dated, lower left, *C.F.L. März 1834*; numbered, by another hand, upper left, *166*; upper right, *32*
Provenance: the artist's estate; acquired in 1880 from Gutekunst, Stuttgart
Berlin, Lessing, no. 27

This drawing served, without changes, as the model for an oil painting commissioned by the Berlin banker J. H. W. Wagener and completed in 1841 (West Berlin, Nationalgalerie). The painting's traditional title, "Silesian Landscape," is certainly not accurate. Lessing did, in fact, come from the Prussian province of Silesia, but he had not seen his homeland since he was fourteen.

At the beginning of his career, Lessing apparently intended to devote himself entirely to landscape painting, and he probably regarded the Barbarossa fresco (Cat. No. 100) as an interlude. With his first sketch, in 1831, for *The Hussite Sermon*, he found a new approach to history painting, which from then on remained his second field of activity. In 1834 he completed the oil sketch for the *Sermon* and the *Eifel Landscape* (Warsaw, Muzeum Narodowe), a Romantic mountain scene, imbued with a dramatic, Ossianic mood. Lessing lent a historical accent to these pictures by adding castles, monasteries, or staffage to the rugged, detailed, and realistically depicted crags. There is none of this in our plain, flat landscape, except for the Romantic motif of the wanderer, who evokes the image of life's journey. While Lessing may have been inspired by seventeenth-century Dutch works, the drawing first and

foremost conveys a direct visual experience, without stylistic embellishment. A moist atmosphere, impressively suggested by the delicate application of wash, permeates this seemingly endless, early spring landscape, and the surface of the large swamp reflects the cloudless evening sky.

Irene Markowitz refers to a second version of this composition, though we know of only this drawing.

<div align="right">C. K.</div>

Bibliography: Berlin, 1880, no. 166; Boetticher, 1891, I/2, no. II/67; Donop, 1902, no. 27; Markowitz, 1969, p. 207, no. 226; Bernhard, 1973, p. 818; Leuschner, 1982, no. 56

ALFRED RETHEL

Diepenbend (near Aachen) 15 May 1816 – 1 December 1859 Düsseldorf

From 1829 to 1836 Rethel studied with Wilhelm Schadow at the Düsseldorf Academy and was inspired by the monumental paintings of Karl Friedrich Lessing. After visiting Munich and the Tyrol in 1835, Rethel settled in Frankfurt am Main the following year. He studied with Philipp Veit at the Frankfurt Städelsches Kunstinstitut. In 1839 Rethel entered the competition for the decoration of the Imperial Chamber in the Aachen Town Hall, and won the commission in 1840. However, the frescos became the subject of protracted controversy that delayed their execution until 1847, which caused Rethel to become severely depressed. In order to gather material for his murals, Rethel undertook his first Italian journey in 1844–45. From 1848 to 1852 the artist lived in Dresden, where, in the winter of 1848–49, he executed the drawings for the woodcut series *Auch ein Totentanz*. The first symptoms of mental illness appeared during his second Italian trip, in 1852–53. In 1853 Rethel's pupil Josef Kehren had to complete the Aachen frescos for the ailing artist. From the end of 1853 until his death in 1859, Rethel was seriously mentally ill, and was cared for by his mother and his sister in Düsseldorf.

Kupferstich-Kabinett, Dresden: 125 drawings and cartoons
Nationalgalerie, Berlin: 88 drawings and cartoons

102

The Head of Charlemagne in the Tomb, 1846–47

Charcoal, watercolor
531 x 355 mm.
Provenance: acquired in 1897 from the artist's estate
Dresden, c 1897–87

In 1839 the Kunstverein for the Rhineland and Westphalia announced a competition to decorate the Imperial Chamber of the Aachen Town Hall with frescos depicting events from the life of Charlemagne (742?–814). Rethel submitted seven sketches that won him the commission.

For the lunette that was to contain the last work of the cycle, Rethel chose the visit of Emperor Otto III (980–1002) to Charlemagne's tomb. Our drawing is a study for the head of Charlemagne. Rethel's literary source was Karl Franz Meyer's *Aachener Geschichten* of 1781, which he followed almost verbatim: "After his death his corpse was . . . carried out of the palace and into the crown chapel, and there placed on a golden stool in a crypt built in the center . . . the crown was put upon his head, and his chin rested upon a chain of fine gold so that his head would not droop . . . his countenance was covered with a cloth, and his golden shield was placed immediately in front of him. . . ."

Rethel's frescos rank among the most significant monumental paintings in Germany. He succeeded in transcending theatricality and eclecticism. Steeped in the Roman frescos of Raphael, Rethel attained monumentality even in the study of the head. In the face of the emperor, he captured the expression of a man who has recently died, in which the distinction between sleep and death is unclear, an impression that is enhanced by the veil covering his head.

<div align="right">G. L.</div>

Bibliography: Valentin, 1896, color pl. 1; Ponten, 1911, color pl. p. 94; Berlin, 1926, no. 138; Düsseldorf, 1956, no. 87; Heise, 1959, fig. 79; Einem, 1968, p. 21 f., fig. 5; Bernhard, 1973, p. 1349; Paris, 1976–77, no. 188; Bern, 1985, no. 184, fig. 295

103
Charlemagne's Entry into Pavia, 1844

Black ink, brown wash, over graphite
488 x 643 mm.
Provenance: acquired in 1897 from the artist Carl Rudolph Sohn, Düsseldorf
Dresden, c 1897–79

The *Entry into Pavia* is one of two compositions that were added to the commission after the restoration of the Imperial Chamber to its original shape. The last of the frescos executed by Rethel himself, it was severely damaged by bombs in 1943–44, and restored after the war. In executing the fresco, Rethel had to adapt the rectangular composition of the drawing to a wall that terminates in a Gothic arch, and, as a result, the grandiose effect of the composition suffers to some extent.

Our drawing depicts the entry of the victorious Emperor Charlemagne into Pavia in the year 774, the captured iron crown of Monza in his left hand, the sword in his right. Charlemagne had helped the pope against his own former father-in-law Desiderius, the king of the Langobards, and crowned himself king of Italy with the iron crown. The captive King Desiderius and his wife are standing at the right, next to the bishops on horseback, and are turning away from the scene.

<div align="right">G. L.</div>

Bibliography: Ponten, 1911, fig. p. 1908; Franke, 1921, p. 21 f., fig. p. 82; Aachen, 1959, no. 314

104
Death Rides to the City, 1848–49

Graphite
229 x 329 mm.
Provenance: acquired in 1908 from the collection of Eduard Cichorius
Dresden, c 1908–432

This is the second and final study for plate 2 of the woodcut series *Auch ein Totentanz* (*Another Dance of Death*). Rethel executed the drawing in the winter of 1848–49 in Dresden. The theme of mortality pervades the artist's *oeuvre*; even as a fifteen year old, he executed scenes of heroic and sacrificial death. Rethel's series of

six woodcuts, however, grew directly out of the revolutionary events of 1848 in Germany. The unusually large number of publications that appeared from the 1820s through the 1840s on the history of the theme of the dance of death in literature and art may also have influenced him. Hans Holbein's famous *Dance of Death*, republished in Munich in 1832, must have impressed Rethel most profoundly, and may explain the title of his series.

Rethel's technique recalls the clean contours and clear modeling of woodcuts by Holbein and his contemporaries. Like Holbein, Rethel combined realism and allegory, and achieved a broad effect in his *Totentanz*. Death wears the attire referred to at the time as a "Hecker habit." Friedrich Hecker (1811–1881), a lawyer from Baden who had participated in the revolution there, wore high wading boots and a Calabrian hat with a rooster feather. After the revolution was put down in 1849, this kind of hat was outlawed in Saxony because it was regarded as a sign of a revolutionary disposition.

<div align="right">G. L.</div>

Bibliography: Ponten, 1911, p. xlviii; Franke, 1921, p. 28, fig. 95; Düsseldorf, 1956, no. 91, illus.

105
Death as Victor, 1848–49

Graphite
Verso: Rejected version of the same subject
331 x 483 mm.
Provenance: acquired in 1908 from the collection of Eduard Cichorius
Dresden, c 1908–102

This is the study for the final plate of the woodcut series *Auch ein Totentanz* (see also Cat. No. 104). Here, Death appears naked and undisguised as the victorious seducer of the people. The message of this pessimistic work is that Death—not the justice they sought through revolution—has conquered the deceived people. Rethel unequivocally revealed his democratic disposition in a letter to his mother of 8 May 1849: "A few hours ago the horrible catastrophe in this city [Dresden] was decided in favor of the military and thus also the king . . . a grand and glorious testament to the honor of

Germany has fallen under cold-blooded, calculating military force and the saber. I viewed the rise of this movement with mistrust and expected a red republic, communism with all of its consequences. However, it brought about, through the truly unified and—in the most elevated sense—proud enthusiasm of the people, the establishment of a great and noble Germany—a mission placed in their breast by God, and not by the radical prattle of second-rate newspapers and orators."

<div align="right">G. L.</div>

Bibliography: Ponten, 1911, p. xlix; Franke, 1921, p. 28, fig. p. 99; Düsseldorf, 1956, no. 97

MORITZ LUDWIG VON SCHWIND
Vienna 21 January 1804 – 8 February 1871 Munich

Schwind, the son of a court official, attended the Vienna Academy from 1821 to 1823, studying under Ludwig Schnorr von Carolsfeld and Peter Krafft. It was during this period that Schwind executed his first illustrations, an activity he continued into his old age. In Vienna, where he frequented the circle of his friend Franz Schubert, Schwind concentrated on watercolors and designs for paintings of Romantic subjects. In 1828 he moved to Munich, where he established a relationship with Peter Cornelius. From 1832 to 1834 Schwind carried out his first fresco commission, the Tieck Saal of the Munich Residenz, and others soon followed. He spent a few months in Italy in 1835. From 1840 to 1844 Schwind lived in Karlsruhe, where he married. He spent the next three years in Frankfurt am Main, and in 1847, settled in Munich, where he was appointed professor at the Academy. With his woodcuts for the *Münchner Bilderbogen* and the *Fliegende Blätter*, he reached the summit of his achievement as a graphic artist. From 1853 to 1855 he executed frescos in the Wartburg Castle near Eisenach, and from 1864 to 1867 he was occupied with the murals in the Vienna opera house. Schwind painted—in both oil and watercolor—cycles of scenes from fairy tales and a series of "travel pictures" (twenty-three of which are in the Schack Galerie, Munich), many based on drawings made in his youth. Schwind's Late

Romanticism varies from lofty monumental works to fairy-tale idylls to humorous, idealized representations of contemporary scenes. Taking inspiration from history, fable, and woodland folklore, he added a touch of rich, melodic beauty to the figure style of the Cornelius school.

Kupferstich-Kabinett, Dresden: 114 drawings
Nationalgalerie, Berlin: 109 drawings

106
The Apparition of Melusina at the Well, ca. 1840–60
Watercolor, over graphite
291 x 468 mm.
Provenance: acquired in 1886 from Frau E. L. Kirchner, Munich
Berlin, Schwind, no. 25

This drawing depicts the opening scene of an old French legend that had found its way into German literature by the fifteenth century. (The earliest written version of the story appears in the *Histoire de Lusignan* by Jean d'Arras, 1394.) At an isolated spring in a forest, Count Raymond of Lusignan meets the water fairy Melusina. She marries him on the condition that she be permitted to leave him regularly. However, she does not tell Raymond that she will be visiting with the water sprites. When he discovers her secret, she leaves him. After years of unhappiness and living as a recluse, he seeks out the well again, finds the water nymph, and dies from her kiss.

Schwind painted this subject twice. In the fresco cycle devoted to Ludwig Tieck's fairy tales, in the so-called Tieck Saal of the Munich Residenz (1832–34), Schwind represented the legend of Melusina by the scene at the well, where the hunter grasps the hand of the beautiful woman. The work is based on Tieck's "Sehr wunderbare Historie von der Melusina" (*Romantische Dichtungen*, part 2, Jena, 1800). The story does not occur in Tieck's *Phantasus* (1812–16), the source of the remaining subjects of the frescos. In the last years of his life, Schwind again treated the fairy tale, this time in a frieze, *Die Schöne Melusina*. The work was originally intended for a circular temple at the Starnberger See, but wound up in the Österreichische Galerie, Vienna. This version is quite similar

to the one in Munich, and also shows the betrothal at the well, with the knight kneeling before Melusina. Although the frieze was executed between 1867 and 1869, the design for it was completed by 1865, and Schwind was seriously occupied with it as early as 1859 (letter to E. J. Hähnel, 1 June 1859). Schwind describes the execution of the frieze in a letter of 28 January 1870 to the poet Eduard Mörike. Its composition departs from Tieck's text in many details, and is apparently based on another version of the legend.

Our watercolor dates from the period between these two frescos. The scene it depicts has an exact counterpart in the opera *Melusina* (music by Konradin Kreutzer, libretto by Franz Grillparzer), which opened in Vienna in 1833. In the fourth scene of the first act, Count Raymond falls asleep at an old well, to which he keeps returning because of a puzzling premonition. In his dream Melusina appears with her two sisters and speaks to him, reaching out her hand: "Sleep, so that the soul may wake!" She declares her love for him, persuades him to join her in her water kingdom, and gives him the following to consider: "Do you cling to what is real and true? Dream envelops us, since we are dreams. That which charms you never changes." All of the motifs in the opera agree with those of the drawing, which lacks only the troll supplied by Grillparzer to warn the young hunter. Schwind knew the opera long before its premiere; in a letter to Franz Schubert of 25 July 1825, he reported that he had visited the author and that the *Melusina* libretto, which Schubert hoped to obtain, was already promised to another. (This was Beethoven; after both he and Schubert died, it was Kreutzer who set the text to music.) Schwind and Grillparzer continued their relationship well into Schwind's old age—the year he died, Schwind executed drawings (Berlin, Nationalgalerie) based on Grillparzer's drama *Weh dem, der lügt*—so there is little doubt that it was Grillparzer's version of *Melusina* that persisted in the artist's mind.

In the watercolor, which probably dates from the 1840s or 1850s, Schwind used the double motif of a spied-upon sleeper and an apparition in a dream—themes that pervade his *oeuvre* from beginning to end—and gives expression to the Late Roman-tic longing for deliverance from the limitations of everyday reality. The Nationalgalerie owns several studies for the frescos in the Tieck Saal of the Munich Residenz (Schwind, nos. 52–54, 66), and for the frieze (Schwind, nos. 72–76).

<div align="right">C. K.</div>

Bibliography: Donop, 1902, no. 25; Berlin, 1904, no. 391; Berlin, 1906, no. 3170; Berlin, 1965, no. 247, fig. p. 238

BONAVENTURA GENELLI
Berlin 28 September 1798 – 13 November 1868 Weimar

Genelli studied at the Berlin Academy from 1814 to 1819. During the decade he spent in Rome (1822–32), he belonged to the circle around Joseph Anton Koch, Johann Christian Reinhart, and Johann Martin Rohden, who encouraged him to develop a classicizing style. In 1832 he traveled to Leipzig to execute a commission for a mural, but the project was never realized. Genelli settled in Munich in 1836. From 1856 until his death he carried out commissions for Count Schack. He was summoned to the Weimar court in 1859.

Nationalgalerie, Berlin: 80 drawings
Kupferstich-Kabinett, Dresden: 77 drawings

107
A Wake, ca. 1840–60
Graphite, black chalk
330 x 780 mm.
Signed, lower right, *B. Genelli*
Provenance: acquired in 1937 from the estate of Dr. Friedrich Lahmann
Dresden, C 1937–1409

I am indebted to Hans Ebert for the following information. This drawing is one of ten variations by Genelli on the theme of Apollo among the Shepherds. The artist dealt with this subject for the first time in 1829 in Rome, and from 1837 on, he freely executed variations of it, in which he assigned Apollo the role of consoler. In this sheet, Apollo is absent altogether; hence, it is entitled simply *A Wake*. On the other hand, the composition of another drawing, *Apollo among the Shepherds* (Ebert, 1960, p. 46), is so similar to

that of our work that the thematic connection is clear. In that drawing, the space is narrower, the staffage reduced, and Apollo sits with a lyre on a piece of square masonry. In our drawing, a figure reminiscent of Bacchus or Silenus takes the sun god's place, with a goat and a standing boy. According to a letter from Genelli to his friend Dr. Giovanni Morelli of Bergamo, the beautiful ram was the favorite animal of the dead shepherd.

G. L.

Bibliography: Ebert, 1960, no. 521

VII. REALISM AND BIEDERMEIER

FERDINAND VON RAYSKI
Pegau (Saxony) 23 October 1806 – 23 October 1890 Dresden

Rayski, whose father died at the Russian front in 1813, lived from 1814 to 1816 in the home of Count Friedrich von Beust in Dresden. From 1816 to 1821 he took drawing lessons from Karl Gottfried Traugott Faber at the Freemasons' institute in Dresden-Friedrichstadt. From 1821 to 1825 Rayski was enrolled in the royal cadet corps and at the Dresden Academy. He served as a second lieutenant under the duke of Anhalt-Bernburg in Ballenstedt from 1825 to 1829. Back in Dresden from 1831 to 1834, he continued his training at the Academy. Rayski visited Paris in 1834–35, and then stayed with friends and relatives in Trier, Frankfurt am Main, Mainsondhausen (Franconia), Würzburg, Munich, Coburg, Danzig, and Düsseldorf. From 1840 until his death, the artist resided primarily in Dresden. He traveled in England with Count von Einsiedel in 1862. Rayski's pioneering role in the development of Realism was not recognized during his lifetime.

Kupferstich-Kabinett, Dresden: 120 drawings, 1 sketchbook with 159 pages, 1 album with 59 drawings
Nationalgalerie, Berlin: 28 drawings

108
Portrait of Karl Friedrich von Broizem, 1842
Charcoal
235 x 172 mm.
Provenance: acquired in 1908 from Abbess A. von Jena, Halle
Dresden, c 1908–25

Privy Military Councilor Karl Friedrich von Broizem (1770–1846) was an uncle of the artist, who helped raise and educate Rayski and his five siblings after the early death of their father in 1813. In 1840 Rayski executed two paintings of his uncle (Walter, 1943, nos. 473–74). This drawing is a study for a third portrait, painted in 1842 when von Broizem was seventy-two years old (Walter, 1943, no. 493).

G. L.

Bibliography: Dresden, 1928, no. 340; Walter, 1943, no. 492

109
Cavalry Battle
Charcoal, graphite
240 x 480 mm.
Provenance: acquired in 1908 from Abbess A. von Jena, Halle
Dresden, c 1908–42

This drawing may be connected with the painting of the battle of Borodino that Rayski executed for Utz von Schönberg in Purschenstein. The battle between the Russian army under Mikhail Kutuzov and the Grande Armée of Napoleon I took place on 7 September 1812, and enabled the French emperor to enter Moscow. In 1834 Rayski painted *Infantrymen in the Snow*, a deeply moving scene of the retreat of Napoleon's troops. Saxony, like most of the German principalities, was allied with Napoleon and had to provide troops. The artist was apparently moved to depict these subjects by the fate of his father, who died a Russian prisoner in 1813, and by the stories of his friend Lieutenant General von Leyser, who had participated in the Russian campaign as a commanding officer. Rayski, who was familiar with military procedures, here shows two cavalry formations charging each other. The focal point is the officer with his arm raised before a blazing

sky and whirling clouds of powder and dust. The sketchy quality of the drawing strengthens the drama of the scene.

<div style="text-align: right">G.L.</div>

Bibliography: Dresden, 1928, no. 339; Goeritz, 1942, p. 39, illus.; Walter, 1943, no. 76

RUDOLF VON ALT
Vienna 28 August 1812 – 12 March 1905 Vienna

The son and pupil of the landscape painter Jakob Alt, Rudolf enrolled at the Vienna Academy in 1826. During extensive annual travels—initially with his father—Alt executed drawings and watercolors of landscapes in the Austro-Hungarian Empire and in Italy. He also painted numerous watercolors of interiors. Oil painting gradually yielded to a preference for watercolor, and Alt became one of the nineteenth century's most brilliant masters of the medium. His keenly observed *plein-air* Realism, his often highly original viewpoints, and his feeling for the characteristic details of the period have much in common with Menzel.

Nationalgalerie, Berlin: 22 drawings
Kupferstich-Kabinett, Dresden: 4 drawings

110
The Cloister of San Giovanni in Laterano in Rome, 1835
Watercolor, over traces of graphite
277 x 385 mm.
Dated, on the verso, *den 22t Juny 1835*; additional inscriptions in another hand
Provenance: Friedrich Jakob Gsell, Vienna; acquired in 1930 at the sale of the collection of Dr. Albert Figdor, Berlin; transferred in 1937 from the General Administration of the Staatliche Museen, Berlin
Berlin, Alt, no. 21

In 1835 the twenty-three-year-old artist traveled to Italy with his father Jakob Alt, and stayed for the first time in Rome (where he became acquainted with Moritz von Schwind and King Ludwig I of Bavaria, among others), before continuing south to the region of Naples. During this sojourn he produced a number of important watercolors of ancient architecture bathed in streaming sunlight suggested by endlessly varied, contrasting warm and cool tones.

The venerable Basilica of San Giovanni in Laterano, founded during the reign of Emperor Constantine the Great (288–337), was considered the *mater et caput ecclesiarum*, the *universalis Ecclesia*, as long as it was the seat and burial place of the popes (until 1308). While the basilica itself was remodeled several times, the cloister—built between 1222 and 1230 by Vassalletto, and a characteristic example of Cosmati work, with mosaic-covered walls and columns—has been preserved. Its graceful forms must have fascinated the young painter, who translated the colorful arcades and the courtyard planted with roses into a picturesque mélange of varying hues of gray, old rose, and ocher. Tiny red dots are scattered over much of the sheet, animating nearly a third of the picture surface with the shimmering color of blooming roses. Alt creates the illusion of a closely observed wealth of detail, despite the free and facile brushwork and the thin, transparent color, which he applied with a dotting technique, rather than in fluid strokes. The projection of minute structures over a large part of the sheet—a virtuoso performance for the *plein-air* painter—characterizes many of Alt's works, particularly those of his later years (for example, *From the Kurpark at Teplitz*, 1875, Vienna, Graphische Sammlung Albertina). An echo of this approach is discernible after 1900 in the landscapes of Gustav Klimt.

Alt painted several views of the cloister (private collection; Koschatzky, 1975, no. A.V. 37/39; and 1838, Vienna, Albertina; Koschatzky, 1975, no. G.K. 33) and of its interior (1835, Vienna, Albertina; Koschatzky, 1975, no. A.V. 35/29). In 1838 he executed a painting of the church for Emperor Ferdinand's peep-show series (Koschatzky, 1975, no. G.K. 33). Thirty years after his first sojourn in Italy, Alt wrote of the watercolors that he produced during one of his later trips: "I wonder how I will like them now, and whether they are better than those from '35," adding, "In my opinion, no!" It was with good reason that Alt felt these works set a standard; they were an early high point in an *oeuvre* that marked a unique achievement in European *plein-air* Realism.

<div style="text-align: right">C.K.</div>

Bibliography: Boetticher, 1891, I/1, no. 13 (?); Hevesi, 1911, no. 102; Koschatzky, 1975, pp. 59, 264, no. A.V. 35/30

111

The Arch of Titus and the Basilica of Maxentius in the Roman Forum, 1835

Watercolor, over traces of graphite
Verso: Sketches, in graphite
266 x 367 mm.
Dated, on the verso, *2t July 1835*; additional inscriptions in another hand
Provenance: Friedrich Jakob Gsell, Vienna; acquired in 1930 at the sale of the collection of Dr. Albert Figdor, Vienna; transferred in 1937 from the General Administration of the Staatliche Museen, Berlin
Berlin, Alt, no. 20

Erected by Emperor Domitian after A.D. 81 and dedicated to his predecessor Titus and the latter's victory over Jerusalem, this is the earliest extant triumphal arch in Rome. It was incorporated into the city walls during the Middle Ages, uncovered by Pope Pius VII, and restored and extended by Giuseppe Valadier in 1822. Alt's watercolor shows the view from the southwest (from the Colosseum). To the right are the monumental barrel vaults of the partially preserved Basilica of Maxentius, or Constantine (A.D. 306–12), where a colossal statue of Constantine once stood. This "last word in Roman greatness, majestic even in ruins," has had "an endless influence on the history of architecture down to the plans for St. Peter's and modern railroad station halls" (Ernst Curtius, *Das antike Rom*, 1944, p. 38).

Alt saw the Roman Forum before the great excavations that began after 1848. A mere four years after Alt's stay in Rome, the philosopher Friedrich Theodor Vischer recorded his impressions of the Forum in a letter of 5 December 1839: "Roma! One hears the muffled thunder of the ancient triumphal chariots along the Via Sacra, the remains of which I now walk upon. Here one can still detect traces of the ancient wheel track under the triumphal Arch of Titus, where one can still see in the relief the candelabrum from the Jewish temple that the victors brought back from Jerusalem." The amazement of this man of the Biedermeier period—"To walk about here, a sharp-nosed, blond, and straight-haired German, where all the great as well as all the horrible men of antiquity walked"—finds a certain parallel in Alt's work: the mundane character of the staffage contrasts with the monumental view upward toward the triumphal arch. The minute, but in individual passages notably free and fluid, application of color does not always follow the preliminary sketch beneath it, at least in the staffage; one can distinguish, for example, a sketch of an additional female figure to the left of the two women, near the middle of the sheet, which was not worked up with watercolor.

This composition was perhaps executed twice in the same year. Walter Koschatzky mentions two depictions of the Arch of Titus (1975, nos. 34/34, 35/35h), though he does not conclude whether or not they are identical. Alt executed a smaller watercolor of the Arch of Titus in 1840 (Koschatzky, 1975, no. 40/38), and two others in 1872 (Koschatzky, 1975, nos. 72/10, 72/11). A small, vertical oil painting of 1837 depicts the left three-fifths of our watercolor: the viewpoint, the staffage near the arch, and even the lighting are identical; however, a large tree is added at the left, concealing the circular building visible in the watercolor.

C. K.

Bibliography: Hevesi, 1911, p. 103; Koschatzsky, 1975, pp. 59, 264, no. 35/35

FRANZ KRÜGER

Grossbadegast (near Köthen, Anhalt) 10 September 1797 – 21 January 1857 Berlin

The earliest influence on Krüger's art was the work of the landscapist Carl Wilhelm Kolbe the Elder, whom he met in Dessau. Krüger enrolled in the Berlin Academy in 1812, and he showed military and hunting scenes in the 1818 Academy exhibition. The patronage of the royal family, particularly of Prince August, and of high military officers like Count von Gneisenau helped Krüger become Prussia's leading painter of portraits and military subjects. He is best known for his large parade pictures and scenes of homage, which were commissioned by the ruling houses of Russia and of Prussia. He became a member of the Berlin Academy in 1825. Krüger traveled frequently to St. Petersburg to execute, or make studies for, commissions awarded by Czar Nicholas I. His

compellingly accurate portrait studies, which number in the hundreds, were often reproduced as lithographs, and are vivid documents of many celebrities of the Berlin Biedermeier.

Nationalgalerie, Berlin: 550 drawings
Kupferstich-Kabinett, Dresden: 35 drawings

112
Self-Portrait in Ill Health, 1826
Black chalk, heightened with white, on light brown paper
227 x 176 mm.
Provenance: acquired in 1882 from Frau von Horn, Berlin
Berlin, Krüger, no. 1

Walter Weidmann dates this self-portrait securely to 1826 on the basis of the artist's age. Krüger, who was appointed court painter in 1825, appears to be about thirty years old and suffering from a debilitating illness. The compelling realism of Krüger's drawing style—one of the great accomplishments of the Berlin artists, from Chodowiecki and J. G. Schadow to Menzel and Liebermann—is combined here with his exceptional gift for capturing a likeness, which he demonstrated in hundreds of lively portraits of his contemporaries.

G. R.

Bibliography: Weidmann, 1927, p. 120, fig. p. 15

113
Studies of Russian Military Uniforms, ca. 1832–47
Graphite, watercolor, gouache
327 x 539 mm.
Inscribed with numerous annotations and color notes
Provenance: transferred in 1877–78 from the Kupferstichkabinett, Königliche Museen
Berlin, Krüger, no. 20

This sheet is one of a series of fifty drawings of Russian army officers and soldiers. According to Krüger's inscriptions, it represents Sergeant Goreloff of the Don Cossacks, Cossack Baloff of the Crimean Tatars, and Sergeant Stiroff of the Grodno Hussars, all in dress uniforms. Because of the Romanov-Hohenzollern

dynastic connections, Krüger, as court painter, was invited to visit St. Petersburg several times (1832, 1837, 1844, 1847). We do not know which of these visits provided the occasion for our study, in which the compelling likenesses and the detailed depiction of the uniforms attest to Krüger's great ability as a portraitist. The large number of similar studies suggests that he was preparing another of his brilliant parade pictures—one that was perhaps never executed.

G. R.

114
The Ballet Master Paul Taglioni and His Wife, the Dancer Amalie Taglioni, ca. 1838
Graphite, watercolor
377 x 229 mm.
Provenance: transferred in 1877–78 from the Kupferstichkabinett, Königliche Museen
Berlin, Krüger, no. 199

In 1829 Krüger completed a large painting, commissioned by the St. Petersburg court, of a military parade on Berlin's showcase boulevard, Unter den Linden. It depicts King Friedrich Wilhelm III reviewing a regiment of cuirassiers led by Crown Prince Nicholas (later, Czar Nicholas I), an event that actually took place in 1822. In 1837 Krüger was once again commissioned to paint a picture of the same sort of event: the First Regiment of Guards, led by Prince Wilhelm (later, King and Emperor Wilhelm I), on review before the king on the Schloss Platz in Berlin.

The spectacle of the parade played a special role in the consciousness of the period, both as an event and as a pictorial theme. It seemed natural to combine, in a painting, the pageantry of the military ceremony and a fictional audience made up of recognizable individuals. "He presented, as it were, two parades to the viewer" (Weidmann, 1927). With his two Berlin parade scenes (later followed by another that takes place in Potsdam, and a similarly conceived *Homage to the King*), Krüger, incorporating ideas taken from French painting, became the master of this particular genre.

Across the middle- and foreground of his second large parade painting of 1839 (250 x 390 cm.; Potsdam), Krüger spread a panorama of almost 250 personalities of the Berlin Biedermeier. Among the many notables of that city, Paul Taglioni (1808–1884), later the director of the Royal Ballet, and his wife Amalie, née Galster (1806–1881), a ballerina, occupy a particularly prominent place. The precise preliminary drawings for this work (Berlin, Nationalgalerie) are penetrating portrait and figure studies, such as this one. At a time when the newly discovered photographic process could not yet be put to practical use, both the artist and his sitters wanted a portrait to be as exact a likeness as possible, and Krüger was one of the outstanding portraitists of his time. This is evident in every one of the hundreds of his portrait drawings that survive.

G. R.

Bibliography: Weidmann, 1927, p. 114 f., frontispiece

EDUARD GAERTNER
Berlin 2 June 1801 – 22 February 1877 Zechlin (Mark Brandenburg)

The son of an unemployed master chairmaker, Gaertner took his first drawing lessons in Cassel between 1806 and 1813. Upon returning to Berlin, he studied painting at the royal porcelain factory, where he remained until 1820–21. He was an assistant in the atelier of the theatrical scene painter Karl Wilhelm Gropius from 1821 to 1825. During this period, he also executed works of his own, and exhibited his first watercolor in 1822. From 1825 to 1828 Gaertner was in Paris, where he worked in the studio of Jean-Victor Bertin. Back in Berlin, he became increasingly successful as a painter and watercolorist specializing in topographic and panoramic views of Berlin and of Moscow, and produced an occasional portrait. Gaertner became a member of the Berlin Academy in 1833. From 1837 to 1839 he visited Moscow and St. Petersburg, and later traveled to Prague, East and West Prussia, southern Germany, Austria, the Harz Mountains, and the Baltic coast. His productivity declined in his old age, commensurate with the di-

minishing demand for his work. Gaertner's *oeuvre* represents a specific phase of the Berlin Biedermeier. He elevated traditional *veduta* painting to the level of *plein-air* Realism: urban space understood as landscape. About 1870 Gaertner retired to the small town of Zechlin in Mark Brandenburg.

Nationalgalerie, Berlin: 84 drawings
Kupferstich-Kabinett, Dresden: 3 drawings

115

Beneath the Pont des Arts in Paris, 1826
Watercolor (unfinished), over graphite
295 x 440 mm.
Signed and dated, lower right, *Ed. Gaertner f. / Paris 1826*
Provenance: gift of the artist's daughter-in-law Frau Pauline Gaertner, Berlin, 1915 (with sixty-two other sheets)
Berlin, Gaertner, no. 52

Although it never attained the status of Rome, Paris was an important training and study center for a succession of Prussian artists during the Napoleonic era, and it remained so even after 1815. With the help of a royal stipend, the young Gaertner spent three years in Paris (1825–28), where he probably worked in the studio of the landscape painter Jean-Victor Bertin, who slightly earlier had taught Camille Corot. It was in Paris that Gaertner produced his first mature works, and that his preference for watercolor took root. Until late in his life, he would continue to paint many fine and meticulously finished watercolors.

A detailed pen drawing (Berlin, Märkisches Museum; Wirth, 1979, no. 158) served as a study for this sheet, which was clearly not a spontaneous creation. The unfinished area at the left—where, as the preliminary sketch attests, a self-portrait was to appear—provides some insight into the artist's working method. The view is from the Right Bank of the Seine near the Louvre, beneath the Pont des Arts, toward the Pont Neuf and the tip of the Ile de la Cité, where the rue Dauphine begins behind the statue of Henry IV (restored in 1818). Because of the low point of view, the towers of Notre-Dame remain hidden. The foreground is dominated by the struts of the footbridge, built in 1803–4,

which leads from the Louvre to the Institut de France. Pedestrians who used this bridge were charged a toll.

The cold, modern form of this technical marvel, one of the first iron structures erected in Paris, seems to have appealed to Gaertner. In this respect he superficially resembles the older Berlin artist Johann Erdmann Hummel (1769–1852), who frequently depicted motifs of extreme rationalism. However, in our water-color, the severity of the impersonal arched structure underscores the delicate handling of the luminous view in the distance. Of all the architectural painters to come out of Berlin during the Bieder-meier period, Gaertner, who portrayed urban spaces as land-scapes, interpreted in the spirit of *plein-air* Realism, was by far the most important.

<div align="right">C.K.</div>

Bibliography: Berlin, 1977, no. 28; Wirth, 1979, pp. 21, 243, no. 59, fig. 19; Berlin, 1987, no. F44, color pl. p. 257

116
The Klosterstrasse, with the Parochialkirche, 1829
Watercolor, over graphite
377 x 291 mm.
Signed and dated, lower right, *E.G. fec. / 1829*
Provenance: bequest of the artist's daughter-in-law Frau Pauline Gaertner, Berlin, 1925
Berlin, Gaertner, no. 72

At the Berlin Academy in 1828, the twenty-seven-year-old Gaert-ner mounted an exhibition of works he had done in Paris. As a result of this show, the artist immediately became well known in the Prussian capital, and even the king acquired several of his pieces. The Klosterstrasse, which runs along the eastern edge of old Berlin by the medieval city wall (remnants of which still exist today), was a subject Gaertner took up that same year in a hori-zontal grisaille watercolor (Berlin, Gaertner, no. 3; Wirth, 1979, no. 165, erroneously described as lost), and in many of his later works (Wirth, 1979, nos. 9, 11, 164–65, 168, 174–75, 184). This watercolor served as the model for a more or less contemporary

lithograph (Wirth, 1979, no. 522) and for a steel engraving of 1833 (Wirth, 1979, no. 540) that was included in Samuel Spiker's album *Berlin und seine Umgebungen im neunzehnten Jahrhundert.*

The Parochialkirche, built in 1695 for Berlin's growing Protes-tant population, was one of three churches on the Klosterstrasse. The building was begun by Johann Arnold Nering, on a central plan in the form of a Greek cross, and continued by Martin Grün-berg. The tower, built by Philipp Gerlach after a plan by Jean de Bodt, was erected in 1713–14, and equipped with a carillon known as the "Singuhr" that was donated by King Friedrich Wilhelm I. According to Spiker, "Should ever the dilapidated condition of the church necessitate the removal of the tower, and should the tower not be rebuilt as it was, this sheet would take on even greater value as a record of how the church once appeared." Al-though damaged during the war, the church still stands today, as does the large, light-colored building next to it, which was also designed by Jean de Bodt (1701–4) and belonged in turn to State Minister von Podewils, to the manufacturer Huot, and—during Gaertner's time—to another manufacturer, Brendel.

In the rendering of the architecture, Gaertner's watercolor may be compared to one of Johann Georg Rosenberg's famous 1786 etchings of Berlin. Rosenberg's print shows the Klosterstrasse from the same vantage point—from the southern end looking north toward the Stralauerstrasse—and reveals that nothing had changed in over forty years. Despite the outward similarities that encourage this comparison, Gaertner obviously strove for some-thing more than an architectural view. With typical Biedermeier attention to the diversity of everyday life and to significant details, but with no attempt to make the scene anecdotal, he portrays the pursuits of all different classes of people in an almost provincial neighborhood, where many Jews, among others, were estab-lished. The soft light of late afternoon, at its brightest only on the two buildings in the background, blends with the many vertical accents that offset the diagonals of the house fronts to create a mood of quiet solemnity.

<div align="right">C.K.</div>

Bibliography: Berlin, 1977, no. 30; Wirth, 1979, p. 244, no. 173, fig. 89; Berlin, 1987, no. F45 (with incorrect Wirth number), fig. p. 27

ADOLPH FRIEDRICH ERDMANN VON MENZEL
Breslau 8 December 1815 – 9 February 1905 Berlin

Menzel's father began his career as a school principal, and later established a lithographic press. His mother was the daughter of a drawing instructor. The family moved to Berlin in 1830 to provide their gifted son with better educational opportunities. When his father died suddenly in 1832, the sixteen-year-old Adolph carried on the lithographic business and supported his mother, sister, and brother. In 1833 he briefly attended Academy classes in drawing from plaster casts, but otherwise continued his training on his own, while earning a living as a lithographer. His earliest recognition came in 1834 with the series of lithographs illustrating Goethe's *Künstlers Erdenwallen*. He was admitted to the Jüngerer Künstlerverein of Berlin and began to receive important commissions: from 1839 to 1842 he worked on 400 wood-engraved illustrations for Franz Kugler's *Geschichte Friedrichs des Grossen*; from 1842 to 1857 he executed 436 pen lithographs for *Die Armee Friedrichs des Grossen*; and from 1843 to 1849 he designed 200 wood engravings for the luxury edition *Werke Friedrichs des Grossen*. While reinvigorating the art of the wood engraving, Menzel began to paint. In 1845 he executed *Balcony Room*, the most famous of the pre-Impressionist landscapes and interiors that were probably inspired by a recent Berlin exhibition of the work of Constable. Menzel's ambition to paint large history pictures remained unfulfilled after he abandoned the "Cassel Cartoon" in 1847. He never finished *The Honoring of the Insurgents Killed in March 1848* because of his disillusionment with the outcome of the revolution. In 1849 he began an uncommissioned series of large paintings of scenes from the life of Frederick the Great, including the *Party at Table*, the *Flute Concert*, and the *Battle of Hochkirch*. Menzel undertook his first lengthy study trip through Germany in 1852. In later years he traveled annually to southern Germany and Austria, where he became particularly interested in the Baroque architecture. In 1855 he visited Paris for the first time, and in 1861 he attended an artists' convention in Antwerp, where Courbet delivered a manifesto on Realism. Menzel received the commission for the painting *The Coronation of Wilhelm I in Königsberg* in 1861, and completed the picture four years later; thereafter, he was invited to the court festivities. Later, the artist turned to the portrayal of life in the large modern city, and also created the "Children's Album" for the children of his sister Emilie, with whose family he lived until his death. In 1866 he made a tour of the regions affected by the war between Austria and Prussia, and in 1867 and 1868 he went to Paris to attend the Exposition Universelle. From 1872 to 1875 Menzel worked on the uncommissioned *Iron Rolling Mill*, the first German painting of an industrial site in which workers play the dominant role. In 1876 he designed 30 wood-engraved illustrations for the jubilee edition of Heinrich von Kleist's *Der zerbrochene Krug* (1877), and made a trip to Holland. He visited northern Italy in 1881 and 1882. The greatest of Menzel's many honors was his appointment to the Order of the Black Eagle, Prussia's highest order, which also made him a member of the aristocracy.

Nationalgalerie, Berlin: 6,190 drawings, 70 sketchbooks
Kupferstich-Kabinett, Dresden: 17 drawings

117
Two Views of a Wooden Gate and Leafless Shrubs, ca. 1843–44
Graphite
209 x 130 mm.
Provenance: acquired in 1906 with the estate of Adolph Menzel
Berlin, Menzel, N 414

The sharp, delicate, and sometimes vigorously wielded graphite pencil, and the careful hatching date this work to about 1843–44. In his contemporary *Radierversuche* Menzel dealt primarily with the subject of landscape (six etchings and etched title page, Berlin, 1844; Bock, 1923, nos. 1137–47). Menzel drew landscapes throughout his life, and only in his last years did he move somewhat toward a preference for figural representation. In addition to making his own drawings from nature, he particularly studied those of Jean-Jacques de Boissieu (1736–1810) and those of Rembrandt (1606–1669). In a letter of 22 July 1843 Menzel wrote to his friend Karl Arnold, "In the meantime, I am studying etching and would really like to accomplish something in this medium. It is

altogether different in every respect . . ." (Wolff, 1914, p. 78). In another letter to Arnold, on 23 April 1844, Menzel began by expressing his thanks for a gift of prints by Boissieu, whom he counted among "the greatest fellows in drawing and etching," and continued: "Moreover, I am spending a lot of time in the Kupferstich-Kabinett, enjoying the etchings of the Dutch—above all, those of Rembrandt, who is and will remain the solitary genius in this field; the more one studies him, the more one admires him, not only because of his lighting effects, but also because of his compositions, knowledge of nature, sense of form!" (Wolff, 1914, p. 79). The true subjects of Menzel's small landscape etchings of the environs of Berlin are the atmospheric effects and the delicate chiaroscuro. The linear prevails in them over the painterly, which comes to the fore in his drawings and paintings from the second half of the forties.

M. U. R.

Bibliography: Menzel, 1976, vol. 2, fig. 810

118
Dr. Puhlmann's Bookshelf, 1844

Graphite
269 x 210 mm.
Signed and dated, lower left, *Ad. Menzel / 44. / Potsdam*
Provenance: acquired in 1906 with the estate of Adolph Menzel
Berlin, Menzel, N 1027

This drawing of a bookshelf is typical of the many sheets that demonstrate Menzel's fascination with inanimate subjects. In these works, the accidental or the chaotic, even the absurd is emphasized and sometimes pursued, in an almost surrealistic manner, to the point of strangeness. In 1838 Menzel had executed a drawing of three shelves of a bookcase, upon which two skulls are visible among the loosely arranged manuscripts (Stuttgart, Staatsgalerie). The vanitas idea was certainly not far from the young Menzel's thoughts. Empty husks, like the skulls, from which life has escaped—cast-off clothing, empty shoes, empty oyster shells, empty beds, empty armor—constitute a small, discrete category among the many lifeless objects that attracted Men-

zel's eye and that he artfully aroused to disquieting life in these freely composed works. They culminate in *Finale* (whereabouts unknown), a late finished drawing of an empty studio in which a little elephant (a statuette by Antoine-Louis Barye that was given to Menzel by Jean Meissonier) that is hastily walking away is the only allusion to life.

Menzel certainly drew the bookshelves during one of his frequent visits to Potsdam, where, since the late thirties, he had wandered through Sanssouci and its surroundings in search of material for his illustrations of the era of Frederick the Great, and where he visited, as often as possible, his loyal friend, the military physician Dr. Wilhelm Puhlmann (1797–1882). They had known each other since at least 1836, when Puhlmann, whose father had been a painter and a gallery director in Potsdam, and who himself had cofounded the Potsdam Kunstverein in 1834, had procured a commission for Menzel to produce an attractively designed, lithographed membership card for the Kunstverein (Bock, 1923, no. 146). In 1850 Menzel did a gouache portrait of Puhlmann (Berlin, Menzel, N 1713; Tschudi, 1905, no. 226), and the artist's numerous letters testify to his longstanding, deep affection for his friend, who was many years older than he.

M. U. R.

Bibliography: Berlin, 1955b, no. 142; Berlin, 1980, no. 151; Hamburg, 1982, no. 4, illus.; Vienna, 1985, no. 93, illus.

119
Road beside a Park Wall, ca. 1845

Graphite, stumping
128 x 205 mm.
Provenance: acquired in 1906 with the estate of Adolph Menzel
Berlin, Menzel, N 383

This deserted landscape exhibits the painterly, atmospheric quality that characterizes many of Menzel's drawings from the second half of the forties, and aligns them with his pre-Impressionistic landscape paintings, such as *Building Site under the Willows* (1846, West Berlin, Nationalgalerie), *Palace Garden of Prince Albrecht* (1846, West Berlin, Nationalgalerie), and *On the Kreuzberg, near Berlin*

(1847, Berlin, Märkisches Museum). The varied handling of the pencil in the different kinds of foliage cascading over the wall—from the firm, dark stroke to the soft stumping—is similar to that in a drawing by Menzel of October 1845 that depicts a ferry boat and a young woman reading in front of swaying trees (Berlin, Menzel, N 1366).

Our landscape, with high walls on either side of a narrow road leading to a house in the background, is strongly characteristic of the harsh, barren Mark Brandenburg, which relates this work to a drawing of 1847 of the Berlin-Potsdam railroad (Berlin, Menzel, N 1750). The glimpse of the surrounding world that is mirrored with great simplicity and poetry in Menzel's work brings to mind the writings of his fellow countryman and friend Theodor Fontane (1819–1898), a member of the literary group Tunnel über der Spree, who celebrated the charm of this landscape in his *Wanderungen durch die Mark Brandenburg*.

<div align="right">M.U.R.</div>

Bibliography: Berlin, 1955b, no. 135, illus.; Menzel, 1976, vol. 2, fig. 898

120
Unmade Bed, ca. 1846
Black chalk, stumping, heightened with white chalk, on greenish-gray paper
221 x 353 mm.
Signed, lower left, *A.M.*
Provenance: acquired in 1906 with the estate of Adolph Menzel
Berlin, Menzel, N 319

Throughout his career, Menzel had an eye for still-life subjects, which he was able to animate mysteriously, and often dramatically, in his drawings. At first, he found his subjects in the household, and later, everywhere. In his sketchbook of 1836 (Berlin, Nationalgalerie), he drew studies of variously crumpled feather pillows. During this early period, when he earned his living as a lithographer, Menzel studied Dürer's prints, but it is uncertain whether he knew the master's *Study Sheet with Six Pillows* of 1493. For the dramatic scene of Cato sinking into his bed in the throes of death, which appeared as a woodcut vignette in the *Werke Friedrichs des Grossen*, 1843–49 (Bock, 1923, no. 947; cf. also the vignette to the *Epistel an das Bett des Marquis d'Argens*, Bock, 1923,

no. 954), Menzel executed several preliminary studies of his brother lying in a disheveled bed (Berlin, Nationalgalerie; Warsaw, Muzeum Narodowe).

Drawings such as *Unmade Bed* are more than mere studies; they could be considered psychographs, which Menzel constantly produced in addition to his works of a public character. It is but a short step from fascination with material reality to symbol; we glimpse another side of Menzel in these works.

This sheet probably dates from the mid 1840s. In 1847 Menzel painted a view of his bedroom in the Ritterstrasse (West Berlin, Nationalgalerie; Tschudi, 1905, no. 35). Although the bed is veiled by a thin sheet hastily thrown over it, it is no less prominent, occupying nearly all of the foreground in front of the brightly illuminated window at the rear.

<div align="right">M.U.R.</div>

Bibliography: Donop, 1908b, no. 1; Kurth, 1941, pp. 38 f., 95; Berlin, 1980, no. 286; Vienna, 1985, no. 95

121
View from the Roof of the Picture Gallery at Sanssouci,
ca. 1840–47
Graphite
210 x 268 mm.
Provenance: acquired in 1889 from Menzel's dealer Hermann Paechter, of the firm of R. Wagner, Berlin (with an extensive collection of drawings)
Berlin, Menzel, Kat. 1582

While working on the illustrations for Franz Kugler's *Geschichte Friedrichs des Grossen*, Menzel sketched extensively in the palaces and in the park of Sanssouci in Potsdam. In 1842 he executed a drawing of the picture gallery, seen from the front (Berlin, Menzel, Kat. 1584). For the second edition of Kugler's work (1856), Menzel drew seven of Frederick II's splendid buildings as well as the six statues of the king's generals on the Wilhelmplatz in Berlin. These views of buildings, including the picture gallery, were not used and were published only after Menzel's death (cf. Bock, 1923, nos. 815–21). Menzel also drew the staircase and balustrade of the picture gallery for Kugler (Berlin, Menzel, Kat. 1574; Bock, 1923, no. 806).

Our drawing, which may date somewhat later, shows a view from the area of the upper terraces of Sanssouci into the Dutch garden and toward the roof and cupola of the picture gallery, which was built by J. G. Büring between 1755 and 1763. To the right is the rear wall of the grotto of Neptune, with the Jäger-vorstadt in the background. Judging from the garden, Menzel's drawing must have been executed between 1840 and 1847, after the remodeling begun by P. J. Lenné in 1840, but before the 1847–50 renovation of the upper terrace. It is comparable to another sheet of the same size, dated 1844, that shows a similar view from the upper terraces, but looking west toward the Neue Kammern (Berlin, Menzel, Kat. 1572). In that sheet, Menzel shows the shady foliage of the park, in the full bloom of summer, with a dark line filled out by soft stumping, whereas in our drawing, the sharp and delicate strokes of his pencil capture the transparency of the branches in springtime.

M.U.R.

Bibliography: Berlin, 1905, no. 1852; Drescher/Kroll, 1981, no. 320, illus.; Vienna, 1985, no. 1, illus.

122
Horse-drawn Sleigh, Seen from Above, 1846

Watercolor
160 x 260 mm.
Signed and dated, lower left, *A.M. / 46*
Provenance: acquired in 1882 from the estate of Dr. Puhlmann, Potsdam
Berlin, Menzel, Kat. 121

This virtuoso watercolor is certainly one of those occasional works that the artist dashed off and enjoyed giving to his friends. Menzel, who was never without a sketchbook, and later carried several in extra pockets sewn into his coat, drew incessantly, whether he was standing or walking. He used both hands with equal skill, a talent he developed during his youth, when he was employed for several years as a lithographer. Contemporary accounts reveal that he nearly always did works in color in his studio, with his right hand. Menzel selected many random motifs from his sketchbooks for use in compositions in oil, watercolor, or gouache or in mere studies.

A seemingly spontaneous view from a window occurs several times in Menzel's work. It is only natural that these views often include horses and coaches, which Menzel studied in many drawings. In one sketchbook alone, which he started in 1839 and completed in 1846, there are fourteen pages of studies of horse-drawn carriages (Berlin, Nationalgalerie). On one of these, Menzel notes, "From the height of two flights of stairs," and on another, "Looking down from the second floor." Menzel drew horses frequently during the 1840s, because of their particular importance in his illustrations dealing with the era of Frederick the Great as well as in his painting *Battle of Hochkirch* of 1856 (lost during the war; Tschudi, 1905, no. 106).

M.U.R.

Bibliography: Tschudi, 1905, no. 191; Liebermann/Kern, 1927, p. 3, no. 8, color pl.; Berlin, 1980, color pl.

123
At the Concert, 1848

Black chalk, colored chalks
262 x 367 mm.
Inscribed and dated, lower right, *3 Dec: 1848 / Erinnerung aus / musikal Soirée*
Provenance: acquired in 1906 with the estate of Adolph Menzel
Berlin, Menzel, N 4464

Many of Menzel's letters attest to his interest in and knowledge of music (cf. Wolff, 1914), a passion that waned only in his old age. *Hausmusik* was often performed at the artist's home and at the homes of his friends, and the young Menzel regularly attended concerts and the opera. From the 1830s on, his letters contain spirited and critical observations about his musical experiences, and, parallel with these, small pencil studies of the theater and the concert hall crop up again and again in his sketchbooks. We know, for example, that he heard Graun's *Tod Jesu* and Haydn's *Creation* as well as Mozart's concertos, and that he repeatedly saw Mozart's operas *Don Giovanni*, *La Clemenza di Tito*, and *The Magic Flute*, with its "divine music." Menzel not only enjoyed music, he was capable of judging it, which he did seriously and, at times, in his characteristically humorous manner, as in a letter he wrote from

Cassel to his brothers and sisters: "The orchestra is good, but what particularly astounded and shocked me was that Spohr [Louis Spohr, 1784–1859] appears to have no feeling for tempo. To cite only one example of many, the tearful aria went at a trot!" (Wolff, 1914, p. 113).

In the 1840s and 1850s Menzel often executed painterly drawings of scenes from operas and concerts. Many, like this work, were done from memory, which Menzel conscientiously noted. Often, he observed the audience, but he drew the performers as well, as in an 1854 pastel of Clara Schumann at the piano, with the violinist Joseph Joachim (whereabouts unknown). Menzel was a friend of Joachim, and did not like to miss his concerts. In 1859 Menzel's sister Emilie married a friend of the family, the composer and conductor Hermann Krigar. The artist lived with them and their two children until his death, and this close relationship naturally fostered his love of music. In the possession of the Krigar-Menzel family were Menzel's drawings of the room where Beethoven died in the Schwarzspanierhaus in Vienna, and of Beethoven's and Schubert's graves (whereabouts unknown). Menzel revered Brahms, to whom he wrote: "I wanted only to have breathed the same air as you" (cf. Gustav Kirstein, *Das Leben Menzels*, Leipzig, 1919, p. 81). Menzel even endorsed Wagner's latest creations. In 1876 he drew the maestro at the podium in Bayreuth during the premiere of *Der Ring des Nibelungen*. When Hermann Krigar died in 1880, having become the royal music director, it was Menzel who wrote his obituary.

M.U.R.

Bibliography: Tschudi, 1905, no. 214, illus.; Scheffler, 1915, p. 164, fig. 139; Berlin, 1980, no. 11

124
Portrait of Dr. Eitner, 1848
Colored chalks, on brown paper
285 x 225 mm.
Dated, center right, *18 juli / 1848*; signed, lower right, *A.M.*
Provenance: acquired in 1907 from the art dealer M. Ksinski, Berlin
Berlin, Menzel, no. 1752

In the 1840s and 1850s Menzel painted several portraits that were far removed from the Biedermeier artistic conception, and focused much more on the psychological dimension of the sitter. He occasionally worked in pastel, but later gave it up completely; he did not consider it appropriate to all subjects and never used it in landscapes, for example. In a letter to one of his pupils, Carl Johann Arnold, he wrote: "It [pastel] is certainly excluded for anything that has to do with air" (1 June 1848; Wolff, 1914, p. 135).

This is Menzel's first portrait of the author and translator Dr. Karl Eitner (1805–1884), whom he met about 1840. Eitner settled in Weimar in the late 1850s, where a mutual friend, the archaeologist Dr. Adolf Schöll, had been living since 1843. Initially, Menzel and Eitner exchanged letters occasionally and went on a short trip together to Bohemia. In one letter, Menzel enclosed a photograph of himself, which Eitner had requested; in another, Eitner asked Menzel for his opinion of Laurence Sterne's *Sentimental Journey* (cf. Eitner's letters to Menzel, Nuremberg, Germanisches National-museum, archives). Later, they only exchanged greetings through Schöll (cf. W. Deetjen, "Menzels Briefe an Schöll," *Jahrbuch der preussischen Kunstsammlungen* 55, supp. [1934]: 30–40).

Menzel and Eitner probably never saw each other later in life, and it was perhaps the memory of their youthful years that prompted the artist to rework in 1901 a portrait of Eitner that he had executed in gouache in 1850 (Schweinfurt, Schäfer collection; see Tschudi, 1905, nos. 227, 681). In keeping with his late style, Menzel added anecdotal elements to the original half-length portrait of Eitner sitting and reading at the corner of a table before a blank wall. In the second version, Eitner is seated in a wooden armchair and reading, his back to an open window with gathered curtains. To his left is an umbrella, and writing materials and small picture frames rest on the corner of a table to the right. Menzel entitled the picture *Awaiting a Visit*, thus grouping it with his many late drawings and gouaches that capture an incidental moment from everyday life in a kind of narrative snapshot, a far cry from his earlier portraits that focused simply on the sitter himself.

M.U.R.

Bibliography: Scheffler, 1938, p. 111, illus.; Berlin, 1980, no. 10; Vienna, 1985, no. 19

125
Wilhelm, Count zu Schaumburg–Lippe, ca. 1843–49

Graphite, watercolor
202 x 128 mm.
Inscribed, upper right, *Wilhelm regierend Graf / v Schaumburg Lippe / Portug. u. Engl: Feldmarschall / (M.d. Acad 1749) / die Farbe des Gesichts / ist recht. Das Gesicht / an sich aber taugt nichts, das andere / ist besser.*
Provenance: acquired in 1889 from Menzel's dealer Hermann Paechter, of the firm of R. Wagner, Berlin (with a collection of his works pertaining to Frederick the Great)
Berlin, Menzel, Kat. 1202

In 1839 Menzel began to focus intensively on the period of Frederick the Great. After completing the 400 woodcut illustrations for Franz Kugler's *Geschichte Friedrichs des Grossen* in 1842, he started to work on 436 pen lithographs for the so-called *Armeewerk* (published in three volumes by Sachse and Co., Berlin, in 1857). From 1843 to 1849 he also designed 200 woodcuts intended as tailpieces for a luxury edition on the works and letters of Frederick the Great. Menzel, who always strove for the greatest possible authenticity and quickly became one of the most qualified experts on the age of Frederick, received this commission from King Friedrich Wilhelm IV, who backed the thirty-volume edition that appeared between 1846 and 1857.

Menzel unlocked the Rococo world of Frederick the Great through the dedicated study of original sources that were still to be found in palaces, armories, art and military-clothing depots, galleries, archives, and print collections. In the process, he executed numerous sketches and drawings of portraits, architectural details, and art objects that he did not ultimately use in his illustrations. This drawing of Count Schaumburg-Lippe is probably one of the sheets Menzel categorized as an "item for use as needed." The edition on the works of Frederick the Great included only a wood engraving after a portrait of Count Albert Wolfgang von Schaumburg-Lippe und Sternberg (on the drawing [Berlin, Menzel, Kat. 144], Menzel erroneously wrote "Albrecht"; cf. Bock, 1923, no. 977). Menzel's inscription "n. Vanloo" and his color notes suggest that he copied a now-lost painting by Charles Amédée Philippe van Loo (1719–1795). In the book, the wood engraving follows two of Frederick's letters, written when he was still crown prince, to Count Albert zu Schaumburg-Lippe, who sponsored Frederick's initiation into the Freemasons in 1738.

Menzel may have intended to include Count Wilhelm von Schaumburg-Lippe (1724–1777) in one of his voluminous illustration projects, since, in addition to this sheet, there are two other drawings of him. The count, who had ruled since 1748, was an important personality who had contacts with many of the most influential men of his time. As a young man he had served successfully as a general in the British army. He was an early advocate of universal military service, and founded a military academy that the like-minded Prussian general Scharnhorst attended from 1773 to 1777. The count fought with distinction as artillery commander of the allied Prussian and English armies in the Seven Years War. In 1762 he led an English and Portuguese army against the French and Spanish, and in 1765 he returned home to Bückeburg and married.

The masterpieces of the painter Johann Georg Ziesenis (1716–1776) were his nearly life-size portraits of about 1770 of the count and his wife, Marie von Lippe-Biesterfeld, of which he produced many replicas (originals destroyed in a fire in Berlin in 1945; cf. Helmut Börsch-Supan, *Höfische Bildnisse des Spätbarock*, exh. cat., Schloss Charlottenburg, 1966, p. 208). Menzel made two drawings of the count after paintings by Ziesenis. On one of these, a bust-length pencil drawing (Berlin, Menzel, Kat. 1203), Menzel's inscription indicates that he must have seen two of the paintings: "Color of face: yellow ocher. This face is from the large painting sent later and is more accurate; everything else is exactly as in the smaller one." It is quite certain that the smaller painting mentioned by Menzel came from the estate of Herder, who had been court chaplain in Bückeburg from 1771 to 1776. In 1807 Herder's widow presented a portrait of the count by Ziesenis to Johann Gottfried Schadow, who was then working on a bust of General zu Schaumburg-Lippe for the Walhalla in Munich. Menzel had probably seen this painting (Potsdam-Sanssouci, Staatliche Schlösser und Gärten) in the palace of Prince August of Prussia, where it was sent about 1817–18 to expand a collection of portraits of

generals (see Götz Eckhardt, ed., *Johann Gottfried Schadow: Kunstwerke und Kunstansichten*, Berlin, 1987, vol. 1, p. 81 n.).

While in this study of the head, Menzel concentrates entirely on the count's face, on his expression of firmness and masculinity, our drawing does justice to the entire figure, posed as in Ziesenis's painting. The medallion at the center of the count's coat bears a portrait of King Joseph I of Portugal set in diamonds, and to the right is the Order of the Black Eagle.

Menzel executed a third drawing of the count (Berlin, Menzel, Kat. 1177)—bust length, wearing a civilian coat—on the same sheet as a portrait of Gustav Adolf, baron von Gotter, which, as his inscription notes, he copied from a painting of 1767 by Sir Joshua Reynolds (whereabouts unknown). The color notes indicate once more that he drew from an original. Once again, in this stylistically related drawing, Menzel captured with eloquent virtuosity the decisive character and noble features of this brave man's countenance.

M.U.R.

Bibliography: Liebermann/Kern, 1927, no. 23, p. 7, color pl.

The Plates

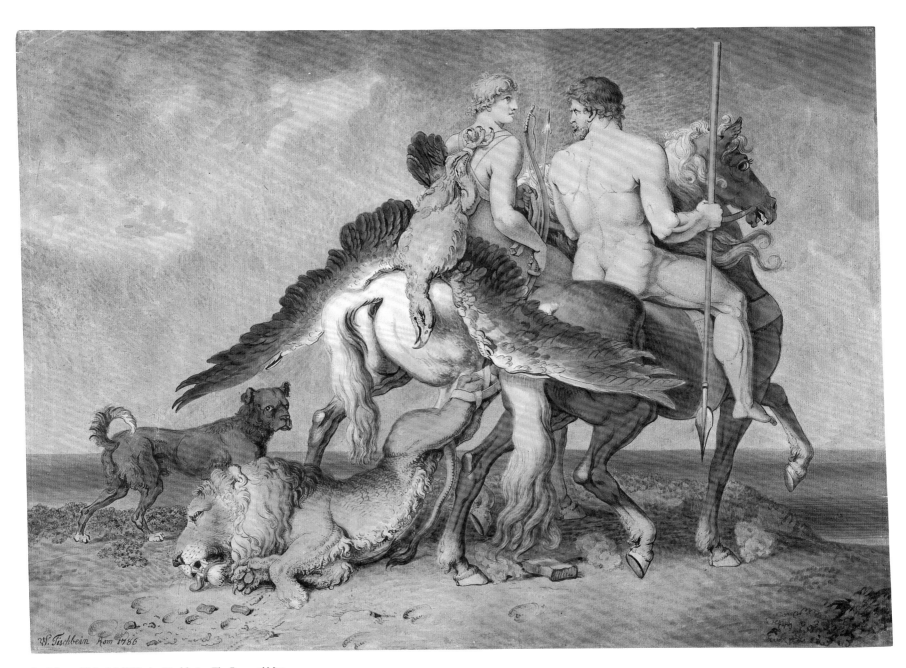

1 Johann Heinrich Wilhelm Tischbein, *The Power of Man*

2 Heinrich Füger, *Self-Portrait with His Wife and Son*

3 Jakob Philipp Hackert, *Entrance to the Catacombs in the Park at Hohenheim*

4 Jakob Philipp Hackert, *Ideal Landscape with Ruins, Cliffs, and Waterfall*

5　Franz Kobell, *Imaginary Mountain Range on the Coast*

6 Asmus Jakob Carstens, *The Greek Princes in Achilles's Tent*

7 Joseph Anton Koch, *Via Mala*

8 Joseph Anton Koch, *Amanda Gives Birth to Hüonnet in Titania's Grotto*

9 Joseph Anton Koch, *Landscape with the Judgment of Paris*

10 Joseph Anton Koch, *Malatesta Surprises Francesca and Paolo*

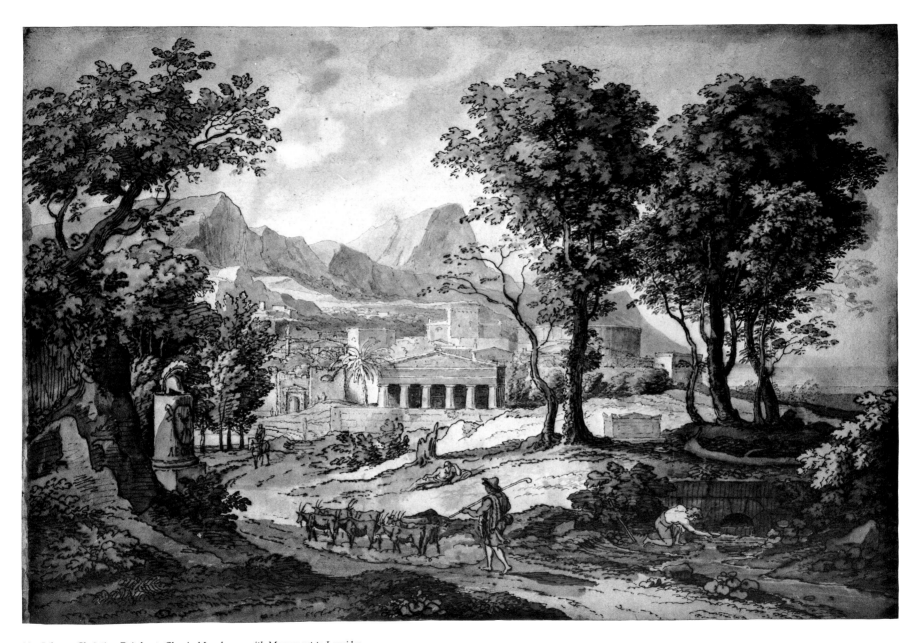

11 Johann Christian Reinhart, *Classical Landscape with Monument to Leonidas*

12 Anton Graff, *Portrait of Duchess Louise Auguste von Sonderburg-Augustenburg*

13 Anton Graff, *Portrait of the Artist's Son, Carl Anton Graff*

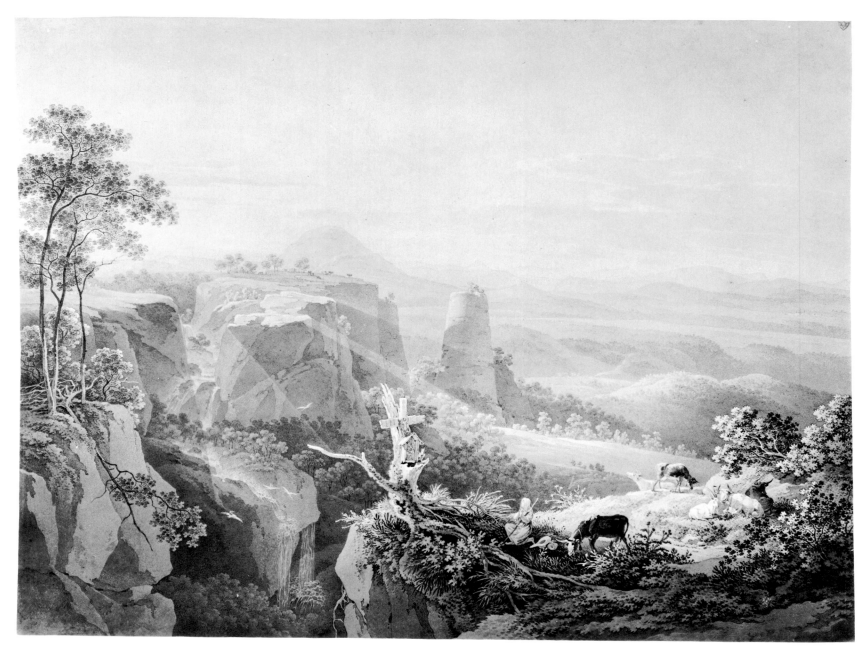

14 Adrian Zingg, *The Prebischkegel in Saxon Switzerland*

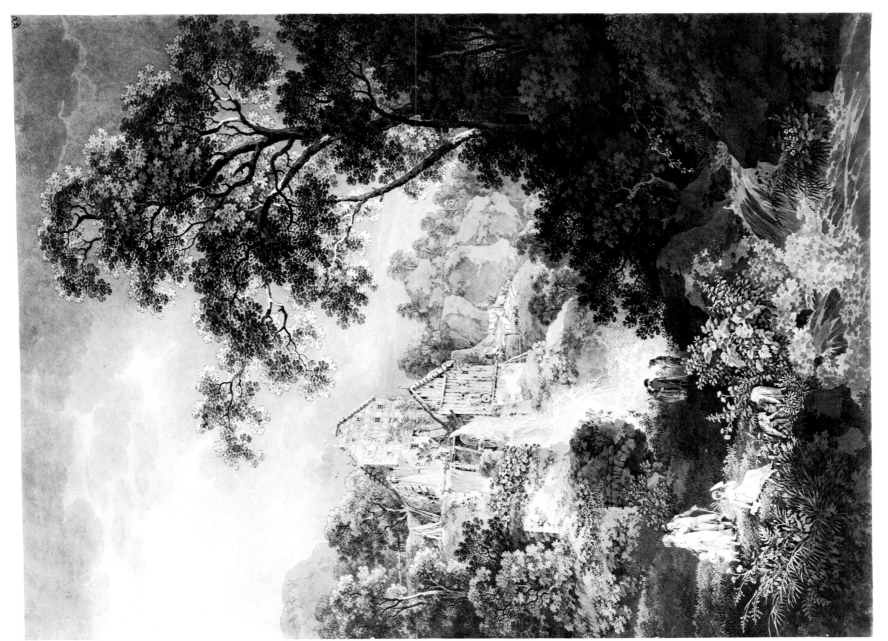

15 Adrian Zingg, *The Kepp Mill near Pillnitz*

16 Daniel Nikolaus Chodowiecki, *A Reading in a Summerhouse*

17 Johann Gottfried Schadow, *The Muse Terpsichore*

18 Johann Gottfried Schadow, *Portrait of Friederike Unger*

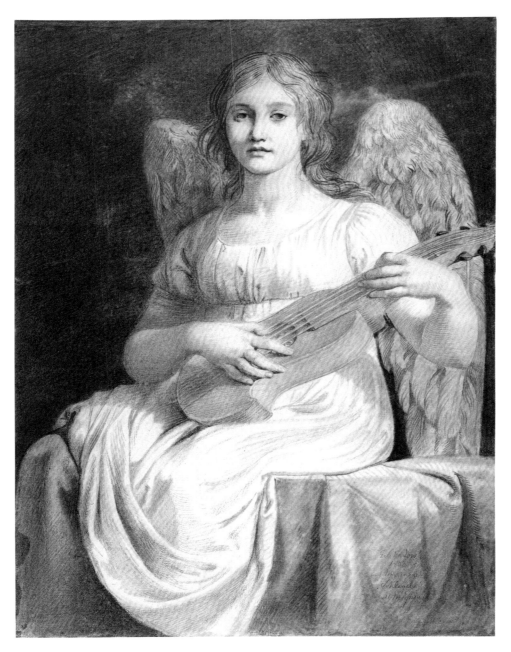

19 Johann Gottfried Schadow, *Marianne Schlegel as Mignon*

20 Johann Gottfried Schadow, *The Senior Government Auditor Rudolf Schadow*

21 Johann Gottfried Schadow, *The Window in Nenndorf*

162

22 Johann Gottfried Schadow, *Self-Portrait*

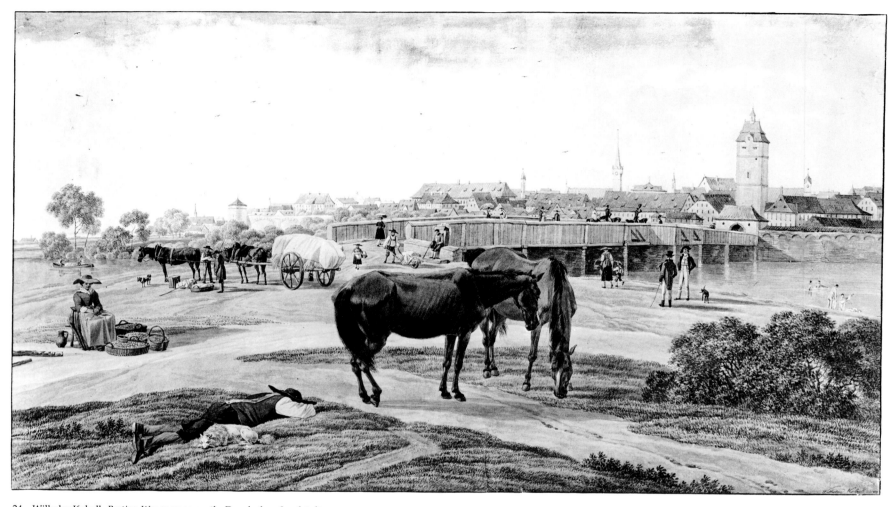

24 Wilhelm Kobell, *Resting Wagoners across the Danube from Ingolstadt*

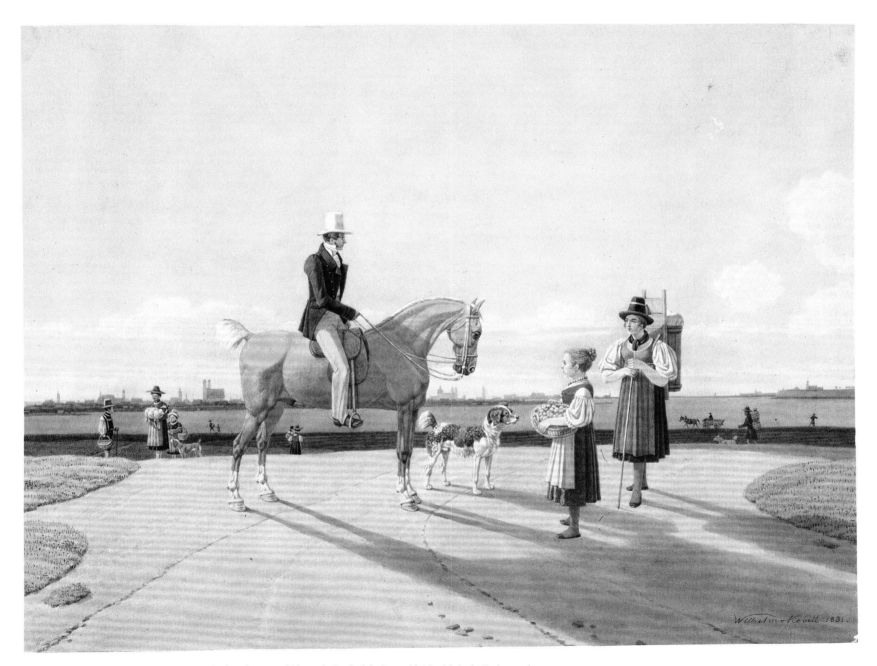

25 Wilhelm Kobell, *A Gentleman on Horseback and Peasant Girls on the Bank of the Isar, with Munich in the Background*

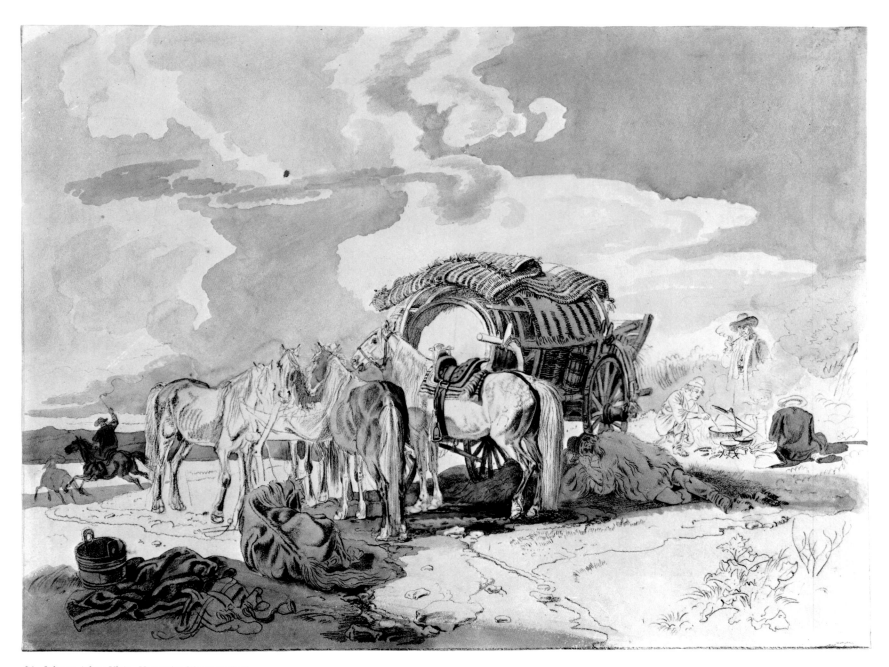

26 Johann Adam Klein, *Hungarian Wagoners Resting*

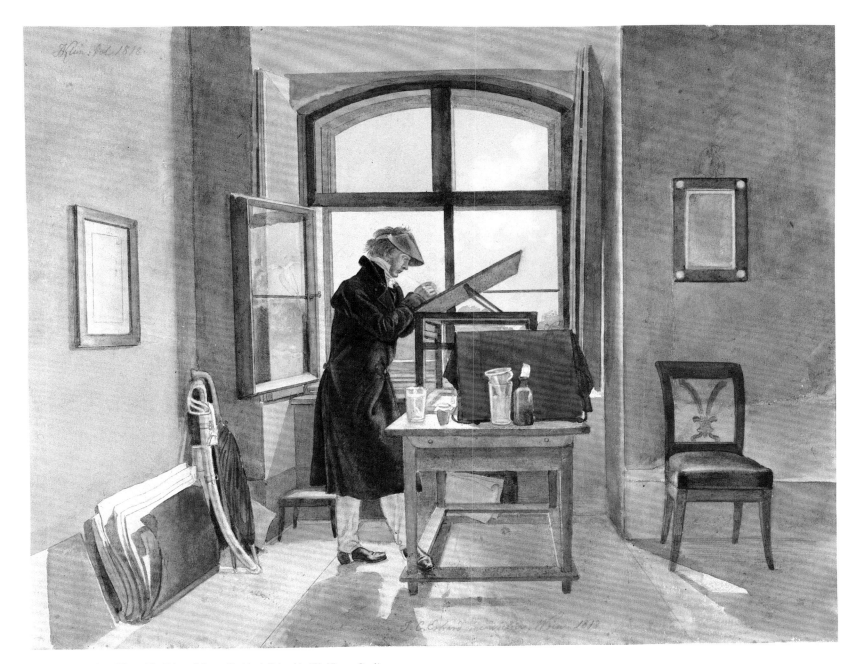

27 Johann Adam Klein, *The Painter Johann Christoph Erhard in His Vienna Studio*

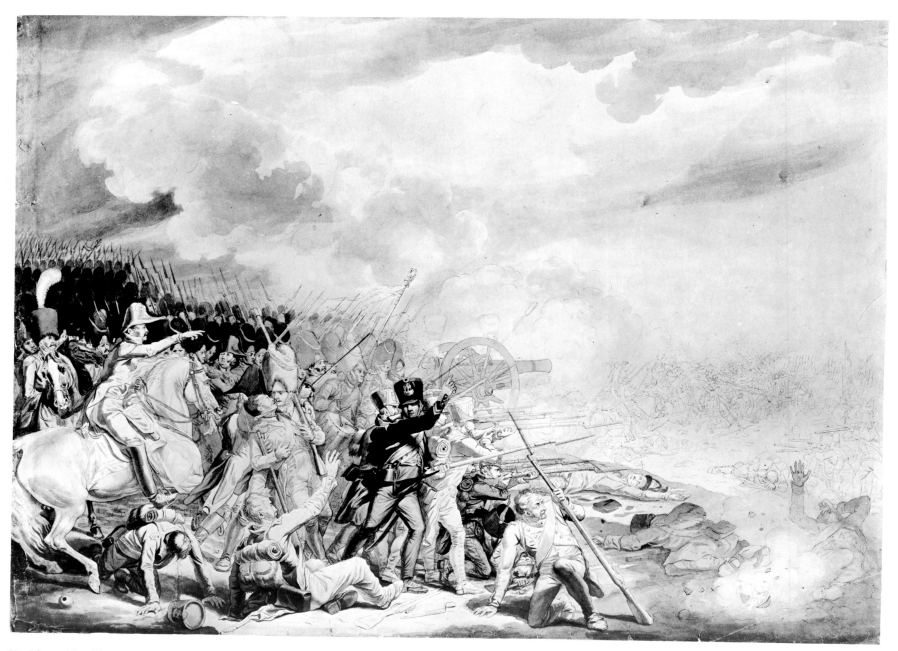

28 Johann Adam Klein, *Battle Scene* (Waterloo?)

29 Johann Christoph Erhard, *The Untersberg near Salzburg*

30 Johann Christoph Erhard, *Portal in the Ruprechtsbau of Heidelberg Castle*

31 Philipp Otto Runge, *Portrait of Ludwig Berger*

32 Philipp Otto Runge, *The Artist's Parents*

33 Philipp Otto Runge, *Morning*

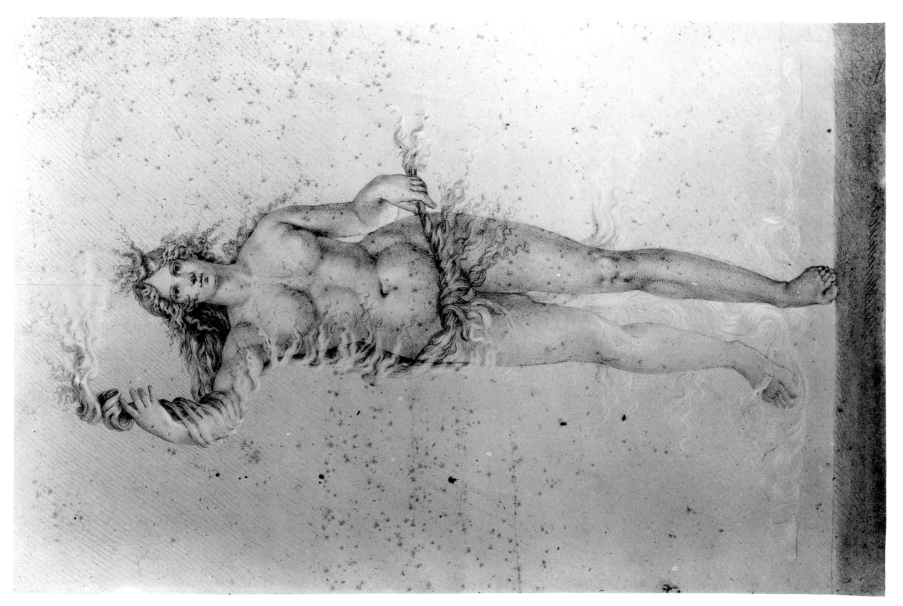

34 Philipp Otto Runge, *Aurora*

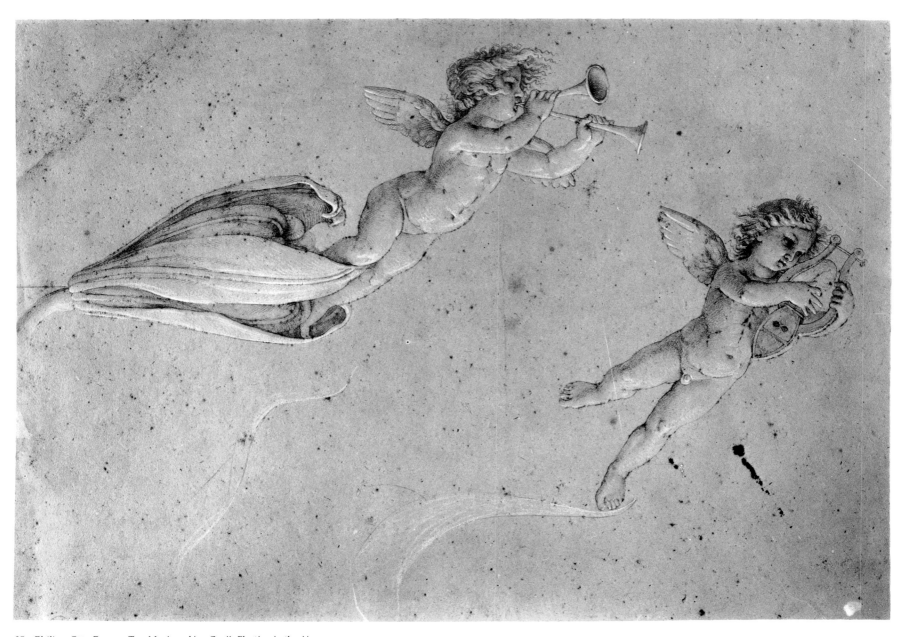

35 Philipp Otto Runge, *Two Music-making Genii, Floating in the Air*

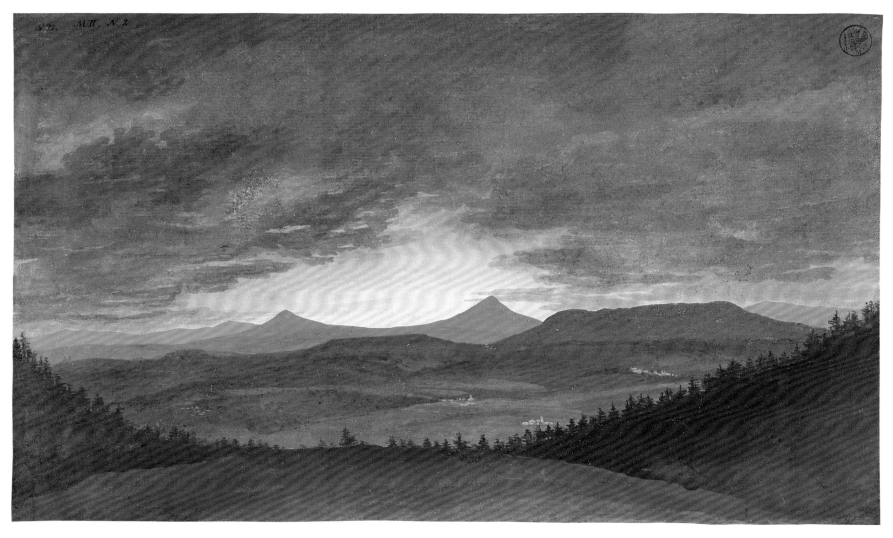

36　Karl Friedrich Schinkel, *Mountain Range in Bohemia at Sunset*

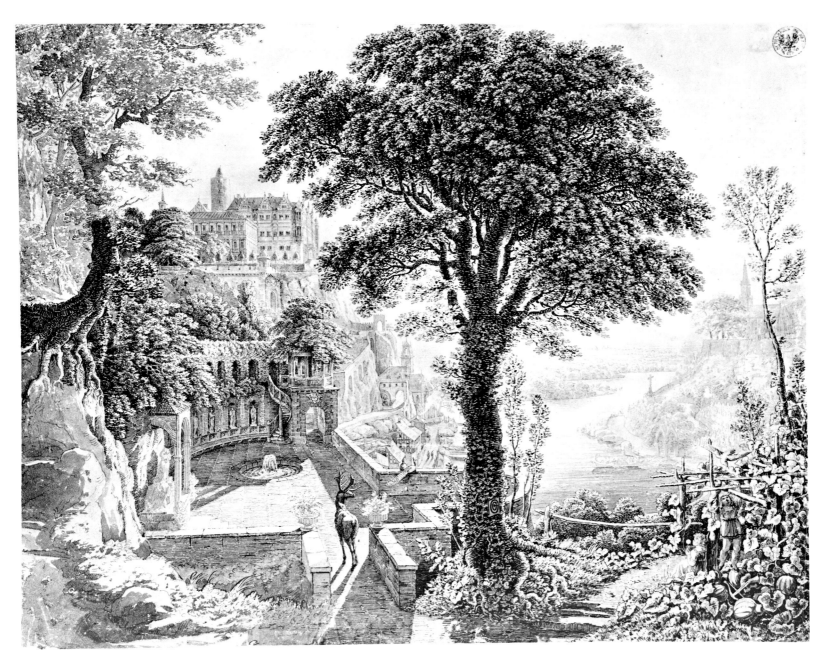

37 Karl Friedrich Schinkel, *Castle on a River*

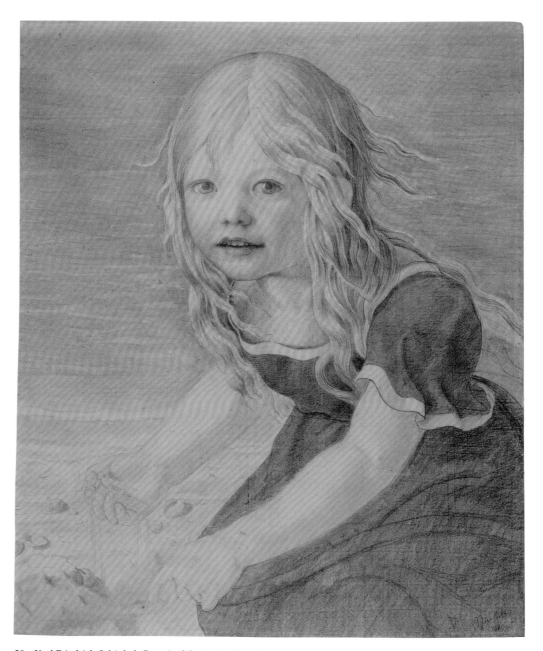

38 Karl Friedrich Schinkel, *Portrait of the Artist's Daughter Marie*

39 Caspar David Friedrich, *Landscape on the Island of Rügen, with a View from Stresow toward Reddewitz and Zicker*

40 Caspar David Friedrich, *A Bare Oak*

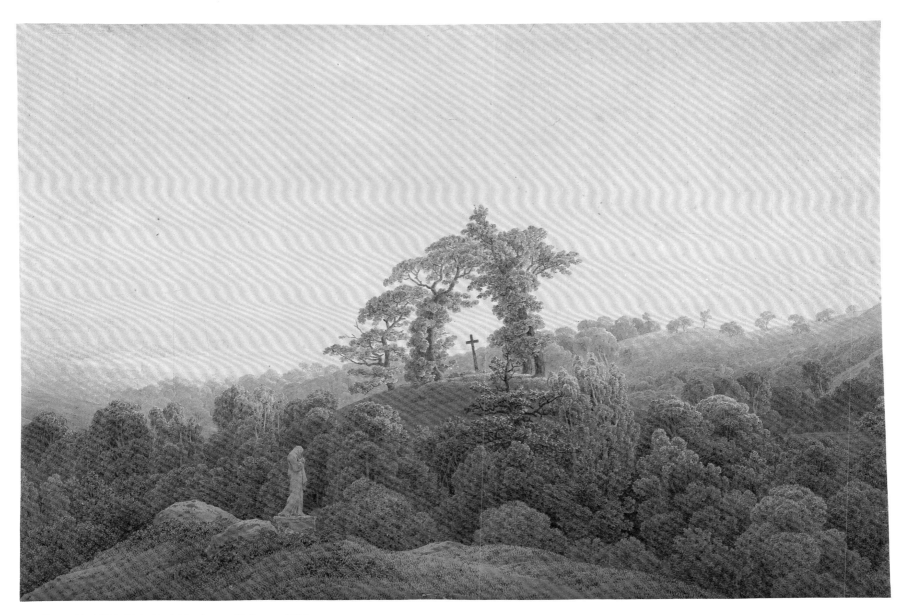

41 Caspar David Friedrich, *Coastal Landscape with Cross and Statue*

42 Caspar David Friedrich, *Path in the Forest, with Rocks*

43 Caspar David Friedrich, *Self-Portrait*

44 Caspar David Friedrich, *Two Men on the Mönchgut Peninsula, Island of Rügen*

45 Caspar David Friedrich, *Sailing Ships on the Sea*

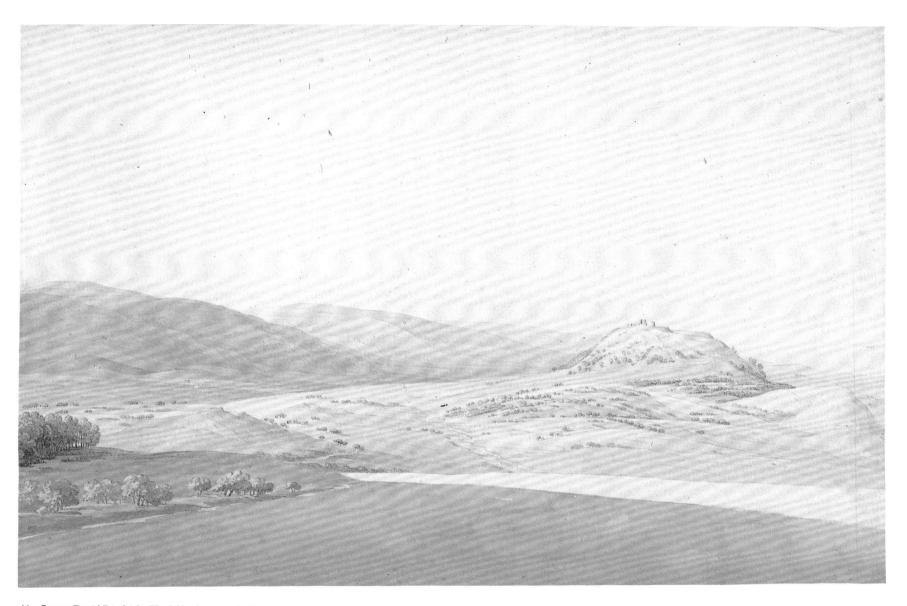

46 Caspar David Friedrich, *The Schlossberg near Teplitz*

47　Caspar David Friedrich, *Rocky Shore with Anchor*

48 Georg Friedrich Kersting, *Caspar David Friedrich on an Excursion in the Riesengebirge*

49 Georg Friedrich Kersting, *Biedermeier Interior*

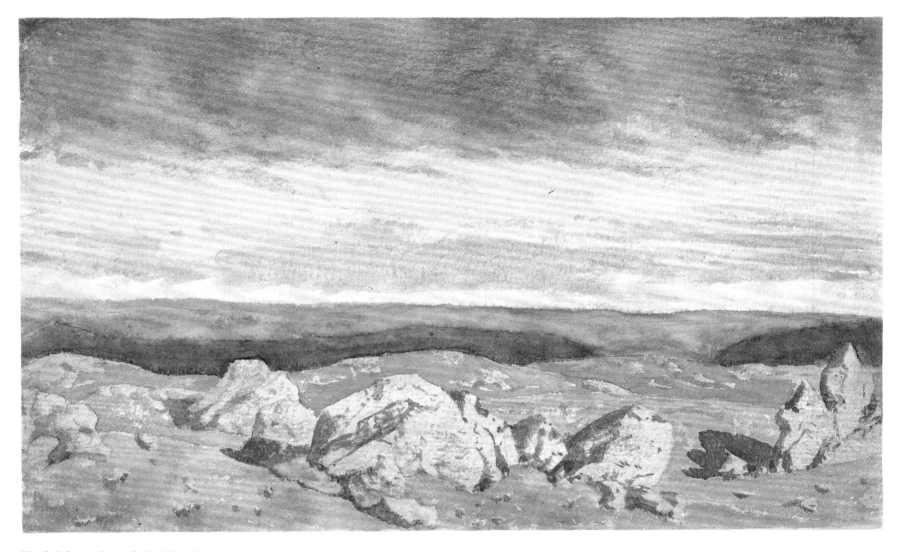

50 Carl Gustav Carus, *On the Ridge of the Riesengebirge*

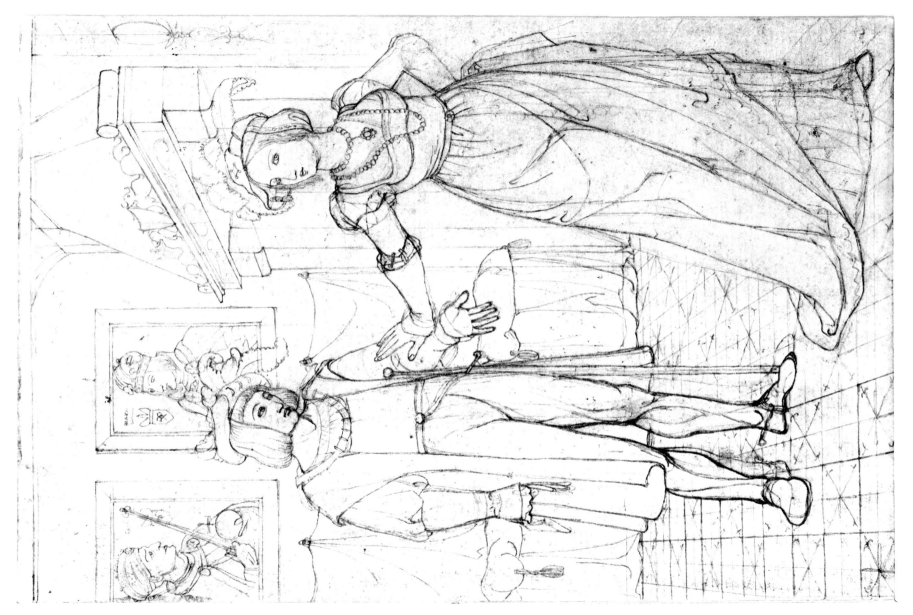

51 Franz Pforr, *Adelheid and Weislingen*

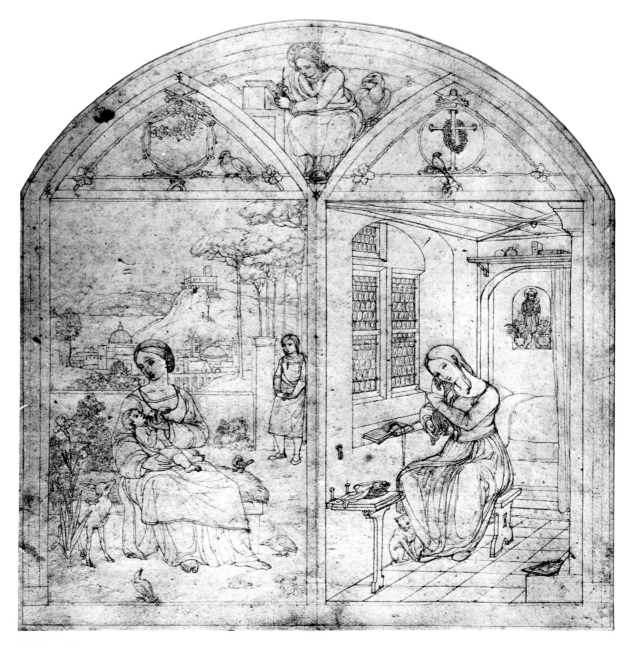

52 Franz Pforr, *Sulamith and Maria*

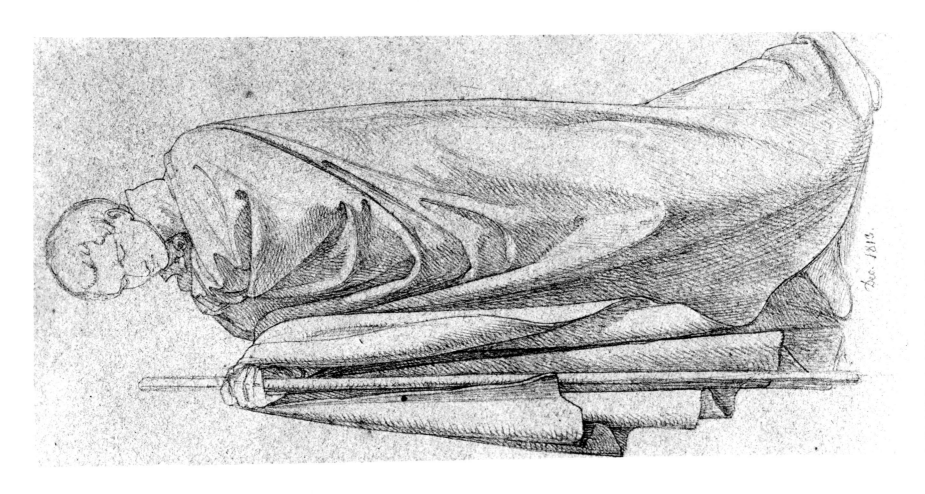

Dec. 1813.

53 Friedrich Overbeck, *Male Figure in a Cloak*

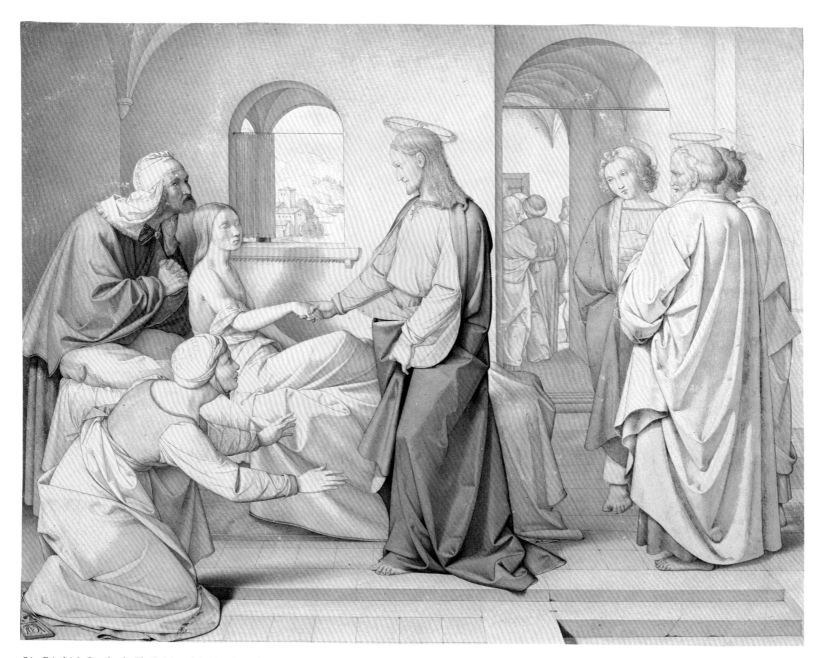

54 Friedrich Overbeck, *The Raising of the Daughter of Jairus*

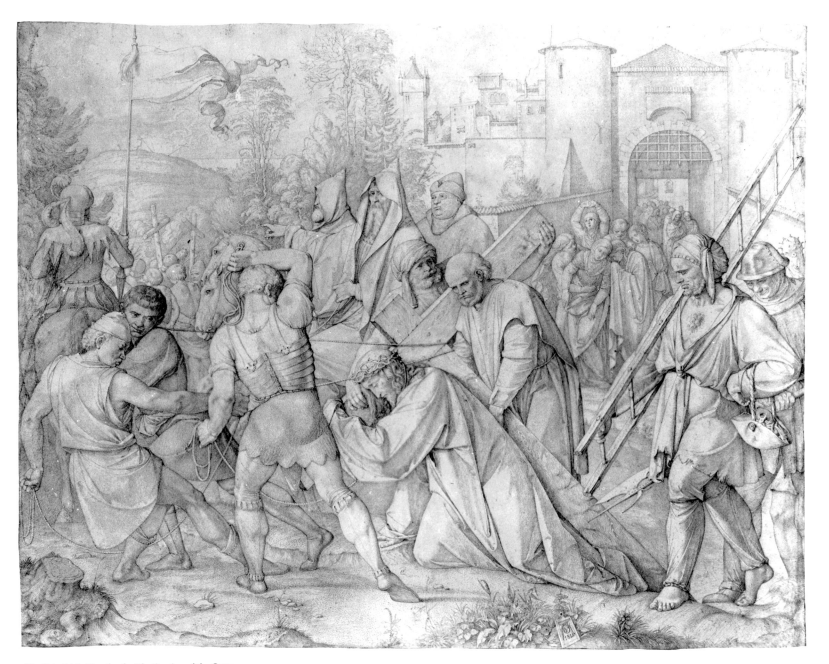

55 Friedrich Overbeck, *The Bearing of the Cross*

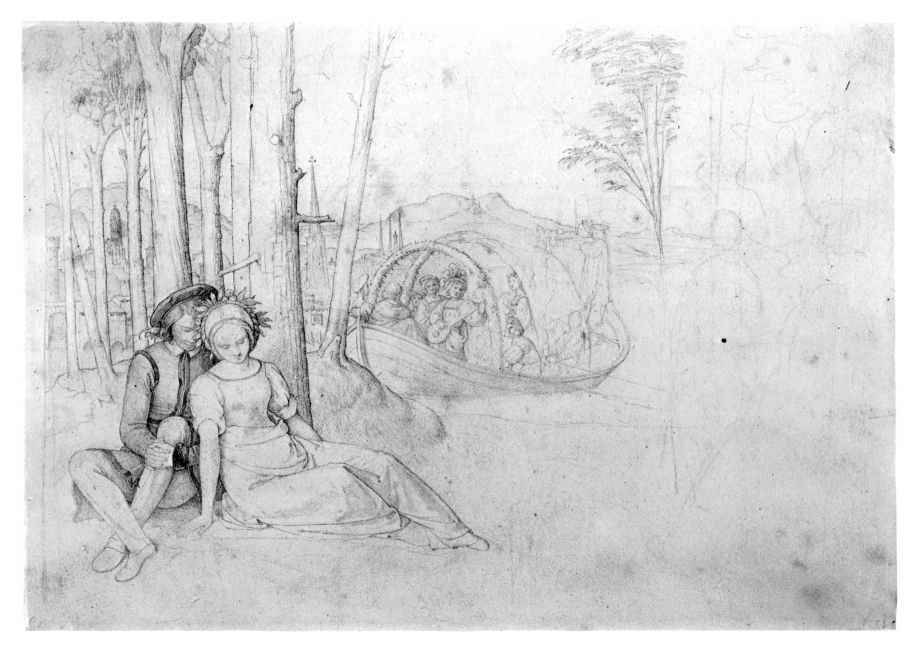

56 Friedrich Overbeck, *Young Couple under the Trees*

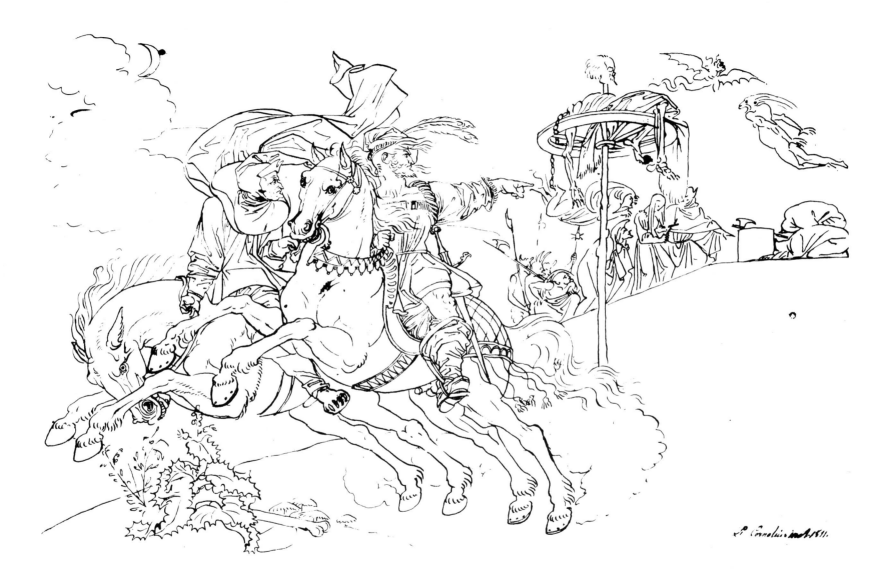

57 Peter Cornelius, *Faust and Mephistopheles on the Rabenstein*

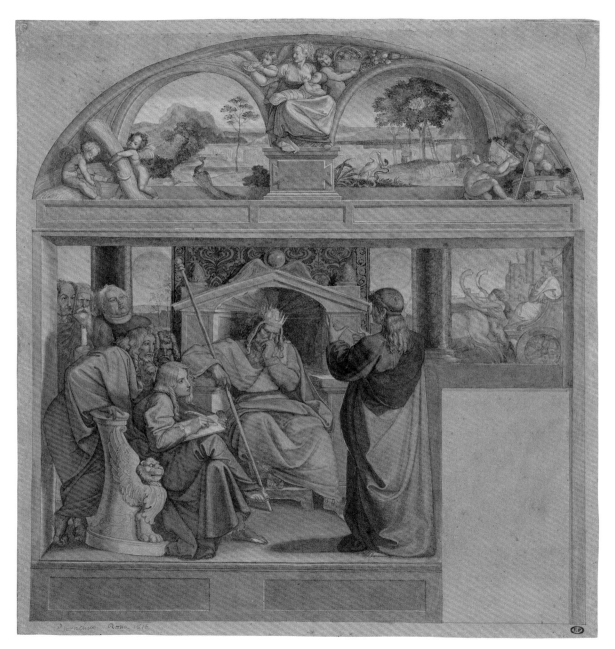

58 Peter Cornelius, *Joseph Interpreting Pharaoh's Dream*

59 Johann Anton Ramboux, *Noli Me Tangere*

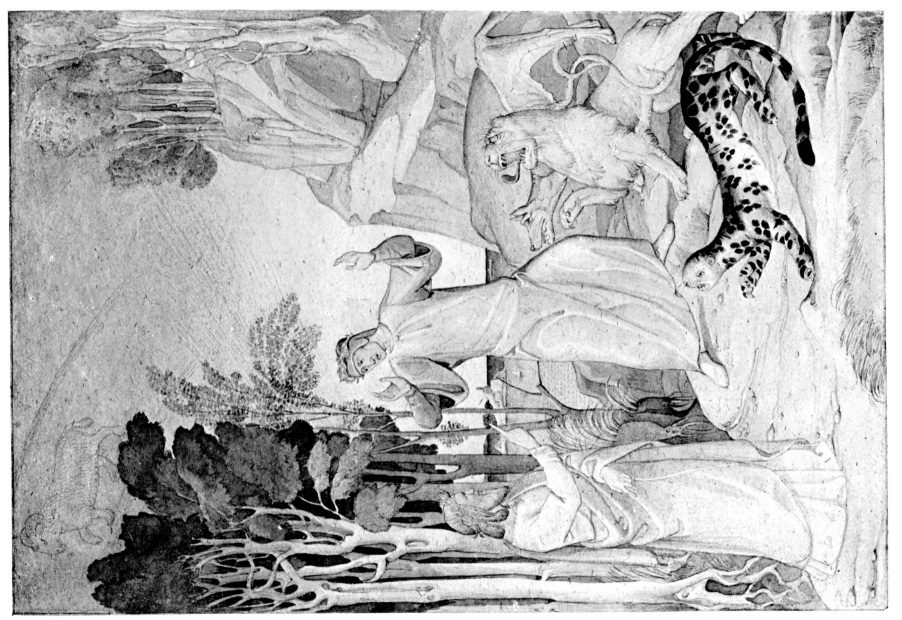

61 Theodor Rehbenitz, *Self-Portrait*

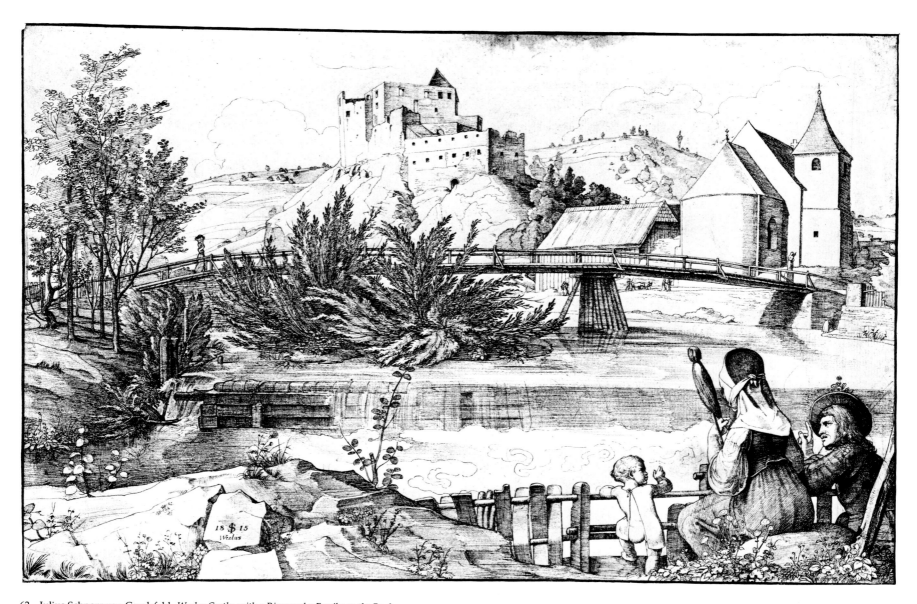

62 Julius Schnorr von Carolsfeld, *Wezlas Castle, with a River and a Family on the Bank*

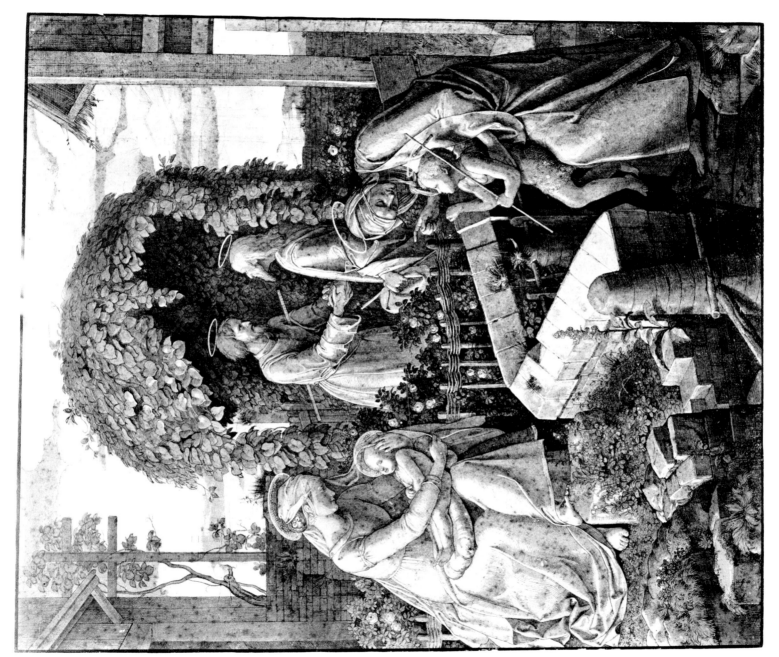

63 Julius Schnorr von Carolsfeld, *The Visit of the Parents of John the Baptist to the Parents of Jesus*

64 Julius Schnorr von Carolsfeld, *Seated Female Nude*

65 Julius Schnorr von Carolsfeld, *Portrait of a Girl with Pinned-up Hair*

66 Julius Schnorr von Carolsfeld, *The Church of Santi Giovanni e Paolo in Rome*

67 Julius Schnorr von Carolsfeld, *Study of a Nude Youth*

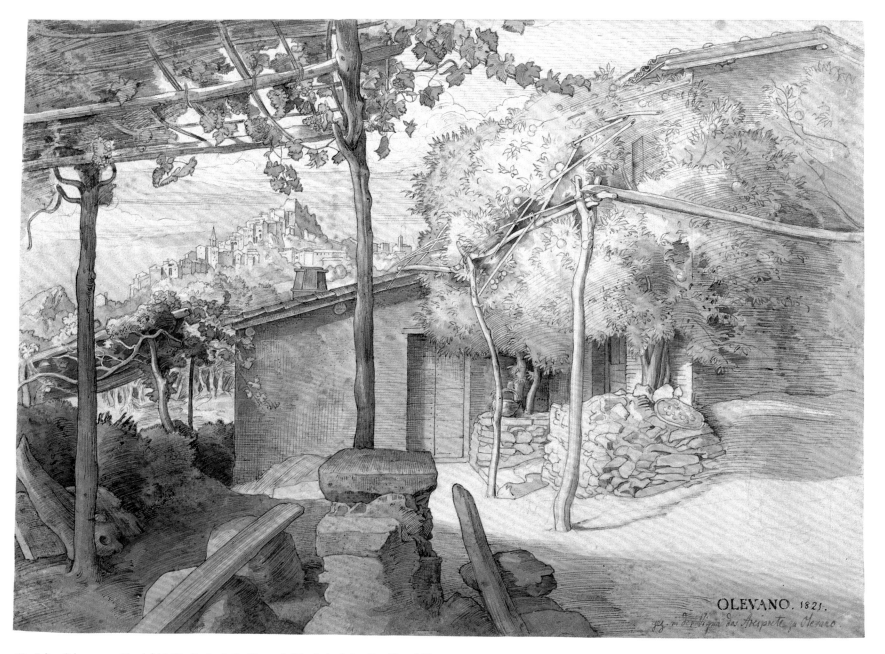

OLEVANO. 1821.
gez. in der Vigna des Arciprete zu Olevano.

68 Julius Schnorr von Carolsfeld, *The Garden in the Vineyard of the Archpriest, with a View of Olevano*

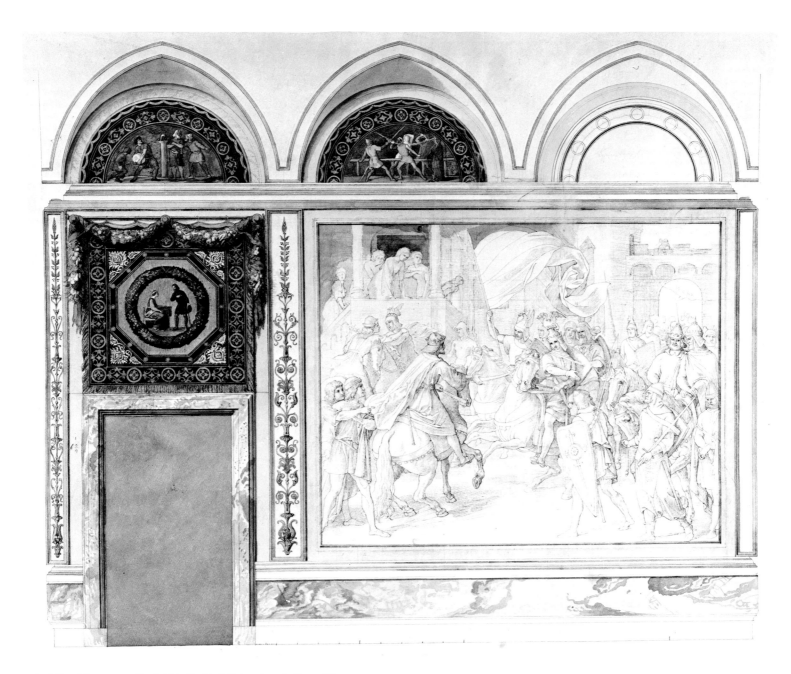

69 Julius Schnorr von Carolsfeld, *Siegfried's Return from the Saxon War*

70　Friedrich Olivier, *Wilted Maple Leaves*

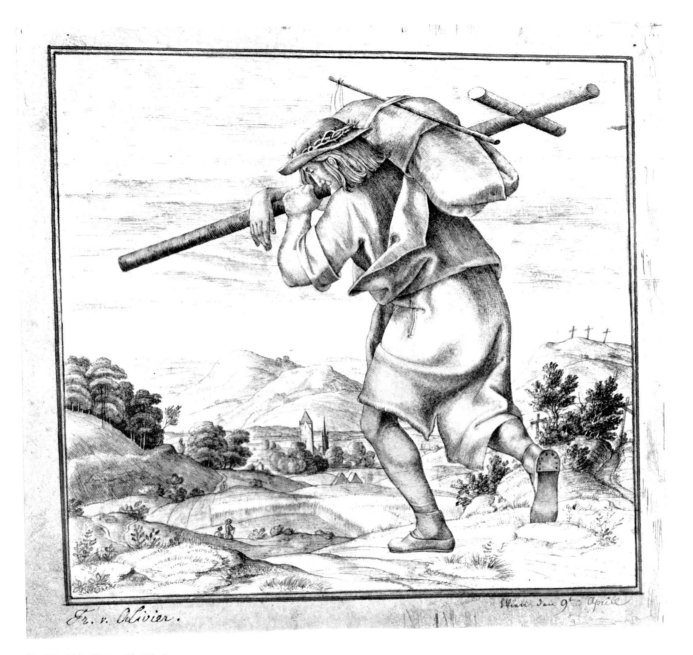

71 Friedrich Olivier, *The Pilgrim*

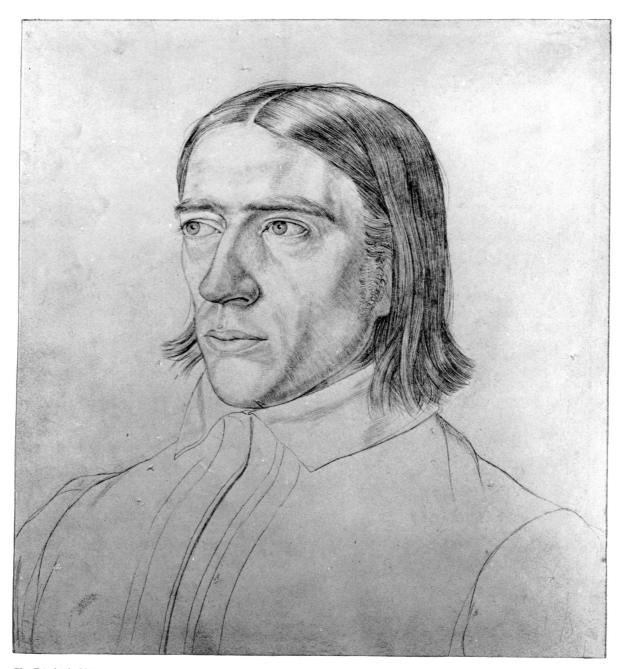

72 Friedrich Olivier, *Portrait of Friedrich Overbeck*

73 Ferdinand Olivier, *Farmstead in Wieden beside the Starhemberg-Schönburg Palais*

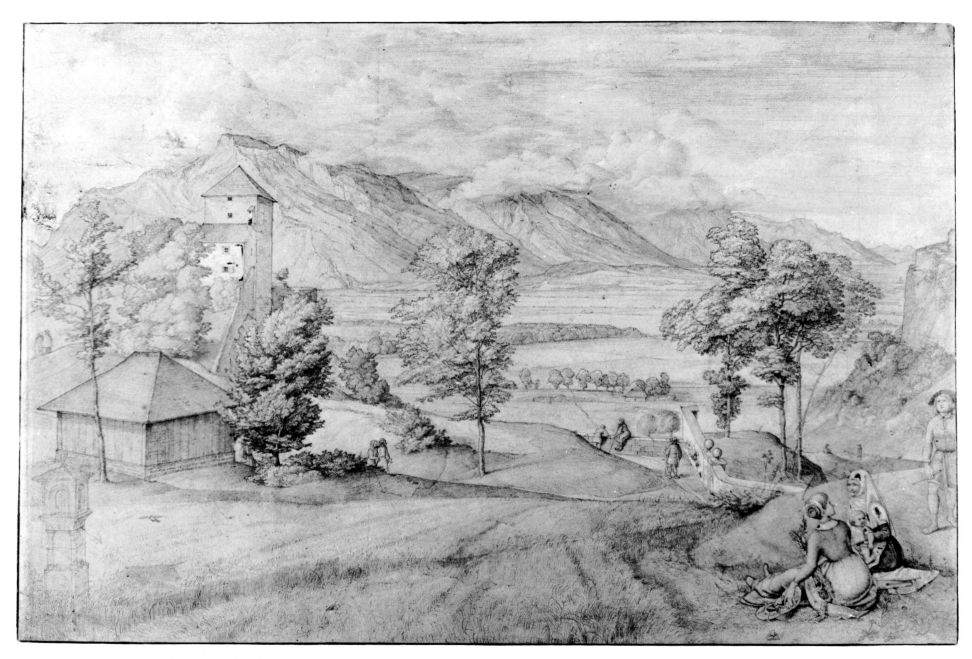

74 Ferdinand Olivier, *View from the Mönchsberg toward the Untersberg, near Salzburg*

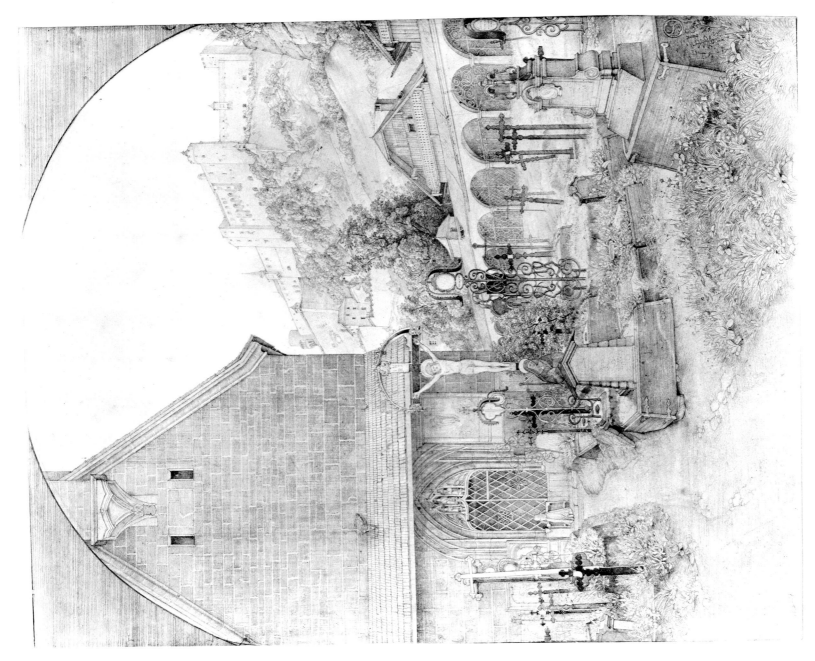

75 Ferdinand Olivier, *St. Peter's Cemetery in Salzburg*

76 Ferdinand Olivier, *Street in Mödling*

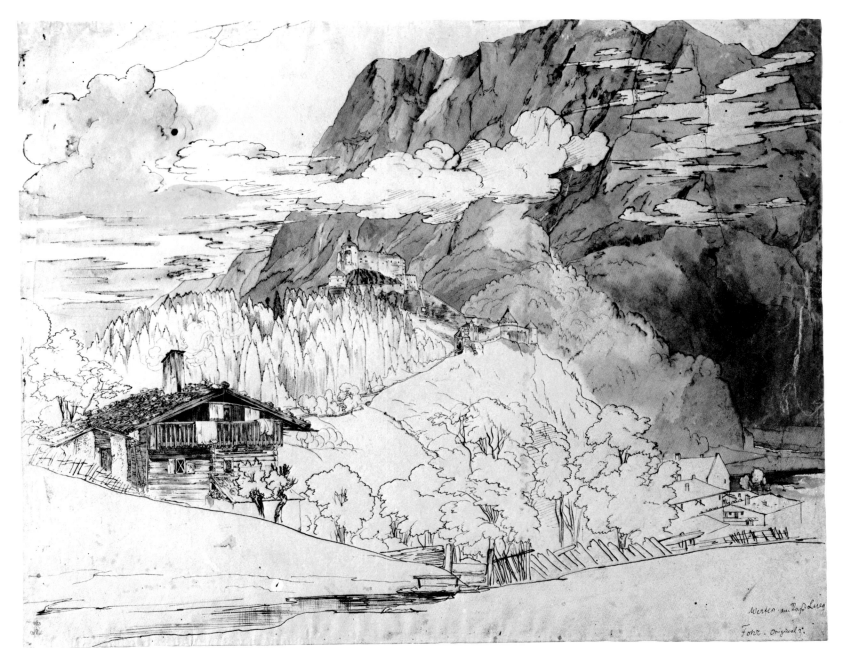

77 Karl Philipp Fohr, *The Village of Werfen on the Lueg Pass*

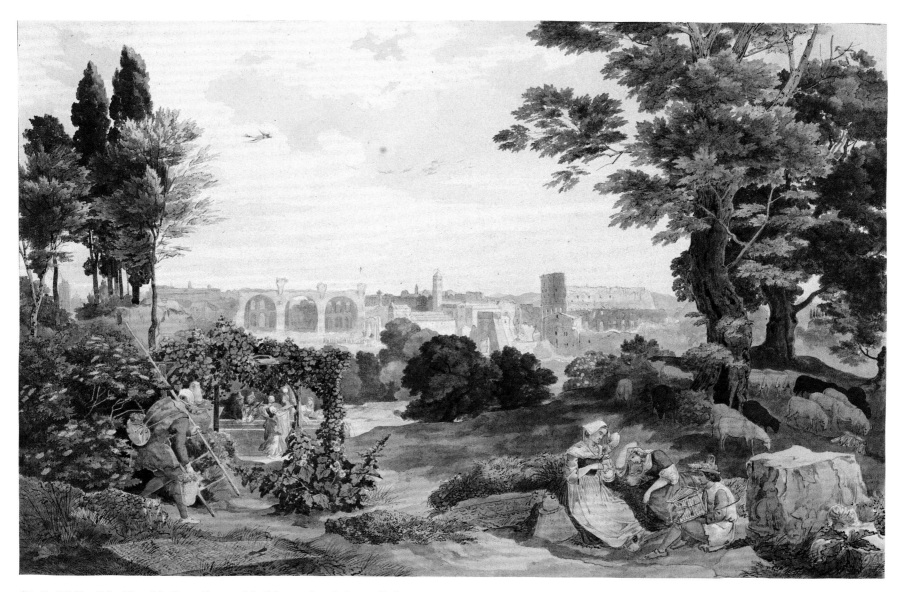

78 Karl Philipp Fohr, *View of the Roman Forum and the Colosseum from the Farnese Gardens*

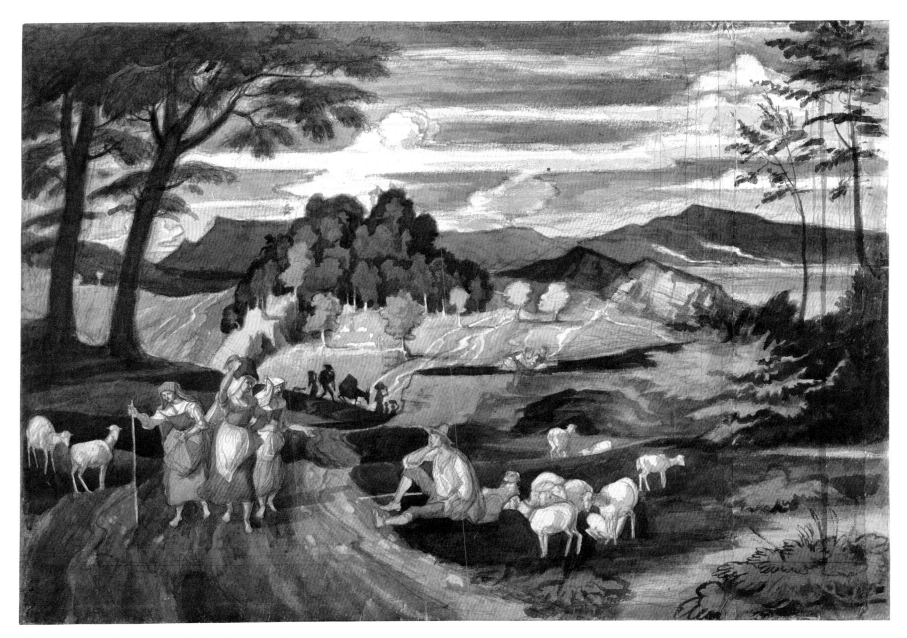

79 Franz Horny, *Italian Landscape with Three Women and a Shepherd*

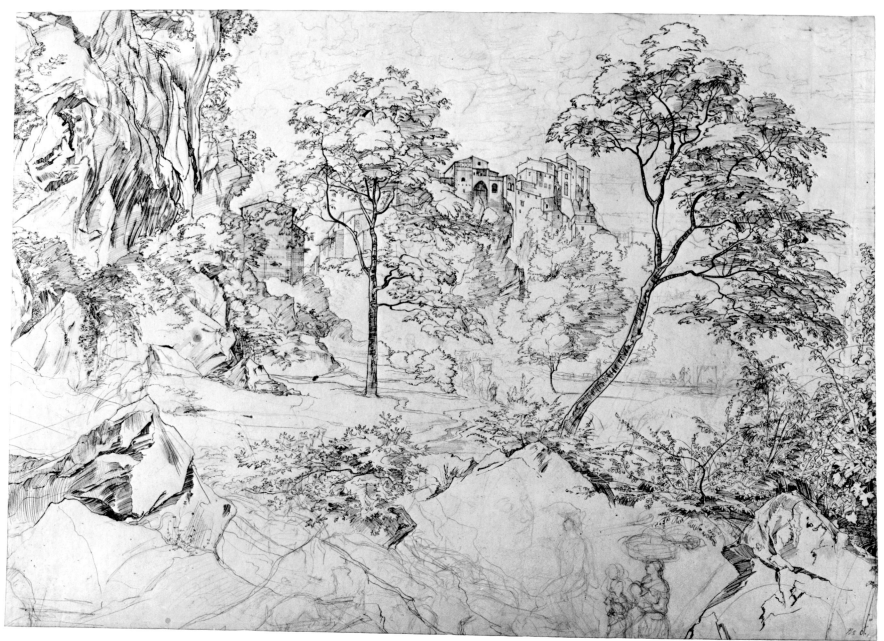

80 Franz Horny, *Landscape near Olevano*

82　Karl Blechen, *The House of the Poet in Pompeii*

83 Karl Blechen, *Trees and Houses in Amalfi*

84 Karl Blechen, *Plateau near Marino*

224

85 Karl Blechen, *Ruins of a Gothic Church*

225

86 Karl Blechen, *Forest Landscape with a Waterfall and Two Hunters*

87 Karl Blechen, *Trees beside a Pond*

88 Karl Blechen, *Landscape in the Mark Brandenburg, with Pines and Figures Shoveling Sand*

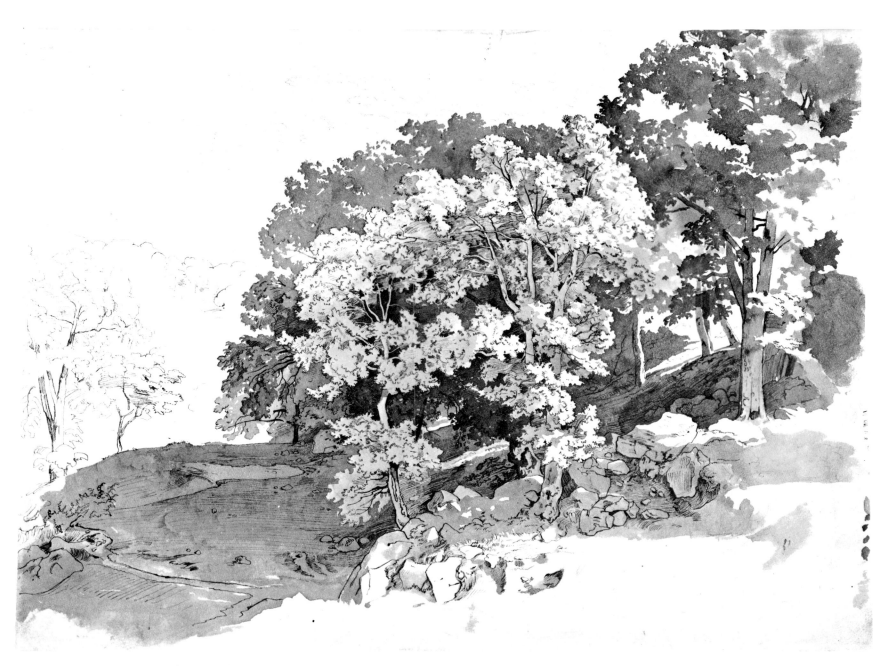

89 Adrian Ludwig Richter, *Group of Trees on a Slope*

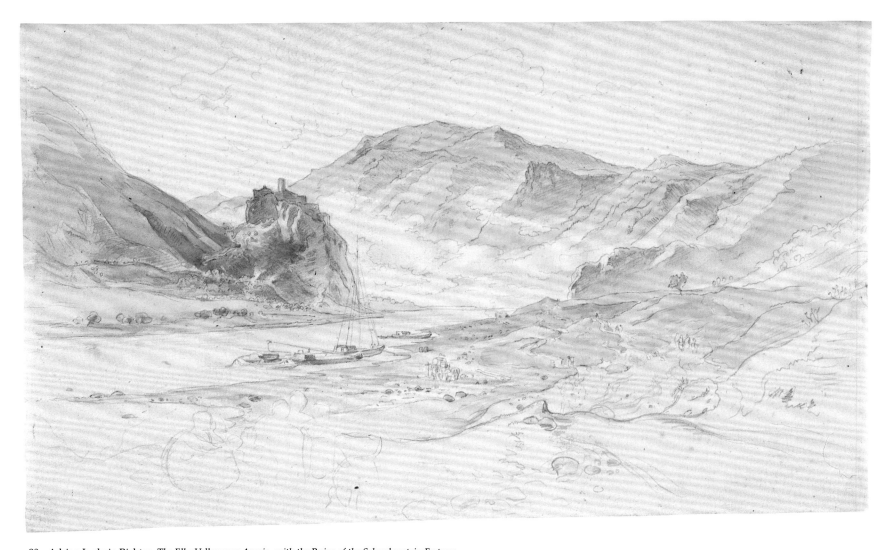

90 Adrian Ludwig Richter, *The Elbe Valley near Aussig, with the Ruins of the Schreckenstein Fortress*

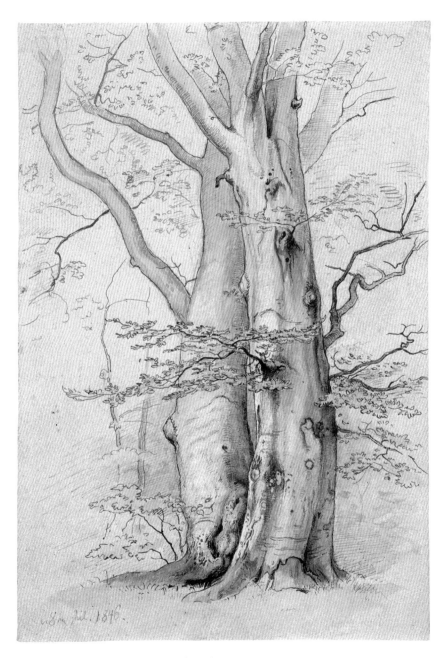

91 Adrian Ludwig Richter, *Two Beech Trunks*

92 Adrian Ludwig Richter, *Rübezahl Frightens a Mother and Her Children*

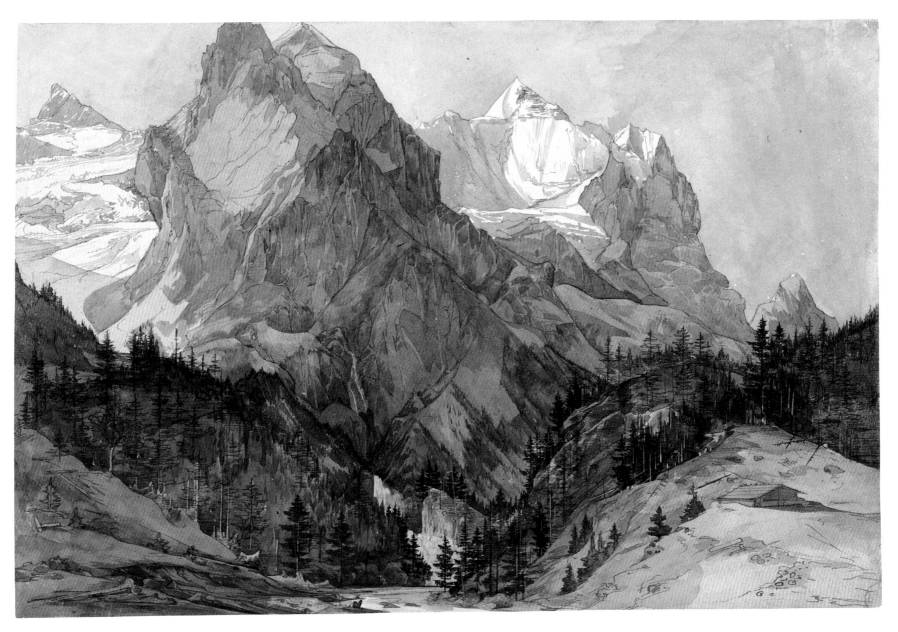

93　Ernst Ferdinand Oehme, *The Wetterhorn, with the Glacier of Rosenlaui*

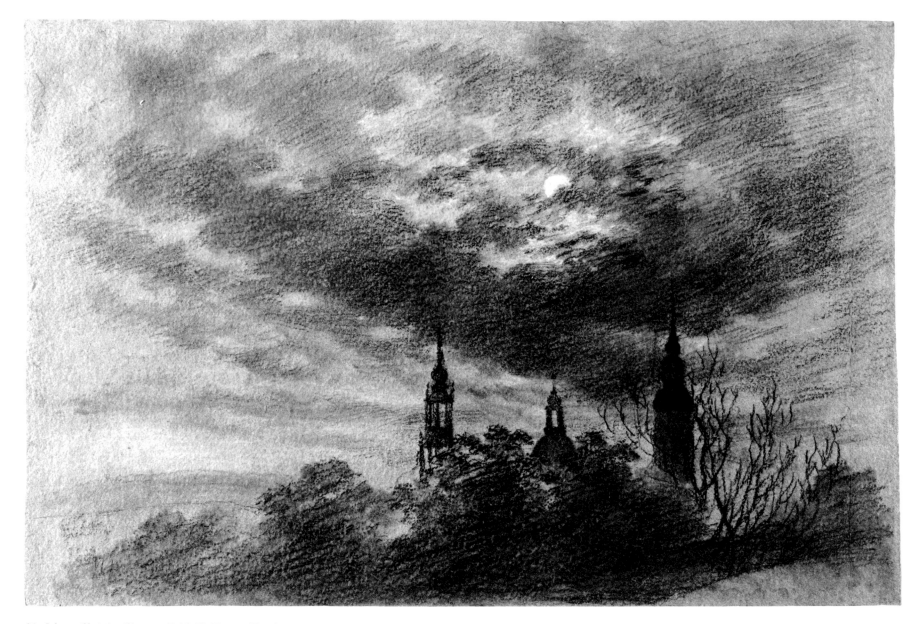

94 Johann Christian Claussen Dahl, *The Towers of Dresden*

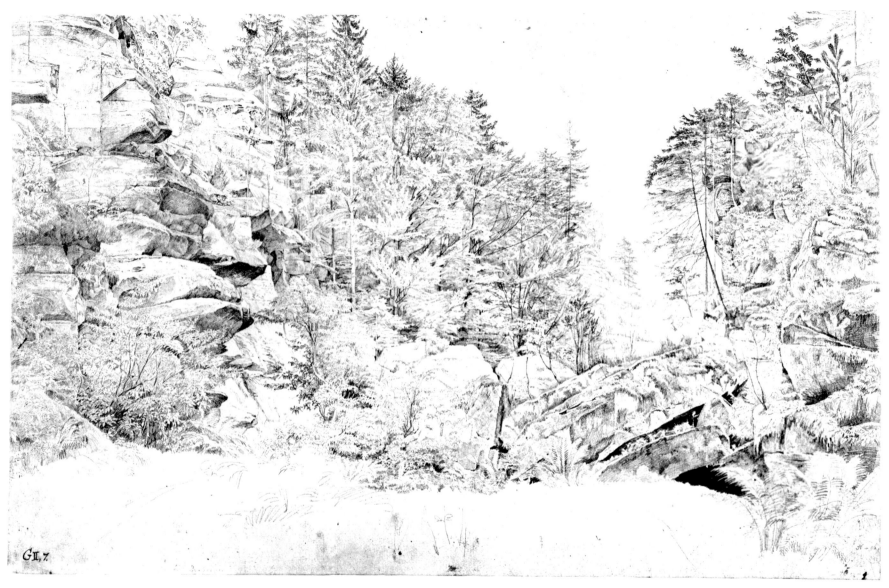

95 Johann August Heinrich, *In the Rabenauer Grund*

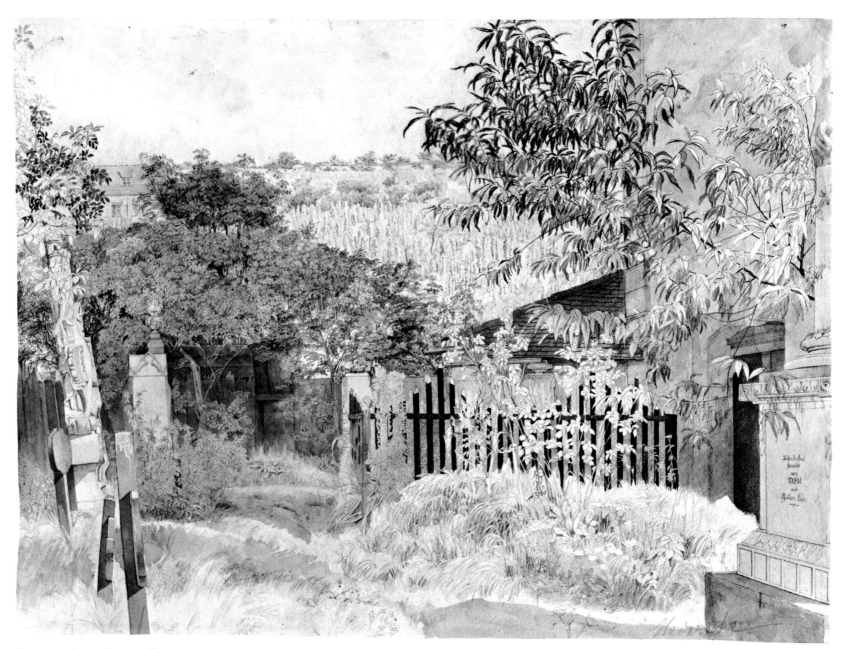

96 Johann August Heinrich, *Churchyard in Loschwitz*

97 Johann August Heinrich, *Wooded Hillside*

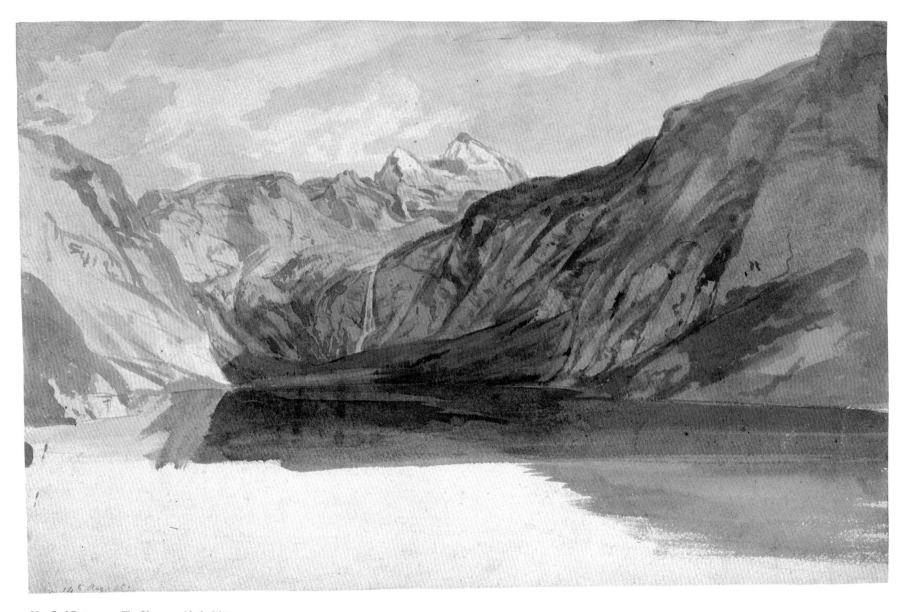

98 Carl Rottmann, *The Obersee, with the Watzmann*

99 Carl Rottmann, *The Island of Delos*

100 Karl Friedrich Lessing, *The Battle of Iconium*

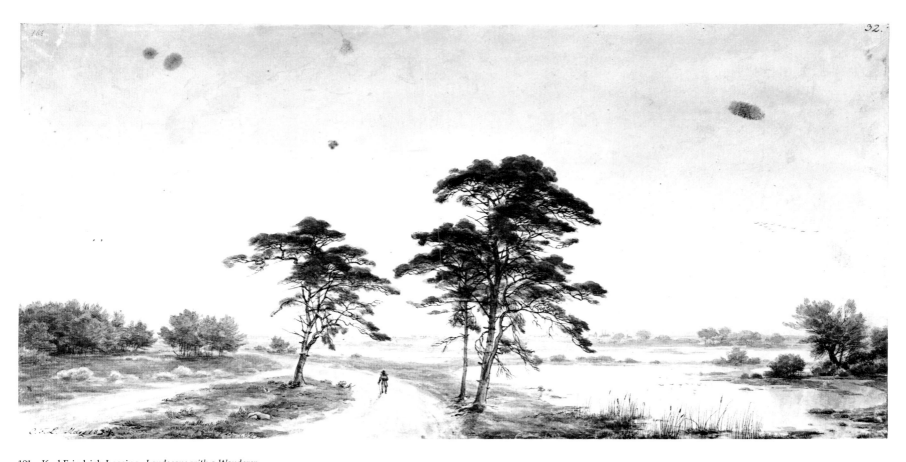

101 Karl Friedrich Lessing, *Landscape with a Wanderer*

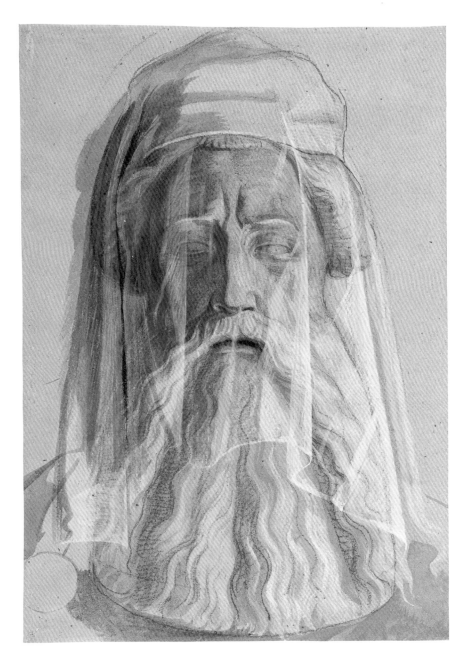

102 Alfred Rethel, *The Head of Charlemagne in the Tomb*

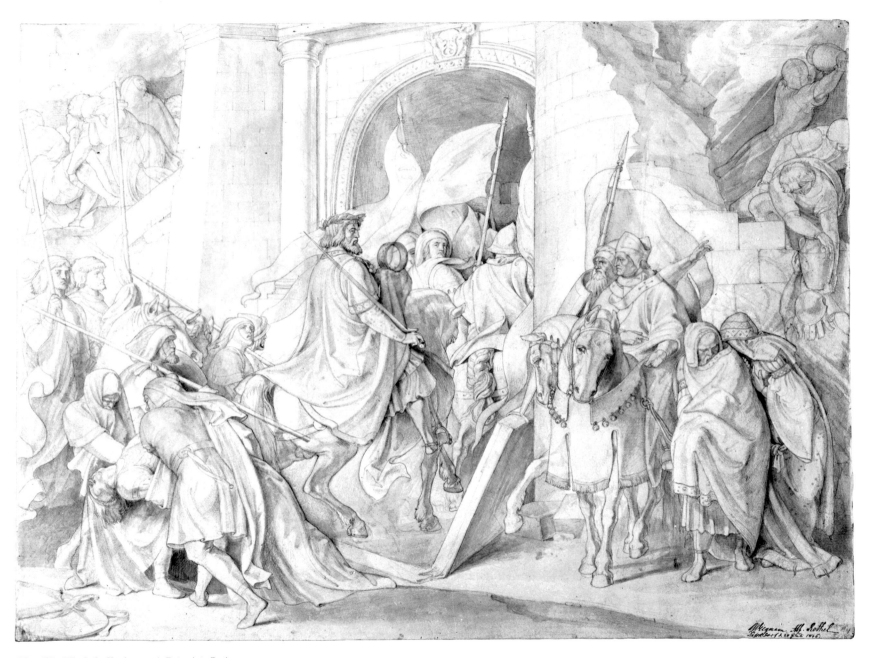

103 Alfred Rethel, *Charlemagne's Entry into Pavia*

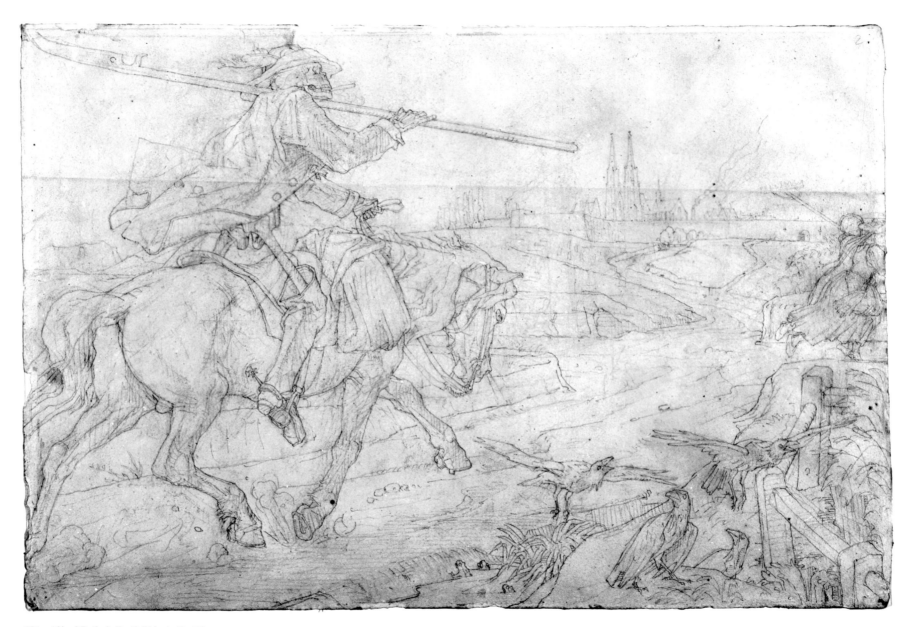

104 Alfred Rethel, *Death Rides to the City*

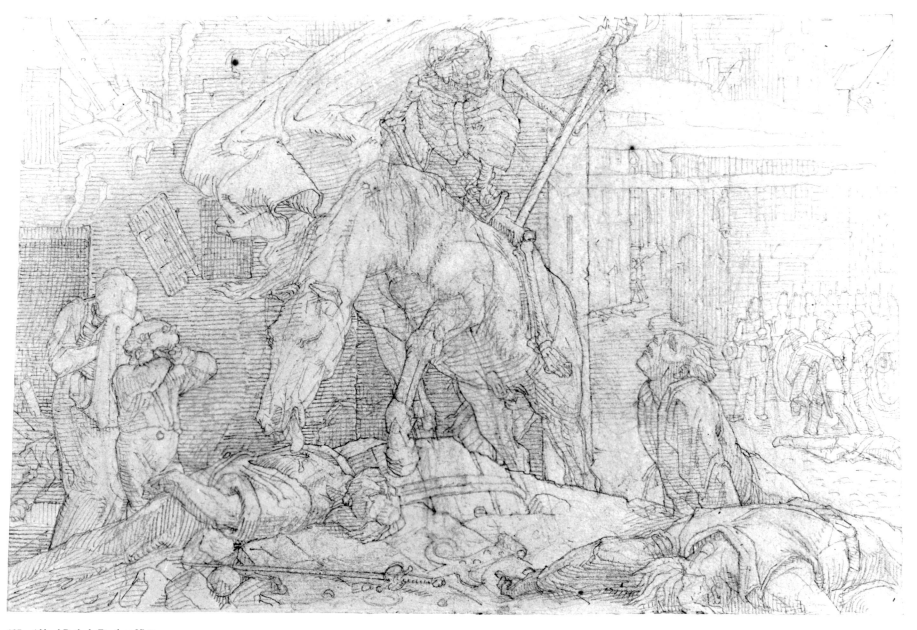

105 Alfred Rethel, *Death as Victor*

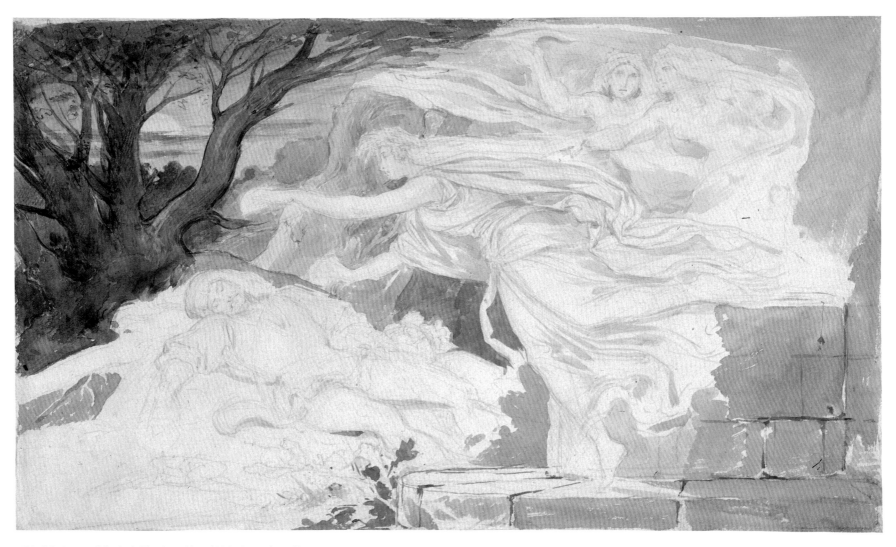

106 Moritz von Schwind, *The Apparition of Melusina at the Well*

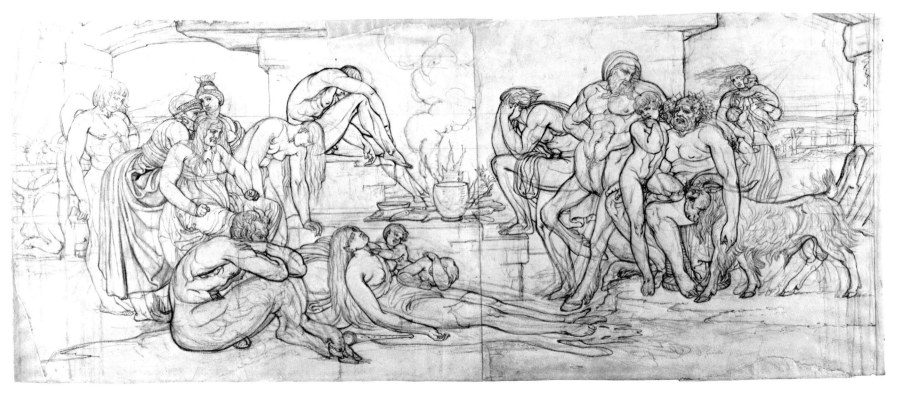

107 Bonaventura Genelli, *A Wake*

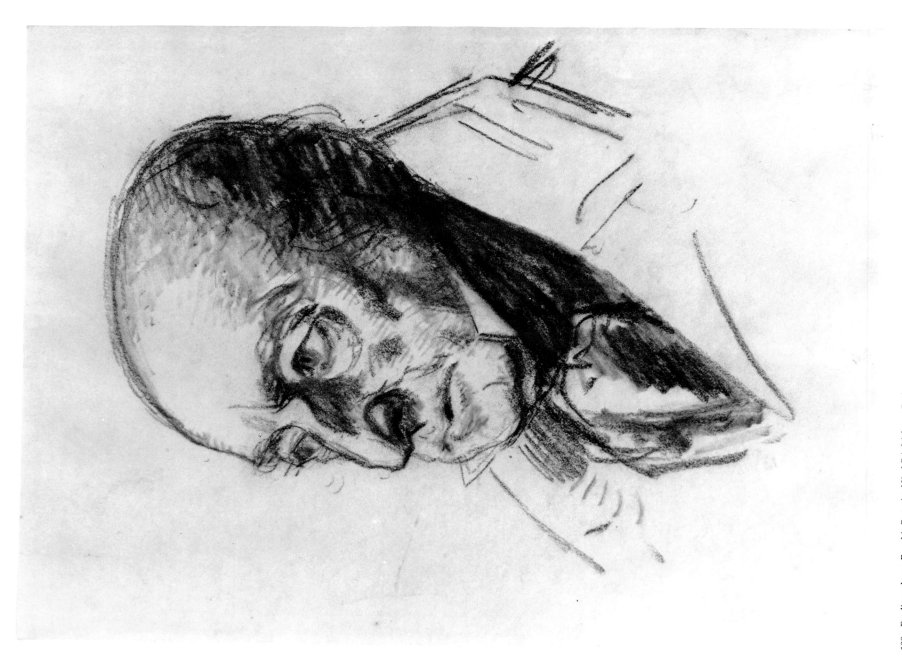

108 Ferdinand von Rayski, *Portrait of Karl Friedrich von Broizem*

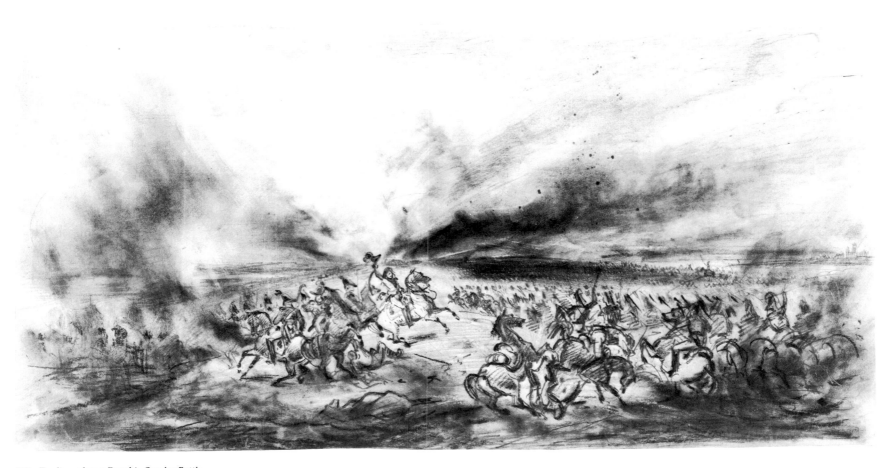

109 Ferdinand von Rayski, *Cavalry Battle*

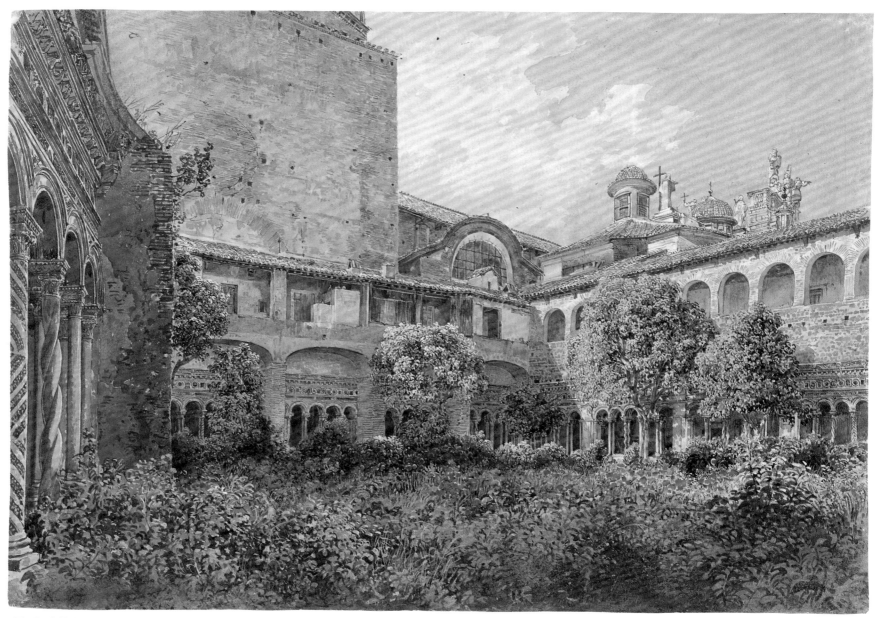

110 Rudolf Alt, *The Cloister of San Giovanni in Laterano in Rome*

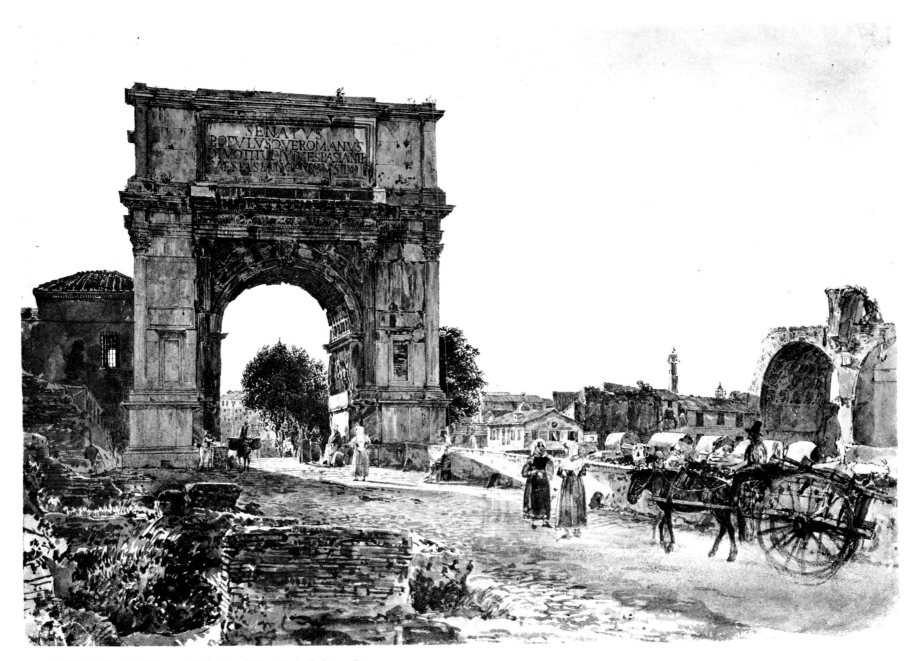

111 Rudolf Alt, *The Arch of Titus and the Basilica of Maxentius in the Roman Forum*

112 Franz Krüger, *Self-Portrait in Ill Health*

113 Franz Krüger, *Studies of Russian Military Uniforms*

114 Franz Krüger, *The Ballet Master Paul Taglioni and His Wife, the Dancer Amalie Taglioni*

115 Eduard Gaertner, *Beneath the Pont des Arts in Paris*

116 Eduard Gaertner, *The Klosterstrasse, with the Parochialkirche*

117 Adolph Menzel, *Two Views of a Wooden Gate and Leafless Shrubs*

118 Adolph Menzel, *Dr. Puhlmann's Bookshelf*

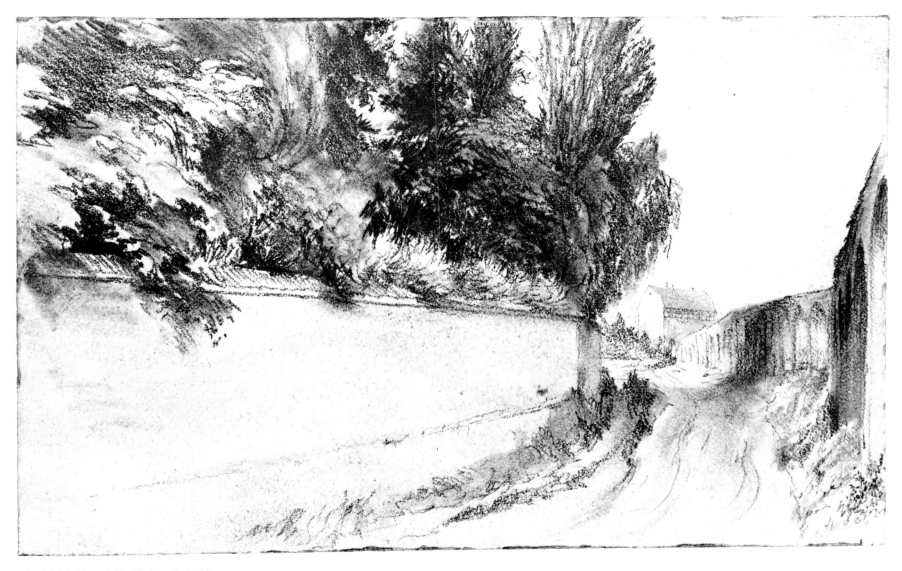

119 Adolph Menzel, *Road beside a Park Wall*

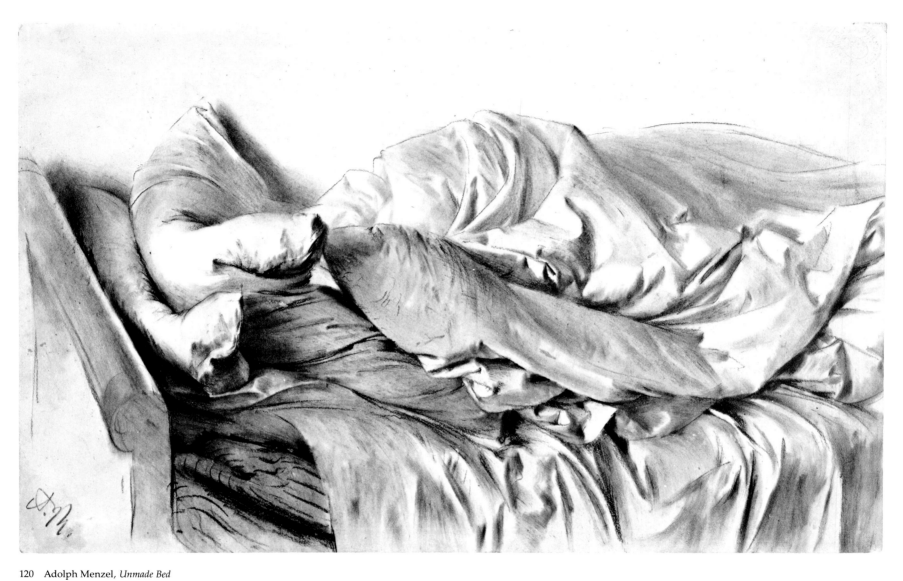

120 Adolph Menzel, *Unmade Bed*

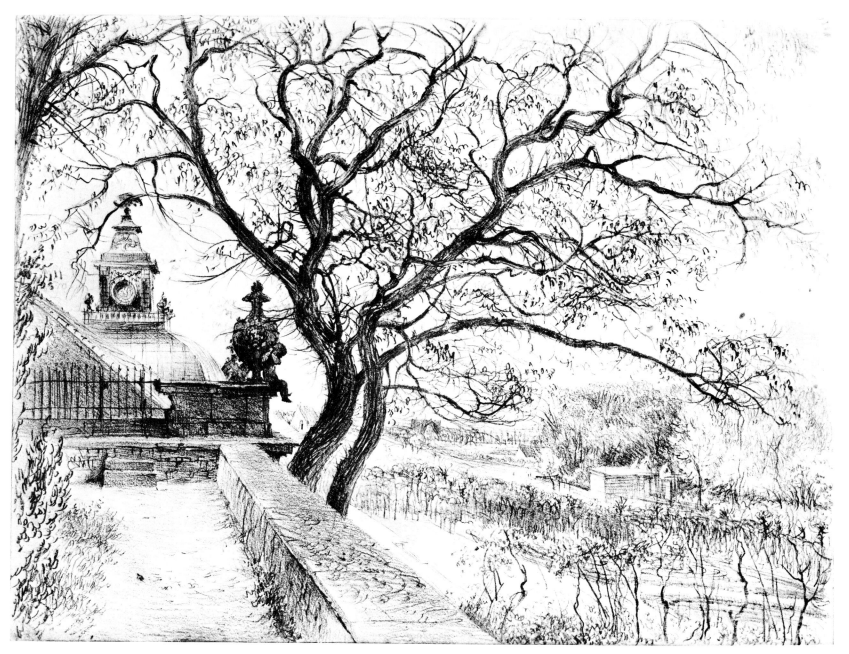

121 Adolph Menzel, *View from the Roof of the Picture Gallery at Sanssouci*

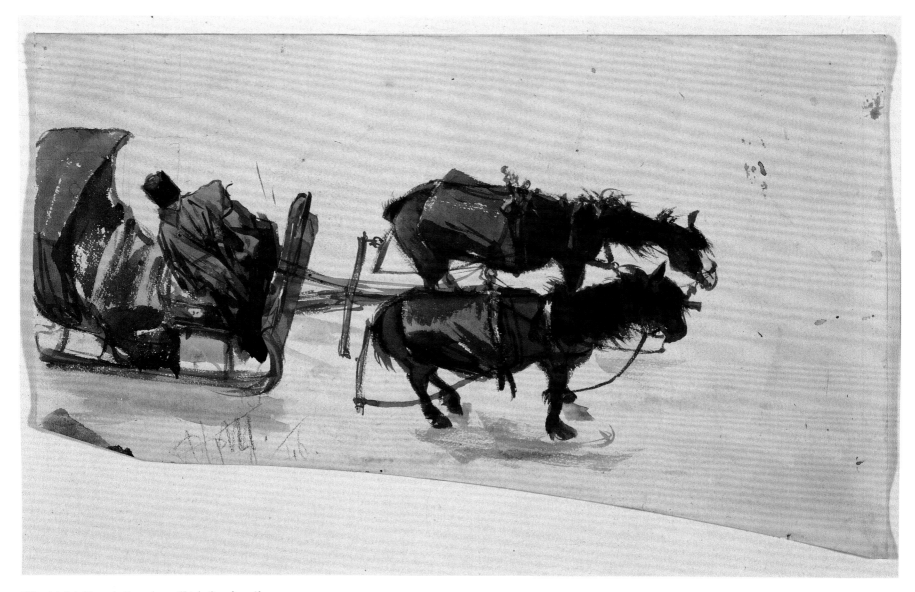

122 Adolph Menzel, *Horse-drawn Sleigh, Seen from Above*

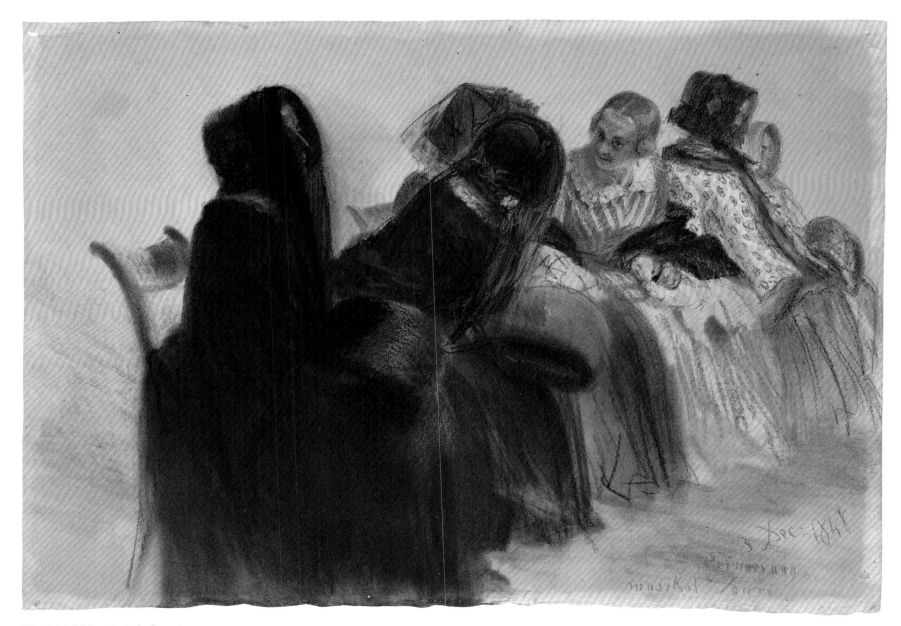

123 Adolph Menzel, *At the Concert*

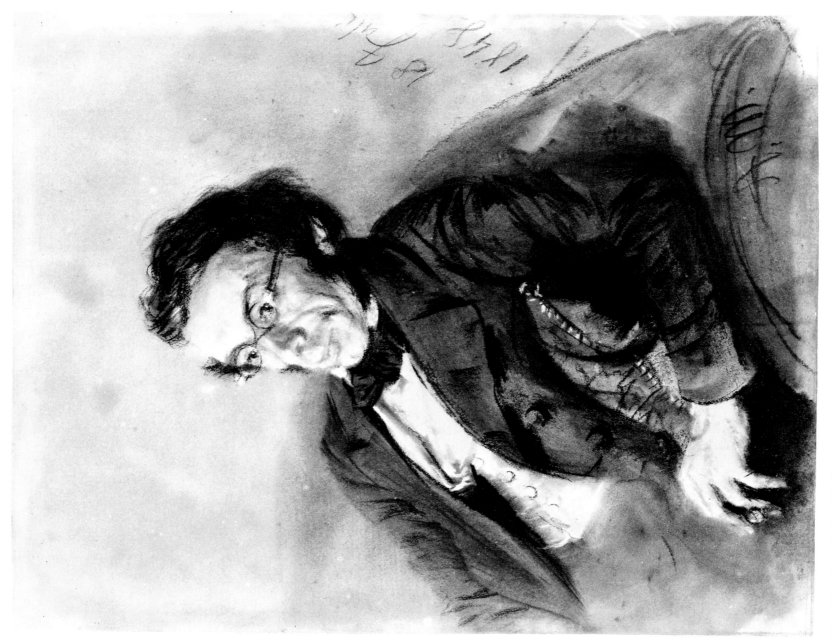

124 Adolph Menzel, *Portrait of Dr. Eitner*

Bibliography

BOOKS AND ARTICLES

Andrews, 1964
Keith Andrews. *The Nazarenes: A Brotherhood of German Painters in Rome.* Oxford, 1964.

Bärwald, 1984
Claus Bärwald. "Theodor Rehbenitz, ein Künstler aus dem Kreis Segeberg." In *Heimatkundliches Jahrbuch für den Kreis Segeberg.* Segeberg, 1984.

Belloni, 1970
Coriolano Belloni. *I pittori di Olevano.* Rome, 1970.

Benz, 1941
Richard Benz. *Goethes Götz von Berlichingen in den Zeichnungen von Franz Pforr.* Weimar, 1941.

Berckenhagen, 1967
Ekhart Berckenhagen. *Anton Graff: Leben und Werk.* Berlin, 1967.

Berefelt, 1961
Gunnar Berefelt. *Philipp Otto Runge zwischen Aufbruch und Opposition.* Uppsala, 1961.

Bernhard, 1973
Marianne Bernhard, ed. *Deutsche Romantik: Handzeichnungen.* 2 vols. Munich, 1973.

Bernhard, 1974
Marianne Bernhard, ed. *Caspar David Friedrich: das gesamte graphische Werk.* Munich, 1974.

Betthausen, 1980
Peter Betthausen. *Philipp Otto Runge.* Leipzig, 1980.

Bierhaus-Rödiger, 1978
Erika Bierhaus-Rödiger. *Carl Rottmann, 1797–1850. Monographie und Werkkatalog.* Munich, 1978.

Bock, 1923
Elfried Bock. *Adolph Menzel: Verzeichnis seines graphischen Werkes.* Berlin, 1923.

Boetticher, 1891
Friedrich von Boetticher. *Malerwerke des 19. Jahrhunderts: Beitrag zur Kunstgeschichte.* 4 vols. Leipzig, 1891–1901.

Börsch-Supan, 1960
Helmut Börsch-Supan. *Die Bildgestaltung bei Caspar David Friedrich.* Munich, 1960.

Börsch-Supan/Jähnig, 1973
Helmut Börsch-Supan and Karl Wilhelm Jähnig. *Caspar David Friedrich.* Munich, 1973.

Böttcher, 1937
Otto Böttcher. *Philipp Otto Runge: sein Leben, Wirken und Schaffen.* Hamburg, 1937.

Büttner, 1980
Frank Büttner. *Peter Cornelius: Fresken und Freskenprojekte.* 2 vols. Wiesbaden, 1980.

Decker, 1957
Hugo Decker. *Carl Rottmann.* Berlin, 1957.

Donop, 1902
Lionel von Donop. *Katalog der Handzeichnungen, Aquarelle und Ölstudien in der Königlichen Nationalgalerie.* Berlin, 1902.

Donop, 1908a
Lionel von Donop. *Der Landschaftsmaler Carl Blechen. Mit Benutzung der Aufzeichnungen Theodor Fontanes.* Berlin, 1908.

Donop, 1908b
Lionel von Donop. *Handzeichnungen A. v. Menzels.* Berlin, 1908.

Dörries, 1950
Bernhard Dörries. *Zeichnungen der Frühromantik.* Munich, 1950.

Drescher/Kroll, 1981
Horst Drescher and Renate Kroll. *Potsdam: Ansichten aus drei Jahrhunderten.* Weimar, 1981.

Eberlein, 1940
Kurt Karl Eberlein. *Caspar David Friedrich, der Landschaftsmaler. Ein Volksbuch deutscher Kunst.* Leipzig, 1940.

Ebert, 1960
Hans Ebert. "Verzeichnis der Werke Buonaventura Genellis, nach Themen geordnet als Anlage zur Dissertation: Themenwelt und Gestaltungsweise Buonaventura Genellis und deren Beziehungen zu einigen Bereichen der europäischen Kunstgeschichte." Phil. diss., Leipzig, 1960.

Einem, 1948
Herbert von Einem. "Das Bildnis der Eltern von Philipp Otto Runge." *Der Kunstbrief* 45 (1948): unp.

Einem, 1968
Herbert von Einem. *Die Tragödie der Karlsfresken Alfred Rethels.* Cologne and Opladen, 1968.

Feldmann, 1944
Wilhelm Feldmann. *Philipp Otto Runge und die Seinen. Mit ungedruckten Briefen.* Leipzig, 1944.

Feuchtmayr, 1975
Inge Feuchtmayr. *Johann Christian Reinhart, 1761–1847. Monographie und Werkverzeichnis.* Munich, 1975.

Franke, 1916
Willibald Franke. *Ludwig Richters Zeichnungen.* Berlin and Vienna, 1916.

Franke, 1921
Willibald Franke. *Alfred Rethels Zeichnungen.* Leipzig and Zurich, 1921.

Freitag-Stadler, 1975
Renate Freitag-Stadler. *Johann Adam Klein, 1792–1875. Bestandskataloge der Stadtgeschichtlichen Museen Nürnberg,* no. 1. Nuremberg, 1975.

Friedrich, 1937
Karl Josef Friedrich. *Die Gemälde Ludwig Richters.* Berlin, 1937.

Geismeier, 1964
Willi Geismeier. *Zeichnungen deutscher Romantiker.* Berlin, 1964.

Geismeier, 1967
Willi Geismeier. "Die Nazarenerfresken der Casa Bartholdy." *Staatliche Museen zu Berlin, Forschungen und Berichte* 9 (1967): 45–53.

Geismeier, 1984
Willi Geismeier. *Die Malerei der deutschen Romantik.* Dresden, 1984.

Geller, 1952
Hans Geller. *Die Bildnisse deutscher Künstler in Rom 1800–1830.* Berlin, 1952.

Geller, 1961
Hans Geller. *Karl Ludwig Kaaz.* Berlin, 1961.

Goeritz, 1942
Mathias Goeritz. *Ferdinand von Rayski und die Kunst des 19. Jahrhunderts.* Berlin, 1942.

Grimschitz, 1941
Bruno Grimschitz. *Deutsche Bildnisse von Runge bis Menzel.* Vienna, 1941.

Grossberger, 1924
Herbert Grossberger. "Carl Philipp Fohr. Ein Umriss seiner künstlerischen Entwicklung." Phil. diss., Heidelberg, 1924.

Grote, 1938
Ludwig Grote. *Die Brüder Olivier und die deutsche Romantik.* Berlin, 1938.

Grundmann, 1931
Günther Grundmann. *Das Riesengebirge in der Malerei der Romantik.* Breslau, 1931.

Hardenberg/Schilling, 1925
Kuno, Count von Hardenberg, and Edmund Schilling. *Karl Philipp Fohr: Leben und Werk eines deutschen Malers der Romantik.* Freiburg im Breisgau, 1925.

Hartmann, 1968
Wolfgang Hartmann. "Dantes Paolo und Francesca als Liebespaar. Entstehung und Entwicklung eines Bildthemas in der Malerei des 19. Jahrhunderts." *Jahrbuch des Schweizerischen Institutes für Archäologie und Kunstwissenschaft* (1968–69).

Heider, 1970
Gertrud Heider. *Carl Blechen.* Leipzig, 1970.

Heise, 1928
Carl Georg Heise. *Overbeck und sein Kreis.* Munich, 1928.

Heise, 1959
Carl Georg Heise. *Grosse Zeichner des 19. Jahrhunderts.* Berlin, 1959.

Hevesi, 1911
 Ludwig Hevesi. *Rudolf Alt: sein Leben und sein Werk*. Vienna, 1911.

Heydt, 1938
 Eduard von der Heydt. *Die wichtigsten Erwerbungen der Nationalgalerie 1933–38*. Berlin, 1938.

Hinz, 1966
 Sigrid Hinz. "Caspar David Friedrich als Zeichner." Phil. diss., Greifswald, 1966.

Hinz, 1973
 Sigrid Hinz. *Philipp Otto Runge*. Welt der Kunst. Berlin, 1973.

Hoch, 1987
 Karl-Ludwig Hoch. *Caspar David Friedrich und die böhmischen Berge*. Dresden, 1987.

Hoff/Budde, 1922
 Johann Friedrich Hoff and Karl Budde. *Adrian Ludwig Richter: Verzeichnis seines gesamten graphischen Werkes*. Freiburg im Breisgau, 1922.

Hofmann, 1960
 Werner Hofmann. *Das irdische Paradies: Kunst im 19. Jahrhundert*. Munich, 1960.

Holsten, 1974
 Siegmar Holsten. "Friedrichs Bildthemen und die Tradition." See Hamburg, 1974.

Howitt, 1886
 Margaret Howitt. *Friedrich Overbeck: sein Leben und Schaffen*. 2 vols. Freiburg im Breisgau, 1886.

Isermeyer, 1940
 Christian Adolf Isermeyer. *Philipp Otto Runge*. Berlin, 1940.

Jenderko-Sichelschmidt, 1973
 Ingrid Jenderko-Sichelschmidt. "Die Historienbilder Carl Friedrich Lessings." Phil. diss., Cologne, 1973.

Jensen, 1962
 Jens Christian Jensen. "Friedrich Overbecks Familienbild in Lübeck. Enstehungsgeschichte und Umkreis, 1818–1830." *Pantheon* xx (1962): 363–74.

Jensen, 1978
 Jens Christian Jensen. *Aquarelle und Zeichnungen der deutschen Romantik*. Munich, 1978.

Justi, 1919
 Ludwig Justi. *Deutsche Zeichenkunst im 19. Jahrhundert: ein Führer zur Sammlung der Handzeichnungen in der Nationalgalerie*. Berlin, 1919.

Kamphausen, 1941
 Alfred Kamphausen. *Asmus Jakob Carstens*. Neumünster, 1941.

Keiser, 1973
 Herbert Wolfgang Keiser. *Des Mannes Stärke und andere Bilder für das Schloss zu Oldenburg von J. W. Tischbein*. Oldenburg, 1973.

Kern, 1911
 Guido Josef Kern. *Karl Blechen: sein Leben und seine Werke*. Berlin, 1911.

Koch, 1905
 David Koch. *Peter Cornelius, ein deutscher Maler*. Stuttgart, 1905.

Koschatzky, 1975
 Walter Koschatzky. *Rudolf von Alt, 1812–1905*. Salzburg, 1975.

Koschatzky, 1982
 Walter Koschatzky. *Die Kunst des Aquarells*. Salzburg and Vienna, 1982.

Krämer, 1979
 Gode Krämer. "Der Maler und Zeichner August Heinrich." Phil. diss., Karlsruhe, 1979.

Krauss, 1930
 Friedrich Krauss. *Carl Rottmann*. Heidelberg, 1930.

Kurth, 1941
 Willy Kurth. *Berliner Zeichner*. Berlin, 1941.

Lehr, 1924
 Fritz Herbert Lehr. *Die Blütezeit romantischer Bildkunst: Franz Pforr, der Meister des Lukasbundes*. Marburg, 1924.

Lehrs, 1908
 Max Lehrs. *Geschichte und Kritischer Katalog des deutschen, niederländischen und französischen Kupferstichs im xv. Jahrhundert*. Vienna, 1908–30.

Leonhardi, 1938
 Klaus Leonhardi. "Neuerwerbungen der Nationalgalerie." *Berliner Museen: Jahrbuch der Preussischen Kunstsammlungen* 59, supp. (1938).

Leuschner, 1979
 Vera Leuschner. "Der Landschafts- und Historienmaler Carl
 Friedrich Lessing (1808–1880)." In *Die Düsseldorfer Malerschule*. Exhi-
 bition catalogue, pp. 86–97. Düsseldorf and Darmstadt, 1979.

Leuschner, 1982
 Vera Leuschner. *Carl Friedrich Lessing, 1808–1880*. Cologne and
 Vienna, 1982.

Liebermann/Kern, 1927
 Max Liebermann and Guido Josef Kern. *A. Menzel: 50 Zeichnungen,
 Pastelle und Aquarelle aus dem Besitz der Nationalgalerie*. Berlin, 1927.

Lippold, 1968
 Gertraute Lippold. "Joseph Anton Koch. Koch zum 200.
 Geburtstag." *Dresdener Kunstblätter* 5/6 (1968).

Lutterotti, 1940/1985
 Otto R. von Lutterotti. *Joseph Anton Koch, 1768–1839. Mit einem
 Werkverzeichnis und Briefen des Künstlers*. 2nd ed. Berlin, 1985.

Mackowsky, 1927
 Hans Mackowsky. *Johann Gottfried Schadow: Jugend und Aufstieg*.
 Berlin, 1927.

Manteuffel, 1924
 Klaus Zoege von Manteuffel. "Die Zeichnungen von Franz Horny
 im Dresdener Kupferstich-Kabinett." *Cicerone* XVI (1924): 272–79.

Markowitz, 1969
 Irene Markowitz. "Die Düsseldorfer Malerschule." *Kataloge des
 Kunstmuseum Düsseldorf* IV (1969).

Martius, 1934
 Lilli Martius. "Theodor Rehbenitz." *Mitteilungen der Gesellschaft für
 Kieler Stadtgeschichte* (1934).

Martius, 1956
 Lilli Martius. *Die schleswig-holsteinische Malerei im 19. Jahrhundert*.
 Neumünster, 1956.

McVaugh, 1981
 Robert McVaugh. "The Casa Bartholdy Frescoes and Nazarene
 Theory in Rome, 1816–1817." Ph.D. diss., Princeton University, 1981.

Menzel, 1976
 Adolph Menzel. *Das graphische Werk*, edited by Heidi Ebertshäuser.
 2 vols. Munich, 1976.

Mildenberger, 1987
 H. Mildenberger. *J. H. W. Tischbein, Goethes Maler und Freund*. Landes-
 museum Oldenburg, 1987.

Neidhardt, 1969
 Hans Joachim Neidhardt. *Ludwig Richter*. Leipzig, 1969.

Neidhardt, 1976
 Hans Joachim Neidhardt. *Die Malerei der Romantik in Dresden*. Leipzig,
 1976.

Neidhardt, 1981
 Hans Joachim Neidhardt. *Ernst Ferdinand Oehme*. Künstlermappe.
 Leipzig, 1981.

Nemitz, 1941–42
 Fritz Nemitz. "Ein neuentdeckter C. D. Friedrich." *Die Kunst für alle*
 57 (1941–42): 269.

Novotny, 1971
 Fritz Novotny. *Ferdinand Oliviers Landschaftszeichnungen von Wien und
 Umgebung*. Graz, 1971.

Nowald, 1978
 Inken Nowald. "Die Nibelungenfresken von J. Schnorr von
 Carolsfeld im Königsbau der Münchener Residenz 1827 bis 1867."
 Phil. diss., Kiel, 1978.

Passavant, 1820
 Johann David Passavant. *Ansichten über die bildenden Künste und
 Darstellung des Ganges derselben in Toscana: zur Bestimmung des
 Gesichtspunctes, aus welchem die neudeutsche Malerschule zu betrachten
 ist*. Heidelberg and Speyer, 1820.

Pforr, 1927
 Franz Pforr. "Das Buch Sulamith und Maria." In *Der Wagen. Ein
 lübeckisches Jahrbuch*. Lübeck, 1927.

Ponten, 1911
 Josef Ponten. *Alfred Rethel: des Meisters Werke*. Stuttgart and Leipzig,
 1911.

Prause, 1968
 Marianne Prause. *Carl Gustav Carus: Leben und Werk*. Berlin, 1968.

Raczynski, 1841
 Count Athanasius Raczynski. *Geschichte der neueren deutschen Kunst*.
 3 vols. Berlin, 1841.

Rave, 1940
Paul Ortwin Rave, ed. *Karl Blechen: Leben, Würdigungen, Werke.* Berlin, 1940.

Reitharovà/Sumowski, 1977
Eva Reitharovà and Werner Sumowski. "Beiträge zu Caspar David Friedrich." *Pantheon* 35 (1977): 41–50.

Richter, 1922
Ludwig Richter. *Lebenserinnerungen eines deutschen Malers,* edited by Max Lehrs. Berlin, 1922.

Richter, 1976
Ludwig Richter. *Lebenserinnerungen eines deutschen Malers, den Jugendtagebüchern und den Jahresheften,* epilogue by Hans Joachim Neidhardt. Leipzig, 1976.

Richter, 1982
Ludwig Richter. *Lebenserinnerungen eines deutschen Malers.* Leipzig, 1982.

Riegel, 1866
Hermann Riegel. *Cornelius: der Meister der deutschen Malerei.* Hanover, 1866.

Runge, 1840
Philipp Otto Runge. *Hinterlassene Schriften,* edited by Daniel Runge. Hamburg, 1840.

Salomon, 1930
Felix Salomon. "Die Faustillustrationen von Cornelius und Delacroix: eine Parallele." Phil. diss., Würzburg, 1930.

Schasler, 1856
Max Schasler. *Berlins Kunstschätze: ein praktischer Führer zum Gebrauch bei Besichtigung derselben.* 2 vols. Berlin, 1856.

Scheffler, 1915
Karl Scheffler. *Adolph Menzel: der Mensch, das Werk.* Berlin, 1915.

Scheffler, 1938
Karl Scheffler. *Adolph Menzel.* Berlin, 1938.

Scheidig, 1954
Walter Scheidig. *Franz Horny.* Berlin, 1954.

Schilling, 1935
Edmund Schilling. *Deutsche Romantiker-Zeichnungen.* Frankfurt am Main, 1935.

Schmidt, 1922
Paul Ferdinand Schmidt. *Deutsche Landschaftsmalerei von 1750 bis 1830.* Munich, 1922.

Schmoll, 1970
J. A. Schmoll, called Eisenwerth. "Fensterbilder-Motivketten in der europäischen Malerei. Beiträge zur Motivkunde des 19. Jahrhunderts." In *Studien zur Kunst des 19. Jahrhunderts,* vol. 6, pp. 13–165. Munich, 1970.

Schwarz, 1958
Heinrich Schwarz. *Salzburg und das Salzkammergut.* 3rd ed. Vienna and Munich, 1958.

Schwarz, 1960
Heinrich Schwarz. "August Heinrich und die geistigen Voraussetzungen seiner Malerei." *Mitteilungen der Österreichischen Galerie* 6 (1960).

Simon, 1930
Karl Simon. "Die Frühzeit des Peter Cornelius." In *Sammlung kleiner Düsseldorfer Schriften.* Düsseldorf, n.d. [1930].

Simson, 1975
Otto von Simson. "Über einige Zeichnungen von Karl Blechen." In *Schloss Charlottenburg. Berlin. Preussen. Festschrift für Margarete Kühn,* pp. 247–53. West Berlin, 1975.

Singer, 1911a
Hans Wolfgang Singer. *Julius Schnorr von Carolsfeld.* Bielefeld and Leipzig, 1911.

Singer, 1911b
Hans Wolfgang Singer. *Katalog der Bildniszeichnungen des Kgl. Kupferstich-Kabinetts zu Dresden.* Dresden, 1911.

Singer, 1926
Hans Wolfgang Singer, ed. *Adrian Ludwig Richter: Ölgemälde, Aquarelle, Zeichnungen.* Leipzig, 1926.

Steffens, 1908
Henrik Steffens. *Lebenserinnerungen aus dem Kreis der Romantik,* edited by Friedrich Gundelfinger. Jena, 1908.

Straub-Fischer, 1966
E. Straub-Fischer. "Der Salzburger Friedhof zu St. Peter in den Zeichnungen deutscher Romantiker." *Mitteilungen der Gesellschaft für Salzburger Landeskunde* (1966).

Sumowski, 1970
Werner Sumowski. *Caspar David Friedrich-Studien*. Wiesbaden, 1970.

Traeger, 1975
Jörg Traeger. *Philipp Otto Runge und sein Werk: Monographie und kritischer Katalog*. Munich, 1975.

Trenkmann, 1985
Petra Trenkmann. "Julius Schorr von Carolsfeld: Zeichnungen bis 1827." Phil. diss., Greifswald, 1985.

Tschudi, 1905
Hugo von Tschudi. *Adolph von Menzel: Gesamtwerk seiner Gemälde und Studien in Abbildungen*. Berlin, 1905.

Valentin, 1896
V. Valentin. "Zum Gedächtnis Alfred Rethels." *Zeitschrift für bildende Kunst*, n.s. (1896).

Verbeek, 1965
Albert Verbeek. " 'Ein Ostermorgen' von Johann Anton Ramboux." In *Festschrift Herbert von Einem*, pp. 293–98. Berlin, 1965.

Waetzoldt, 1951
Stephan Waetzoldt. "Philipp Otto Runges 'Vier Zeiten.' " Typescript. Phil. diss., Hamburg, 1951.

Walter, 1943
Maräuschlein Walter. *Ferdinand von Rayski: sein Leben und sein Werk*. Bielefeld and Leipzig, 1943.

Weidmann, 1927
Walter Weidmann. *Franz Krüger*. Berlin, n.d. [1927].

Werner, 1982
Winfried Werner. "Ludwig Richter als Landschafter in Böhmen und Schlesien." Master's thesis, Karl-Marx-Universität, Leipzig, 1982.

Wichmann, 1970
Siegfried Wichmann. *Wilhelm von Kobell: Monographie und kritisches Verzeichnis der Werke*. Munich, 1970.

Wiedemann, 1944
Karl Wiedemann. "Adrian Zingg, der Künstler: seine Werke und die sächsische Landschaftskunst." Incomplete typescript. Kupferstich-Kabinett der Staatliche Kunstsammlungen, Dresden, n.d. [1944].

Wilhelm-Kästner, 1940
Kurt Wilhelm-Kästner. *Caspar David Friedrich und seine Heimat*. Berlin, 1940.

Winkler, 1936
Friedrich Winkler. *Die Zeichnungen Albrecht Dürers*. 4 vols. Berlin, 1936–39.

Winter, 1965
Wolfgang Winter. "Dante Illustrationen der deutschen Romantiker." *Dresdener Kunstblätter* 11 (1965).

Wirth, 1979
Irmgard Wirth. *Eduard Gaertner: der Berliner Architekturmaler*. Frankfurt am Main, Vienna, and Berlin, 1979.

Wolff, 1914
Hans Wolff. *Menzels Briefe*. Berlin, 1914.

EXHIBITION CATALOGUES

Aachen, 1959
Alfred Rethel. Suermondt-Museum, Aachen, 1959.

Berlin, 1880
Ausstellung der Werke Karl Friedrich Lessings. Königliche National-Galerie, Berlin, 1880.

Berlin, 1881–82
Werke von Marie Parmentier, Karl Blechen, Adolf Schrödter und August Bromeis. Königliche National-Galerie, Berlin, 1881–82.

Berlin, 1904
Katalog der Ausstellung von Werken Moritz von Schwind. Königliche National-Galerie, Berlin, 1904.

Berlin, 1905
Ausstellung von Werken Adolph von Menzels. Königliche National-Galerie, Berlin, 1905.

Berlin, 1906
Ausstellung deutscher Kunst aus der Zeit von 1775 bis 1875 in der Königlichen National-Galerie. 2 vols. Berlin, 1906.

Berlin, 1936
Preussische Akademie der Künste: Jubiläumsausstellung 1786–1936. Berlin, 1936.

Berlin, 1938
Die wichtigsten Erwerbungen in den Jahren 1933–1937. National-Galerie, Berlin, 1938.

Berlin, 1939
Joseph Anton Koch: Gemälde und Zeichnungen. National-Galerie, Berlin, 1939.

Berlin, 1949
National-Galerie—Gemälde, Zeichnungen, Bildwerke. Cat. by Paul Ortwin Rave. Berlin, 1949.

Berlin, 1954
Zeichnungen deutscher Meister vom Klassizismus bis zum Impressionismus. Cat. by Ludwig Justi. Staatliche Museen zu Berlin, Nationalgalerie, 1954.

Berlin, 1955a
Patriotische Kunst aus der Zeit der Volkserhebung 1813. Deutsche Akademie der Künste, Berlin, 1955.

Berlin, 1955b
Adolph Menzel Zeichnungen. Cat. by Werner Schmidt. Staatliche Museen zu Berlin, Nationalgalerie, 1955.

Berlin, 1962
Deutsche Bildnisse, 1800–1960. Staatliche Museen zu [East] Berlin, Nationalgalerie, 1962.

Berlin, 1963
Anton Graff, 1736–1813. Staatliche Museen zu Berlin, Nationalgalerie, 1963.

Berlin, 1964
Zeichnungen deutscher Romantiker. Cat. by Willi Geismeier. Staatliche Museen zu Berlin, Nationalgalerie, 1964.

Berlin, 1964–65
Johann Gottfried Schadow, 1764–1850: Bildwerke und Zeichnungen. Cat. by Gottfried Riemann and Annegret Janda. Staatliche Museen zu Berlin, Nationalgalerie, 1964–65.

Berlin, 1965
Deutsche Romantik: Gemälde, Zeichnungen. Cat. by Willi Geismeier and Gottfried Riemann. Staatliche Museen zu Berlin, Nationalgalerie, 1965.

Berlin, 1966–67
Deutsche Kunst des 19. und 20. Jahrhunderts. Staatliche Museen zu Berlin, Nationalgalerie, 1966–67.

Berlin, 1973
Karl Blechen, 1798–1840: Ölskizzen, Aquarelle, Sepiablätter, Zeichnungen, Entwürfe. Cat. by Lothar Brauner. Staatliche Museen zu Berlin, Nationalgalerie, 1973.

Berlin, 1974
Julius Schnorr von Carolsfeld, 1794–1872: aus dem zeichnerischen Werk. Cat. by Gottfried Riemann and Maria Ursula Riemann-Reyher. Staatliche Museen zu Berlin, Nationalgalerie, 1974.

Berlin, 1977
Eduard Gaertner, 1801–1877. Cat. by Ursula Cosmann. Märkisches Museum, Berlin, 1977.

Berlin, 1980
Adolph Menzel: Gemälde, Zeichnungen. Cat. by Claude Keisch. Staatliche Museen zu Berlin, Nationalgalerie, 1980.

Berlin, 1980–81
Karl Friedrich Schinkel 1781–1841. Cat. by Gottfried Riemann et al. Staatliche Museen zu Berlin, 1980–81.

Berlin, 1987
Kunst in Berlin, 1648–1987. Staatliche Museen zu Berlin, 1987.

Bern, 1985
Traum und Wahrheit: deutsche Romantik aus Museen der Deutschen Demokratischen Republik. Kunstmuseum, Bern, 1985.

Cologne, 1966–67
J. A. Ramboux: Maler und Konservator, 1790–1866. Wallraf-Richartz-Museum, Cologne, 1966–67.

Cottbus, 1960
Sonderausstellung Carl Blechen im Museum Cottbus. Schloss Branitz, Cottbus, 1960.

Cottbus, 1963
Sonderausstellung Carl Blechen im Museum Cottbus. Schloss Branitz, Cottbus, 1963.

Dresden, 1913
Anton Graff: Ausstellung. Sächsischer Kunstverein, Dresden, 1913.

Dresden, 1928
Kunst in Sachsen vor 100 Jahren. Dresden, 1928.

Dresden, 1933
Sächsische Zeichnungen aus vier Jahrhunderten. Dresden, 1933.